ORPHANED LANDSCAPES

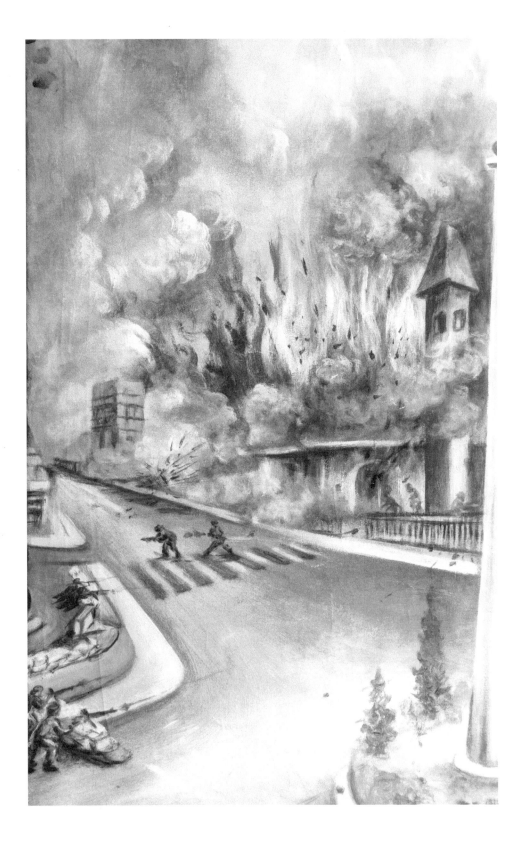

ORPHANED LANDSCAPES

VIOLENCE, VISUALITY, AND APPEARANCE IN INDONESIA

PATRICIA SPYER

FORDHAM UNIVERSITY PRESS NEW YORK 2022

Fordham University Press gratefully acknowledges financial assistance
and support provided for the publication of this book by the Swiss National
Science Foundation.

Visit us online at www.fordhampress.com.

Library of Congress Cataloging-in-Publication Data available online
at https://catalog.loc.gov.

24 23 22 5 4 3 2 1
First edition

for Rafael

Contents

ORPHANED LANDSCAPES

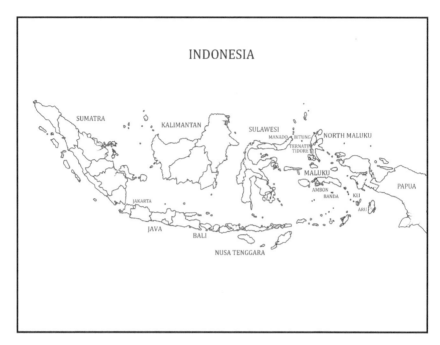

Figure 1. Map of Indonesia. Map by Ratih Prebatasari.

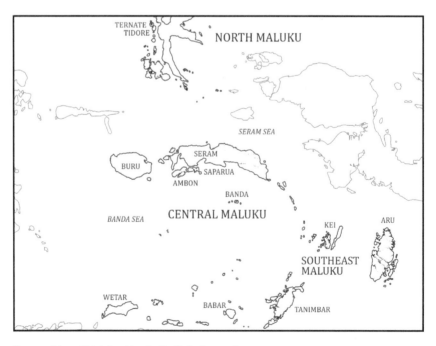

Figure 2. Map of Maluku. Map by Ratih Prebatasari.

Introduction

Violence, Visuality, and Appearance

> It is only shallow people who do not judge by appearances. The true
> mystery of the world is the visible, not the invisible.
> — OSCAR WILDE, *The Picture of Dorian Gray*

A great haze envelopes the city. Shadowy figures stalk the streets and fire the imagination. Lurking at the edge of vision, they inspire terror, incite rumors, and provoke conspiracy theories. Cries of "Halleluyah" or "Allahu akbar" echo from the embattled streets, piercing the pervasive unseeing that cloaks the city and striking fear into those who hear them. Afflicted by the uncertainty of the situation, familiar forms of the everyday suddenly loom large, appearing treacherous, even grotesque. In such charged circumstances, the most familiar things provoke terror: the well-known face of a neighbor possibly masking something else, a strange lack of clarity clouding habitual surroundings, or the intense horror instilled by objects as they shed their usual shapes, gushing blood or casting shadows that dance eerily on the walls of the intimate spaces of home, religion, and community. In this dense fog of war, huge pictures unexpectedly rise up, bearing faces that tower over the city's barricaded streets and the debris of battle. Shiny, bright, and assertive, they emerge littered among war's ruins as points of clarity in the all-encompassing gloom. Haunting perception, especially during crisis when everyday appearances can no longer be assumed, this chiaroscuro terrain between visible and invisible is the fraught space where the forms of the world are figured and come about. But it is also where they can be fatefully undone. Much of what I have to say in this book originates there.

* * *

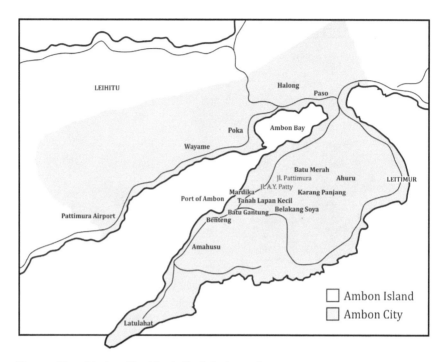

Figure 3. Map of Ambon City. Map by Ratih Prebatasari.

Ambon, 2005 (Figure 3). When I arrived in the Central Malukan provincial capital in the wake of the interreligious violence that wracked the city at the turn of the last century, the first thing I did was to go for a walk, setting out from my hotel facing the Maranatha church, the seat of the colonial-derived Protestant Church of the Moluccas (I. *Gereja Protestan Maluku*, or GPM).[1] Having landed shortly after daybreak on a night flight from Jakarta, it was already midmorning when I started along the once-elegant Pattimura Raya Avenue, named for a nineteenth-century national hero from Maluku who famously stood off the Dutch colonizers in this eastern part of Indonesia. The trees that had always cast a welcome shadow on the hot pavement were still there, some new banks had arisen in the place of older ones, and a bigger, more ostentatious cathedral appeared under construction, its front lot strewn with building materials and its imposing entrance boarded shut. The city's large telecommunications office stood across from the post office as it always had. And I was relieved to find the Rumphius Library—commemorating the seventeenth-century German botanist employed by the Dutch East India Company and author of writings on the region, such as the *Herbarium*

Amboinense and *Amboina Curiosity Cabinet*—in the Catholic diocese's complex, newly located in more spacious surroundings. Like the statue of Saint Francis Xavier next to the old cathedral with a crab clutching a cross between its claws at his feet, the library was a familiar landmark where I always stopped on my many trips to Ambon, beginning in 1984 when I passed through the city en route to the Aru Islands in Southeast Maluku for an initial visit before beginning fieldwork there for my doctoral dissertation.

But there was also much that had changed. Traffic congested the formerly quiet thoroughfare where previously only pedicabs and the occasional minibus traveled, while pedestrians and street vendors peddling an array of snacks and colorful drinks claimed the sidewalks. Pedicabs still cycled slowly down the avenue but now hugged the side of the street, avoiding the minibuses, whose numbers had multiplied, the new Toyota Kijang vans transporting army staff, government officials, representatives of humanitarian organizations, and the place's more prosperous citizens, and the motorbikes that darted in and out of the cars. Mindful of the traffic, I joined the crowd of people walking and strolling in the street: women returning from their morning errands, boisterous schoolchildren dressed in the red, navy, and gray uniforms that indicated their level of schooling, civil servants in their characteristic khaki attire, and other passersby. With them I wove my way around the makeshift shacks and numerous stalls that had mushroomed along the avenue and on sidewalks after the city's main market burned down in January 1999 in the first days of the religiously inflected conflict between Muslims and Christians. A few food stalls with a handful of customers stood between the vendors of newspapers and magazines, computer rental stalls, shacks advertising photocopy services or a haircut, and others with racks displaying music CDs and video compact discs (VCDs), divided into sections marked Western, Pop, and Religious.

If you were looking for Muslim music or sermons, however, you would search in vain, for in this central part of town—dominated historically by Christians, especially Protestants, who formed the majority of Ambon's civil bureaucracy and its largely uncontested elite until the 1990s—*religious* was a gloss for *Protestant*. To purchase Muslim CDs and VCDs, one would head to the Muslim areas of town, where a wide range of retail and wholesale shops and vendors crowded the streets adjacent to Ambon's busy harbor. Although the town has been largely segregated along religious and ethnic lines since colonial times, the religious conflict hardened these divisions as territories claimed by either side displaced populations who no longer belonged and further homogenized neighborhoods into Christian and Muslim enclaves. After the war, people were acutely attuned to this georeligious topography and were often wary when passing from one part of town to another. Like so much else in the postwar city,

even the name for the jumble of shacks that had sprung up on Pattimura Avenue, along with others like it elsewhere, *pasar kaget*—literally, a market that had been "shocked" into existence—seemed to evoke the conflict. While used for informal markets throughout Indonesia, in Ambon the name appeared to echo the excessive violence that overtook the city from 1999 until the early 2000s, as I discuss below.

At the end of the avenue, I veered left, continuing until I arrived at a street leading into the hills above the city where many of the middle-class Christians live. Turning the corner, it was a shock to find myself looking up into the face of Jesus Christ. On what had once been a commercial billboard, a close-up of Christ's anguished face blown up to monumental proportions overlooked the street. Several letters from the phrase "King of the Jews" in Latin could be seen extending behind his head on the cross. Other enlarged scenes unfolded on an adjacent wall—Christ in prayer, twigs of holly and bells, another Christ face framed by a star. In a city known for its Dutch-derived Calvinist Protestantism where such public displays of Christian piety had previously been absent, the discovery of the gigantic street pictures was all the more surprising.

None of my trips during the previous two decades had prepared me for this startling encounter, not even the short visit I made two years before, in 2003, when I spotted a large Jesus portrait in front of the Maranatha church and caught glimpses of a crudely rendered Santa Claus and some Romans crowding around Christ on the walls of a Christian neighborhood. Far less strident than this huge street-corner Jesus flanked by Christian scenes, those images had struck me at the time as incidental. Although my short walk up Pattimura Avenue and my taxi ride earlier that morning had taken me past numerous mosques and churches, this demonstrative religious presence was unlike anything I had seen before.

In retrospect, this was one of those serendipitous yet preconditioned encounters to which the anthropological method, one of intimate ethnographic engagement with everyday life over extended periods of time, makes us especially susceptible.[2] Well before I had seen Christ at large in Ambon, I had already described the city's wartime conditions as a pervasive unseeing or blindness akin to a thick fog blanketing the place and triggering forms of extreme perception among its inhabitants, or the challenging atmospherics of conflict that I conjured at the opening of this book. When I happened upon the street corner embellished with Christian scenes, I immediately sensed their importance. But I wondered what I was to make of these images. Might they manifest a new way of seeing—one, to be sure, that announced itself assertively? Had those weary of war's uncertainty and gloom thrown up pictures as points of defiance, solace, and religious identification in the midst of the city's devastation?

Throughout this book, I move back and forth between the figuring impulse that compelled some Christians to paint Christianity in Ambon's streets and the disfiguring momentum of violence as many of the city's everyday rhythms and familiar texture were undone by war, a dynamic that, over time, I came to see as significant.

The description of the conflict and my analysis of the fog of war and its enfolding within the conflict's violence are the subject of Chapter 1. It especially draws on several months of fieldwork in 2000 and 2001 in Manado, the Christian majority capital of North Sulawesi province. During my time there, I divided my attention among the swelling numbers of primarily Christian refugees fleeing the violence in Maluku, journalists from the city's print media institutions, representatives of religious organizations and churches, and a handful of NGOs who worked in the camps. Equally important was my reading of the initial reports and analyses about Ambon and other parts of Indonesia where numerous incidents, large and small, of ethnically and religiously inflected violence occurred around the country in 1998 and soon thereafter, following the collapse of the authoritarian regime of Indonesia's president, Suharto.[3]

The formal announcement on May 21, 1998, of Suharto's momentous decision to step down from the presidency after more than thirty-two years in power fell on National Awakening Day. Much could be read into the coincidence of the resignation with this holiday, which commemorates the 1908 birth of a national student movement, dedicated to achieving independence from Dutch colonial rule. Far less recognized was the resignation's coincidence with a second holiday, the Ascension of Jesus Christ, which in 1998 also fell on May 21. I only became aware of this second holiday as I began to write the Introduction of this book, but in light of much that follows, it is hard not to discern some poetic truth in the concurrence of the regime's collapse and the ascent of Jesus Christ.[4]

From my first startled encounter with Christ's immense face on a public street through the weeks and months thereafter in which I came to know Ambon in its new postwar circumstances, I encountered a city crowded with such pictures. Along highways, at important crossroads, or facing outward from the gateways of Christian neighborhoods, huge Jesus faces towered over the passersby and traffic moving below, while murals showing Christian martyrdom or emblems snatched from Christmas cards formed attention-grabbing backdrops to the urban congestion of pedicabs, motorbikes, pedestrians, minibuses, and Toyota Kijang vans. In 2005, I began fieldwork in the Malukan capital by pursuing the pictures, following them to different locations around the city, up into the hills where many Christians live, and into churches where, arresting

and unprecedented, figures of Jesus had recently appeared behind some Protestant altars. Over time, I discovered more new pictures tucked away in Christian homes, whose well-to-do owners had commissioned small painted rooms set aside for prayer or Christian-themed walls, and an enormous triptych, prophesizing the apocalypse, hidden out of sight in a warehouse only a short drive outside of Ambon.

During the years in which I visited and carried out fieldwork in the city, the magnitude, number, and heterogeneity of these images never ceased to amaze me: from the tormented Jesus face with a crown of thorns and huge eyes upturned to heaven on a billboard along the highway from the airport into Ambon, or another brilliantly blue-eyed billboard Christ acclaimed by many of the city's Christians, to scenes of Jesus surrounded by Roman soldiers stretching out on city walls or his head hovering above an urban battlefield where tiny, white-clad jihadis clashed with Indonesian army soldiers. Some, like the cameo Jesus portraits with painted serrated edges, stood out even more than others, their cut-out distinctiveness recalling the Indonesian citizen identity card's requisite photograph. Striking, too, was the indigenous brown Christ in Ambonese attire from a Protestant minister's drawing that he fantasized blown-up and on display in the national library in the capital Jakarta. There was also the more regal Christ dating from a later moment, emanating authority and protection from behind Protestant church altars in Ambon and across the Malukan islands.

Orphaned Landscapes asks why the image of Christ has moved center stage and, more broadly, why images are being publicly monumentalized at this historically and politically fraught juncture in Indonesia. It analyzes their affective charge in Ambon as a new medium, one capable of offering some comfort to the city's Christians during the conflict that engulfed the city in intermittent violence for three years starting mid-January 1999, with tension and disturbances continuing for some time thereafter. On the eve of the so-called Malino II Peace Agreement in early 2002,[5] the conflict left a city divided into Christian and Muslim territories, with up to ten thousand persons killed. When one includes those fleeing violence, close to seven hundred thousand were displaced, a number equaling one-third of a total Malukan population of 2.1 million, comprising also those on neighboring islands.[6] Beyond their significance in Ambon's war or its aftermath, the book also attends to how these pictures, in the first place, were something to be seen, admired, and gazed at by Christians, offensive to or ignored by Muslims, catching the eyes of passersby, interrupting the flow of traffic, or marshaled as a backdrop in wartime for photographs of young Christian men brandishing weapons or other poses caught on camera. Potent material presences standing on sidewalks and along streets in the wartime and postwar urban environment, these images had the

capacity for some to imaginatively transport them beyond any specific context, even something as dire and encompassing as the deep disturbance and brutality of war. If any image necessarily establishes its own "force field," this ethnographic study examines the forces that coalesced around and animated these pictures.[7] Besides those outlined below, the force emanating from the material presence of the pictures themselves, as they sprung up and claimed a place in the city, was palpable.

In what follows, I single out for attention the most important among the histories, discourses, imaginations, and affective dispositions that fed the dynamic, mutable environment in which the Christian pictures proliferated. I also consider questions of power, including the waning of the social, political, and economic power of Protestants in Ambon and Central Maluku, and the regional and national politics that are relevant to understanding the transformation of the city and its appearance. Although I separate them for clarity's sake, what concerns me most is how these different forces came together, creating a mobile field around the street pictures where they interacted with each other. Also, how these convergences helped to determine how the pictures mattered or did not matter to the myriad people who saw them, whether those comprising Ambon's diverse urban population or others who came to the city, for a host of reasons, during and after the war. Although I will have occasion to mention others in this book, the most relevant forces include the legacies of Dutch colonialism in Maluku, especially the relative visibility and privileging of Protestant Ambonese versus the exclusion and invisibility of Muslims, and the erosion of this long-standing difference with Indonesia's greening or Islamicization from the early 1990s on. Of overriding importance for understanding the pictures' raison d'être are also the enormous repercussions around Indonesia, with particular implications in Ambon, of the unraveling of the Suharto regime. These include the profound uncertainties but also possibilities unleashed by the dissemination of the discourses of the student-led Reformasi (political reform) movement that brought Suharto's so-called New Order government down as these reverberated at a far remove from Jakarta in Ambon. The conflict also intensified the spread and eager embrace of new visual and audiovisual technologies that were already underway due to the liberalization of media in Indonesia during the late Suharto years and the lifting of draconian media and censorship laws by his successor, Habibie. It is no coincidence that the Christian paintings took off at precisely the time a surge in new visual and audiovisual technologies helped shape diverse modalities of communication and experience. Apart from participating in a wider attunement to visual experience and media characteristic of the time in Indonesia, some of the street pictures and the discourse around them explicitly evidence the impact of media

technologies and practice. For instance, a billboard of Christ looking down on a globe turned to Ambon and the neighboring islands recalls the establishing shot of national prime-time news as it homes in on a newsworthy location.

In the sections below, I introduce the analytical vocabulary and theoretical stakes of the book centered on questions of images, visuality, and appearance. An introduction to Ambon follows, in which I highlight the skewed history of visibility between Christians and Muslims. I then provide an overview of the crises and month-long protests that culminated in the Suharto regime's collapse and its consequences in the Central Malukan capital, and the effects of the deployment of new media technologies in Ambon's conflict. As I discuss briefly below and at greater length in Chapter 1, the war itself, and especially the vast unseeing that characterized it, was another factor that helped foster the street pictures and influenced the forms they took. This general blindness or challenge to seeing served, generally, to enhance the critical role of seeing among the urban population as it also precipitated forms of extreme perception that aimed to pierce the uncertainties and treacherous realities that prevailed in the embattled city. All of these forces abetted and helped to consolidate an acute attunement to and valorization of visual artifacts, technologies, experiences, and knowledge during the fraught years of Ambon's conflict, resulting in a particular constitution of what I understand as the terrain of the visual. One of the most remarkable aspects of the conflict was the way in which people's enhanced affective and material investment in visual phenomena, broadly conceived, consolidated and extended their impact in the life of the city. This is also what makes the violence of Ambon's war and its aftermath such a fertile site for exploring the contribution of visual phenomena to social and political life more generally, especially today.

Image, Appearance, Figuration

If, as Oscar Wilde claims, "the true mystery of the world is the visible," then it is worth lingering over the evanescent appearances through which it is known rather than simply bypassing or dismissing them. Under ordinary circumstances, the surface appearances of persons, objects, behavioral patterns, and visual habits; the arrangement of things and physical structures in space; and the patterning of the urban environment form part of what the French political philosopher Jacques Rancière calls the distribution of the sensible upheld by a given sociopolitical order.[8] In his understanding, this system of self-evident facts of sense perception consists of a delimitation of spaces and times, of the visible and the invisible, of speech and noise and thereby, too, of the particular place and stakes where politics unfold. In identifying the inherently political

determination of the experiential conditions that enable and privilege partic-
ular forms of sensory perception, thought, and action while foreclosing others,
the theory posits an intimate connection between aesthetics and politics. By
the same token, it is a connection sustained and mediated by the specific sen-
sible forms, material structures, and practices that describe a given historically
situated distribution of the sensible.

In singling out the visual dimension of the distribution of the sensible, my
approach is more circumscribed than that of Rancière.[9] In this respect, I am
especially interested in two interrelated processes. The first I call the work *on*
appearances—my main example being the deliberate interventions on the part
of Protestants in the urban visual environment through the production of
Christian-themed pictures. If this process is especially sociological, the second,
or the work *of* appearances, is more phenomenological. Through the latter, I
aim to understand, for instance, how elusive if palpable phenomena like the
fog of war or the more concrete yet fleeting images of Christ that loomed over
urban space left their mark and helped to shape experience, thought, and ac-
tion in the wartime and postwar city of Ambon. *Orphaned Landscapes* focuses
ethnographically on the forces and dynamics operative in producing a particular
visible environment and the perceptions thereof, as opposed, for example, to
the aural or linguistic aspects of a distribution of the sensible. In doing so, I
home in on moments of instability when, no longer taken for granted, the
sensible begins to change, contributing, however incrementally and diffusely,
to disruptions and alterations in the ways this was experienced before.

In the ethnographic material at the heart of this book, images and, more
broadly, the work *on* and *of* appearances offer a privileged vantage onto how a
particular social world, especially that of Ambon's traditional Protestants, re-
figures itself and moves on in the wake of profound social and political change,
traumatic events, and crisis. *Images, the work on and of appearances*, and *figu-
ration* and *disfiguration* are the terms I use to distinguish different dimensions
of these far-reaching transformations. *Image* here covers a range of predomi-
nantly visual media[10]—in the first place, the Jesus portraits and murals that
arose in Ambon's streets and the globalized Christian print capitalism upon
which, for the most part, they depended. It also comprises other mediations of
war and peace, like the antiviolence public service announcements aired on
television, but also graffiti and the drawings of paired mosques and churches
produced by children in peace and reconciliation programs that are the subject
of Chapter 5. In an explicit fashion, such images demonstrate the wider work
on appearances through which Ambonese and others—both intentionally and
unintentionally—aimed to manage and make sense of a wartime environment
that often defied their understanding in startling and disturbing ways. Somewhat

differently, the work *of* appearances foregrounds the more diffuse effects on people of the devastation of the war, such as the zoning and mass displacements that turned Ambon into an increasingly unfamiliar place for many over time. Like the work *on* appearances, the work *of* appearances includes novel experiences, such as the encounter with the huge Christian pictures that, impossible to avoid, filled the sight of pedestrians and other passersby "by force."[11]

The twinned forces of figuration and disfiguration intrinsic to processes of world-making and—crucially, too—world-unmaking are another aspect of Ambon's wartime visual environment to which I pay close attention.[12] I see the energetic forces of figuration and disfiguration tracked in the coming pages not as opposed but as propelling one another within the larger disruption and redefinition of the aesthetic and affective forms that influence what presents itself to sense experience. In the most straightforward sense, *figuration* describes the act of creating or intervening in the appearance of the world in an artistic manner as through a drawing, graffiti, or painted billboard. More broadly, *figuration* in this book designates a world-making capacity that emerges in dynamic relation to the devastation or disfiguration of the environment in which the Christian street art appeared. A third aspect of figuration that I attend to are particular imaginary and social types or figures that became endowed with newfound significance in the context of the Suharto regime's unraveling and Ambon's war and were widely disseminated in diverse media of the time. Specifically, I am interested in how the figure of Ambon's painted Christ aims to bring into view and conjure some version of community for Protestant Ambonese by providing them with a face at a time when, as many Christians saw it, their very existence in Indonesia was under erasure. Or how the ubiquity of the child witness to violence in diverse media around the country, including Ambon, aimed to secure the nation's integrity and futurity via this image of uncontaminated innocence that surfaced insistently in the turmoil accompanying Indonesia's 1998 regime change. As these examples suggest, I will especially track figures and processes of figuration emergent within situations of pronounced disfiguration—whether the precarity of Ambon's Protestants in the context of the city's war and the country's mounting Islamicization or the downfall of the Suharto regime and the fears it unleashed regarding the prospects of Indonesia as a nation-state. Both, if differently, offer an entry into understanding the particular ideological formations of the time and, by extension, even the distinct texture of the epoch.[13] If the figure of Christ and that of the child in violence surfaced in the charged circumstances of Indonesia at the turn of the last century, they continued to be informed by their prior use and conventional circulatory forms in addition to their specific affective and historical genealogies.[14] Before addressing these wider circumstances and figures,

I turn now to Ambon and its complicated history of religiously differentiated visibilities.

A Christian Town

To all appearances, Ambon was a Christian town through at least the 1980s. This, at any rate, was a pervasive stereotype in Indonesia that only began to lose force with the onset of Muslim-Christian violence in early 1999. In the 1980s, when I spent short periods of time in the provincial capital on official business and waiting for boats leaving for Southeast Maluku, but also on a return visit in 1994, the administrative and political center of the city where the public offices, banks, post office, a number of schools, and the GPM Maranatha church and large Catholic cathedral were located had a decidedly Christian look about it. Apart from the pedicab drivers from South Sulawesi, Muslims, by and large, kept to the coastal areas of the city. The majority of Muslims I encountered back then were Arabs and non-Ambonese who populated the market stalls and shops clustered around the harbor where I would stock up on reams of tobacco, flashlights, mosquito nets, sarongs, and other valued commodities before heading to Aru. Unless one ventured beyond the town into the Muslim villages scattered along the coast of Ambon Island and on the neighboring Lease Islands (Saparua, Haruku, Nusa Laut, and uninhabited Molana), one might easily have been left with the impression that there were no Muslim Ambonese at all.[15] Strikingly, in contrast to most other parts of Indonesia, Muslims in Ambon and the adjacent islands had over time been rendered largely invisible. This pattern of marked Christian visibility and Muslim invisibility has a long history in Ambon and the Lease Islands, composing today's Central Malukan province, that dates to the arrival of the Dutch in the seventeenth century and the imposition by the Dutch East India Company (D. *Vereenigde Oost-Indische Compagnie*, or VOC) of a monopoly on the coveted spices for which Maluku by then was widely known.

The town of Ambon, on the island of the same name (strictly speaking, not reckoned among the original Malukan spice islands),[16] developed around a Portuguese fort that was taken over by the VOC in the early seventeenth century. The town rapidly became the epicenter of the highly lucrative spice trade (especially cloves, but also nutmeg and mace), a site of aggressive competition between different European and Asian traders, and, by the end of the seventeenth century, a cosmopolitan colonial city populated largely by migrants.[17] Already early on, the establishment of the draconically enforced VOC monopoly on clove cultivation on Ambon and the surrounding islands, the imposition of corvée labor to support the company's political and military infrastructure, the

destruction of the Muslim polities and traditional federations together with the continuation of the Christianization begun under the Portuguese, and the establishment of the seat of VOC power on the Christian Leitimor peninsula of Ambon Island set the general pattern of community relations that was to characterize Ambonese colonial society until the late nineteenth century.[18] With the bankruptcy of the VOC at the very end of the eighteenth century and a flagging world market in cloves, Ambon entered a period of economic decline. Against this background, but especially in light of Dutch imperial ambitions around the archipelago, education in Christian communities was reformed and extended and the mass recruitment of Christian youth for the colonial army (D. *Koninklijk Nederlands Indische Leger,* or KNIL) and bureaucracy began.

Considered loyal, these Black Dutchmen, as Ambonese came to be known elsewhere in the archipelago, enjoyed special privileges over the other indigenous peoples of the Netherlands East Indies, were a significant presence in the KNIL and the lower ranks of the civil administration, and often worked and lived far from Ambon in military barracks and émigré communities in Java and elsewhere. This meant that the Ambonese encountered by other Indonesians outside of Ambon—in Java, Sumatra, and elsewhere in the colony—were almost always Christian, reinforcing the impression that Ambon and, by extension, its alleged Christianness covered all Malukans.[19] Another factor that encouraged this view was the separatist movement of the Republic of the South Moluccas (I. *Republik Maluku Selatan,* or RMS) that sided with the Dutch against the new Indonesian nation when it declared independence on August 17, 1945, following the capitulation of the Japanese Imperial Army. In 1949, after a protracted colonial war that the Dutch, to this day, disingenuously call "police actions," they were forced to relinquish their claims to the colony.[20] In the context of competing visions regarding the governmental form of an independent Indonesia, Malukans who feared domination by Jakarta declared the Republic of the South Moluccas in Ambon on April 25, 1950. Indonesia's first president and revolutionary leader Sukarno sent troops to the islands that subdued Ambon in 1950, although fighting continued in other parts of Maluku through the early part of that decade.[21]

As late as 1980, the Australian historian Richard Chauvel wrote an article about the history of the Muslim population of Ambon and the Lease Islands that he called "Ambon's Other Half." Although not made explicit, the title recalls Jacob Riis's 1890 photographic study of New York's poor that aimed to explore the unseen misery in which this portion of the urban population lived.[22] As in Riis's study, emphasizing the role of the visual as a component in the creation and consolidation of inequality is warranted here. Beyond the appearance of

Ambon town, Christians are highly visible in Dutch archives and in photographs dating from the mid-nineteenth century until the Japanese occupation of the Netherlands East Indies in 1942. Conversely, Ambon's Muslims, much less an object of direct colonial intervention, maintained customary forms and practices and local language use to a much greater degree than was the case for Christians and to an extent that remains noticeable today.[23] Indeed, the early suppression of Ambonese connections with other Muslim centers of trade and learning in the archipelago largely cut them off from the mainstream of Islamic thought until the end of the nineteenth century.[24] For an extended period of time, Muslims were simply out of the picture—not just politically and historically but also visually.

"Few, if any, early-twentieth century images of Ambonese Muslim women [or, by extension, men] have been captured," writes Marianne Hulsbosch, the author of a fine history on Malukan dress, with some frustration. "[Colonial officers] like Riedel and Sachse did not even consider Muslim dress although they left descriptive notes on Christian and native appearances. For them the Muslims were invisible—a sad statement considering that at the end of the nineteenth century they made up 28.3% of the population [in Ambon town]. On the main island of Ambon, the Muslim population even topped 38%. This ignorance says much about the colonial regard for the Muslim [as opposed to Christian] population."[25] Occasionally, one sees an exception to this general rule. In his report to the colonial administration upon leaving his post, a Dutch colonial officer countered the pervasive stereotype of the island's peoples by evoking another Ambonese world that was Muslim while he also described Christian villages where the inhabitants were neither soldiers nor clerks but did manual labor and expressed themselves quietly or, in other words, did not conform to the stereotype.[26]

Despite the rare exception, the general disregard of the Muslim half of Ambon's population on the part of the authorities did not end with decolonization. The skewed and in part, but only in part, bifurcated colonial experience that privileged Christians over Muslims, especially locally in Maluku but also nationally, was continued in some respects under the quasi-secularist, nationalist politics of presidents Sukarno and Suharto. If nationally both Protestants and Catholics enjoyed some prominence, a connection facilitated linguistically by the Indonesian designation of Protestants and Catholics alike as Christian, hegemony in Central Maluku remained solidly in the hands of Protestant Ambonese. This perpetuated their dominance beginning with the early conversions under the Dutch East India Company of parts of the population to Protestantism. It was only in the late nineteenth century, moreover, that Catholic missionaries were allowed to proselytize in Maluku, with their activities

restricted to the southeastern islands. Under Suharto, representations of Ambonese culture continued to be Protestant Christian, from the bridal couples featured on government posters representing the country's different provinces to Ambonese songs, based on church choirs and Western harmonics and orchestration and sung by schoolchildren across the nation.[27] Likewise, Ambonese contributions to national historiography celebrated—until very recently—Protestant Christian uprisings and resistance leaders like Martha Tiahahu and Pattimura, whose statues occupy prominent positions in the town, the first overlooking Ambon and its bay from the spot conventionally said to offer the most scenic view, the second dominating Independence Square with a fearsome look and raised machete. By comparison, Muslim Ambonese presence in both national and regional history has been remarkably silent.[28] This is because, with only a few exceptions, Christians authored the regional histories and controlled Ambon's large civil bureaucracy, including its top positions, like the regional Ministry of Culture and Education and the provincial Pattimura University.[29] Tellingly, an anthropologist who did fieldwork in a Muslim village in Central Maluku in the mid-1990s reports that the people whom she studied felt that the nation-state ignored their identity as Muslims.[30]

The Christian hegemony in Ambon and Central Maluku underwrites the long-standing sense of entitlement and superiority conveyed by the eager appropriation of the expression *Black Dutchmen*. In my experience, Protestant Ambonese would invoke this phrase to designate their special status and perceived kinship with the former colonizer, if privately and less frequently after the conflict. Yet even as this claim was seldom voiced, the white Christ that proliferated on city walls during the conflict may be understood as a graphic rendition of the colonial-derived connection. Along with other factors, this general attitude on the part of the Protestants helps to explain the growing awareness and pride among Muslim Ambonese in their history of resistance to the Dutch and their noninvolvement in the colonial project. It also fuels the circulation of covert counterhistories that question Christian contributions and celebrate Muslim importance in regional and national history—including the claim that the renowned war captain Pattimura was in fact a Muslim.[31] If confided cautiously to an anthropologist in the 1990s, the Muslim man who drove my husband and me around Ambon Island in 2005 spoke to us with no hesitation about the secret history that allegedly proved Pattimura's Muslim identity. Confirming just how much the conflict had changed the relations between Muslims and Christians, our driver's disclosure spoke to the waning of Christian hegemony in the city and Central Malukan province that began in the 1990s with Suharto's promotion of Indonesia's Islamicization and was further consolidated during the war.

Not surprisingly, the *longue durée* of Christian visibility versus Muslim invisibility became refracted in the dynamics of Ambon's conflict, as was the partial reversal of this relationship as Muslims not only gained power nationally but assertively and visibly profiled themselves as Muslims to a much greater extent than before. In Maluku, this meant that Muslims began to occupy key government positions that had long been claimed by Christians or Muslims from outside Maluku, especially Javanese. One way of understanding the appearance of the Christian street pictures is precisely as a response to the new situation—the increasing displacement of Christians from the civil bureaucracy in Central Maluku and the perceptible change in Ambon's urban environment as it began to lose its characteristically Christian look. The dynamics I have outlined here, but especially the historic hegemony of Christians in the region, meant that the feelings of abandonment by authority that were pervasive in Indonesia following Suharto's downfall were especially pronounced among Christian Ambonese. At the same time, the repercussions of the national crisis in the country's eastern outskirts were attenuated by distance and the long history of difference that characterized the relationship of Maluku to Indonesia's political and demographic center on Java.[32] This meant that the evacuation of authority with Suharto's departure arrived in Ambon imbued with a sense of possibility that manifested itself in various ways. Most pertinent for the purposes of this book is the decidedly religious character of the Protestants' turn to picturing. This move marked a difference vis-à-vis Muslim majority Indonesia and partook of the energies emanating from the capital during the upheavals of Reformasi. I turn now to this tumultuous time surrounding Suharto's downfall and to the Reformasi movement's discourse of transparency and desire to bring things hitherto hidden into public view, something that also animated Ambon's street pictures, if less explicitly.

The Appearance of Crisis

After more than thirty-two years in power, the spectacular end of the Suharto regime caught many Indonesians and long-time Indonesia watchers, whether journalists, academics, foreign diplomats, or NGO activists, by surprise. Engineered by Suharto, the authoritarian regime emerged from the 1965–1966 massacres of between five hundred thousand and a million people in a U.S.-supported anticommunist purge. The mass killings followed an alleged coup attempt on the part of leftist army officers that was subsequently dubbed the September 30 Movement (I. *Gerakan 30 September*) and became codified under Suharto in national historiography, monuments, and a film screened annually on national television and in schools. While exceptionally brutal, the regime

managed throughout much of its extended rule to generate an "appearance of order" sustained by a carefully orchestrated diversity that relied on a cultural policy and discourse that was itself violently coercive and authoritarian.[33] As late as the 1990s, this apparent bastion of order and strategic anticommunist positioning at the heart of Southeast Asia was celebrated by the World Bank as one of Asia's miracle economies, boasting an impressive record of national development, a broad-based increase in people's living standards, and a rise in the proportion of the population with some schooling, among other standard measures of success.[34] Even during its last decade, when Suharto's New Order initiated a policy of carefully controlled openness, it remained exceedingly "difficult to imagine political change."[35]

When change did finally come, it came first as a full-blown financial crisis, "the strange and sudden death" of one of Southeast Asia's economic tigers triggered by the free fall of the Indonesian rupiah and the flight of capital, following closely on the heels of the Thai baht's collapse in July 1997 and its reverberations around the region.[36] A series of cascading crises and events, all tellingly bearing their own name, rapidly overtook Indonesia, starting with Krismon, the 1998 monetary crisis, giving way to Kristal, or total crisis, through the heady spring of protests inaugurating the period of student-led Reformasi, and the horrific riots and gang rapes of May 13–14 in Jakarta that targeted Indonesians of ethnic Chinese descent and precipitated Suharto's resignation on May 21.

For many Indonesians, the first real confirmation of the national crisis was visual. It arrived in the form of a photojournalistic image of President Suharto signing an International Monetary Fund (IMF) memorandum of economic and financial policies on January 16, 1998, as Michel Camdessus, the IMF's director at the time, looks down on the strong leader's highly mediated public humiliation with folded arms.[37] In the ensuing months, the time of Reformasi and its aftermath were remarkable, generally, for the heightened awareness of visibility in the country as many Indonesians felt that the eye of the international community was upon them (I. *di mata internasional*) while visual metaphors proliferated as an expression of this perception, among other factors.[38] Less than six months after the May riots, the term *transparency*, hijacked from IMF discourse, had come to describe "the desirability of not just economic institutions but also political events being open to view."[39] Almost two years after this observation in 2001, the term came up at a refugee camp meeting that I attended in Bitung, North Sulawesi, where refugees who had fled the fighting in Maluku complained that the source of their Supermie noodle ration was "insufficiently transparent" or, in other words, that they did not know when or how much they would receive. If more colloquial in this setting than in Jakarta's streets in 1998, the term still conveyed the sense of transparency's "possible

antonym KKN, short for *kolusi, korupsi, nepotisme* in Indonesian (collusion, corruption, nepotism)," and the more general assumption that what was hidden from view had to be brought forth and subjected to public scrutiny.[40]

At the nation's center but also beyond, transparency and its related vocabulary captured both the desire and the possibilities of seeing beyond the Suharto regime and especially through its sordid history of corruption, crony capitalism, endless abuses, obfuscations of truth, and violently repressed secrets. Other terms and expressions characteristic of the discourse came similarly charged with a strong moral and political connotation of exposing the New Order's crimes, bearing witness to violence, and uncovering the mass killings of 1965–1966 or the perpetrators behind the disappearance of more than a dozen young male activists in the early days of protest.[41] Notwithstanding the euphoria of Reformasi, the desire to make public what had long been concealed was often accompanied by trepidation and even dread vis-à-vis what was imagined as transparency's full potential.[42] For instance, the genre of horror films popular at the time participated affectively in the political project of transparency as viewers were enjoined to look, again and again, for the dreadful secrets of power.[43] Language was another site where some people objected in mainstream media to the excesses of a more explicit vocabulary that began to substitute the euphemisms common under Suharto—for instance, saying that a person had been arrested rather than "made safe" or "secured."

Stepping in amid the drama and chaos of Reformasi, Suharto's successor, B. J. Habibie, aiming to take distance from the previous regime and establish his reform credentials, began to lift and replace some of the most widely criticized and draconian of the laws and regulations instituted by the New Order.[44] These included freeing restrictions on the press, curtailing the military's political power, introducing electoral reforms like lifting the limitations on the number of political parties, calling for democratic elections, and redressing the extreme political and economic imbalance between the center and the regions through a radical program of decentralization.[45] Passed by the legislation in early 1999, even before the country held its first relatively free general elections since 1955, but implemented at the start of 2001, the country's regional autonomy program was of such scale and ambition that the World Bank called it the Big Bang.[46] Along with processes of demilitarization and democratization, this program had profound effects on the national political, economic, and social order, if unevenly and by no means everywhere with the same results. Not surprisingly, decentralization's far-reaching political and social interventions also had profound effects on the perceptions of this order, giving rise to the fears, pervasive insecurity, and psychosocial adjustments that often accompany profound change. Indonesia's appearance of crisis, sudden and startling

as it was for many both within and outside of the country, was no single event but rather a multilayered constellation of shifting forces and adjustments that played themselves out in different ways in Ambon and elsewhere in the country over an extended period of time.

Matters of Perception

A key factor in the expansion and increased attunement to the powers of the visual in Indonesia in the early 2000s was the liberalization and spread of media technologies. This includes the internet and, more importantly at the time in provincial settings like Ambon, the relatively cheap, easy to use, consumer-oriented video, VCD, and cell phone technologies. These became available with the liberalization of the media in the late Suharto years of the 1990s but took off especially with the Reformasi movement. Whether or not the downfall of the New Order may be rightly understood as the result of an internet revolution, as some claim, is not the issue here.[47] But certainly the role of these relatively new media technologies in the reporting and witnessing of the events of Reformasi by journalists, student activists, humanitarian workers, protagonists, and ordinary citizens, and in the work of the new emergent generation of Indonesian filmmakers, cannot be overstated.[48] Further afield in Ambon, where there is inevitably a lag in the adoption of trends and commodities from the capital, it is no coincidence that the impact of the communications revolution, media's liberalization, and the spread of visual and audiovisual technologies only really registered when the circumstances of war provided this impact with an undeniable local impulse.

Along with the mobilization of media technologies within the conflict, Ambon City also became a recurrent focus of media attention. During the war and the immediate years that followed, a diverse population of organizations and their representatives arrived in the city from the transnational humanitarian operation that, after the regime's collapse, drove an entire industry focused on conflict and violence in Indonesia. Besides introducing conflict intervention mechanisms and methods for ending violence and securing peace, these organizations disseminated their own media to counter violence and promote reconciliation.[49] The heightened media attention also occasioned an influx of national and international media practitioners, the production of public service announcements (PSA) and pro-peace documentaries but also provocative Muslim and Christian VCDs, and the local bolstering of the national television station, along with the expansion of Jakarta-based stations into the area. These include, for instance, a pro-peace PSA that went awry in Ambon's war and those produced by an international organization to foster awareness of violence

against children that I discuss in Chapters 1 and 5, respectively. With Ambon as a focus of acute media attention and the spread of image-based and other media technologies came the novel commodified value attached to the audio-visual testimony of the war and documentation of human suffering and urban destruction. Another novelty was that of seeing one's own locality relayed back in the form of national and international news via, say, Australia's ABC channel or through the provocative VCDs that spun off the conflict.[50]

It is a central argument of this book that the arrival to Ambon of the monumental Christian pictures and their insistent public visibility may be understood as but one expression of a momentous turn to the visual—discursively, politically, technologically, and affectively—that accompanied the unraveling of the Suharto regime. If anything, due to the chronic sense of unseeing occasioned by Ambon's war, such a turn was more pronounced there than elsewhere in Indonesia. Put otherwise, if transparency or the aim to see through the regime's corruption and crimes was a rallying cry of Reformasi, Ambon's own turn to the visual, while inflected by these national circumstances, must also be understood against the backdrop of blindness specific to the war. Acknowledging the impact of the chiaroscuro terrain of violence suspended between visibility and invisibility helps to explain the emergence of forms of extreme perception as those caught in its midst aimed to pierce the treacherous uncertainty and lack of clarity that reigned in the city, as I discuss in Chapter 1. It also helped to push the production of the paintings erected by Protestants around Ambon as a medium through which to make themselves seen. Relevant, also, to the city's visual turn is the Malukan history of Christian visibility and Muslim invisibility and the spread and uptake of new media technologies, among other factors.

Orphaned Landscapes is not just a history of the visual as it emerged under especially stark conditions in Ambon. Rather, the book presents what is through and through a material history of the visual. A central part of this history involves attending to the sensuous, embodied, and affectively powerful aesthetics that shaped how people—all kinds of people in Ambon in the early to mid-2000s—apprehended and experienced the pictures and appearances that I analyze in the coming pages. *Aesthetics* in this book embraces the double sense of how something looks or appears, such as the way a traditional landscape painting or billboard might look or the appearance of a person of one's acquaintance or a stranger, and the particular modalities of looking and seeing through which a given aesthetic form or appearance is engaged, whether wittingly or unwittingly. It involves the particular qualities of an object and the semiotic potential of materials and materiality, or how the way an object looks is inseparable from how it is looked at and apprehended, as well as the locations and

modalities of its use.[51] In Ambon during the war, this relationship between seeing, sensing, materiality, and semiotics mediated everything from the rough textures and shiny surfaces of painted city walls or the bullet-marked buildings lining the main avenues of the besieged city to the newfound importance of the material contents of pockets in the clothing of corpses that were ransacked by victors on urban battlefields. An especially noteworthy aspect of this sensory environment was scale, insofar as Ambon's street pictures were all about monumentality—meant to provoke the gaze while refusing the passing glance or casual dismissal.

Orphaning the Nation

In 2003, as I boarded a plane headed for Padang, West Sumatra, en route to a conference, the paper folder holding my Garuda airline ticket caught my eye. Beseeching me from its shiny surface was the stricken, wide-eyed face of a child framed against a fiery red background and captioned with an appeal to adults traveling around the country to envision the threatened future of Indonesia's youngest citizens and, through them, that of the nation itself. This was only one of many images of the child in violence that confronted me on successive visits to different parts of Indonesia in the early 2000s, including Jakarta, Central Java, West Sumatra, North Sulawesi, and Ambon. While novel in certain respects, the child figure was indebted to older forms of state governmentality where children served as the authenticating source of state genres: as the authors of the Letters to the President, published in national and regional newspapers and compiled in state-endorsed collections, in drawing contests where they produced codified images of Javanese landscapes boasting rice paddies and the requisite volcano, and as props in national holidays and ceremonies like flag raisings.[52] Nor was the witnessing of violence new to Indonesia's children. Under Suharto, children, along with adult Indonesians, were subjected to enforced modes of viewing violence produced and authorized by the regime to spread its version of history and terror.[53] Foremost among these was the film that all Indonesians were enjoined to watch, year after year, in obligatory school screenings and on national television, *The September 30, 1965, Movement/Communist Treason*, "which set the terms for legitimate public fantasy and discussion for much of the New Order period."[54] Equally important, the film and its material iteration in the Sacred Pancasila Monument, the focus of numerous school trips, were visual tools of the state that initiated citizens into adulthood and national citizenship while also conveying a sense of the nation's fragility should it be bereft of the strong paternal figure of its head, Suharto.[55]

For many Indonesians, Reformasi was a time of enhanced visibility that would allegedly have left behind such forced witnessing. Intan Paramaditha, an Indonesian novelist and film critic, went so far as to suggest in 2011 that post-Reformasi, everything had been laid bare "before our eyes," ending the crisis of visibility that plagued the corrupt Suharto regime where the ability to see was a luxury. At the same time, she wondered whether the spectrality of information (and violence) characteristic of life under the New Order was, indeed, a thing of the past.[56] Notwithstanding these doubts, what stands out is the investment in the ability to see characteristic of the Reformasi movement and how Paramaditha's claim resonates with several key figures who at the time were credited with almost sacrosanct powers of witnessing and pure vision. These are the student activists who spearheaded the mass demonstrations that rocked Indonesia's capital and other cities during the Reformasi spring, whose youth, opposition to the regime, and ascribed purity placed these "witnesses of history" in direct genealogical relation to the nation's storied *pemuda* or revolutionary youth.[57] While the child figure is akin to that of the student activist in her purity and embodiment of nationally sanctified vision, her role is in relation not to national history but rather to its violence.

Marshaled as a privileged bystander to violence in media productions, the child's mere presence often serves as a sentimental antidote to violence. Occasionally, children's faces and drawings serve as a kind of cordon sanitaire or container of violence. For instance, in the opening of a documentary on Ambon's conflict, *Peace Song* from 2001, children's drawings successively fill the screen while stills of children's faces come in at the film's end to frame footage excerpted from national news broadcasts showing Muslim migrants frantically scaling departing boats as they are driven out of Ambon and the destruction of the city's markets during the first days of the war.[58] Repeatedly in different media productions, the child stands apart from violence, witnessing brutality and national destruction yet safeguarding the nation's integrity through her position as a "vacillating outsider," wavering between belonging to the nation, on the one hand, and a detachment from authority and position beyond it, on the other.[59]

Exemplary in this regard is the fiction film *Viva Indonesia! An Anthology of Letters to God* from 2001, a so-called omnibus comprising five minifilms launched in the same year that the country's ambitious program of decentralization went into effect.[60] Registering the view from the national center, the film captures the nagging sense of an absence at Indonesia's core. Against the backdrop of the sounds of the national radio broadcasting the serial crises afflicting the country, each of the film's five vignettes singles out a child from one

of Indonesia's exoticized regions who sends a letter to God detailing her particular plight and seeking his solace and attention.[61] Uncertainty accompanies the dispatch of any letter.[62] Yet those sent in the film miraculously survive church bombings and other catastrophes symptomatic of Indonesia's fraught democratic transition, as if to confirm Lacan's dictum that a letter always arrives at its destination.[63] Trickling in from around the archipelago in what amounts to a seamlessly composed ideological scene, all the letters fatefully arrive to a Javanese post office where God appears absent and a childless postman stands in as deus ex machina. The film concludes with one final posting: early one morning the postman finds a box left in front of the post office door. It holds a toy, a few blankets, a newborn infant, and a note that reads, "God, I send this to you because adults no longer think of us."

The child's abandonment—and miraculous rescue—that constitutes the affective subtext of the film visually condenses the orphaning of the Indonesian nation bereft of the paternal force that for long had held it together, if violently. Yet, if the national predicament finds some resolution in the film when the Javanese subject at the other end of the mailbox steps in as father and pretends to be God, the pure innocence of the child standing in for the nation and the uncertainty of communication with authority intimates how she is always already at risk. Rather than opposites, the child's innocence evokes its violation.[64] In the immediate years after Suharto, the pornographic spectacle of all-encompassing violence hovered in the background of depictions of the child's body, face, and voice. If on-screen this looming violence could be held at bay, its presence intimated the possibility that it might eventually overwhelm her. Off-screen, not surprisingly, things were different.

Orphaned Landscapes tacks back and forth between the distinct mediations on Indonesia's eastern outskirts of the national predicament characterizing the period after Suharto's withdrawal—from the nation's orphaning or precarity of citizen-subjects bereft of the paternal force that had previously authorized their place, granted them recognition, and orchestrated everyday national appearances, to the painted urban gallery of Jesus portraits and Christian scenes authored by Protestants connected to Ambon's colonial-derived church, the GPM. In this city, not only were children victims of the conflict, but quite a number of them became implicated as participants in various ways. Nor was what was seen on-screen there immune to the brutality and prejudices of the war. In what became an infamous incident, the innocent child figure broadcast around Indonesia after Suharto's downfall became enfolded within Ambon's violence. As I describe more fully in the next chapter, the names of a Muslim boy and a Christian boy, bosom friends at the center of a pro-peace television ad set in wartime Ambon, were hijacked from the PSA early on in the conflict

to designate its religiously marked enmities. Throughout the war and for some time thereafter, the names of the Muslim Acang and the Christian Obet circulated profusely on both sides as Ambonese spoke of Acang's versus Obet's territory and how Obet or Acang had launched an attack, committed atrocities, or been driven out of a neighborhood.

And although no one in Ambon ever mentioned the film *Viva Indonesia! An Anthology of Letters to God* to me, it is possible to see the Christian street gallery as, among other things, an anthology of pictures for God. A crucial part of my argument, developed in Chapters 3 and 4, explores the import and implications of the embrace by Ambon's traditional Protestants of a new visual medium. In painting Christianity in city streets, these Protestants not only brought the Christian God into vision but, in doing so, brought themselves into view as they creatively retooled visual imagination in new directions. Within Calvinist tradition, their unprecedented acts of picturing in public space launched an innovative, potentially controversial mediation of transcendence. In making the Christian God visible and material in the city's war-torn environment, he became inserted in unexpected ways in the world around him and exposed—via his image—to its contingencies and risks. Foremost among these was the critical appraisal of fellow Christians and others, the possibility of violence and defacement, but also, over time, such phenomena as the wear and tear of tropical downpour and blazing sun, or even neglect.

Orphaned Landscapes

The book's title serves as a gloss that draws different strands of the argument together—both ethnographically and theoretically. Ethnographically, *Orphaned Landscapes* evokes the general predicament of uncertainty, crisis, and rupture, or the orphaned landscapes that issued in the wake of the Suharto regime's collapse and the withdrawal of a leader who styled himself the father of the nation, Indonesia, by extension, as one big family, and addressed even his cabinet ministers as children.[65] In the capital Jakarta, a sense of "'looseness' at the center" afflicted city residents with feelings of insecurity, vulnerability, and general disorientation.[66] While this situation provides a significant if distant backdrop to the events in Ambon, the book homes in on the Christian men and women who identified with the city's oldest church and their sense of waning privilege and abandonment by authority within the violence that inflected the national situation at the eastern end of the archipelago, or another sense of orphaned landscape. One of the main foci in the coming pages is how these Protestant Ambonese responded to and attempted to shape these circumstances discursively, performatively, and especially through the street pictures.

At odds with—indeed, a form of graphic protest within—the environment in which they emerged, the Christian street pictures may themselves be seen as a kind of orphaned landscape, an argument I develop in Chapter 3.

Theoretically, *Orphaned Landscapes* returns repeatedly to the relationship between images and the circumstances in which they emerge to problematize and complicate a connection that all too often is disregarded or understood only in expressive terms. All images necessarily enjoy certain autonomy and excess with respect to their surroundings. They cannot simply be seamlessly inserted into or made to speak unproblematically to the sociological or political reality of a given historical moment or to what presents itself as the most compelling context around.[67] To be sure, the immense energy with which the Christian pictures surfaced in Ambon and clamored to be seen had everything to do with the devastating conflict in which they came to be. Yet, even as crucial connections exist, the pictures neither reflect nor express the war carried out in religion's name. By the same token, the war's blindness or pervasive unseeing is itself an enabling, scene-setting dimension of violence that needs to be understood as generated rather than merely assumed. When it comes to images, the transitory, delicate nature of the associations between any given social reality and the image-world to which it is provisionally conjoined must be recognized as such—that is, as provisional, and therefore as something that requires explanation.[68] This is even more the case when pictures aim so overtly to intervene in the world as they do in Ambon.

A nuanced history of images—including the figuring scenes within which they emerge—cannot fall back on notions like "cultural context," "style," or "genre."[69] While such notions are undoubtedly helpful, they risk foreclosing other ways of understanding the complexity and power of images and the myriad ways they have impact in the world. Faced with what might be "the most fundamental problem of visual representation,"[70] that of the relationship between image and reality, I take distance from sociological theories that epistemologically assume a given ground or context as the point of departure for analysis, focusing on the status quo and its normative institutions, identities, and the other determinations held to sustain a given social world. For such theories empty the concept of institution, broadly conceived, of one of its intrinsic components—namely, that of instituting in the sense of founding, creating, and breaking with prevailing social realities and creating new ones.[71] As a result, they end up endorsing the status quo of habit and the necessary forgetting that this assumes—of its social construction and arbitrariness, of the historical contingencies of which it is made, and of the violence inherent to its foundation through the foreclosure and rupture with other possibilities.[72]

What the ethnography presented in this book suggests is how such a for-getting can become impossible to sustain. Also, that no matter how supple and illuminating and, indeed, necessary such contextualizing moves may be, what they ultimately leave mysterious is the power of the image or the capacity images have to seize beholders and move them in profound ways, to order subjects' sensuous apprehension of the world around them, to orchestrate the myriad appearances that comprise the everyday, to design and characterize what counts as context. In Ambon, what transpired in the relationship between image and social reality was dramatic. With respect to the violence that overtook the city, it is less an issue of comprehending the complex, even mutually accommodat-ing relationship between the Christian visual canon and the less and less Christian-dominated provincial capital than the sudden appearance of a highly fraught mismatch, an argument I develop in Chapter 2. If this book is about the work of appearances, then it is also, unavoidably, about how appearances do not work. Here, about how the images hitherto deployed by Christians in the city—from small-scale posters and wall calendars to scenes of the Last Supper inlaid with the Malukan islands' lustrous mother-of-pearl—and re-stricted, for the most part, to the interiorized spaces of Christian homes and stores began to visually fall short of what was expected of them in the anxious, dramatic circumstances of the early 2000s. Put otherwise, from the perspective of many among the privileged Protestant part of the urban population, the world had itself began to lose the image that they had long held of it.

Of situations of crisis, it is often claimed that the need for art and novel forms of expression becomes enhanced.[73] Elias Khoury, the Lebanese novelist and prominent public intellectual, writes of Beirut's crisis in a way that exposes how the present comes to defy the aesthetic forms of an earlier precrisis mo-ment, "The present has to be written about, not contextualized in historical terms. The present is mute, it cannot be evoked in yesterday's language. . . . Repeatedly, in our interviews we heard about changes in art and language during and after the civil war."[74] This sense of a profound rupture between representational forms and the realities these are supposed to address is similar to the postconflict situation in Ambon, making it possible for Khoury's words to resonate powerfully with this other troubled city at a far remove, in most respects, from Beirut.

Along these lines, I propose in this book that the present of warfare and rampant uncertainty in Ambon was blind—enclosed in a kind of twilight that made it impossible to evoke any intelligible, stable reality through yes-terday's pictures. In their stead, huge scaled-up public images rose up, refig-uring a globalized Christian print repertoire in ways that poignantly—if also

defensively—spoke to the predicament of Ambon's Christians. Or at least, I argue, this was part of the figuring impulse behind them. Seen in this light, it becomes possible to understand Ambon's new pictures, strewn among war's wreckage around the city, as a response to the significant mutual orphaning of image and world—the Protestants' pictures aiming anxiously to address and figure the world around them and the world perceived as morphing out of the precrisis forms and appearances through which it was previously known. From this perspective, it is no exaggeration to claim that many among the city's traditional Protestants, for reasons I explore in this book, felt themselves figuratively and literally orphaned in relation to their taken-for-granted contexts of production and activity.[75]

Always attentive to their implication in the violence that overtook Ambon at the turn of the last century, my narrative, roughly chronological, follows the trajectory of the street paintings themselves, beginning with the war and ending almost a decade later when, in 2011, a startlingly innovative Christ portrait appeared on city walls when others had largely disappeared from view and been forgotten. Successive chapters take up questions of violence, visuality, images, and appearances, along with religion's redeployment in Ambon, during the approximately ten years corresponding to the emergence and gradual disappearance of the Christian pictures in the city. It is no coincidence that the arrival and departure of these pictures provides the book's narrative arc. The period they frame parallels the virtual collapse of a Christian hegemony of appearances, marked by an unfathomable figurelessness that served as a foil against which the city's new images asserted their figuring power. Chapter 1, "Fire without Smoke," describes the onset of the war and the myriad consequences for vision of its terror settling over Ambon. Chapter 2, "Christ at Large," tracks the arrival to the city of the Jesus billboards and murals from their reliance on the Christian visual canon through their monumentalization along Ambon's streets. While this chapter investigates the drive to figure Jesus Christ's face across a plethora of street productions, Chapter 3, "Images without Borders," explores the unprecedented bringing-into-vision of the Christian God and its implications for the mediation of transcendence by Ambon's Calvinist Protestants. A fourth chapter, "Religion under the Sign of Crisis," homes in on the far-reaching redeployment of religion during the conflict—among a highly mobile, heterogeneous urban population of Christians and Muslims—and the dramas of displacement that exacerbated this process. A final chapter, "Provoking Peace," returns to the figure of the child to consider how her intimate association with violence finds a new outlet in postconflict reconciliation programs. Other initiatives carried out in the name of peace and reconciliation

include the peace journalism promoted as part of Indonesia's widely proclaimed democratic transition and projects launched in the postwar city that circulated photographs and sketches of urban life, online and offline, to counter rumors and prevent violence and to foster more positive images of Ambon in and around Indonesia—the work, respectively, of the so-called Peace Provocateurs and the Maluku Sketch Walker collective.

As this brief overview of the book makes clear, I have largely left to others those topics that are commonly considered more fundamental to war. In the case of Ambon, this would include an analysis of the shift from the initial violence targeting migrants to violence carried out in religion's name, the specific dynamics of the battles unfolding in city streets and the role of gangs, thugs, national army soldiers, and jihadis in inciting it, as well as the massive displacement of persons, and the alarm, disruption, and territorial adjustments accompanying this. Relevant for such studies would also be the many enabling conditions and provocations of the violence, including the waning during the previous decade of Protestant Christian hegemony in the city and the ascent locally and nationally of Muslims, the heightened competition among Ambon's religiously defined political elites, the influx of petty criminal gangs from Jakarta, and, last but not least, the reverberations of the national crisis and end of the Suharto era and the perceptions and uncertainties accompanying these in Ambon and around Maluku.

My own approach comes at Ambon's violence and its aftermath more obliquely—or so it may seem. What I hope to show is how the practice of figuration, rather than extrinsic, is in fact deeply connected to the war and its devastating effects both as stimulant and antidote. Moving back and forth between figuration and disfiguration throughout the book, I stay close to and return repeatedly to the Christian pictures, keeping them in view, along with their defiant public materiality and the exacerbated circumstances in which they arose. If I have chosen to frame my narrative by the arrival and departure of these gigantic pictures, it is because I am convinced that while they risk being overlooked as mere signposts of slower, allegedly more fundamental social and political change, for instance, in the field of urban religion, they constitute the most glaring instance of the subtle, diffuse work on appearances that is a main concern of this book. While I argue that figuration and, more specifically, the work on appearances is central to sustaining social life anywhere, my specific investment here is to show how in crisis such work becomes not only more urgent but also more visible or apparent. Equally importantly, that such work is an indispensable part of profound sociopolitical transformation anywhere, whether progressive or conservative.

A Symptomatology of Crisis

Ambon's street pictures were only the most obvious and assertive among a wider array of symptoms of the deep crisis that afflicted the city. In contrast to other manifestations of crisis that I discuss later, these pictures were deliberately made and unleashed in public space and therefore represent not only symptoms but also highly creative, provisional solutions to the crisis.[76] I have coined the expression "symptomatology of crisis" as a gloss for things like the pictures that were simultaneously symptomatic of crisis and energetic rebuttals to it. Along with other phenomena, they are revealing of the degree to which nonhuman actors and material stakes in the conflict had effects on the violence and the particular forms it took. Similarly, other symptoms that surfaced within the flow of everyday activities, inciting surprise, confusion, and terror, should be seen not as expressive of crisis but as central components of it, with wider implications for the manner of its unfolding. Somewhat different from the vocabulary introduced above—images, the work on and of appearances, figuration and disfiguration—a symptomatology of crisis offers a methodological tool through which to examine the messy, challenging realities of crisis and war.

In the most straightforward sense, a symptom is a happening or sign that does not escape attention, its presence or effect registered and taken note of, as opposed to something that goes unnoticed or is only perceived laterally.[77] Understood here specifically as a sign of crisis, a symptom betrays something that is in some sense untoward and novel, out of sync with everyday expectations. Analytically, it offers a method of working through the signs of crisis and distress manifest in a highly volatile, mutable situation. A symptomatology of crisis is therefore not simply a series of signs but a form of knowledge in its own right. Drawing on a terminology that is conventionally used to identify the presence of disease and bodily affliction, my use of *symptomatology* is meant to highlight not only the physical alterations and human duress of living in wartime but also the sheer viscerality of many of its manifestations. In contrast to the strict etiological sense of *symptom* as the manifestation of something more fundamental, a symptom of crisis, as I use it here, should not be understood as a secondary order phenomenon.

While certainly out of the ordinary, the symptoms that I single out for attention are lodged in the everyday, being especially odd and incongruous in relation to it. Assigning primacy to symptoms of crisis as an analytical device has the added value of revealing just how much what we call the everyday is, under any circumstances, a significant achievement—the result of routine, the repetition and codification of practices, and sedimentation of habit.[78] Beyond crisis and war, these forms participate relatively unobtrusively in the work of

everyday world-making or, more precisely, "poetic world making" following a more aesthetically informed understanding.[79] As the presumed texture of the given, these forms are largely invisible, hovering at the edge of perception. Attached to things and embedded in quotidian habit and routine, they tend to be "forgotten" and, for the most part, remain unremarked and "beyond critical appraisal."[80] As such, they correspond to a certain "recalcitrance of representations" through which people experience and take for granted the world in which they are born—its "language, institutions, economic circumstances, and social others, that are, historically and logically, already given before any capacity to act."[81]

In the extreme circumstances described in *Orphaned Landscapes*, some of these forms begin to lose their "recalcitrance." As they dramatically relinquished their role as, among other things, fixtures of everyday existence, a treacherous instability afflicts persons and objects. The urban landscape, damaged by war, becomes increasingly unknowable and dangerous, while much of the environment of the city imposes itself in novel, contingent ways—as incongruous, assertive, newly opaque, beholden to a "disruptive, alternative aesthetics," or in the process of becoming something else.[82] A symptomatology of crisis especially homes in on untoward events—faces darting across chapel walls, Christians possessed by Muslim spirits, bullets ricocheting off of bodies, blood gushing out of faucets—or things marked as "happenings," following one definition of a symptom mentioned above. Besides events singled out for attention in rumor and hearsay, the materiality of forms themselves can become "an agent provocateur of historical change."[83] To assign this role to Ambon's street pictures would be to overstate their importance. Still, I propose in this book that the impact of these Christian images not only responded to the extreme circumstances in which the city's Protestants found themselves but helped to precipitate and contributed to a number of far-reaching transformations in the city, especially (although not exclusively) in the realm of the visual and religion.

In Indonesia, the number of anthropologists, historians, art historians, cultural theorists, and experts on architecture, urbanism, and the history of technology who have studied the manifold "outward appearances" of the country's elaborate, highly diverse social, political, artistic, and economic life is high.[84] This focus may be a legacy of the significant influence of a culturalist tradition of scholarship on the country, beginning in the late 1960s and exemplified by the American anthropologist Clifford Geertz.[85] Scholarly work singles out articles of clothing and style, like shoes and the Muslim headscarf, but also photographs, shopping malls, radios, and asphalt roads, economic speculation, money, magic, Islamic calligraphy, the theatrical character of the traditional

polity, urban design, art, and infrastructure characteristic of colonial and post-colonial Indonesia, including the long period of Suharto's New Order.[86] Especially relevant is the general characterization of the regime in terms of an appearance of order built up from the Dutch colonial era but reaching an apotheosis under Suharto's authoritarian state.[87] Besides brute force and the threat thereof, this appearance of order thrived on the continual summoning of specters, lurking allegedly just beyond sight, that posed a potential threat to the regime. First and foremost among these were the scapegoated communists, but also such things as the sinister formless organizations that, according to the regime, were waiting to take shape and mobilize at every turn. Especially during times of election won by the New Order with predictable regularity, there was a sense of things held at bay, of the possibility of an approaching moment when something might occur.[88] Year after year in the wake of Indonesia's national elections, rumors proclaimed that nothing after all had happened, that the moment had passed.[89] In 1998, if not directly in the context of elections, the moment finally arrived as the appearance of order—it seemed without warning—suddenly gave way to crisis.

Beyond Indonesia, recent work by anthropologists, art historians, and visual theorists explores questions of visibility, visuality, and the deployment of images, especially in the wars against Iraq, the United States' proclaimed "War on Terror," the Danish cartoon controversy, and the Abu Ghraib prison photographs.[90] These works recognize and analyze the changes that images are subject to as a consequence of the rise of digital media and the numerous ways in which images contribute to the production of violence, terror, and war. Images, predominantly photographs, act as weapons, are integral to torture, enfold normative assumptions about enemies and the self, and underwrite violence as they frame war for audiences at home and abroad.[91] The best of such scholarly work demonstrates how politics itself comes to be visualized—whether through the uneven allocation of visual rights as a means of distinguishing citizens from alleged lesser or noncitizens, the interaction of visibilities, invisibilities, hypervisibilities, and gray zones in situations of occupation and political repression, or how something as seemingly innocuous as posting a selfie—that is, the everyday use of digital technologies and platforms—helps to sustain military oppression.[92] Equally important are the racialized, ethnicized, and class-based forms of looking that show people what they *should* look like, even if what they look like will never allow them to represent or fully imagine themselves as part of a given collectivity.[93]

In this book I begin, however, not with images or appearances but with conditions of pervasive blindness corresponding to crisis. Rather than starting with the production and deployment of images within war, I develop my

argument in relation to circumstances of disintegration, disruption, and relative figurelessness in which images surface unexpectedly, forcing themselves into public view in situations where appearances fail to work or do not work as anticipated. In urgently and repeatedly calling attention to themselves, the strident images of the Christians and the elusive, potentially treacherous appearance of persons and things wrapped in war's twilight evidence the profound difficulty experienced by Ambon's population in upholding and maintaining the forms that had hitherto characterized the city and the fabric of its complicated, urban everyday. At the outset of this book, it is worth noting that some five years after my fieldwork in Ambon, few traces could be seen of what I describe here—whether the Christ that had been so demonstratively at large in the war-torn city or the disfiguring momentum of violence and crisis that compelled some Protestants to produce pictures, thereby crafting an alternative, unprecedented medium to access their God. These ephemeral mediations—along with others more difficult to grasp, like the fog of war—became enfolded in various ways in the life and emergent possibilities of the city as it became refigured within and in the wake of its religiously inflected conflict. While their impact is impossible to measure and their effects hard to gauge, these transient and elusive processes and phenomena were inherent to and productive of the orphaned landscapes that describe some especially fraught times and circumstances in Ambon City and the neighboring Malukan islands along Indonesia's eastern outskirts.

1

Fire without Smoke

On January 19, 1999, a run-of-the-mill fight between a Protestant bus driver and a Muslim passenger escalated into a full-scale battle between what rapidly became designated as Christian "red" and Muslim "white" forces that was fought in the streets of Ambon with traditional or makeshift weapons—knives, spears, machetes, arrows shot from slingshots, fishing bombs, and Molotov cocktails. Occasionally, weapons like arrows were dipped in homemade poison to ensure their deadly impact. Overall, the violence in this initial phase of the war was remarkable for its ferocity, with the attacks and killings on both sides being especially horrific. By the end of the second day, numerous houses, stores, offices, churches, and mosques had been destroyed or burned and scores of people had been displaced, while others were wounded or killed. In the largely segregated city of Ambon, the kind of sectarian border skirmish that set all this off was common. Under normal circumstances, it would also have remained a nonevent—except, of course, for those immediately involved. Three years later, upon the signing of the Malino II Peace Agreement in early February 2002, the conflict had left the city radically transformed.

In what many scholars have identified as the first phase of the war, lasting from mid-January 1999 until May 2000, periods of violent confrontation between native Ambonese Protestant and Muslim mobs and mass destruction alternated with lulls in which attempts at reconciliation involving elite Ambonese from both sides were occasionally made.[1] Jakarta's blunders also began early on, with the dispatch of the first troops to quell the violence from South Sulawesi—or that part of Indonesia from which the Muslim migrants driven out of Ambon during the conflict's first weeks also hailed—with shoot-on-sight orders and with a general lack of initiative and direction. Far from Jakarta still

reeling from Reformasi's many upheavals, Ambon did not rank particularly high on anyone's priorities. What is more, the authorities' will to intervene also depended on their assessment of the seriousness of the situation.[2] In the case of Ambon, many hoped it would simply blow over.[3] This first phase was also marked by the outbreak of violence in the Kei Islands in southeast Maluku in April 1999 and in the soon-to-be-declared new province of North Maluku in August of the same year.[4]

The second phase marked a qualitative change in the conflict with the May 2000 arrival of the so-called Laskar Jihad in Ambon.[5] Called into existence out of Muslims' rising concern that the Christians had the upper hand in the conflict, this militant Muslim organization with recruits from Java, Sumatra, and South Sulawesi provided both partisan humanitarian assistance and armed support. The Laskar Jihad emerged in the wake of a massacre of four hundred Muslims in a mosque in the town of Tobelo on the North Malukan island of Halmahera in late December 1999.[6] News of the massacre spread rapidly via print media and, crucially, a VCD showing devastating scenes of the charred mosque interior littered with bodies, body parts, remnants of clothing, and other traces of the life that had once been there.[7] A general call for jihad in Maluku followed shortly thereafter during a mass rally in Jakarta in early January 2000 under the auspices of such major national political figures as the country's former vice president Hamzah Haz and the People's Consultative Assembly Speaker Amien Rais. Several months later, on April 6, 2000, the announcement of the foundation of the paramilitary organization was staged as a spectacular event, a flamboyant display of numbers and Muslim power, as some ten thousand Laskar Jihad members demonstrated before the Presidential Palace, an image that became "etched in the minds of the Indonesian body politic."[8]

The arrival of two thousand members of the Laskar Jihad in Ambon in May 2000 was no less momentous. The amount and sophistication of the weapons used in the war had grown over time, but the group brought a surplus of professional arms to Ambon, along with advanced radio communications technology. It also introduced some order into the local Muslim militias, who at least initially welcomed these supporters as heroes, and it enjoyed the clear backing of segments of the armed forces.[9] The Christians found themselves significantly outnumbered and outgunned, and casualties and devastation increased proportionately. This is also when Catholics began to be drawn into the conflict—notwithstanding the effort of Ambon's bishop to play a mediating role—since the jihadis attacked Christians indiscriminately, making no distinction between Protestants and Catholics.[10] By late June 2000, then president Abdurrahman Wahid announced a state of civil emergency in both Maluku

and North Maluku provinces, and a special conjoined force of elite troops under a Balinese Hindu commander was dispatched to Ambon. If the declaration of the state of emergency greatly curtailed civil liberties—not the least of which being the press—and further enhanced the militarization of everyday life, it also gradually limited the number of large-scale confrontations.

This second phase of the conflict was further characterized by a deepening of the religious definition of the opposing parties and the crystallization of relevant extremist discourses[11]—on the one hand, that of militant Islam and jihad, represented first and foremost by the Laskar Jihad and the smaller, more covert Laskar Mujaheddin, and, on the other, that of nostalgic sovereignty and separatism, embodied by the Christian Maluku Sovereignty Front (I. *Front Kedaulatan Maluku*, or FKM). Posing as the successor to the former separatist Republic of the South Moluccas movement (which in actuality exists primarily as a shadow of its former self among segments of the Malukan population in the Netherlands), the FKM envisioned its future as the nostalgic resurrection of an indigenous Malukan identity and boasted a leader who modeled himself after Xanana Gusmão, the former charismatic leader of Timor-Leste, which, at the time, was a very recent success story of national sovereignty.

By 2001, with the decrease of large-scale confrontations and their replacement by sporadic bombings and sniper attacks, the partial restraint of the Laskar Jihad under civil emergency conditions, and the signing of the Malino II Peace Agreement in South Sulawesi on February 12, 2002, the period of postviolence may be said to have begun. Civil emergency remained in effect, however, until mid-September 2003, along with the concomitant militarization of daily life and the restriction on foreign visitors to Maluku. The initial sense of relief in Ambon's streets following the Malino agreement was marred in the following months by intermittent explosions and attacks that many suspect were orchestrated by those who profit from the perpetuation of chronic, low-level violence— segments of the military and police, individual deserters from the same, local gangsters, militant groups, and possibly more shadowy protagonists.[12] The influx of humanitarian aid and the presence of security forces in the city, along with lingering desires for revenge and religious militancy, further spurred profiteering on, resulting in "a well-funded industry of sporadic violence."[13] For quite some time, the city remained divided into rigorously defended, religiously marked territories, or, as one source acutely observes, "concentrated pools of resentment and bitterness"—or, in other words, potential breeding grounds for more violence—alongside emerging neutral zones and places of resistance and peace.[14] This, in broad strokes, is the war. Much has obviously been left out—not the least of which are the kinds of atmospherics with which I began this book.

War's Fog

I was moved to write about the situation in Ambon several months after the Malino II Peace Agreement was signed and before returning to the city that I had visited off and on since 1984 en route to Aru in Southeast Maluku. Numerous others—in and around Ambon, in Jakarta, Manado, and elsewhere in Indonesia, and farther afield in Australia, the Netherlands, and the United States—had already written before I did, analyzing the conflict, its possible causes and myriad enabling conditions, and describing its protagonists, warring parties, and behind the scenes power plays, both local and national. They include anthropologists and other social scientists, within and outside Indonesia, activists and representatives of a range of local, national, and international NGOs, a number of the main players in the conflict, as well as media practitioners based in Ambon and the neighboring islands, the capital Jakarta, or abroad. My initial response was simply one of reaction to such assessments and reports and, notwithstanding the contribution and insights of many, some dissatisfaction with the overall story they told or, more pertinently, failed to tell about the city, its people, and the unfolding conflict among them. Much of what I wrote in 2002 still stands today and is therefore reproduced in an elaborated, updated version here.[15]

Ranging from highly engaged and informed analyses to the more codified versions of NGO-speak and the slanted partisan stories that bolster the truth claims of one or another side, the origins, complicating factors and backgrounds, major events, and relevant national and international developments have been scrutinized and amply discussed in terms of their respective contributions to Ambon's violence. As so many theatrical backdrops against which the main action unfolds, important externalities and internal factors named as enabling and providing fertile ground for the outbreak of Ambon's violence include such macropolitical and macroeconomic structures as the Southeast Asian financial crisis of 1997 and its aftermath, the unraveling of Suharto's New Order and the upheavals of Reformasi, and the behind-the-scenes connivings of Jakarta's political elite and the military. Tensions among Ambonese Christians and Muslims, more specifically, are seen as having been aggravated over the long term, as well as more recently by the religious division of labor established under Dutch colonial rule that privileged Christians and marginalized Muslims socially, economically, and educationally; by the parallel processes of Islamicization and Christianization in Maluku in the wake of World War II and the related erosion of the common ground of custom shared by Ambonese; and by the Islamicization of Indonesia generally under the late Suharto regime, as evidenced in Ambon by the appointment of two Ambonese Muslims as

provincial governor, leaving the Christians feeling that they were left behind. Add to this the increasing shortage of land, population pressure, and the in-migration of Butonese, Buginese, and Makassarese Muslims from South Su-lawesi, as well as those who benefitted from the New Order's immigration policies,[16] skewing the once more or less equal numerical balance on the island between Christians and Muslims in favor of Muslims, and the involvement of some, especially urban Ambonese, in gangs and criminality, and one has a situation waiting to happen—waiting to happen perhaps, but still not yet, not quite, happening.

While many of the arguments and analyses produced over the years since the conflict began have added to my understanding of Ambon's conflict, I was troubled from the outset by the sense that something was missing. Some of this writing is just too grand, too abstract, and too removed from the volatile, fractured field where, throughout the violence, Ambonese men, women, and children pieced together their everyday lives out of the fears, contingencies, insecurities, and apprehensions that then weighed upon them. What tends to be passed over in foregrounding the influence of Indonesia's major political players, the networks of militant Muslims and Christian gangs and militias, the nefarious wheelings and dealings of thugs, the inbred violence, corruption, and partisan affections of the police and the military, is the character of the very space in which all of these figures, for better or for worse, deploy their schemes and make their dubious marks.

Elusive as this may sound, terms like *climate, ambiance, atmospherics,* and *milieu,* often invoked in descriptions of social and political violence, most closely approximate what I am getting at. If tangential, these terms still conjure and gloss the influence and effects of a certain presence that, while lacking any real precision, is understood, nonetheless, to have definitive power in the shaping of events, human agency and subjectivity, and the production of mean-ing. While relatively unstudied, this presence is a long-acknowledged condition of war. In the words of the nineteenth-century Prussian general and military theorist Carl von Clausewitz, referring to the uncertainty and challenge to perception posed by warfare, "All action takes place, so to speak, in a kind of twilight, which like a fog or moonlight, often tends to make things seem gro-tesque and larger than they really are."[17] A key aspect of this process, as I elab-orate below, is the emergence of extreme perception among many of the city's inhabitants, Muslims as well as Christians, in the form of an anxious play between efforts at acute seeing, on the one hand, and an overwhelming sense of unseeing or blindness, on the other. As the war went on, another component was the production of religion as a highly visible, public phenomenon that became crystallized in the marked contrast between Muslim and Christian

opponents. In short, while my entry onto the scene of Ambon's violence may strike some readers as oblique or peripheral to the allegedly more central issues of politics, economics, and sociology—whether local, regional, national, or even international—my intention is to offer not only different ways of understanding but also different things to understand, as has been suggested is possible in the field of visual anthropology generally.[18] This is because, as I argue in Chapter 2, the huge Christian pictures and the photographs featuring them and their makers are closely attuned to the affective dispositions and intensities of the street. What this book will add is not only attention to ordinary people and the predicaments they faced in a city at war but an understanding of the atmosphere that made elite manipulations effective, the change from neighborliness to paranoia plausible, and uncertainty a persistent ingredient of encounter and exchange. This atmosphere comprised everything from the myriad ephemeral mediations of war like graffiti and provocative pamphlets, which have received some attention from scholars, to much more difficult to grasp phenomena like Clausewitz's fog of war or the diffuse appearances that characterize, however tangentially, a given time and place.

A few caveats are in place. I do not mean to suggest that Indonesia is an especially or unusually violent country. A number of scholars have expressed concern about the centrality of violence as a topic of study following Suharto's fall from power. This, however, would seem to overlook how all the writing about violence represents an attempt to come to grips with the legacy of a regime that was itself inaugurated by extreme violence and that deployed violence strategically in the process of developing its particular brand of governmentality. Some ventured that writing about violence is itself laden with risk. An Indonesian colleague, for instance, in a private conversation with me, condemned the publications appearing on Ambon's conflict while it was still underway as unequivocally "written in blood." Other authors hastened to underscore how Indonesia's violence is neither novel nor recent but long-standing as they marshaled such glaring examples of New Order brutality—beyond its foundation on the "mountain of skeletons" left by the 1965–1966 massacres—such as the invasion of East Timor, the devastating military actions in Aceh and Papua, the surreptitious killing of alleged criminals in the 1980s by the regime, and the present-day impunity of the leaders and henchmen toward the events of 1965–1966.[19] Besides Suharto and his brutal regime, there is the legacy of long-standing Dutch engagement in Maluku as part of the world's violently contested spice islands and what is today Indonesia, more generally, beginning in the sixteenth century under the Dutch East India Company. There is also the Japanese occupation from 1942 to 1945 when the revolutionary leaders Sukarno and Hatta declared Indonesia's independence, followed by the colonial war waged against the former Dutch colonizer from 1945 to 1949.[20]

Such legacies *are* legacies. Although they may fade and be transformed over time, they do not necessarily disappear but instead leave their mark in more obvious or subtle but, inevitably, complicated ways. Relevant in this regard is routine violence or the violence that is part and parcel of the production and continuity of contemporary political arrangements, or, put otherwise, the enabling conditions of what commonly counts as violence.[21] Notwithstanding the dramatic changes wrought by the 1998 Reformasi movement and the far-reaching nature of the national decentralization program launched shortly after Suharto's downfall, decentralization was by no means a deus ex machina but rather a significant realignment of existing force fields.[22] More surreptitiously, state or authoritarian violence, especially when it is as well-honed as that of Indonesia's New Order, tends to penetrate and suffuse as a spirit of violence in every space of society from the economy and domestic life to language and consciousness—even after it is gone.[23]

In what follows, I pursue, as closely as possible, in the minutiae and momentum of Maluku's conflict, but with a special focus on Ambon, the dynamics, modalities, and material technologies through which violence proliferates and becomes sedimented. The radical refiguration over time of what was previously considered possible, expected, or so taken for granted as to go unremarked and the concomitant breakdown of trust in what everyday life has to offer—especially the visible appearances through which it is conventionally known—describes the particular kind of violence at issue here. At the same time, I heed Mary Steedly's call not only to localize violence—something that much work on violence in Indonesia does a very good job of—but to keep "the landscape of the banal in view."[24] To the crucial temporality of the "things that don't fall apart" and "the ordinary routines of everyday life . . . when expectations hold," I would add the way in which the banal is itself rearranged by violence as the investment and trust in everyday appearances wane and the taken-for-granted shape of things—foremost that of selves and others—and the circumstances in which these ordinarily present themselves shift and morph in often highly disturbing and startling ways.[25] In so doing, I pay special attention to those things to which many Ambonese were themselves most attuned in these unusual, horrific times, including the changes in the city around them and their relation to it.

Already in the early days of the conflict, barricades sprung up in Ambon's streets, inhabitants set up command posts at the edges of neighborhoods, bullet-scarred surfaces began to replace the shiny facades of fish restaurants, coffeehouses, and gold jewelry and souvenir shops that had once lined the city's main arteries, now increasingly littered with the debris of battle and garbage that often remained uncollected. In the wake of the destruction of Ambon's main market at the onset of the war, smaller, religiously segregated markets

emerged in its stead, obstructing sidewalks and cluttering streets, while the itinerant vendors of chicken satay, yellow rice, and hot tea began to sell articles previously available only in the city's shopping mall and fancier stores, like clothing (Figure 4).[26] For most of its inhabitants, the space of the city shrank as it became zoned and they were increasingly confined to one or another of its religiously marked territories. At the same time, the city was unmoored in unprecedented ways. Much of its population was on the move, beginning with the forced exodus of the derogatively named BBM (short for Buginese, Butonese, and Makassarese or Muslim migrants)[27] in the first days of the war and the multiple displacements occasioned by the fighting—the destruction and torching of homes and buildings, and refugees fleeing from one part of the city to another, as well as into and out of Ambon—through the emergence of what one priest dubbed new "categories of mobility."[28] The latter comprised, for instance, pedicab drivers and easily mobile others who, as the war dragged on and the city became increasingly divided, began to traffic between the different sides of the conflict, supplying Muslims with, among other things, vegetables from the city's traditionally Christian hills and Christians with fish from the largely Muslim-controlled coastal areas. Relevant, too, are the motorbike-taxi drivers whose numbers increased exponentially in the early to mid-2000s, since they could more easily navigate the challenging segregated space of the city than minibuses or cars. As the population of Ambon dwindled from a prewar count of around three hundred thousand to almost half of that, all kinds of new people arrived to the city, from battalions dispatched by Jakarta to quell the violence, to the influx of journalists and other media practitioners, humanitarian workers, and reconciliation experts but, as mentioned earlier, also some two thousand jihadis from Java a good year after the conflict began. All of these changes, along with the presence of ruins, the new obstacles and divisions in city streets, not to mention the conflict itself and its many ramifications, radically shaped and continued to reshape the appearances that had hitherto made Ambon what it was. Over time, the city became an increasingly unfamiliar place for many of its inhabitants, permeated with new and not always easy to determine dangers, as I describe below.

Fire without Smoke

Let me begin at the beginning—itself a point of bitter contention between Christians and Muslims, since each side accused the other of largely preparing and masterminding the onset of violence. Even though Ambon is located on Indonesia's eastern outskirts, it is hardly an island unto itself, which means that Christians and Muslims there are cognizant of violence elsewhere, especially

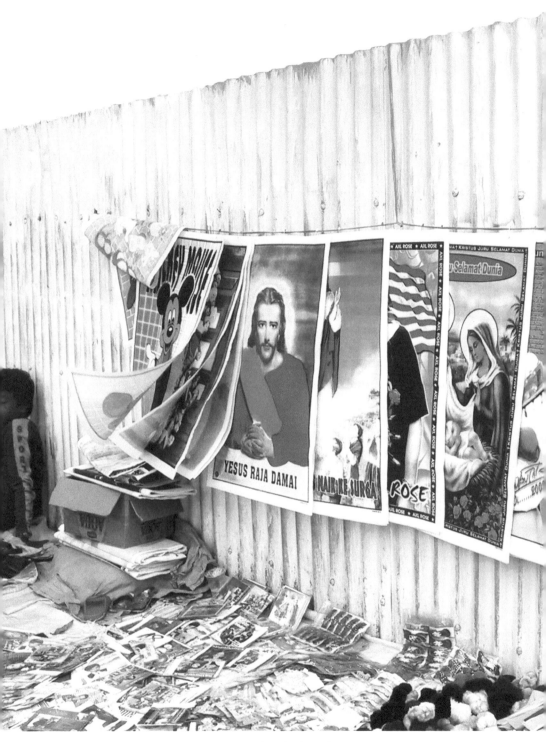

Figure 4. Street market, Ambon, August 2003. Photo by the author.

when it is religiously inflected. As on Lombok, an island about one thousand miles west of Ambon, where, following an outbreak of anti-Christian riots in early 2000, graffiti on a house read "This is in response to what was done to Muslims in Ambon,"[29] so, too, may events in other places seize hold of the imaginations of Ambonese, especially those that took place during this time in the nation's capital, Jakarta. Most accounts of the war name a fight between Ambonese gangsters at a gambling den in Jakarta's Ketapang neighborhood in November 1998, the ensuing anti-Christian violence and church burnings following the deaths of four Muslims, and the arrival of more than one hundred uprooted underworld gangsters (I. *preman*)[30] to Ambon as the prelude to the city's trouble in January 1999. While evidence that these thugs took to Ambon's streets on January 19 is inconclusive, many Ambonese to this day, both Christian and Muslim, believe that they were sent to the city by "the center" to instigate violence.[31] Whatever the case, the arrival of this large group of violent men, along with the widespread awareness of the recent brawl implicating them in Jakarta and the overall uncertainty of these times, left at least some people with the impression that something imminent was about to befall their city.

Although this is usually not mentioned in descriptions of Ambon's conflict, in the wake of these events the Malukan governor convened a meeting of community leaders in December 1998.[32] The governor impressed upon Ambon's Muslim and Christian communities the need to be prepared for violence, to be on the alert, and to guard against provocateurs and rumors. Meant as precautionary, the meeting instilled a sense of the possible in an already nervous city, working as an augury of what might happen before it actually occurred. Besides inaugurating a watchful, anticipatory form of imagination, both sides went home and set up *posko*, which are either communication or command posts (a slippage that suggests how easily the one slides into the other), with networks of mosques and churches connected by telephones. In the last week of Ramadan, which ended on the day the conflict began, sightings of Jesus in the suburb of Gudang Arang caused thousands of believers to flock to the site for days, frightening Muslims with their displays of emotion.[33] Throughout the war, such sightings persisted in the city but also elsewhere. For instance, in Pineleng, in the hills above the Christian-majority city of Manado, where many Protestant and Catholic refugees from Maluku had fled and where, in July 2001, crowds gathered in the hope of catching a glimpse of the Jesus face that had surfaced on a chapel wall.[34] In Ambon, one visionary had committed to canvas his dream of the apocalypse engulfing the Malukan capital as an angry God looked down on the city (see Chapter 4). Dated in large, luminous white letters several days before the conflict began, the depiction of his dream

prefigured not only the violence but also the figuring momentum of Jesus pictures erupting in the city's war-torn streets.[35]

In the case of Ambon, anticipating and preparing for the worst can in crucial respects be said to have produced the worst. When the fight broke out in the city's main marketplace on January 19, each side quickly mobilized its members—staging in no time at all a battle between forces that were rapidly designated Christian reds and Muslim whites. On either side, representatives claimed that the opposite party appeared in the streets wielding matching machetes, something that was taken as a sure sign of their culpability in initiating the violence. Others pointed to the colored head ties—red for Christians and white for Muslims, allegedly worn by one or the other side from the first day of the confrontation—that betrayed the premeditation of belligerence. Depending on the perspective, either Christians or Muslims would have formed a huge swath of homogenous color reminiscent of the vibrant bands characteristic of political rallies, school parades, and civil servant gatherings in Indonesia.[36] Ironically, it is precisely this preparedness and visible organization that each side repeatedly held out to the other as proof of their opponent's preconceived plan to mount an attack. It is also what many scholars seized upon as evidence of the conflict's large-scale, coordinated, behind-the-scenes machinations.

My second example of how anticipation augurs what actually comes to pass also derives from that same first, fateful day—one that happened to coincide with Idul Fitri, the festive close of the Muslim fasting month Ramadan. In retrospect, some may see January 19, 1999, as falling into the category of "likely violence days," a formulation coined by a U.S. embassy security officer in Israel in recognition of the patterned repetition of violent outbreaks on Palestinian commemorative occasions.[37] Whether conjoining identity and trauma or, as with Idul Fitri, religious celebration and community, such days are charged with a practiced, ritualized sense of collectivity. Yet in many parts of Indonesia and in Ambon, until the war, the celebration of Idul Fitri was also crosscut, its alleged communalist potentiality complicated by interreligious conviviality, hospitality, and sharing. Nor was Christmas in Ambon much different in this regard. In 1999, however, the last day of Ramadan saw fights break out among young men in various parts of the archipelago, including four places in Central Java, also in West Java, Central Sulawesi, North Sumatra, the South Sumatran city of Lampung, and West Kalimantan.[38]

"Bloody Idul Fitri," the Muslims' preferred name for the day, yielded "Bloody Christmas" later in the conflict, commemorating the destruction of Ambon's landmark Silo church on December 27, 2000.[39] In opting for such names, each side aimed to blame the other while claiming victimhood for itself within the

intense negative reciprocity that, together with anticipation and the counter-moves this provoked, was another key dynamic of the war. The reciprocity played itself out in multiple registers—from the back and forth of onslaughts carried out with crude weapons in the conflict's initial phase, in which the brutal actions of one side elicited even more gruesome retaliations by the other, to the colors, names, forms of address, and graffiti through which Muslims and Christians aggressively mirrored and engaged each other.

On that first day, a journalist friend of mine found himself at the office of Ambon's oldest newspaper, *Suara Maluku*, alternately taking calls from a Muslim friend at home in the neighborhood where the battle subsequently broke out, making plans for the Lebaran celebration that evening, and from a Christian friend with whom he was coordinating their joint attendance at the feast.[40] On call from different ends of the city, his ongoing double conversation with his two friends and colleagues is itself an instance of the first stirrings of the conflict. After finalizing their plans, the Muslim friend immediately called back, telling my friend to bring his camera since a fight had broken out—a regular fight, he said, the kind of thing we have seen before. The other friend called again, too, saying he would not come because people were in the streets with machetes, up in arms because of a burned-down church. Caught in between, my friend heard of both mosques and churches being burned before any smoke was seen in the city. As he himself put it, the rumor preceded the event and, contrary to the laws of nature, where there was fire, no smoke had been seen. Indeed, the only fire around was a wildfire of misinformation and suspicion sweeping with incredible speed across Ambon.

Any kind of balanced information, not surprisingly, was one of the first victims of the violence. Soon after the conflict broke out, the three friends and *Suara Maluku* journalists who happened to be Muslim, Catholic, and GPM Protestant, and who had conversed by phone across the city as the violence began, could no longer come together. The location of the paper's office in what rapidly became marked as Christian territory meant that Muslim journalists could not safely come to work, while Christians dared not venture into the Muslim area where the newspaper's printing press was now located. Seizing a good business opportunity when it emerged, the Surabaya-based media conglomerate the *Jawa Pos* group, of which *Suara Maluku* was a member, created a Muslim spin-off newspaper, the *Ambon Ekspres*, where the former Muslim *Suara Maluku* journalists were employed. With the increasing severity of the conflict and the rise in partisan feelings, this situation further aggravated the rapid polarization of local media—not just print but, as we will see, the vernacular forms that especially predominated in the conflict, like graffiti, VCDs, and

incendiary pamphlets or "hardcopy rumors"—into Christian and Muslim mouthpieces, thereby glossing over the heterogeneity within each religious camp.[41]

A strict chronological account would fail to do justice to the erratic rhythms and unfoldings of the war, which depended as much on fantasy and desire as on apprehension and fear. If experience, contrary to popular belief, is mostly imagination in any circumstance, this is all the more so in the fraught mobile environment of war, where the tendency to make things seem grotesque and larger than they really are is enhanced, as Clausewitz already recognized in the nineteenth century.[42] In much of the scholarship on Ambon, too little attention is given to "the work of the imagination" and the construction of knowledge in violence's production and sedimentation and, specifically, how these compel and propel particular actions and shape those who carry them out.[43] The mobile, dense, and murky terrain in which something that is waiting to happen does in fact happen is built on spirals of information, misinformation, and disinformation, on the revamping of criteria of credibility, customs of trust and accountability, and on knowledge forms that blur the boundaries between what is seen and what is heard, what is known and what is suspected, what is feared and what is fantasized, what is fact and what is fiction. Rather than try to extricate a causal chain, I argue that confounding any clear trajectory from which one might plot the actions of the various parties involved is a swirl of images, vocabularies, sound bites, slogans, and vectors introducing a host of mediated and mediatized elsewheres into the picture—or, inversely, projecting Ambon, with all its troubles and sufferings, onto a larger-than-local scale. It is in the thick of such things and their powerful effects that one may begin to address Ambon's violence.[44]

This means situating violence in all its complex specificity at the myriad sites of its production as a structuring and destructuring force of social life. It is there where violence emerges and spawns its own supplementary effects, which, in turn, are evidenced by new outbreaks of violence in other parts of the city, across Ambon Island, or elsewhere in Maluku.[45]

The Thick of Things

Let us turn now to the myriad images, vocabulary, anticipatory practices, elusive agencies, and specters, and to the consolidation of hard-edged religiously inflected enmity that characterized the war. This means seriously engaging the thick of things that, for many Ambonese and others implicated in the violence, was part of its defining conditions. It was in these conditions, too, that the protagonists came to see and, significantly, *not* see each other within the

aggravated perception that over time came to describe an important dynamic of the war.

Take the difference between the Christian reds and the Muslim whites. Despite the common perception that these groups stood opposed from that first day as ready-made enemies, this is hardly the case. Notwithstanding the serious grievances, suspicion, and intense competition between religiously embedded networks[46] and insidious stereotypes that marked the relation on both sides, many of those who clashed in Ambon's streets were also in an important, hardly negligible sense neighbors. Whether one understands such relationship in terms of poor knowledge of the other, the "alien but proximate" space inhabited by culturally and socially different "strangers" in another depiction of one of Ambon's crowded, religiously mixed, urban neighborhoods harboring many poor migrants, or intimate, as in my own preferred description of the religiously based enmity that subsequently evolved between Christians and Muslims, the more pertinent issue is not the factual knowledge held on one side or the other.[47] It is rather that the large majority of Ambonese, both Christian and Muslim, assumed with no uncertainty that they *knew* their long-standing religiously distinct neighbor. To be sure, the intensely populated conditions in Ambon City proper where Muslims and Christians lived cheek by jowl, including the dense proximity of more religiously homogeneous neighborhoods, are relevant to this understanding. But beyond any empirical reality, the assumption of long-standing familiarity and knowledge of the other was what really came to matter in the messy terrain of the war (see also Chapter 4).

The cruel work of severing what was once the largely livable city of Ambon for many of its inhabitants and the congealing of difference into hardened binary identities resonates with instances of so-called communal forms of conflict elsewhere, where—much as in the Malukan capital—ordinary people had for a long time tacitly agreed to live together with all their differences and, therefore, also with greater or lesser degrees of communal tension and occasional, small-scale violence. This is a somewhat different perspective than the anodyne one offered by then president B. J. Habibie, who lamented in November 1998 that the religiously inflected brawls involving Ambonese in Jakarta shattered the long-standing reputation of Ambon as a model of religious tolerance in Indonesia. However one describes this kind of cohabitation, once enmity is sealed in bloodshed and memory and codified through collective talk and imagery, ordinary people can apparently engage in and commit the most horrific acts, and dehumanization of the opposing party can become second nature for just about anyone—over time.[48] Contrary to easy discussions of "dehumanization" (as if it involves something that people wake up to one

day and decide to do), the distancing that dehumanization presumes must actually be produced, with an enemy made and identities recognized and reforged in the heat of impending and ongoing confrontation. What it means to be human and, therefore too, nonhuman will also be inflected by attitudes toward killing, suffering, and the body, as well as by notions of vengeance, retribution, and reconciliation, among many other things.[49]

I do believe that the extreme violence in Ambon was, at least in part, attributable to the need to turn those in one's own image into something else, with the violence figuring as part of the work involved to bring about a radical difference.[50] For all the underlying tensions, interreligious rivalry, dark legacies of the Suharto era, and even turf wars between the military and police, the civil war in Ambon was just that: largely fought out among Ambonese—that is, among former colleagues, friends, and neighbors. A refugee from the area even suggested that the differently colored head ties worn from the beginning on both sides were imperative for telling each other apart—given, he said, that we are all Ambonese.[51] One might even venture that in this example, the work of appearance was superficial, operating solely at the level of outward appearance—that is, with the difference between Christian and Muslim imposed externally by Ambonese who found it difficult to discern friend from foe. Over time, however, as the violence persisted, a different discourse became increasingly prevalent. Following this discourse, religious difference increasingly came to be *seen* as naturally embodied and, as such, identifiable by physical appearance alone, which was understood to operate independently of externally imposed signs like head ties or other cultural accoutrements.

Already early on, however, distinctive colors and other distinguishing marks seemed unable to sufficiently conjure difference out of taken-for-granted sameness or to contain the weight of growing fear and hatred as the experience of war, with its trail of anger, loss, and grief, increasingly shaped the terms of perception and action on either side. Perhaps hatred is precisely such a restless search for new names and new labels in which to provisionally shelter an emotion that inevitably exceeds them, or perhaps such a search is simply part of the effort that goes into consolidating a radical, hard-edged rift between those who previously—notwithstanding all their differences—lived in some sense together as a workable urban collectivity. Whatever the case, additional names and images of the enemy Other accreted along the way, further deepening the divide between Muslims and Christians and making it more difficult to imagine its undoing. A by-now-infamous public service announcement broadcast on national television and on several commercial channels some months after the violence began seems to have been compelling enough to emerge as an emblem of mutual enmity. Shortly after its airing, the spot took on a life of its

own—one quite different from that intended by its producer, who, as a result, claims to have suffered trauma.

A sweet, sentimentalized vignette of only several minutes, "Voice of the Heart—Acang and Obet" features two young Ambonese boys, the Muslim Acang, short for Hassan, and his bosom friend, the Christian Robert, or Obet.[52] The scene is an abandoned, gutted-out basement of a large, concrete building, evoking the ravages and dislocations of war. The spot opens with Acang awaiting his friend, anticipation on his face, and the smiles and joy on both sides when Obet arrives (Figure 5). The two share a quick, stolen conversation in which the more obvious problems afflicting Ambon's children somewhat stiffly parade by: Obet complains we cannot go to school, see our friends, study at home, or sleep; Acang, that he misses school since moving to a refugee camp, where life is difficult. To Acang's question "Why did Ambon fall apart like this?" Obet responds, "I don't know, it's a problem of adults." Acang is left with the punch line: "It's an adult problem and we kids are the victims."[53] The camera zooms in on the two friends, their arms around each other, speaking jointly from the heart, the one echoing the other, voicing the hope and mutual promise

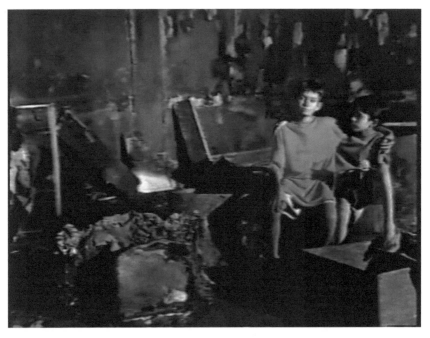

Figure 5. Screenshot from the video CD "Voice of the Heart—Acang and Obet." Produced by Franky Sahilatua, 2001.

that "even if Ambon is destroyed like this, our bond of brotherhood should not be broken."

The spot has all the trappings of the documentary—sophisticated, objectivist aesthetics and a credible backdrop bolstering cinema's illusory realism,[54] authentic Ambonese dialect, Indonesian subtitles, and two emblematic, young Ambonese boys. The drama resurrects the trope of friends torn apart by uncontrollable circumstances—seen on-screen as early as D. W. Griffith's 1915 classic *The Birth of a Nation*, set during America's Civil War, but also more recently with the Indonesian Revolution as backdrop in the film version of the 1948 Dutch novel *Oeroeg* by the grande dame of Indies literature, Hella Haasse. Strikingly though, unlike their predecessors—whether standing in for America's North and South or for the Netherlands and the birth of Indonesia—the Ambonese heroes of "Voice of the Heart" do not grow up. It is worth pointing out, incidentally, that the theme of a nation divided not only underwrote the "Voice of the Heart" PSA but was often read into the rupture between red and white in Ambon's war as allegedly corresponding to the two horizontal bands of the "red and white" (I. *merah-putih*) Indonesian flag. In the immediate postwar period, the popular genre of reconciliation art and media focused on children's faces, voices, and drawings also uncannily reiterates the bifurcated symmetry of both the PSA and the Indonesian flag, something I discuss in Chapter 5. Yet, notwithstanding its compelling aesthetics, the trope of bosom friends, and the PSA's message of peace, the names Acang and Obet came to be shorthand for enmity for each side in the conflict.

To be sure, children are the future of any nation and emphatically so in Indonesia, where a large proportion of the population is under the age of twenty-five.[55] The war in Ambon had terrible effects on everyone—not least the children, many of whom were left fatherless, orphaned, homeless, in refugee camps, and out of school.[56] Many saw and experienced horrific things and many, too, participated in their making, serving as militia messengers on both sides, becoming skilled producers of crude, deadly weapons, torching houses, and vandalizing neighborhoods after an attack. One source claims that between two thousand and four thousand children aged seven to twelve—the same age as Acang and Obet—took part in raids on enemy villages or assisted in defending their own. On the Christian side they were known as "sandfly troops," among Muslims, "crowbar troops."[57]

Apart from their involvement in the conflict, children featured prominently on the online site of the Protestant newsgroup Masariku and on the website of the Communications Forum of the Sunna and the Community of the Prophet (I. *Forum Komunikasi Ahlussunnah wal-Jama'ah*, or FKAWJ), of which the Laskar Jihad was the paramilitary wing.[58] On both sides, the appeal and

propaganda value of children—also the point of departure for the Acang and
Obet ad—was deployed to portray children as both victims and key agents in
the war.[59] Books with a jihad theme targeted children, while the FKAWJ web-
site produced reports on the "DIY Troops" and "Plastic Troops," the latter
evocative perhaps of toy soldiers, or their terms for Malukan children who
dressed as jihadists and aimed to partake in their struggle.[60] Masariku, in turn,
in its *Portraits of Maluku* series, showcased photographs of child members of
the sandfly troops in uniform, wielding wooden swords with miniature bibles
hanging from their necks or protruding out of their pockets.[61] In short, while
the Acang and Obet ad aimed to promote peace rather than generate sympathy
for either of the warring parties, the hijacking from the ad of the boys' names
to serve as key terms of enmity suggests that what mattered most was the con-
nection between violence and the figure of the child characteristic of the
genre—a connection that, as here, can be mobilized for quite different ends.

As opposed to the more belligerent depictions, what fantasy structures the
pro-peace PSA "Voice of the Heart"? It is a fantasy that at the time also under-
wrote letters and poems of refugee children published in Indonesian newspapers
that similarly emphasized the longings for each other among former Christian
and Muslim playmates.[62] To set off the pair from the violence around them,
Acang and Obet's cave-like shelter is a microcosm where, speaking from their
child hearts, the pair evokes the *pela* blood brotherhood alliances mythologized
in Maluku and frequently held up in peace and reconciliation initiatives as a
model of harmonious religious plurality and coexistence (see Chapter 5). These
alliances conjoin some Central Malukan Christian and Muslim villages but
also some Christian villages through bonds of kinship and mutual aid that are
stereotypically evoked in the image of Muslims building the church of their
Christian pela partners or Christians aiding their Muslim brothers in con-
structing or repairing a mosque. If these blood-brother relations were already
widely acclaimed examples of cross-religious relationality before the war, it was
only in its context that the bond developed into an instrument of Christian
and Muslim reconciliation and peace generally. As such, the ad offers not only
an early intimation of its later importance but also the degree to which the
alliances have been romanticized.[63] The space where the two friends meet is
also a haven of apolitical innocence—located less beyond the upheavals of
dislocation, refugee status, interrupted schooling, and everyday trouble, which
the ad clearly names, than beyond the politics, power structures, and political
economy permeating and informing all of these. The diminutive child's world
also serves to diminish the conflict—bringing it down to size, to that of spoken-
from-the-heart childhood honesty and clairvoyance—and thereby trivializes
its real impact on Ambonese children. At the same time, the PSA's exaggeration

of interiority—its portrayal of a miniaturized world of children, the voices of the two friends issuing directly from their hearts, and the secluded surroundings in which the meeting between Acang and Obet occurs—enhances the ideological impact of the message it hopes to convey.[64] The spot offers a fantastic world unto itself, one that makes the exacting, difficult circumstances of wartime absolutely exterior to itself, presenting a time out of time that negates change and the lived reality of the war.[65]

In blaming adults for Ambon's violence, the spot also conjures an orphaned landscape via a double delegitimization: of the parents of all Obets and all Acangs, of pemuda—or "youth," a morally charged category on the crest of all revolutionary change in Indonesia, recently reinvigorated during Reformasi—of students, and of all others excluded from the enclosed world of "Voice of the Heart."[66] Like *Viva Indonesia! An Anthology of Letters to God*, discussed in the Introduction, and other child-centered productions of the time that launched children's faces and voices as sentimental antidotes to violence, the ad unambiguously declares violence an adult problem and the result of their agency. Other productions similarly named or portrayed the abandonment by Indonesians of their duties as parent-citizens, the violent disruption of the father-child bond, or, more abstractly, children who appear alone in orphaned landscapes of one kind or another.[67] In the case of "Voice of the Heart," what remained after this pernicious erasure was an abstract, easily appropriable clarity—a schema amenable to multiple ends, including violence.

A name and face for the enemy is all that Ambonese took from the spot meant to foster peace among them. Refugee talk on my tapes from 2000 and 2001 is replete with phrases like "Acang attacked," "Obet's territory," "Acang retreated," and "Obet retreated," testifying to the currency of the public service announcement's unforeseen afterlife, the rampant circulation and uptake of media, especially pronounced in such overheated circumstances as Ambon's conflict, and the unpredictability of audience reaction. As late as September 2003, the names hijacked from the PSA could still be heard in Ambon—cautiously if talking about the recent opponent but also exuberantly in peace songs and propaganda. For instance, a drum inscribed with the names Acang and Obet hung in the office of the Jesuit Refugee Service that organized reconciliation events for children.

If, arriving unwittingly from elsewhere, Acang and Obet's message went awry in its adjustment to Ambon's belligerent conditions, so, inversely, did Ambonese actively borrow examples from other places that seemed to approximate their own fraught world. Like a voracious fire consuming anything in its path, everything became swept up and recast in the conflict's polarized terms. Although I cannot date its emergence, the city's main dividing line between its

Muslim and Christian parts was known colloquially as the "Gaza Strip" (I. *Jalur Gaza*), although several others emerged over time. This name had already been prepared in the first days of the conflict, when graffiti desecrating walls and buildings included insults of Jesus and the Prophet Mohammed, references to Jews, Israel, Muslim Power, and Muslim Pigs, stars of David, and *allahu akbar* in Arabic writing. Along similar lines, when the Laskar Jihad arrived in Ambon, its members quickly set about renaming streets and tagging guardhouse walls, clinics, and other buildings with the organization's logo, calligraphy, and characteristic images in the Muslim-dominated areas of the provincial capital.[68] In this way, for instance, Ambon acquired a Martyr's Street that it had never had before. Such fragmentary, free-floating bits of discourse work best in display mode—on T-shirts, banners, posters, and head ties—as visual and verbal slogans. Taken out of context, they also transcend it, becoming monumental and indexing a universe—one of closed ideological systems and stand-off positions.[69]

Soundtracks of War

Language was another frequent casualty of the war as names like Acang and Obet became codified, venomous accusations and everyday communication was highly politicized—to an extent that accords with the claim of some scholars that in circumstances like that of Ambon, language, along with much else that comprises the everyday, becomes inflected by violence. Violence's effects can be so dramatic that what remains in its wake is merely "the debris of language."[70] In the Introduction, I proposed that the present of a city at war may become alienated from the images or language through which it was previously known.[71] A compulsion to label usurps the place of everyday conversation and exchange, one that in Ambon gave way to a belligerent religiously inspired call-and-response—the Christian cry of "Halleluyah," for instance, countering the Muslim "Allahu akbar" in Ambon's streets, along with numerous other examples of nefarious mutual mimesis.[72] The aggressive mutual engagement of the opponents left a long-lasting legacy in the Malukan city; for instance, in the Christian convention, dating from the war, of using *syalom* as a greeting "since the Muslims have *wassalamu alaikum*," or in the need, when addressing a young Ambonese, to quickly determine whether he is a Muslim *bang* (from *abang*) or a Christian *bung* or she is a Muslim *cece* or a Christian *usi* and to use the appropriate gendered and religiously marked terms of address.[73] Such examples of language's extreme reification may be especially suited to capture the traumatized concretism of the aggravated situation of danger corresponding to the experience of war.[74] As an attempt by people to visually and linguistically

get a hold on the increasingly elusive realities around them, reification surfaces as a corollary and symptom of the atmosphere and uncertainty that wrapped the city in war's fog.

Not only language but also sounds were another potent ingredient on the urban battlefield: Muslim VCDs came with *nasyid* songs that make explicit use of religious dogma and were especially composed for jihad in Maluku, while Christians sung hymns like "Onward Christian Soldier" as they moved toward combat.[75] Not surprisingly, such soundtracks of war had important effects on those who heard them, instilling courage and a sense of collective purpose before battle and anger and hostility in those on the opposing side. "Us Christians still have the fear of God in us," a young Malukan in Manado told me. "We are diligent churchgoers, now all the more so, more determined. When there is violence, we sing Onward Christian Soldier, onward. When we hear this sung, we feel courageous, and when we go off to battle, we pray first, either in church or at home. We don't want to kill but are forced to do so. If we don't kill, we will be killed ourselves. That is the situation."[76] By the same token, such singing often instilled fear in Muslims. "Smoke was everywhere, so we were confused," a Muslim woman who had fled Ambon early on in the conflict told me as she described how she saw fires burning everywhere on the first day of violence.[77] "This is so sad, fires while it is Lebaran. It's a holiday while houses are burning" was how she recalled her thoughts at the time. Two days later, she remembered how "kids between the ages of fifteen and twenty, bare-chested with red ties around their heads" showed up near her home.[78] "At the time, I could not read the situation, but they were lined up and began to sing. They were singing and yelling and yelling like I don't know what." I asked if they sang religious songs and she replied, "No, those are slow, but these were kind of different. They were singing and taunting the soldiers."[79] Such aggressive cries and songs could have an effect even on those who aimed to maintain distance vis-à-vis the conflict. A Muslim journalist representing a national news magazine, whom I met in Manado, confessed that while he did his utmost to remain neutral as a reporter, he was so concerned that "one more cry of 'Halleluyah'" would bias his reporting that he asked to be transferred back to Jakarta.[80] Similarly, a priest complained to me of the effects on Protestants who would tune in to the Laskar Jihad radio station and become revved up by what they heard.[81] Since the station dominated the airwaves, it was often impossible to drown out, so the incessant insults and provocations of the jihadists continued to infiltrate the walkie-talkies of clergy and others around the city. Much better equipped and more technically savvy than their opponents, the Laskar Jihad included a download section on the organization's website with sound files of such memorable events as the speech given by their founder, Ja'far Umar

Thalib, at the mass meeting held at Jakarta's Senayan Stadium in April 2000, the event that led to the jihadists leaving for Ambon a month later.[82] There were also the myriad sounds of wartime communication—from passwords and rapping on utility poles meant to convey secret information to those in one's camp, to the explosions and sounds of different weapons going off and the noise of confrontation and attack. Loudspeaker technology deployed on both sides meant that the sounds of the Muslim call to prayer and imam's khutbah competed with Christian sermons broadcast beyond church walls as congregations gathered up to three times a day at the height of the war. Over time, the aggressive back-and-forth and mirrored vocabularies and practices of Ambon's intimate enemies, emergent out of their ongoing negative exchange, further sedimented violence in the city and, with it, a projection of the conflict's alleged intractability emblematized by its own Gaza Strip(s).

Amplifications

I am interested in this usurpation of a powerful name from elsewhere because of its effects within the dynamics of the conflict—both more than local and less than global, though feeding off of and beholden to much larger than national designs—and because of the mediatized, mediated realities of Ambon, as virtualized as almost anywhere these days, especially since the war. Akin to the synchronic nomenclature identified by Benedict Anderson with the beginnings of the imagination of community as nation—like New York, New London, Nuevo León, Nieuw Amsterdam—Ambon's Gaza Strip could "arise historically only when substantial groups of people were in a position to think of themselves as living lives parallel to those of other substantial groups of people—if never meeting yet certainly proceeding along the same trajectory."[83] In our own highly globalized times, however, such neat parallelisms between metropole and colony have increasingly opened out, giving way to multifaceted and more rhizomatic forms of imagining.[84] Thus, the potent trope of the Gaza Strip not only assumed definitive power in Ambon but also insistently cropped up elsewhere—even in what seems such an unlikely place as Venezuela—to characterize what appear to be the most hardened and intractable of violent situations. Another factor that fed into the analogy in Ambon was the locally prevalent assumption that the conflict between Israel and Palestine should be interpreted in religious terms. The specifically Pentecostal understanding that the apocalypse presumes the habitation by Jews in the biblical homeland prior to the Christian end-time further supports this interpretation. Given the importance that charismatic churches assumed during the war, it is safe to conclude that this understanding was also at work here.

Twinning Ambon with this other, more famous, intensely mediatized war-torn place may have been one way of making the violence in Maluku—hardly a priority in Jakarta—matter, a way of lending local suffering and loss a larger-than-local meaning.[85] It also demonstrates the theatricality and dramatic imagining of social actors in a world dominated by NGOs, international peacekeeping initiatives, Human Rights Watchers, and other important audiences. If the sense of audience is always crucial to the production of political violence,[86] in Ambon's conflict different senses of audience may be discerned that draw on identification and desire for recognition across vast distances, build on histories of connection (or presumed connection), and were facilitated by changes in communication and media technology and, not the least, imagination. In an admittedly oversimplified fashion, there is the immediate sense in which Christians and Muslims in Ambon were significant audiences for each other, something that I have repeatedly emphasized. But there was also the widespread perception, or at least hope, that important international actors held to be potential supporters might be watching as well—such as, for Christians, the United Nations or European Union, and for Muslims, their fellow coreligionists around the country but also in Southeast Asia and the Middle East. Another crucial ongoing dimension of the sense of audience for Ambonese on both sides of the conflict was the more transitive awareness that others were seeing what they saw.[87] Necessarily, the ways in which the gaze of such others is imagined varies socially and historically, but it figures increasingly as a dynamic in situations of crisis and conflict everywhere. If during Indonesia's Reformasi people felt that the eyes of the international community witnessed events in the country,[88] the gaze of others in Ambon was, as so much else, religiously defined, as Muslims and Christians alike imagined and hoped that their transnational coreligionists would not only be watching them but also be watching *with* them as partisan witnesses and coviewers of the war. And to some extent, they were: Muslims rallied in Jakarta against the alleged Christianization of Maluku or tagged walls in Lombok with graffiti about the burning of a mosque in North Maluku, while Dutch Malukans, the majority of whom are Protestants, maintained close contact with their relatives in Ambon and mobilized in different ways around the conflict.[89]

Notwithstanding such examples, arguments that foreground the empirical fragmentation across different media of incidents of violence according to the type and location of audience or insist that the "actual participants" of a given "transnational or macropublic sphere" may in fact only constitute a "numerically small group" miss the point.[90] While useful perhaps for purposes of market research, such analyses bypass the role of imagination in the amplification of war's import—including the imagination of others who see what you

see, as suggested here—but also, how, as with any other public, religious publics are never wholly present to themselves.[91] In any event, one wonders if the import of the conflict, once amplified, can thereafter so easily be scaled down. For once you imagine Ambon as "Gaza," or a stage for an epic contest of Christianity and Islam, how do you get back to some version of a messy, if more or less workable, cohabitation? Besides the enormous difficulties of moving on and reassembling lives after conflict, due, among other factors, to how its violence lingers in the patterns, language, and gestures of everyday social existence, much of war's materiality may long remain in place. It has certainly done so in Maluku, in myriad ways,[92] not least via the spectacular assertions of aggression and exclusion performed by Ambon's Christ pictures vis-à-vis Muslims. For let us not forget that these adamantly Christian productions continued to be maintained and repainted for a good decade after the official peace. An example from the conflict in North Maluku are the martyrs' graves and other monuments that, while offering a material counter to an official discourse on "reconciliation," repressive of memory of the violence, run the risk of objectifying the volatile religious terms in which the conflict was played out as they also bear witness to the trauma and dead of war.[93] Like the VCD showing a Christian mural where the camera zooms in on Jesus holding a globe on which the state of Israel has grown to continental size, such literal amplifications were also part of the conflict's aggravated stakes and the wider enhancement of its significance.[94]

Neat schema and ideologically compelling images, like those from "Voice of the Heart," Ambon's Gaza Strip, or insults sprayed on city walls, facilitated amplification since they summed up so much in succinct condensations of abstraction and affect that could circulate and be remediated easily. Within a much larger arena of conflicting messages, fragmentary information, and representational immediacy, amounting to a veritable infrastructure of the imagination, some stood out more than others, proving provocative enough to trigger large-scale violence. One especially infamous incident involved a phantom letter allegedly issued by Ambon's GPM church calling for Maluku's Christianization. Once multiplied, read aloud over megaphones, and spread about, this letter contributed directly to the dislocation and deaths of numerous North Malukans.[95] While Muslims seemed to have accepted its veracity without question, Christians indulged in forensics that exposed the letter's falsity: "bizarre and mysterious, the leaflet lacking a letter head and using a language that is not that of the church only circulated among Muslims," one report notes.[96] Such dark circuits underlaid, crossed, and competed for attention with partisan descriptions by the local press (the *Suara Maluku* newspaper, as noted above, not only consolidating into a Christian paper but spawning a Muslim

competitor), village gossip presented as truth on Christian and Muslim websites, Christian-inclined state radio vying with the illegal Laskar Jihad station, banners spanning avenues or hanging from buildings, rumor piggybacking on techno-logical reproducibility to produce "xeroxlore" in folklorists' terms,[97] graffiti sprayed on walls, streets, and war-damaged buildings, and numerous processions and protests that occupied the main thoroughfares of the city. These included mass ambulatory prayer sessions as Christians took to the streets with red head ties, bibles in hand, and pictures of Christ that floated above the crowd. Mus-lims, in turn, wore white head ties, unfurled green and white flags, and bore banners with Arabic calligraphy. Local representatives of the national organi-zation of Concerned Women, a procession of Christian clergy in February 2001, including Ambon's bishop and former bishop, priests, brothers, and nuns, and numerous Protestant ministers representing different denominations pro-tested against the forced conversion of Christians by jihadists on the Malukan islands of Kesui and Teor in late 2000 and early 2001. Demonstrations by Mus-lim refugees objecting to the ban of the jihadist radio station, or others protesting the imposition of civil emergency, were among the many public manifestations of the city at war.[98] These divergent and convergent voices and views drowned out, echoed, interrupted, and jostled each other in the cramped, ideologized, divided space of Ambon, made up of myriad mediated elsewheres, amplified, narrowcast, obscure, and confusing realities.

Even the supposedly, on the face of it, simple problem of actors—the whodunit of the violence—could be hard to pin down. Take the abstract lexicon produced by some nonpartisan, pro-peace press journalists—people with the very best of intentions. In the aim of diminishing the conflict, they often deliberately obfuscated the information about a violent exchange.[99] In part, this may be a legacy of the self-censorship and prohibition under Suharto on SARA—or "Suku, Agama, Ras, Antar-Golongan," publicizing differences based on tribe, religion, race, and class—that remained operative in many quarters during the Reformasi era, notwithstanding its call for transparency and a new openness. But it also had to do with the way in which peace journalism, only recently introduced in Indonesia at the time, was often interpreted. Reading the ac-counts of some journalists, one is left none the wiser: houses of worship are stripped of denomination, and only elusive actors are named—"certain parties," unidentified "political elite," "puppeteers," and the ever-popular "provocateur."[100] Applied, in short, was a systematic unnaming of the war's combatants.[101] What-ever its aim, I argue elsewhere that this lack of specificity with regard to agency may in fact produce a sense of phantom danger, lurking both nowhere in particular and therefore potentially everywhere in general, provoking fear and, perhaps, new violence.[102] Moreover, with the use of phrases like "Muslim

cleansing," imported early on from Jakarta, and other vivid, slanted versions of war, a more neutral source is quickly marginalized since—as one Ambonese journalist put it—it appears ludicrous by contrast.[103] I further discuss some of the dilemmas that reporting on the conflict posed for journalists in Chapter 5.

Anticipatory Practices

Throughout this chapter, I have stressed the role of the possible and the conditional in the spread and sedimentation of violence. It remains to give some sense of what people caught in the midst do—with multiple influences and images impinging upon them. Let me begin with the VCDs made by both Christians and Muslims but circulated only by the latter (which I therefore highlight). At first glance, they fly in the face of the stripped-down media reports, sound bites, and schematic images discussed above. The VCDs' appeal depends upon their sympathetic, almost tactile engagement with, especially, victims and their bodies—on close-ups of oozing wounds, bullets protruding from body parts, maimed and charred corpses, and the bodily contortions, moans, and screams of people's suffering too painful to watch. But they were watched—over and over again. Besides the victims, the occasional imam, Muslim NGO spokesperson, or, in the case of Christians, Protestant minister delivering an emotionally charged sermon in the ruins of a burned out church, and the hands of surgical intervention (doctors themselves are rarely seen), the main action is that of mass scenes of attack and violence drawn largely from the war's earliest moments. Very much in the thick of things, these VCDs provide little perspective on events and often make no pretension to having a narrative—besides, that is, the insistent, repetitive one of victimization resurrected on and out of body parts.[104] Indeed, part of the affective appeal of this VCD genre, if necessarily different for Muslims and Christians, may reside precisely in its obsessive return to the "wound" and repetitive enactment of disaster that does not resolve itself easily into narrative but repeatedly assaults the viewer.[105]

These VCDs are composite works; they range from the more professional to the homemade, though both often contain the very same clips, which were clearly shared and copied profusely. In Ambon I was told that, during the war, just as around Indonesia one could commission a CD of favorite songs, so, too, in some of the city's shops, could a compilation of select scenes be put together on a personalized VCD. Some of the clips were produced, or at least endorsed, by the military and feature soldiers casually standing by or going about their business, neither shying away from nor interrupting the camera. Others are said to have been filmed by doctor-volunteers who not only stitched wounds

but lent their steady hands and surgical gazes to the close-up cinematic en-
gagement of broken bodies. Many VCDs, at any rate, are pieced together, and
many evidence the presence of different hands—some steady, others shaky,
and still others apparently entranced by the zoom function.

How did the mass appeal of the VCD genre translate into the actual creation
of a sense of community and the shaping of perception and action in the con-
flict? This is a question with inevitably somewhat different answers for Ambon's
Christian and Muslim populations, one that I address in more detail elsewhere
with regard to Muslims.[106] If, however, community in the sense of collective
purpose and futurity has anything to do with the circulation and consolidation
of shared symbols, memories, and sentiments, then the nature of their mode
of transfer and sedimentation is clearly important. Among Christians in Ambon,
VCD traffic was relatively small scale, difficult to break into, and closely con-
trolled, with VCDs bearing advisory labels like "intended for own group."
Similarly, the founders of the Christian website Masariku expressed their con-
cern that materials from the site might fall into the wrong hands, and they
repeatedly warned their members that circulation should only take place within
the Masariku group.[107] Such concerns evidence the sense shared by many of
Ambon's Christians that they were a tiny minority under continual threat of
attack or even annihilation by an aggressive Muslim majority. For even if Prot-
estants received support from their relatives in the Netherlands and via church
networks there, around Indonesia, and to some extent internationally, they had
difficulty collaborating, probably due to the number of denominations in the
region and the divisiveness among them. This may have further enhanced
their paranoia and insistence on group loyalty. By contrast, the Muslim VCDs
were not only mass-produced, sold during the conflict in markets and streets
across Indonesia, but transnationally popular and quite homogeneous: Ambon's
VCDs looked much like Kashmir's, Bosnia's, and those of Palestine watched
in Malaysia and elsewhere.[108] Once the Laskar Jihad began to arrive in Ambon
in May 2000, its members trafficked openly in jihad VCDs and print media
on the large passenger boats heading to Maluku from the western parts of the
archipelago. Their newsletters also explicitly located Ambon's conflict within
a larger, transnational arena of religious warfare by referring, for instance, to
religious war in Bosnia.[109]

For any of these VCDs to have any effect—whether in the claustrophobic
enclave of Ambon's Christians or in the transnational Muslim space stretched
thinly perhaps across the geopolitical mosaic of different Islams—a number of
things are needed. The first are codified discourses like those of the Laskar
Jihad or Christian FKM mentioned earlier or the more general panics aroused
by accusations of Christianization and Islamicization that served as rallying

cries or even captions orienting and providing a framework for perception and action. Many of the VCDs also contained authorizing discourses, slogans, and religious leaders—from the emotionally charged scene of a minister speaking in the charred hull of Ambon's landmark Silo Church following Bloody Christmas, or the voice of a man disciplining a visually incongruous crowd of jihadis by reciting the rules of jihad (no stealing, no felling of trees, no raping of women . . .), to imams soliciting donations, to energetic displays of the physical prowess of the *cakalele* warrior in performances of the famed Malukan war dance on-screen.[110]

Apart from such authorizing figures and discourses embedded in the VCDs, another aspect inherent to the effects of these and other media during the conflict are what Raymond Williams calls "social expressions in solution," as distinct from other semantic formations that he considers more evident and immediately available.[111] Neither institutionalized nor reflexively present but tentative and incipient, such social expressions in solution—or "modes of affect and feeling attendant on emergent social processes"—inhabit a patchy, dispersed terrain, constituting community only as a potential.[112] If they do congeal, then this is as structures of feeling that operate in tandem with other historical and political conditions and the aspirations, uncertainties, and contingencies of a given moment. In the context of Ambon's war, the attention of those who watched such VCDs as I witnessed, among others, at a screening in an *ustad*'s home in Manado and, therefore, at a relative distance from Ambon's violence, was acute and affectively charged.[113] Their brutal graphics and unambiguous visualization of victimization made the VCDs, on both sides, key components of social expressions in solution in which the tendency to produce a strong sense of the communal—however transient—was overdetermined.

One of the most professional VCDs, called *North Maluku's Suffering*, graphically intimates the kind of fluid, contingent expressions in solution that must have suffused the Muslim collectivity congealed on-screen.[114] There, the gathering of people is bent to the common task of jihad in North Maluku but, I believe, in another situation, just as easily dispersed. Visibly at least, this public is an ad hoc collection of eclectic affinities.[115] While everyone present, primarily men but also a few women, is dressed more or less in white, some appear orthodox and sober, others are inscribed from head to waist with *ajimat* (magical charms dating to the Crusades),[116] some wear Saudi-style dress, others are wrapped in Palestinian headscarves, and still others exhibit Jihad-Central Javanese Yogyakartan style. Several carry Philippine Moro-type machetes, others have bows and arrows or spears, some have AK-47s, and a few even wield plastic guns, perhaps for their effect on unsuspecting audiences.

In sociological terms, the question of the VCDs' effects on those who engaged them is, at least in part, one of mobilization or another way of asking how the mass appeal of the VCD genre shaped perception and action during the war. Compelling evidence from the conflict in Poso, Central Sulawesi, that, much like Ambon, played itself out along religious lines, suggests how only a small group of poorly organized men is capable of galvanizing a large segment of the population.[117] Also that such group is often responsible for the majority of the killings, implying that most people implicated in collective violence are not themselves drawn to kill others.[118] Nonetheless, as in Ambon, it seems to have been the case that hundreds of Protestant men joined vigilante brigades and committed—or at least actively participated in—gruesome acts of violence.[119] Although not a central concern here, this means that it is crucial to recognize different levels of engagement, commitment, and action in the production of violence. More importantly, how forms of imagination, discourse, and imagery in inciting and perpetuating violence—the focus of this chapter rather than sociology per se—are much more broadly dispersed across a given population. This is a dimension of violence that is often underestimated or not given the attention it deserves by observers and analysts of violence, whether those employed by official government bodies, NGOs, or scholars, as I suggest above.

Another example of the imagination that appears to have suffused the city during the war are what I call anticipatory practices or the compulsive need to interpret and mine just about everything for hidden meaning, to see any trivial occurrence as a sign or omen of what might come or a hyper-hermeneutic.[120] There is, relatedly, the drive to produce signs (head ties, graffiti, and the like) for one's own group, for other social actors, for larger relevant audiences, and, not the least, for the enemy Other. Lest this seem too cerebral, the crucial dimension filling out this constellation of anticipatory practice is extreme, pervasive distrust: things are so thoroughly scrutinized because their nature and appearance are suspected of concealing something else.[121] Again, as elsewhere in this chapter, the general climate of fear, insecurity, and mental and physical exhaustion that Ambonese inhabited on an almost continual basis during the war is important to bear in mind.

A prevalent assumption that things are other than they seem is nowhere more evident than in the discourse of disguise and revelation that followed an attack and ran through the more general talk about the conflict. A discourse of hidden depth, such talk revolved around the discoveries made when corpses were undressed, when the folds and pockets of garments were explored and turned inside out, disclosing a truer identity underneath—a jihad fighter with

an army uniform under his robe, dates in a pocket indexing a devious connec-
tion to the Middle East, folded papers with talismans, and so on.[122] A young
Christian man who had participated in the fighting told me that, while initially
Muslims wore white and Christians red, as the conflict dragged on, some
Muslims wore red to make Christians think they were a friend rather than an
enemy.[123] This discourse on disguise fed into that of hidden depth and, besides
red and white head ties, often involved army uniforms. In a clip I saw in 2003,
for instance, a stringer's video camera moves back and forth, repeatedly re-
turning to and lingering over an army uniform laid out on the floor as if such
persistent technological scrutiny might force it to yield another truth. This
predicament—of being trapped in events beyond one's grasp and comprehen-
sion, of seeing no way out, of immersion in the thick context of terrible things—
comes through poignantly in my taped conversations with Malukan refugees
from 2000 and 2001, in the voices and demeanor of Ambonese speaking on
news reports before the 2002 Malino II Peace Agreement, and in the recollec-
tions of the men and women with whom I spoke in Ambon in September 2003
and during the time I spent in the city thereafter. "Everything is oppressed by
rumor and the stories [that circulate] are always more fantastic than what is
actually evident," is how one person characterized the atmosphere in
wartime.[124]

More disturbingly, as the war went on, more and more people claimed to
discern just under the surface of your ordinary Ambonese face its Christian or
Muslim contours (see Chapter 4). A striking indication of the sedimentation
of violence, this claim stands in sharp contrast to the assertion of an Ambonese,
cited earlier in this chapter, who, at the onset of war, explained the Christian
and Muslim practice of wearing differently colored head ties as due to the
inability to tell each other apart—because, he explained, we are all Ambonese.
While prepared in multiple ways and waiting, as it were, to happen, the hard-
ening and primordializing of communal identities, evidenced in the natural-
ization of visible religious difference, must be understood as an outcome and
not the origin of Ambon's conflict, as one sign, among many, of violence sed-
imenting and taking hold of the city. What this example also suggests is how,
over time and to a much greater extent than was previously the case, the dif-
ference between Ambonese Muslims and Christians came to be something to
be *seen*, something allegedly apparent beyond superficial distinctions of dress
and habit. Such an essentialized understanding of religious difference was by
no means absent in Ambon before the war. But it assumed a new volatile sig-
nificance as violence provided religion with a highly elaborated, publicly
visible dimension, one that helped to crystallize in ways visible to all the al-
legedly inherent difference between the city's Muslims and Christians. This

essentialized visualization of difference is merely one outcome of the extreme perception that prevailed during Ambon's war.

Official Peace

On February 12, 2002, the Malino II Peace Agreement was signed after over three years of intermittent and devastating warfare. Of the Malino agreement's eleven points, no fewer than six invoke the rule of law, law enforcement, law and order, and human rights, while others refer to principles of transparency and fairness. The largely elite parties who took part in the two-day meeting convened by Indonesia's then coordinating minister of people's welfare, Jusuf Kalla, were familiar with the new laws brought into being under Reformasi and, along with many Indonesians, undoubtedly regarded the law, however flawed and limited its application in practice, as somehow inherently just. The weight and value accorded to the law in Indonesia (which, following Dutch colonial tradition, is a *negara hukum* or, in Dutch, a *rechtstaat*—literally, a state of law or a constitutional state) only increased as the dramatic changes around and following Suharto's fall were inflected by the prevailing global discourse on democracy, transparency, rights, and human rights in our contemporary Age of the International Community.[125] Since the heady times of Reformasi, a great deal of attention has been paid to law, much of it focused on the courts, the police, and prosecution, in that order, and there have been some successes. As elsewhere, there is also a multitude of legally oriented NGOs focused on legal reform, corruption, rights, gender, and environmental issues at work in Indonesia, and a new energetic and promising generation of young legal reformers and activists. In recent years, social media provides another venue where people may mobilize to combat social injustice, although the success of such social media activism is often more restricted than it might seem since, in Indonesia at least, it depends on a particular felicitously conjunction of different factors.[126]

During Ambon's conflict, even after the imposition of civil emergency in June 2000, the security forces and police were, for a variety of reasons, virtually powerless when it came to taking legal action against those responsible for disorder. In a section on failure to uphold the law, an International Crisis Group report states that no fewer than 490 criminal cases were investigated and 855 suspects arrested as of July 2000, while a month later there was talk of holding trials on naval ships.[127] More than a year thereafter, however, in November 2001, the governor described the courts as still paralyzed and admitted that under the circumstances the law could not be upheld. In April and May 2001, some symbolic legal steps were taken against extremist leaders on both the

Muslim and Christian sides but, for different reasons in each case, prosecution has not been successful. What we have, in other words, is, on the one hand, a genuine regard for the law and repeated appeal to the judiciary as a privileged instrument deemed capable of restoring order and, on the other, a legal vacuum in terms of the means to enforce the law, along with considerable resistance to change by those schooled in the old system, and, in Ambon, until 2003, the ongoing presence of the armed forces under civil emergency, which are generally known for lending their support to local clients.

Throughout the conflict, multiple attempts were made to reconcile the warring parties, many of which appealed to grounds other than the law that were seen as potentially offering a solution or alternative to the war. These include customary law, most notably through the invocation of the pela blood brother alliances and the reinstitution of the older raja system of rule under Law 32/2004 that was part and parcel of decentralization in Maluku.[128] Other arenas of reconciliation and peacemaking include the mass media through the broadcasting of pro-peace public service announcements on radio and television, projects advocating peace journalism and more neutral forms of reporting, and the interventions of various charismatic leaders on both sides who at different moments and through a variety of means tried to stop the fighting.[129]

It is difficult to evaluate how much significance, in the end, should be attributed to the relative success of the Malino agreement and its appeal to the law, given that this agreement benefitted from the relative calm imposed over time by the civil emergency and was met with skepticism by many ordinary Ambonese, who saw it as yet another elite move that only minimally touched on their problems. Notably, Ambonese I spoke with in September 2003, when the violence was still a recent memory, spoke of four and not three years of war and insisted that whatever calm existed in the city was more than anything else the result of the extreme fatigue among the city's population and the feeling that they had suffered enough—and, although this was not mentioned, without any clear advantage on either side.[130] Others, testifying to the appeal of conspiracy theories in Indonesia, attributed Ambon's troubles to meddling by outsiders, especially to the operation of otherwise unspecified politics in Jakarta. "When they beat drums in Jakarta, we dance in Maluku," is how one minister put it.[131] Yet, however important the peace accord might have been in establishing the relative détente that prevailed from early 2002 in Ambon— barring a number of major disturbances thereafter—not just one but at least a hundred Malinos were needed, a local cultural activist insisted, to remake a city that had been so radically transformed and disfigured by war, not the least by the enormous Jesus pictures that sprung up along its streets during the

violence.[132] Another instance of amplification, these pictures offered clarity and even solace for Protestants caught up in war's uncertainty and its aftermath. But for all their monumental posturing and contribution to change in the city, the peace and normality that has gradually consolidated in Ambon emerged not out of one hundred but out of the many more mini-Malinos that occur every day—from the minute gestures of hospitality and mutual acknowledgment that connect neighbors and the exchange of pleasantries and passing conversations among people on public transportation and in markets to the fading of the memories and trauma of conflict and crisis, including their expression on Ambon's walls, to which I now turn.

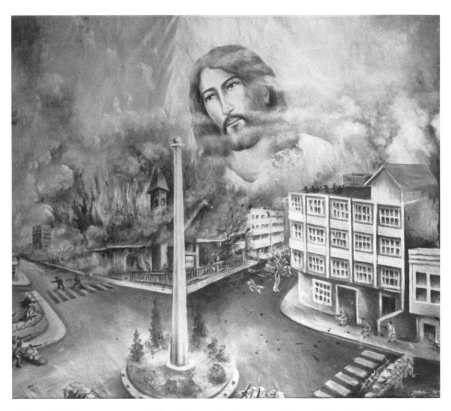

Figure 6. Painting on canvas by Jhon Yesayas, Ambon, 2005. Photo by Danishwara Nathaniel. One day when discussing his street art with me, Jhon mentioned that whereas his postwar murals and billboards were "comforting," those he did during the war depicted the violence in the city, as he went on to recall painting with bullets flying around him. I asked if he could do a painting for me like the ones he did during the war. It is the only painting I commissioned for this project. The painting, reproduced here, shows the attack on Ambon's GPM Silo Church on December 26, 1999, an event often referred to by Christians as "Bloody Christmas." When I showed up in early August 2005 to collect the painting, Jhon was adding a few final details—small figures crouching behind the barricades of the Christians, rocks and debris scattered in the street, cracks running up the side of a building. He explained that the scene "should not look too clean, so that it would be obvious that the atmosphere was terrifying." Expressing regret that the painting was small, he mentioned that he would like to do the same picture on a large scale. (Notes from an interview with author, Ambon, Indonesia, August 3, 2005.)

2

Christ at Large

"The moment was actually during the violence," Jhon explained when I said I was interested in the pictures that had arisen in Ambon's streets,

> when the faith of us believers, us Christians was shaking—many people fled from Ambon . . . so we thought even if it is only a picture, a painting, we were always convinced that he was here. . . . Back then, the situation was really hot, so we imagined this spontaneously. We wanted to ensure that God would really and truly be present in the conflict. We wanted to do this even though the city was burning on all sides, but we were convinced God was here. So I painted while Ambon was in flames, God on clouds. And this is truly what we think: if you figure it, Christians in Ambon should already have been done with. Just imagine what we had here—what kind of weapons did we have? We had nothing. We only had bombs that we made out of bottles. When they went off they sounded like firecrackers.[1]

A year later, I returned to the Christian neighborhood where Jhon lived to spend more time talking with the motorbike-taxi drivers as they hung around their stand waiting for customers. My argument in this chapter draws especially on fieldwork in 2005 and 2006, but it also moves between different temporalities—from the time of the war and recollections of the violence, as in the passage above, to the postwar circumstances in which such recollections took place. The paintings themselves straddle these distinct temporalities, since in the mid-2000s many that had been done during the conflict continued to be touched up or repainted in the immediate years thereafter.

Facing a large mural depicting canonical scenes from Christ's life, the men spoke to me about what they claimed was the city's first picture to have been produced during the war—a hijacked billboard showing Jesus looking down on Ambon and the surrounding Malukan islands that stood next to the mural facing their bike stand. The most talkative among them recalled:

> During the conflict in Ambon Christians were slaughtered by Muslims. We took the decision to do this picture even as the Muslims were attacking us. We took the decision with Jhon who is a youth from here. Jhon said, "Why don't we paint Jesus blessing Ambon here?" The guys liked the idea because Jesus blesses Ambon so that we feel close to God. Lord Jesus cries as he looks down on Ambon City. He cries to see the suffering of the community of Ambon City. Long ago we lived happily, but now we kill each other.[2]

Another account of the Protestant turn to picturing comes from a GPM council member who described how his church commissioned a Christ reaching out with extended arms from behind the altar as early as 1999 or during the conflict's first year:

> There was a general atmosphere of panic and fear, so this was done to strengthen the faith so that people would know that God was always here. People had the feeling that God was not here. Violence was all around. Fires were everywhere. The picture was [intended] to provide the assurance that God is with us—that he lifts us up. Faith was still shaky.[3]

Sammy Titaley, a prominent Protestant minister and the GPM synod head during the conflict, offered a theologically more grounded explanation that similarly draws a connection between the street pictures' emergence and a surge in faith afflicted by crisis among the city's Christians:

> I think this was done only to channel the conviction that God was here, because according to us what kind of appearance does God have? Is the image of God like a photo? It's not, right? But if there were a photo . . . So, now what emerged was the desire to make God visible. Whatever God is, a man, we don't know. Maybe it could be a woman. And what kind of face would she/he have? Also that we don't know. But because of the enthusiastic flaring up of faith, he wanted to paint as if this was the God he worshiped. And he did not care if in the street our young people sometimes thought, "So what if we die." So because of this whatever they did—painting, singing—all of this was actually a form of expression, an expression of faith.[4]

Insisting on God's presence during the conflict—he was *here*—along with the desire to ensure such presence in circumstances in which "faith was shaky," was a recurrent theme in the interviews, casual conversations, and passing exchanges I had with Christians in Ambon in the mid-2000s—besides painters, motorbikers, and Protestant ministers, also local journalists, ordinary women and men, the occasional aid worker, and in sermons in GPM churches. Echoing the statements I heard in the streets, for instance, the repeated reassurance that "God is *here*, you must not doubt, he is loyal," punctuated a minister's sermon one Sunday morning in July 2006 in the Maranatha church. As such, it is just one example of how church officials repeatedly invoked God's unwavering presence amid the difficulties besetting wartime and postwar Ambon and, beyond the city, the myriad disasters afflicting Indonesia in the mid-2000s—from volcanic eruptions and the spread of HIV/AIDS to the 2004 tsunami.[5]

Not everyone was as taken by the street productions as the above excerpts from my field notes and recordings suggest. Given that they signaled a highly public departure from the aniconic tradition of the Calvinist church, this is hardly surprising. But other attitudes were also relevant, especially the GPM clergy's evaluation of the young men who supported the pictures and put them in place. They ranged from people like Minister Titaley who welcomed them as "expressions of faith" to others who voiced their concern that the behavior of the motorbikers in the vicinity of the pictures might not correspond to what they considered Christian. Jhon, for instance, described to me some of the opposition he faced as a street painter but then quickly cast aside any criticism by insisting on the overwhelming need to demonstrate that Jesus "really, really is *here*, he is *here*":

> "Why are you painting in the streets? You are just wasting time" [is how
> some people challenged him]. There were certainly some who spoke
> like that. There were. At the office they also got mad at me because
> I didn't show up for work. Occasionally because I was tired from paint-
> ing I did not go into work. I was tired. I would work until morning
> using a lamp. Until morning. And if I was sleepy in the morning I
> would not go into work. But this is only because sometimes there are
> those in favor and those who are against, some who do not approve and
> think, "Hey, what are you doing painting Jesus in the streets?" But
> while some thought Jesus was not here, you have to think that Jesus is
> here, and make him large so that all can see it. Once and a while people
> think what are these pictures for, but we have to show that Jesus really,
> really is *here*, he is *here*, you must not be doubtful, you must not, that is
> the objective. But once and a while, people have an understanding that
> is different, one that is not the same as our own. We are people of God.

We want what is good, so that all people can see this. Sometimes
people are that way but in general people liked the pictures.[6]

During the conflict, not only was Christ present, he was present in particular
ways. Jhon's recollections of the billboard on which he painted Jesus overlook-
ing Ambon on a Sampoerna cigarette advertisement suggest that key elements
in ensuring the Christian God's presence were scale, visibility, and an omni-
scient ordering gaze:

> When I paint, I paint large-scale, on the walls of homes, the same on
> ceilings. In the big houses—great houses—of businessmen, on the ceil-
> ing, angels then God at the center with angels all around him. His ori-
> gin, his origins are those angels, right? Previously, you know, there was
> another picture of ascension. Birth, death, resurrection, ascension. The
> picture of that ascension is already ruined, that is the one we made like
> an advertisement, so we raised it up high, higher than all the other im-
> ages because of his being on high. We used his face, we raised it up
> high, using supports, scaffolding. So it was like an advertisement, we
> raised it up high, so we pictured him up on clouds so that was high.

Jhon further underscored the importance of the street pictures' visual appeal
akin to that of the billboard ad that his painting of the ascension had covered
over: "They should be pleasing to look at," he added, "and be able to be seen
from a distance."[7] Part of this appeal lies in how the painting provides a per-
spective, a reassuring, all-seeing presence capable of being seen from a distance
overlooking and apart from the chaos of war.

But in addition to Christ's appearance on billboards and murals, he was re-
peatedly sighted in the city during the war—emerging in different places around
Ambon, bearing arms on urban battlefields—and more far-flung even in Ma-
nado, a provincial capital at the northeastern tip of Sulawesi Island that harbored
many Christians who fled the violence in Maluku. There, in the summer of
2001, Christ's face darted across a chapel wall, appearing and disappearing and
drawing crowds who hoped to see it. Minister Titaley explained:

> Here is an example. During the Time of Violence, many people saw
> images of Jesus appear on walls. There were people who saw this and
> there were those who did not. ["What do you mean they did not see
> this?" I asked.] It was not visible, like that. It was not seen but there
> were people who said, "It is there, and there, and over there," like that.
> But it was not seen. What emerged were apparitions. His face ap-
> peared. Before that there was even an image of Jesus that bled, in

Manado. But in Ambon we just saw images, images of his face. In
Benteng, in . . . almost everywhere. I went to look but I never saw
them. People asked me, "Pak is this true or not?" I said to them, "Let
us not say this is true or not true, let us not say that they lie." Because it
is possible, and when an image appeared almost all of Ambon went to
look. And it also made people afraid; they did not like it. The image of
Jesus. Everyone went to look. At the time I was in Namlea [on the
neighboring island of Buru], so because of this I did not know about it.
There was one that appeared in Dobo [the capital of the Aru Islands in
Southeast Maluku], in the church. The minister back then was a
woman. There was violence in Dobo. Then it appeared again, follow-
ing the violence in Dobo. In the church but also in houses. In Benteng
it was not in the church but in a pigsty. It also appeared in Gonzalo up
there among the Catholics. Many people asked, "Where? Where?
Where?" They could not see it. But it was seen before violence, it was
seen during violence, it was seen after violence, so people were
afraid—"What if this means there will be violence again?"[8]

Another way that Christ was at large, if equally immersed in the violence,
was as a war commander. Rather than a frightening apparition auguring vio-
lence's onset, Christ surfaced in the midst of fighting, where he was seen striding
forth into battle leading the Christians against the Muslims. Here, again, is
Minister Titelay:

There were many stories that circulated, right? Saying that there was a
white commander among us, a large man with shoulder-length hair.
He was seen everywhere. Those who wanted to kill him never could.
Shooting at him was like shooting at the wind. He appeared every-
where—in Tanah Lapang Kecil, all over, as far as Seram he appeared.
Over there in Poka Rumah Tiga he appeared. They [Muslims] said,
"Christians are afraid. They are using a commander from Europe, a
Westerner, a foreigner." His hair was shoulder-length, long. People said
this is Jesus, right! Among those people who spoke about this were also
soldiers. [He appeared] in the midst of violence, during the conflict.
Because of this I always say, *"Believe it or not!"* [in English]. Never
before did he come like that. So this is why I often say, *"A kind of mira-
cle, no?"* [English]. Actually this should be written about in books.
There were even some people who came especially from Malaysia
when they heard about this, they came to check it out. Office girls
from Jakarta, Malaysians. I say just ask the kids in the street, go around
and ask them to tell you about it. They all can tell the story.[9]

Christ was on the move, elusive and mobile, appearing here, there, and "everywhere" during the war, if not to everyone. In Manado he drew crowds hoping to spot his face migrate across chapel walls, he led Christians into battle in city streets, and showed up in a pigsty in a Catholic neighborhood above Ambon. Surfacing in the thick of violence, his apparition and especially his face measured out violence's duration—prefiguring its onset, marking its direction, haunting its aftermath. Emerging frequently against the backdrop of a cross, the tormented Christ face of crucifixion folded his martyrdom into the general suffering of Ambon's Christians.

I quote at some length here in order to convey the tenor of the conversations I had with Christians about the street paintings and to highlight a few themes. Noteworthy are the desperation and terror that drove the impulse to make the pictures: statements that their "faith was . . . shaking," that "people had the feeling that God was not here," that "Christians were [being] slaughtered by Muslims," and that "Christians in Ambon should already have been done with," for example. Noteworthy also is the sense of God's estrangement, the wavering of faith in a burning city, and the lack of any defensive mechanism to fall back on: "What kind of weapons did we have? We had nothing." But also, how Christ at large in the city articulated a dynamic among different manifestations—on the one hand, he was immersed in violence where his fleeting appearance acted as a harbinger of violence and caused fear, on the other, his painted appearance on billboards and murals situated him *here* in Ambon as an empathetic figure arising above the fray.

My interest is in understanding the insistence on God's presence across diverse settings and how such presence materialized monumentally on sidewalks, along highways, in homes, behind altars, and at Christian neighborhood gateways. But also, the qualification voiced by at least some GPM Protestants that the billboards and murals were, of course, "just pictures." Minister Titelay's position is more ambivalent, echoing the dynamic outlined above. Although he characterized the street pictures as welcome "expressions of faith," casting them nonetheless as epiphenomenal vis-à-vis the more primary phenomenon of religion, he also called them "apparitions," miraculous and ungraspable like the wind. The latter attitude comes closer to the adamant insistence on God's presence often heard in the streets insofar as it complicates any dismissal of the new popular medium as mere portrayals of Christian themes modeled after familiar print originals. It also points to an unresolved tension surrounding the Christian paintings as to whether they acted as efficacious presences, bringing God into vision and enabling physical and emotional identification and interaction with him (something I take up in Chapter 3)—in short, behaving like devotional images—or whether they were only neutral, uninterested surfaces

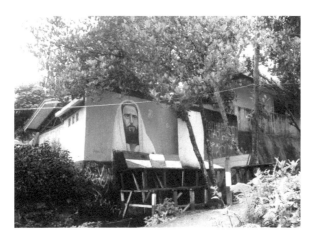

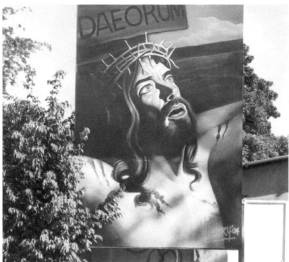

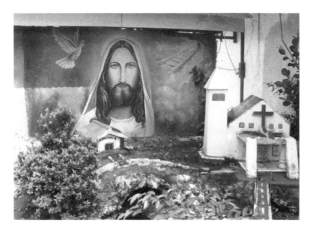

Figure 7. Murals and billboard paintings of Jesus Christ, Ambon, 2005 and 2006. Photos by the author.

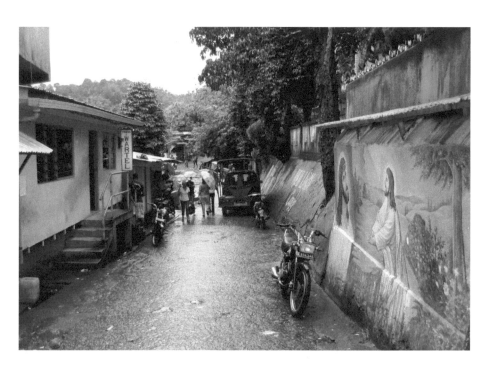

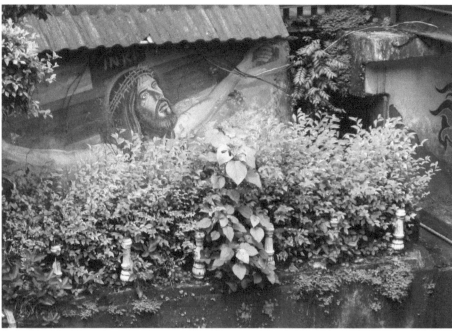

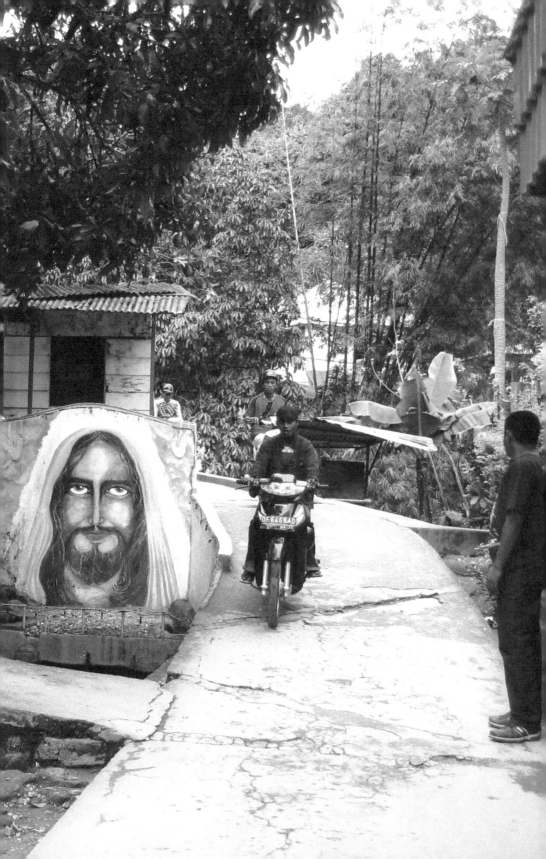

easily assimilable to canonical Protestant attitudes about images.[10] An enormous sense of precarity regarding the position of Protestants in Ambon and around Indonesia fed this dynamic, one that comes through in the frequent claims about how faith was on the wane and fragile, or how some people felt that God was either *not* here or that he needed to be brought close, suggesting, at the least, that the Christian deity was somehow drifting or distracted. Put otherwise, I am interested in the coming-into-vision of Christ in Ambon City but also in the anxious uncertainty surrounding his appearance, in the nagging sense that God might *not* be watching over the city's Christians, that rather than being in situ, *here* in Ambon, he was disturbingly at large in an increasingly precarious and threatening world.

Christ at Large

The commentary offered by Ambonese on these images and the production and spread of the pictures themselves all beg the following question: When did the Christian God begin to appear inaccessible via the ordinary means available to his followers? When did he begin to appear so absent that a picture of him—albeit "just a picture"—needed to be put in place to offer the assurance that he really and truly was here, always here? To paint pictures and embrace them in the calamitous, edgy environment of the war was to experiment in certain desperation, to launch a new medium in the hope that it might engage and moor the Christian God who appeared elusive or at least too far away to provide the necessary solace. But this God was not simply absent or out of reach. At large in what Minister Titaley called the "Time of Violence," he was also insistently present. He was "here, there, and everywhere," manifest as a fugitive figure visible to some but not to others—a transitory apparition moving across walls, sighted in a pigsty, passing through or announcing violence that unfolded in full brutality around him. In the context of these extraordinary times, a number of young men took the decision to paint Jesus looking down on the suffering in Ambon City from a billboard facing their motorbike stand. Alternating paintbrush with prayer, this painting and the others that proliferated during and after the war bear poignant testimony to a vast effort to bring God in intimate connection with the world, to visually pinpoint and circumscribe his location *here* overlooking the violence that cast a thick cloud over Ambon and severely taxed religious faith. Rather than caught up in the violence like the Ambonese, he is pictured at a close, comforting distance, on a larger-than-life scale high up on clouds and surrounded by angels. This perspective that repeats itself across the street paintings helps to diminish the conflict, making

it picturable and seeable to God's eye in contrast to the all-encompassing horrific, murky realities on the ground.

To assess the creativity of the drive to picture as well as that of the pictures themselves, it is worth considering the discontinuities that mark this newly invented practice. At stake in these dramatic times was the articulation of a desire and a force that was daring, experimental, and aggressive—hence, not just the urgency that drove the pictures' production but also the undeniable energy with which they sprung up and spread across the city. For what the pictures bear witness to and helped to put in place was nothing less than the imagination of something quite different from what had been seen before—perhaps most radically in the sense of figuring a novel mode of mediating transcendence or accessing the Christian God by bringing him into view and close. Sites of experimentation in more than a few respects, the paintings break with the past and, specifically, with the antimaterialist, aniconic tradition of Ambon's Dutch-derived Calvinist church, the GPM, and they are assertive in the new publicness they accord to religion—although certainly not alone in this in Indonesia after Suharto (see Chapter 4). So, too, are they radical in seizing upon the traveling images of a globalized Christian print capitalism and in the inspiration the new artisanal practice found in the range of other materials around. Daring, also, are the city's Christian images in their envisioning of myriad mise-en-scènes as the possible loci of new understandings of community and in their visualization of heterotopias that potentially transport those who engage their effects beyond the discursive frames of the Indonesian state and its codified forms of citizenship or those inherited from its predecessor, the Dutch colonizer (see Chapter 3). They are radical as a new medium of expression and communication—socially, politically, aesthetically, and spiritually. Last but not least, they are novel in their self-organizing capacity—no church or other institution or authority rallied around or pushed the production of the images.[11]

Yet, while radical in so many ways, not the least in the brute fact of their physical presence around the city, in other respects these picturing projects were quite nostalgic, especially in their positing of a visual public that excludes anything incompatible with a wholly Christian universe. Constituting what might be called a postwar poetics of world-making, what these pictures want is to repair and restore the everyday lifeworlds of a previolent moment when Ambonese Christians still, by and large, enjoyed relative power and privilege.[12] They were world-making, too, in their dramatic sense of arrival and in the novelty with which they stood out from the ruins of the recent war and forced themselves into public view. Put simply, this world-making condensed two

distinct temporalities—the first is evident in the obligatory, recuperative reit-
eration of Christ's face across myriad productions. The second is more open-
ended, future-oriented, and, in some respects, disoriented. I refer here to the
wildly experimental backdrops to the Christ figure and face that I mention
occasionally in this chapter but address more fully in the next. Admittedly, this
division between foreground and background is heuristic since the two not
only function together but the former, while stereotypical, is also unstable and
may, in some respects, be equally described as lacking orientation. This chapter
focuses more on the globalized Christian iconographic canon, how it became
articulated and transformed in Ambon's streets and infused by the energies
and passions of the young men who supported them. Chapter 3 introduces the
painters and homes in closely on different pictures and clusters of pictures,
exploring both their diversity and their similarity in bringing the Christian
God into vision and close to Ambonese.

Both this chapter and the next are concerned with the paintings and the
environments in which they arose—how, through graphic means, the street
pictures aimed to put in place and restore the appearance of a city that, through
the early 1990s, had a decidedly "Christian impression about it."[13] Through a
nostalgic form of representational redress, the pictures reinstated the public
visibility that Ambon's traditional Protestants had long taken for granted as an
everyday aspect of their entitled, state-authorized position—at least locally and
regionally in Central Maluku. The formulation "representational redress" was
coined in the context of postapartheid South Africa to designate the progres-
sive process of "re-figuring *who* we are but also *how* we define our future socio-
spatial and political relations."[14] Although driven by similar concerns in Ambon,
and notwithstanding the considerable innovation of the street pictures, the
urge to refigure *who* we are and *how* we can ensure our future was not progres-
sive but restorative and bent on self-preservation. In a somewhat perverse take
on poetic world-making, Christian Ambonese aimed to seize hold of a disap-
pearing world, one that upheld their historically accumulated privileges, not
the least the Christian domination of the city and provincial civil bureaucracy,
including prize positions like that of Maluku's governor.[15] Via the pictures, they
recalled a world that faithfully reflected back to them its reassuring Christian
contours in sociospatial and political terms and, through these, the image that
the Protestants had long held of themselves. This is an embattled vision, one
that looks to the past and relies on and recasts old iconographies, albeit neces-
sarily in innovative ways.

Put otherwise, the concerted work on appearances undertaken in Ambon's
streets was inflected by the desire to (re)institute a sociopolitical order and
distribution of the sensible with a decidedly Christian appearance, one that

sustained Protestant Ambonese privileges, assumptions, and sense of place. Articulated through the visual medium of painting, this work may be seen as yet another manifestation of the extreme perception that developed during the war along with the anticipatory practices that I described in the previous chapter. More pragmatically, amid the conflict's zoning of urban space and its many displacements, hijacking billboards and spraying Christian scenes and symbols along public sidewalks and walls claimed territory for the Christians as Christ's visual presence Christianized the public space around them. Equally importantly, although impossible to determine with any precision, the rise of the street pictures paralleled but seems also to have partially preceded the dramatic redeployment of religion during the war and the changes in religious affiliation, practice, and experience that characterized this redeployment—to which, significantly, the pictures contributed. Among other noteworthy transformations in urban religion, as I discuss in Chapter 4, were the significant numbers of Protestants who abandoned the GPM for charismatic churches in search of a less hierarchical, more intimate relation to God in contrast to the distant, fatherly figure of Calvinism.

The Canon in the Street

Notwithstanding their dramatic appearance, a striking feature of the paintings scattered around the city was their essential restorative impulse. To be sure, the pictures were inevitably striking and, in many respects, experimental, if nothing else because of their immense size. I refer instead to the intentions that drove their production and their insistent reiteration of the globalized, if locally conventional, Christian iconography. With only a few exceptions, the handful of artists who I worked with around the city, some more than others, set out to reproduce rather than change or reform the images that they borrowed from the Christian iconographic canon familiar to them as Protestant Ambonese. Regularly, on my stopovers at the motorbike stands, and especially when I visited the painters in their homes or, in the case of the most commercially minded among them, at his roadside studio, I would come upon the painters engaged in their artistic work. Almost always, on such occasions, a book would lie open next to them on the floor or a page torn from a Christian calendar or magazine would be taped alongside or tucked behind the canvas, showing illustrations drawn from Euro-American examples. More often than not, these Christian scenes focused on the figure of Christ in the guise, for instance, of a shepherd with a flock of sheep, a pilgrim pausing before a house door, or Jesus praying in profile at Gethsemane or up on clouds with angels. People who commissioned painters often described to me the models they had

provided—for instance, a minister mentioned the "photo" of Gethsemane from the Christian magazine *Gloria* that had inspired the design of the small prayer room in his home, a GPM council member recalled the calendar image of Christ of the Second Coming that he had asked Jhon to reproduce in his church, while the larger than life angel on the exterior wall of a Christian home was similarly copied from a calendar, the kind given out by Christian stores around the Christmas holiday (Figure 8). Again and again, traveling in and around Ambon in the mid-2000s, I saw copies of the same Christian print-derived pictures: for example, the kneeling angel in a Halong home was the same as another in Belakang Soya, although painted by different men; the billboard of a gentle, brown-eyed Christ in front of the Maranatha church and the portrait-size Jesus hanging in a Christian home reproduced the same image of the German painter Heinrich Hofmann, whose religious body of work, dating from the late nineteenth and early twentieth centuries, has been reproduced widely (Figure 9). His *Christ in Gethsemane*, seen on walls around Ambon, is one of the most copied paintings in the world.

Apart from the repetition of the global Christian print repertoire, there was also a brisk two-way traffic between the canonical print imagery and apparitional forms, especially during the war. Christ's common depiction as a European derives, Ambonese often remarked, not only from the pictorial examples provided in church and schools but from his own occasional appearance to them. If rumors circulated of Christ arising as a white commander upon the city's battlefields, in a more direct translation of the apparitional into the pictorial, an Ambonese with a gift of prophecy engaged a painter to commit his visions to canvas, resulting in a large triptych, dated ten days before the conflict began, that forecasts Ambon's apocalyptic destruction (Chapter 3).[16]

Notwithstanding such spectacular examples, what most characterized the traffic in Christian images was, again, repetition—repetition that involved interchanges, substitutions, and replicas within a canon of images and variations thereof. No strict divide, in other words, walled off the apparitional from print media or separated dreams, apparitions, and prophetic visions from print models and their painted reproductions. Indeed, these myriad image forms seemed to cycle seamlessly into each other—making any strict adherence to an aniconic ideology that asserts pictures are "just pictures" difficult to sustain. A short example will suffice. Following a minister's injunction to his son one morning before church to imagine Christ's face while praying, this face arrived repeatedly to haunt the family throughout the remainder of the day. During a nap following church, the minister's wife had a dream in which Christ appeared to her—first, she explained, as identical to a framed print of Jesus's head that hung before us in her home as she described to me her vision and, subsequently,

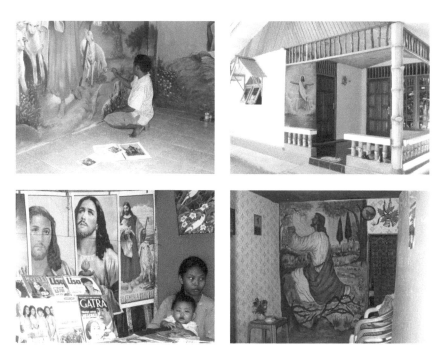

Figure 8. The painter Jhon Yesayas working on a mural of Christ as shepherd with the print images he is copying from on the floor beside him. Walls depicting Christ in Christian homes and market stall with posters that are a common source of inspiration. Ambon, 2005 and 2006. Photos by the author.

in the guise of another print she recalled in which he appeared with a bare torso and emanating light. In the minister's wife's account of her experience, these mediated appearances surfaced, in turn, in two additional appearances—each an exact replica of the other—in the form of framed prints of Jesus in the homes of two families of the minister's congregation that she and her husband visited that day. What is more, a widow in the second home the minister and his wife stopped by that Sunday owned two prints corresponding to the first apparition, which, I was told, had appeared to the widow in the exact form as it had to the minister's wife. One of those prints, a gift by the widow to the minister's wife, also hung before us at the time of the interview.[17]

What stands out in this account is not only the reproducibility but also the sheer force of Christian mass print culture, as well as the emphasis on its dominant mediating role. Also noteworthy is the insistence on Christ's face, on the light rays radiating from his head—which the minister's wife evoked for me by pulling her hands repeatedly out from her head—and the role of print media as a visual currency in the reproduction of the GPM community.

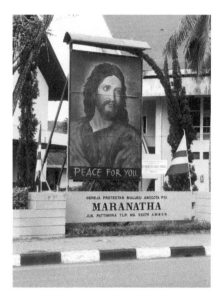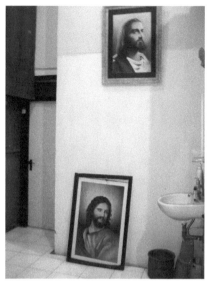

Figure 9. Painted billboard in front of the Maranatha church based on Heinrich Hofmann's painting *Christ at 33*, Ambon, 2003. And a home with framed images of a Warner Sallman and a Heinrich Hofmann Christ, hanging on the wall and propped up against it, respectively, Ambon, 2006. Photos by the author.

Notwithstanding the uncanniness of her experience, one wonders if the Calvinist insistence that pictures are "just pictures" does not also intervene in this particular case, given that what the minister's wife claims she saw was not or at least not conclusively Lord Jesus but a proliferating series of print renditions of him.

The majority of the pictures around the city drew on calendars and illustrated books that featured the work of the American painter Warner Sallman, whose paintings of Christ were a crucial component of popular religiosity and Christian visual culture from the mid-twentieth century, especially in the United States. Repeatedly, in Ambon I saw such Sallman classics as *Head of Christ* (1940), *Christ at Heart's Door* (1940), *The Lord Is My Shepherd* (1943), and *Christ in Gethsemane* (1941) both precisely and more approximately rendered.[18] To a somewhat lesser extent, Heinrich Hofmann's Christs were also popular. Such models provided a steady reference, a source of inspiration, and even control for the painters' work, as they tended to delimit the kinds of pictures that could be made. Experimental and daring as they also surely were, representationally they largely remained tethered to the Christian print canon. It would be a mistake, therefore, to understand the artistry in Ambon's streets or behind church altars in conventional creative terms. From this perspective,

the question posed by Jhon to the motorbikers manning the stand at the edge of his neighborhood—"Why not paint Christ blessing Ambon here?"—should especially be understood as an effort to visualize the Christian God as an empathetic figure watching over the city as opposed to indebted to any decorative impulse or understanding of painting as creative expression alone.

A canon presumes a delimited, knowable, and, in the Christian case at least, somewhat orderly visible world. When the world is more or less in place, the appearance of things and the actions of one's fellows correspond to common expectations: persons and objects moor each other in predictable ways, enabling the canon to unfold its conventional images in an environment where family, churches, community, and polity are more or less in place to receive them. When, by contrast, the world falls apart, the canon may succumb to unprecedented pressures, especially in circumstances where the visual is a focus of attention and under revision, as it was in Indonesia generally during Reformasi and even more in Ambon for reasons that I analyze in this book. In such circumstances, what images want becomes frustrated, since their correspondence to the world no longer applies.[19] Put otherwise, they can no longer count on the frames that hitherto sustained them. In such moments of intensified desire and frustration, pictures may come out, bursting from their frames, becoming assertive and monumental, demanding new forms to satisfy their needs.[20] Under such conditions, the provisional connection that pertains between canonical images or, for that matter, any image world and the world for which the images were made can become strained. Different possibilities may arise. Under duress, the canon may be abandoned or the images that comprise it may assume new forms as these are reworked and extended in new directions. The profound materiality of such images then comes to the fore—as evidenced in Ambon, for instance, by the aggressive encroachment of Christian pictures on public, urban space, by their exaggerated, blown-up proportions, and by the way they "filled the sight by force."[21] Hence, notwithstanding the restorative urge that largely drove them, the ways the pictures strained and adapted to the canon's frames and experimented on city walls demonstrate their world-making capacity.

If *Orphaned Landscapes* is about the work on appearances, then it is also about how appearances do not work. Evidence of the latter can be found in the constant adjustments made to the canon to ensure that the pictures addressed the circumstances around them, especially the plight of the Protestants and the sense prevalent among them during the war that not only they themselves but their everyday existence was under siege and even at risk of annihilation. The first adjustment was the Protestants' own pictorial turn involving not only an embrace of pictures but, with it, a significant departure from the

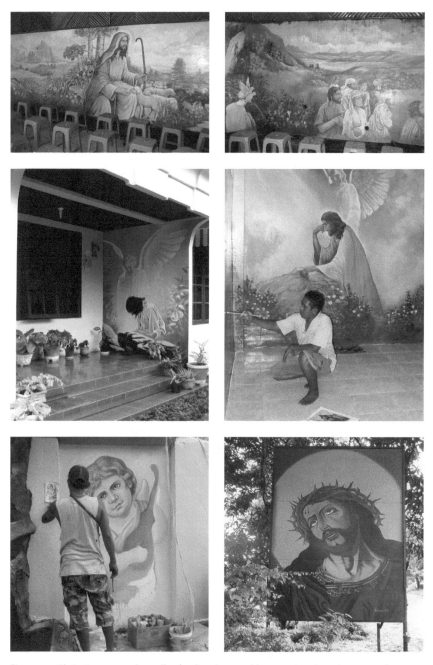

Figure 10. Christ images on the walls of a church assembly room, in private homes, and on a billboard along the highway into Ambon. The mural of a cherub playing a musical instrument signals a noticeable departure from the centrality of Christ in the Christian street art of the early 2000s. Ambon, 2005, 2006, and 2016. Photos by the author.

aniconic tradition of the Calvinist Protestant Church. Admittedly, before the war, calendars and, to a lesser extent, posters and embroidered or mother-of-pearl inlaid Christian scenes were conventional props of Christian homes and stores. Such elements of decor, together with Sunday school manuals, are a familiar component of the global Christian print repertoire that has long been available in Ambon. Confined to interior spaces, they seem not to be subject to the kinds of restrictions on images that existed in the GPM churches. Yet, if the Christian sacred was never invisible or faceless in the city, prior to the war it was—visually at least—not a privileged focus of attention, public or otherwise.

Of course, in Ambon as elsewhere, and notwithstanding Calvinism's anti-materialist ideology, transcendence unavoidably relies on mediation. Writing of mediation, Hent de Vries, a philosopher of religion, underscores its intrinsic, enabling role given that "without and outside of [it] . . . no religion would be able to manifest itself in the first place."[22] But this is precisely what makes religion vulnerable, since mediation means that religion is always already subject to the risks, contingencies, limits, and translations that the material world presents to human desires and schemes.[23] If already the case in ordinary circumstances, the vulnerability of religion at large in the world becomes enhanced in conditions marked by crisis and dramatic change, as in Ambon at the turn of the century. At stake then was much more than religion's regular vulnerability on account of its unavoidable material mediation. Rather, it was the anxious if also enthusiastic adoption of a new medium driven by the Protestants' desire to ensure God's presence and draw him close via his image.

Despite the long history of Dutch-derived Calvinism in the area, Ambon's Protestantism and that of the wider region were never as adamantly aniconic as that of their former colonial masters.[24] Around Maluku, other traditions of materiality and ritual performance remained operative; indeed, some of these witnessed a significant revival during the war (see Chapter 5). National practices such as the requisite display of photographic portraits of Indonesia's president and vice president in government offices and public buildings (which in Ambon were populated predominantly by Protestants) perhaps had an impact as well. In a more intimate register, Indonesia's citizen's identity card (I. *Kartu Tanda Penduduk*), with its obligatory ID photograph and declaration of adherence to one of the five world religions recognized by the Suharto state, seems also to have been refracted in some of the street pictures, as we will see below.[25] Besides the commercial advertisements for things like cigarettes, cell phones, and English-language and computer classes strategically positioned around the city, there were the faces and party affiliations of local political candidates that proliferated with regional autonomy and state-produced genres like maps and posters of married couples in ethnic dress standing in for Indonesia's

unified diversity decorating government offices and classroom walls.[26] During
the New Order, billboards that translated the Suharto state fetish of "develop-
ment" into visual form—happy, uniformed students, white-coated scientists,
and planned families (with the slogan "Two children, That's enough!")—were
seen all over the archipelago.[27] Others showcased the regime's endorsement of
the five world religions it recognized. The more temporary banners suspended
over main thoroughfares in the postwar city announced university registration
dates, competitions in marching, disco dancing, and the increasingly popular
Muslim fashion shows, but also propaganda put out by the police and occupy-
ing armed forces mimicking—usually poorly—Ambonese Malay language and
calling out for anything from postwar reconciliation and peace to proper gar-
bage disposal.[28] In today's visually crowded world, all sorts of image flows, visual
modalities, and discourses—the density and diversity of which augmented
during Ambon's war—converged upon, were taken up or discarded, and frag-
mented in different ways in the postwar environment.[29] I address these visual-
ities and their multiple divergent perspectives in Chapter 3.

Along with the Protestants' turn to pictures, a second, related adjustment
made to the canon was the effort to bring the Christian God close, something
that, necessarily, involved significant iconographic departures from the canon
as, for instance, Christ was depicted, in an unprecedented manner, hovering
over Maluku or in situ in Ambon and the surrounding islands. Besides the
teary-eyed Jesus looking down on a globe turned to Maluku on a billboard, his
head floats over the destruction of the GPM's landmark Silo Church on a
canvas where tiny white-clad jihadis engage khaki-colored National Army
soldiers in battle; on another he extends his arms to refugees fording a river as
they escape violence on neighboring Seram; on yet another he appears as an
indigenous Malukan with dark skin and curly black hair, in a clear departure
from the Euro-American iconographic canon centered on a white Christ. Not
negligibly, bringing the Christian God into vision and up close also meant
bringing oneself into view—via the church at which one worships, the islands
where one resides, the portrayal of one's wartime predicament or that of fel-
low Christians similarly caught up in violence, or as Christ in the image of an
Ambonese.

Commenting on these pictures, local painters occasionally recalled how
they abandoned the canon's iconographic conventions. Discussing his work
during one of our recurrent conversations, Jhon underscored how, in choosing
to portray Jesus overlooking Ambon Bay rather than Jerusalem, he had used
his "imagination." He also drew my attention to how Jesus not only overlooks
Ambon but does so from the vantage of Karpan or Karang Panjang, a location
above the city that is celebrated by its inhabitants as offering the best view of

Ambon and that was often featured on the odd tourist brochure put out by the city's Department of Education and Culture before the war (Figure 11). The same view crops up in a colonial album of photomechanical scenes from around the archipelago, evidencing its framing already under the Dutch. On another occasion, during a tour of several days in which Jhon took me to visit churches and other locations around the city to see his work, we stopped at a small church that, with the madrasah next to it, served the religiously mixed population of the hospital on the grounds on which it stood. A large Christ painted behind the altar clasped a red heart to his chest in a scene that Jhon identified as the ascension, while a series of four paintings ran along the wall under the church windows. These, he said, depicted "creation" as a luxuriant green landscape, followed by the "birth" of Christ, "crucifixion," and "death" or, more precisely, resurrection showing a small illuminated Christ surfacing at the center of a circle of women in a cave-like enclosure. Except for the crucifixion, Jhon assured me, all the paintings were based on "models." When I remarked that the Christ with the heart struck me as Catholic, Jhon agreed but then quickly qualified any possible sense of emerging difference among diverse Christianities by insisting that "the objective is the same,"[30] an ecumenical discourse that I take up in Chapter 4. Still, it is safe to assume that the model for the Christ with the sacred heart was not taken from the Protestant print repertoire. Instead, it evidences the tendency to bricolage that, along with loyalty to the canon and the desire to bring Christ close, also informed the changing iconography of Ambon's canonical pictures.

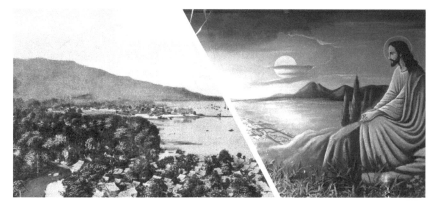

Figure 11. A composite image of a photomechanical picture of Amboina (*left*), the name of Ambon City under the Dutch colonizers, and a painted mural of Christ overlooking Ambon Bay from the same location (*right*). The photomechanical image originates from an album of scenic views of the Netherlands East Indies from the 1930s or 1940s. Reproduced by permission of the University of Cambridge Museum of Archaeology & Anthropology (BA5/4/1). Mural painting by Jhon Yesayas, Ambon, 2005. Photo by the author.

If in overt statements almost all of the painters emphasized their adherence to the Christian iconographic canon, in practice they creatively remediated and reimagined it in startling ways. Even as they departed from the reproduction of time-worn visual models, copying predominated as the point of departure in the artistic practice of the handful of men—with one notable exception—who painted Jesus Christ in the streets, behind church altars, and in private homes during and after the war. Given the restorative impulse that drove the Protestants' pictorial turn, such upholding of tradition is to be expected. However, due to the enormous pressure that the conflict exerted on the canon and what must also have been the sense of a diminishing correspondence between the print repertoire and the circumstances of war, all of Ambon's painters also, whether explicitly or not, relied on their "imagination," finding inspiration in the myriad materials around them to alter, elaborate on, and deploy the canon in unprecedented ways. Given how much the iconographic canon was rooted in European depictions of Christ and biblical scenes, the crisis of faith in the city may have summoned forth an awareness of the lack of correspondence already there—namely, between the colonially derived images and Ambon's Christian Protestant world. Continuing the focus of this chapter on Christ at large, specifically in Ambon's streets, I leave my introduction of the painters to the following chapter and turn now to the young men who supported the street pictures.

Guardians of the Neighborhood

In his fascinating analysis of the long history of guardhouses (I. *gardu*), "visible at almost every junction in major cities" in today's Indonesia, Abidin Kusno describes a photograph of pemuda, or male youth, from the Indonesian revolution waged against Dutch colonizers—young men who might have belonged to either the Indonesian National Army or unofficial militias but whose stylistic formation (in the photo at least) recalls the image of security guards standing at guardhouses in more contemporary times.[31] But the scene is especially worth citing for the powerful ways the image resonates with the young men grouped across the city at the edge of their neighborhoods in postwar Ambon:

> It was an image Indonesians would expect to confront as they
> approached the entrance to a guarded neighborhood. These youth
> represent the city (in ruins) behind them. They consider the city as
> being under their guard and see themselves as its protectors, as well as
> the destroyers of things associated with the enemy. Patrolling in self-
> styled uniforms, they considered themselves to be the vanguard of the

newly liberated world of the Indonesian masses (the *rakyat*). They took
the urban space as a gigantic canvas on which they inscribed writing,
slogans, and flags associated with this new time and new identity. They
saw themselves as the embodiment of order and security, even though
many of them participated in political violence and acts of destruction.[32]

Importantly, this passage captures not only the longue durée of such loci and
the young men with whom they are identified but also the masculine style and
sense of threat that the men equally embody. Dieter Bartels, an anthropologist
who has worked for many years in Ambon, observes how the more open atmo-
sphere resulting from Reformasi, along with the unrest of the city's conflict,
offered such young men "an opportunity to express their freedom from authority
through acts of violence."[33] He also writes of "Western-style gangs" that at times
fought each other in some parts of the city before the war, as well as how these
gangs morphed during the violence "into freedom fighters defending their
neighborhoods against outside attacks and invading those of their enemies to
burn them down."[34] Some of the motorbikers recalled how in wartime men
would pose before the Christian billboards and murals to be photographed,
weapons in hand, before setting off to battle. A few others showed me their
scars; one man, identified by another as "a victim" as he whirled his bike around
to join us at the stand, rolled up his T-shirt to show me the ugly dark scar across
his chest. Still others had tattoos, including the Star of David, a key symbol
among Christians during the war. For the most part though, except for recur-
rent complaints about the Christians' makeshift weapons or statements about
how the Muslims slaughtered them, the men avoided any reference to the
violence. When they did remember the war, it was most often to compare the
amount a biker could earn then with the much more meager take they could
expect today.

When I inquired about the existence of biker associations, motorbike stand
or group names, or neighborhood gangs, the men commonly reeled off the
names of loud musical groups with which they or other motorbikers identified.
For example, the response at one stand was the Sex Pistols, the name of the
all-male disco group that some of the men had formed in order to participate
in dance competitions. Not surprisingly, the wall behind the platform on which
the bikers sat between rides and during lulls in business bore the logo of the
band enclosed in a ring of dripping blood that made it resemble a bullet
hole—"because we live and die for this," one of the bikers explained when I
wondered about the design (Figure 12). "For us," another continued, as a num-
ber of the men crowded around to listen in on our conversation, the logo or,
perhaps more accurately, brand "is the same as Coca-Cola—always Coca-Cola,

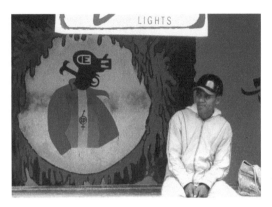

Figure 12. Sex Pistols and Guns N' Roses logos at a Christian motorbike-taxi stand (*left*) and a Muslim one (*right*), Ambon and Ternate, 2006. Photos by the author.

always Sex Pistols."[35] Around the city, many such biker "brands" were similarly adopted and, at times, adapted from the emblems of musical groups.

Not only the young Christian men whom I spent time with in Ambon in the mid-2000s but also those I met in April 2006 in North Malukan Ternate and in 2008 both there and in neighboring Tidore—where the populations are predominantly Muslim—embellished their stands with designs taken from the CDs and DVDs of bands like Guns N' Roses, Limp Bizkit, Linkin Park, and, of course, the Sex Pistols. Some names were apparently holdovers from earlier times, such as the Gipsy Kings, a band popular in the 1980s, "during the time of our fathers," one of Ambon's bikers remarked. Faces like those of Che Guevara or the Indonesian cult singer Iwan Fals, along with slogans like "Punk" and "Rebel," also moved indiscriminately across Indonesia's many religions and regions and settled into the rich stratigraphy of these sites (Figure 13).[36] Besides such consumer- and youth-based sources, a study of these sites' stratigraphy would reveal other group markers as well, especially, as I noted earlier, those of political parties and soccer teams. Apart from the display of consumer culture and myriad emblems, the Christian billboards—whether freestanding or adjacent to murals covered with Christian scenes—often emerged in the same kind of location, along the city's main thoroughfares or at crossroads facing onto major streets, as commercial advertisements, if, indeed, they had not been painted over these. This, for instance, was said to be the case of the alleged first Christ portrait in the city that overlay a former Sampoerna cigarette advertisement.

Beyond their explicit wartime and postwar identification with Christianity, Ambon's men and their bike stands form part of a wider masculine youth

culture that draws inspiration, emblems, and sources of style from a common repertoire that is seen across Indonesia. In 2006 and 2008 in the North Malukan sultanates of Ternate and Tidore, I even came across a few Muslim power murals, similarly connected to male neighborhood stands, although these were few and far between.[37] Unlike the Christian murals, I only saw one in North Malukan Ternate, although there was also a billboard showing Saddam Hussein on a stallion chasing a tiny, sweating George Bush. On the small neighboring island of Tidore, there was another Muslim power mural, but I saw none in Ambon or elsewhere in Central Maluku. Although only the Ternate mural bears the "Moslem Power" slogan, both form stunning portrait galleries featuring such historical and political male heavyweights as Indonesia's first president, Sukarno; the eighteenth-century anticolonial Malukan hero Nuku; long-time opposition singer Iwan Fals; Muammar al-Qaddafi; and Osama bin Laden (Figure 14). Like the Christian walls, they served on occasion as open-air photographic studios. In Ternate, I was shown photographs of groups of young men as well as married couples posing in their new Ramadan clothing in front of the power mural there. When I began to photograph the Tidoran mural, a man repairing the gutter next to the wall spontaneously jumped in front of my camera, raising his thumb in approval of the huge portrait of Saddam Hussein in front of which he stood. Similar to the Christians, the Muslims took their examples from print media, in this case, hard-line Islamist magazines like *Sabili* or more traditional print lineups of Muslim religious leaders like those I saw hanging in Ternatan homes along with larger images of the holy city, Mecca. Importantly, the men who did the mural were themselves not Islamist in orientation. Both the Muslim and Christian propaganda at these locations and their designation as motorbike-taxi stands dates from the war when the bikes flourished as substitutes for public minibuses and cars due to their safer and more malleable mobility. Nonetheless, the major difference between the Muslim and Christian murals is that while the former proclaim a long history of Muslim greatness, if somewhat defensively in the aftermath of war (see also Chapter 5), the latter claim in the first place a novel visibility as they envision a more proximate connection to the Christian God.

It is worth pointing out that, in all of my conversations with the bikers of different stands around Ambon, only infrequently was any mention made of the city's most famous—or infamous—gang. Dating from the war and hailing from the Christian neighborhood of Kudamati, the group Coker, short for *Cowok Keren* or the "cool men," were led by Agus Wattimena, a man widely recognized as a *preman* or thug. Whatever wartime violence any of the bikers had been involved in, none of these self-assigned neighborhood guardians, as far as I could tell, formed a gang along the lines of Coker that lived and

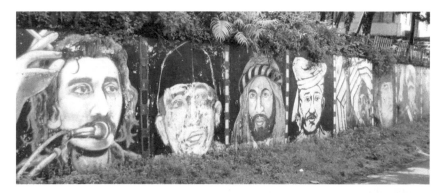

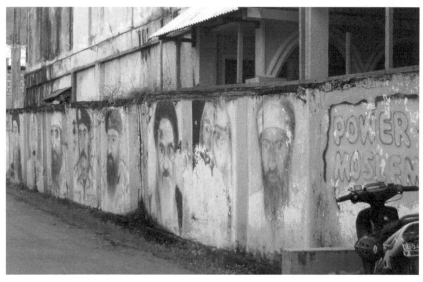

Figure 13 and Figure 14. Muslim power murals in North Maluku (*top*), Tidore, 2008. Photo by the author. The Ternate "Moslem Power" mural painting (*bottom*) was painted and photographed by Aki Saleh, reproduced with permission.

reproduced itself through violence and extortion. Speaking of the gang, a Christian woman who I will call Lusi used the phrase "Christian pemuda," to refer to its members, evoking the revolutionary youth described above, but adding a local twist that merged the storied heroes of the Indonesian nation with Ambon's own homegrown Christian freedom fighters. But Lusi's praise for these pemuda was ambivalent, since members of the gang would apparently betray their fellow Christians for a fee, or so she claimed, by, for instance, setting their homes on fire. This explains her other name for the men—"Judas's kids," the term used for duplicitous Christians during the conflict.[38]

In contrast to the gang, the men I came to know in the mid-2000s—including as a frequent motorbike-taxi passenger—formed loose motorbike-taxi collectives, the members of which identified strongly with their neighborhood and stand, including its corresponding signs—the "brands" of their favorite musical groups; those of preferred political parties, notably in the early 2000s, Megawati Sukarnoputri's PDI-P political party with its black-on-red water buffalo logo among the Christians; and the especially charged Christian billboards and murals. Not all of the men associated with a given bike stand had necessarily grown up together, given the many displacements of the war. But they were closely knit by ties of loyalty, friendship, shared history, and their common identity as both Christians and young men. Although by no means systematic across the biker groups, some collected fees to cover the costs of treatment should any member be involved in an accident or fall ill. Collectively, they pooled the resources to pay for the street paintings—supplying the painters with paint, brushes, and other materials, including the usual, so-called cigarette price, a gloss for the cigarettes and snacks given to the painter while he worked. They also took charge of the upkeep of the murals and their immediate surroundings, especially in anticipation of Christian holidays, when they would decorate the sites festively. Members of the neighborhood often chipped in, especially around Christmas.

Although the general function of these locations was clear to me, it proved impossible to obtain detailed information about their history during the war. This may have had something to do with my gender and age at the time of fieldwork but also perhaps because for most of the men, there was not a great deal to say: as in ordinary times, the defensive function of the neighborhood guardhouses was obvious; in wartime this had simply been expanded and made more explicit. But, once in a while, I sensed reticence on the part of some men who seemed reluctant to recall war's troubling episodes, as well as things that they may have felt were better left unsaid, if not forgotten.

But if these men, like the Indonesian revolutionaries before them but also youth the world over, took the city as their canvas as Abidin Kusno describes, equally evident in Ambon was the diffuse sense of threat that he also records—but also, by extension, neighborhood security—that emanated from the men and their stands. Recall that, in many cases, the combination of command and communication posts that were established during the war occupied the same strategic locations at the borders of urban neighborhoods as the motorbike-taxi stands do today. These were especially potent sites at the time, as we saw in Chapter 1—places where prayers were said and trumpets blown, where processions of Christian men and women set off holding images of Jesus Christ high above the crowd, and where the alarm sounded, rousing the neighborhood, in

the case of an attack. Tellingly in the Southeast Malukan islands of Aru, the Indonesian state required villages to construct the guardhouses that, at this eastern end of the archipelago, had never been seen before, as part of the preparations for the 1987 national elections. As I came to understand, the need for such defensive structures was meant to conjure the possibility of an unseen enemy who might emerge at any time to challenge the Indonesian state. According to the same logic, Aruese men were forced to train with mock guns they were told to carve from wood in case "something happened."[39] I mention this example to underscore the enormous strategic role linked to the ubiquitous guardhouses—whether in everyday circumstances, elections under Suharto, or wartime. But also to bring out their long-standing, intimate connection with forms of state control—connections that were enhanced during the Japanese occupation of Indonesia during World War II (1942–1945) through the system of neighborhood organization that the occupiers imposed to monitor and control the population and that was consolidated and expanded under Suharto.[40] To give just one example of their defensive function in ordinary times, a Catholic priest based at a church across the road from one of the biker stands, a man who I knew from my time in Aru, told me of an incident in which the electricity in the neighborhood had gone out and a woman employed in his home called out for help when she saw someone spying on her through a window. Within minutes, the priest recalled, along with his own surprise at the time, forty motorbikers had surrounded his house. When they caught the offender, the bikers "roughed him up a bit," but the priest insisted they turn the man over to him since he had been caught trespassing on church grounds.[41] Socially, symbolically, but also defensively standing in for their neighborhoods, the guardhouses, in other words, are places where multiple social and strategic needs are met, today as in the past.

Due to their predominantly young age, gender, and, commonly, unmarried status, the men who hang out at these spots in front of their neighborhoods tend to inhabit a place at authority's edge. Their creative activities, notably the Christian pictures, are not sanctioned by the local churches, who tend to regard them with ambivalence, often commending the images for how they showcase Christianity but voicing doubts about the religiosity of the young men who make the pictures or cynicism regarding the un-Christian behavior that they assume takes place around them. Indeed, it is these young men who the painter Jhon had in mind when he described his street art to me as pictorial khutbah or sermons, and he claimed some success. Sitting across from Christ's face, these men are less inclined to drink or fool around with women, or so Jhon said.[42] In casting his paintings in the role of Pentecostal witnessing, the painter also betrayed the influence of the charismatic church he had begun to attend

at the time even as he continued to join services at the GPM, intimating a shift in which he was hardly alone (see Chapter 4).

As elsewhere, such men are the recurrent object of suspicion and surveillance and, where possible, are mobilized to political ends in decentralized Indonesia's continual campaigns and elections. For instance, around election time it is not uncommon to see small television monitors appear in motorbike stands in addition to the even more common bright new T-shirts on the motorbikers.[43] Importantly, these groups are a phenomenon of orphaned landscapes, surfacing in wartime and afterward, when the guardhouses and their occupants became exemplary of the grassroots emergence of forms of authority and regulation, the enhancement of defensive protection, and, in Ambon, a religious definition of these processes. In this respect, it is important to recall that on the other side of the city, young Muslim men grouped at motorbike stands mirrored the loose neighborhood gangs of the Christians. As memories of the war faded, some of these groups collaborated as the Christians manned the Muslim stands during Muslim holidays, providing transportation for Muslim passengers and vice versa, as I discovered in 2017.

But in war's immediate aftermath, many more men than women were left without sources of employment.[44] Un(der)employment in the city especially affected its young people, comprising close to 60 percent of the urban population. There is also disturbing evidence of quite widespread domestic violence, as well as violence in schools following the war.[45] For many of the young motorbike-taxi drivers who are neither married nor in schools, these specific types of violence may not be directly relevant. But they do speak to the war's widespread trauma and other effects and to its ongoing consequences in the postwar city—including those that resulted from the devastation and scrambling of neighborhoods due to the redrawing and hardening of territorial boundaries and internal displacements, the memories of violence and the psychological and psychosocial damage resulting from the constant threat of violence, the loss of family and friends, the interruption or termination of school and employment, the destruction of futures and hope. There were, of course, differences among the men in this regard. In the mid-2000s, some of the older members of the biker groups were those who, in war's wake, were among Ambon's most adrift—their past clouded and often violent, their present precarious, and their future up for grabs. Others were more settled—younger men for whom motorbike-taxi driving was a source of income and a privileged component of masculine style, students aiming to support their studies, or the odd civil servant moonlighting to supplement his salary.[46] Among the differences were also those of class, since before the war a civil servant, and especially a Christian one, would not have been easily caught driving a pedicab or

motorbike. Indeed, one of the most common ways that middle-class Christians had of summarizing the decline in their social position was to point out that after the war, even Christians drove pedicabs, considered the lowliest of occupations.

Streetwise Masculinity

War and the city's postwar streets elicited masculine performances in which the male body figured centrally. It is possible that the precarity of postwar existence, more aggravated in many respects for men, may have further provoked the display of male power, whether in the form of domestic or other physical violence or through more sublimated forms like the Christian street art. Whatever the case, style among the city's young men is an ongoing preoccupation in which the motorbike assumes special importance as a crucial component of masculine performance. Demonstrative strutting and cruising has long been a feature of Ambon's streets, where men critically assess each other's performances.[47] Equally important is the creative work that goes into embellishing the motorbike as an accessory and instrument of masculine display and, collectively, the painting and decoration of the motorbike stand.[48] These different elements of style, male bravado, and group identity come together in stunning photographs of men performing stunts on their motorbikes in front of the Christ murals, as I discuss below.

If style generally is something to be put on show, then such style was performed with a vengeance during and after Ambon's war. A Protestant minister spoke to me of the first Pattimura Day celebration held in the city in mid-May 2005 to commemorate the resistance to Dutch colonial rule on the part of the nineteenth-century Christian hero and his followers.[49] Part of the ceremony includes a performance of the cakalele war dance by Christian men dressed in ancestral wartime attire upon their arrival to Ambon City from Saparua Island. If always impressive, the first postwar performance took place in that part of the city where the conflict began and in other ways, too, was especially uncanny. Following so closely upon the war's conclusion, the spectacle of the bare-chested men brandishing many of the same machetes they had only recently used in combat could not but evoke the city's immediate past and, what is more, be infused by some of the same passions and energies that drove the widespread violence, or so the minister said. With a hint of amusement, he added how it was obvious that a number of the men had prepared themselves for the public performance through some extra bodybuilding. Two years earlier in 2003, as I sat in front of my hotel enjoying the relative cool of the evening, I witnessed countless practice sessions that filled the wide, tree-lined Pattimura Avenue leading up to the city's first national Independence Day celebration

since the war. Late into the night, groups of twenty to thirty young men—but also some women—marched up and down the avenue in military style to the tune of a harmonica or a whistle blown to keep them in line. Variations on the style included "beautiful marching," which replaces the tight discipline of the military version with graceful, flowing movements, or another in which the military march alternates with short bouts of break dancing. Eager for some entertainment after the difficult years of conflict, people at the time commented enthusiastically about the impressive number of groups that had signed up for the Independence Day parade and how fabulous they would look in their different, color-coordinated clothing.

Cocky, streetwise, and displaying a decidedly Christian sense of style, Ambon's young men were key customers for the booming wartime market in Christian-themed T-shirts and the crosses that grew to immense sizes around their necks like some sacred Malukan bling. Music, stickers, and signs distinguishing minibuses destined for different parts of the city became demonstrably religious in nature, echoing in a different scale and register the aggressively spectacular Christian billboards and murals. Not surprisingly, the street pictures lent themselves to masculine performances, resulting in striking juxtapositions of canonical Christianity and monumentalized male bravado. While taking photographs of a motorbike-taxi stand one day, a few of the bikers offered to show me what they called their own *dokumentasi,* or photo collection documenting the "before" and "after" of their decorated motorbike stand and adjacent wall.[50] Some of the photographs showed these sites at different stages of completion; in others, the men gathered proudly around the partially done or finished wall. Among the stacks and small plastic albums provided by stores when they return printed photographs were scenes of group activities that captured male camaraderie and fun on camera—a motorbike excursion and boat trip to Seram during durian season, men striking poses next to their bikes or performing stunts at motorbike rallies. Taken over a period of time, the photographs recorded the shifting stylistic, political, and religious identifications of the group and the creativity displayed in their articulation.

But the most striking in the bikers' self-documentation were several photographs that showed young men performing motorbike stunts in front of Christian billboards and murals. In these pictures, male bodies merge with the Christian scenes behind them, as in one remarkable image in which the erect bike, supported by its owner dressed in his Christmas best, aligns perfectly with the crucified Christ behind it. In these carefully preserved photographs, the double import of backdrops in the construction of Christian identity and youthful masculinity alike comes to the fore: bikes, bling, and backdrops work together as prostheses of male bodies in public space, as the props of male performances, or even, following a more expansive definition, as a bodily

adornment of the pictured body, fashioning the subject within.[51] This is no-where more evident than when the bike aligns with the Christ backdrop in a dramatic expression of male motorbiker style and a masculine assertion of public Christianity. As a photograph, specifically, the picture offers a more intimate take on who this man and others like him "want to be when they pose before the camera."[52] In doing so, this remarkable shot folds into its frame but also into each other the seductive bravado of youthful male bluster and the power of pictures—including that of the global print Christianity from which the model for the billboard derives; the imaginative, theatrical space offered by the backdrop itself;[53] the glossy appeal of advertising that suffuses the gigantic airbrushed Christ; the performative force of being who you want to be before the camera, as well as, explicitly here, out in public space and poised for wide-spread consumption; the material presence of the monumental, in-your-face Christian street picture itself.

Figure 15. A photo album showing the range of sources that different Christian motorbike-taxi groups draw on, from the logos of political parties and portraits of political leaders, Christian print media, and the Israeli flag, to Dutch Christmas cards, T-shirts, and musical groups. Notable is the importance given by some groups to documenting the creative embellishment of their stands and the ubiquitous presence of the motorbike. Ambon 2003, 2005, and 2006. Photos by the author and by motorbikers.

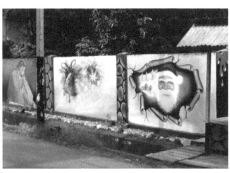

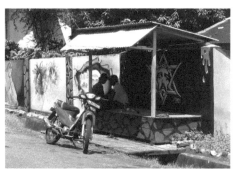

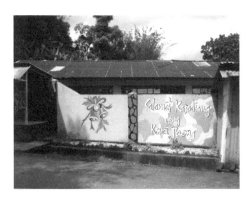

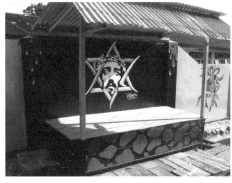

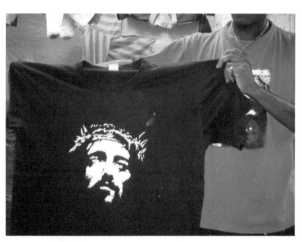

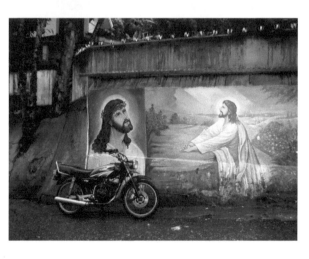

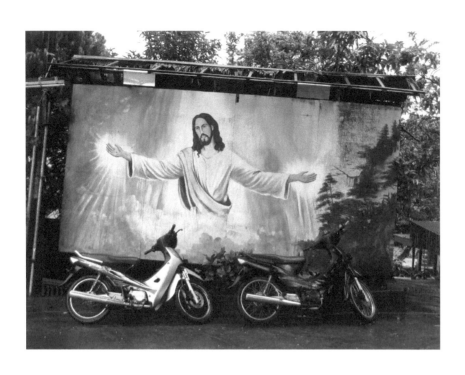

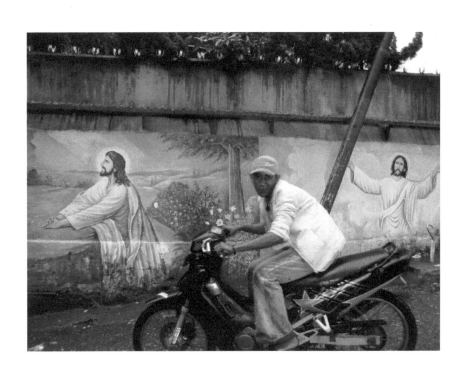

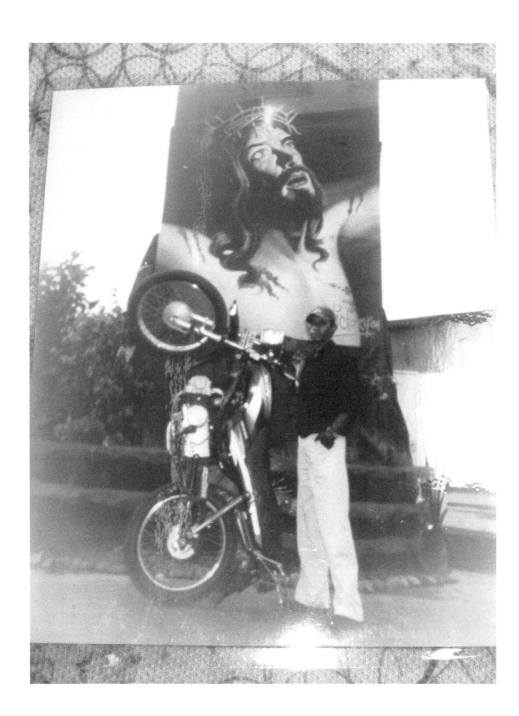

This Face Wants YOU

This is what the Christian billboards and murals say to the pedestrians, mo-
torcycles, cars, and minibuses that pass them by. It is also what they say to the
young men who, in Christian neighborhoods around the city, hang out on the
raised platforms facing the megapictures—passing their time, smoking ciga-
rettes, gossiping, and reviewing passersby (especially young women) while
awaiting motorbike-taxi customers. Looming over this terrain, Jesus's gigantic,
glossy face with its adjacent murals simultaneously gates the community and
brands it as decidedly Christian. In doing so, these pictures posit a direct rela-
tionship between the core symbols of the Ambonese Christian community
and physical territory at the same time as they facilitate an identification be-
tween the martyred male Jesus and the young men who gather around his
image and, in turn, through them, a connection to the wider community for
which they stand. This, incidentally, is an identification fully enabled by the
teachings of Protestant Christianity. In Chapter 3, I consider more closely the
identificatory circuit that is established discursively and via the pictures between
Jesus Christ and Christians, one based on an inherently visual idea—namely,
that of man being created in the image and likeness of God. For the young
men who sponsored and cared for the pictures, the significance of the connec-
tion between themselves and Jesus was, however, not circumscribed by the
teachings of Christianity but centered also on his identity as a young man.
Whether Christian or, for that matter, Muslim, Indonesia's neighborhood
guardhouses have long been sites of masculine identity and expression. This
explains why, besides men, only older women from the neighborhood might
pause briefly with their parcels from the market in the bike stand before head-
ing up the hill. But it also explains the concern on the part of the priest whose
church is in full view of one of the biker stands that the large statue of the
Virgin Mary planned for its pinnacle might offend its occupants (Figure 16).
In my view, his observation had less to do with any explicit difference between
Protestants and Catholics, something that was actually deemphasized during
the war, than the more elevated position of the Virgin vis-à-vis the stand and
its adjacent Christ murals. Recall, in this respect, Jhon's description of the
billboard that stood in front of this motorbike stand during the war but was
removed when its scaffolding rusted: "That is the one we made like an adver-
tisement, so we raised it up high, higher than all the other images because of
his being on high." Not only would the Catholic statue symbolically eclipse
Protestantism's privileged position and superiority, but it would also install a
markedly Catholic female figure looking down on the male sociality grouped
around the bike stand. Not surprisingly, the adamant masculinity of these

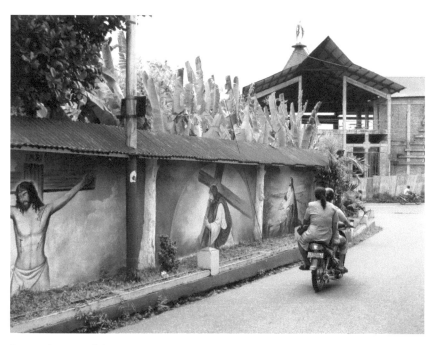

Figure 16. Statue of the Virgin Mary overlooking the mural painting of Christ across from a motorbike-taxi stand, Ambon, 2005. Photo by the author.

stands comes across in the iconography of the Protestant murals where the only women occasionally depicted serve as props to Christ, either as his mother Mary or the handful of women witnessing his resurrection.

Taken together, the territorial claims and Christian scenes built into and arising at these defensive neighborhood locations fed on and were energized by the symbolically charged, dense sociality that converges on the borders demarcating Ambon's Christian neighborhoods—increasingly anxiously and self-consciously—from the city and country around them. At these potent sites, highly territorial versions of community became articulated at the same time as the very idea of community in relation to territoriality became the site of creative exploration and experimentation—especially via the pictures thrown up on billboards and walls. Born out of conflict and an intimate part of the scene of war, the Christ at large in Ambon's postwar streets was, among other things, an emblem of violence where the difference between self-love and other-directed aggression was hard to discern. Seen in this light, the street art has much in common with the wartime graffiti that a journalist described as either self-referential or about the enemy—Israeli versus Egyptian territory,

Muslim power or Muslim pigs.[54] "We live and die for this," one biker explained, speaking of the musical group linked to his stand—and although he referred to the Sex Pistols, it might as well have been Jesus Christ. Invoked frequently by Christians lamenting their circumstances during the war, many claimed that "Christ was our only weapon," as they went on to recall the flimsy bows and arrows, makeshift rifles, home-brewed poisons, and occasional black magic with which they aimed to protect themselves. The Lion Alley wall showing Jesus holding a Sacred Heart encircled by thorns with flames shooting out of it looked to some like an exploding bomb encased in barbed wire (Figure 17). Such comments speak less to the skill—or lack of such—on the part of the particular artist involved than to how easily Christ and violence collaborated during the war. Recall, along these lines, how Jesus Christ's apparition often prefigured the onset of violence, or how some Christians—but allegedly, too, a handful of soldiers and several Muslims—saw him commanding the Christians in battle. Beyond these religious associations, bullet holes with bloody skin bent back to frame motorbike emblems or pistols in the place of heads on torsos have long been popular images at bike stands. Even if Christ on billboards and murals is depicted overlooking rather than immersed in violence—a crucial distinction—he remains close to and engaged with it. What his separation from war's all-encompassing terrifying terrain enables is seeing Christ as a comforting rather than a foreboding force.

If, during the war, Ambon's Christian pictures poetically, but also provocatively, publicized the question of territory in a city rent by violence, the practice of graffiti, often deployed in anticipation or in the aftermath of confrontation, served to advertise territorial conquests by inscribing the respective losses and gains of the enemies directly onto urban space. On either side, competing sound bites sprayed on city walls claimed territory for the self while defacing the opponent. Insults of Jesus or the Prophet Mohammad traded places with Stars of David, the names Israel and Mossad, or "Allahu akbar" in Arabic writing (Figure 18). All of these markings violently scratched onto the face of the city bore within them highly charged figures of territory: they staked claims to homes, public buildings, beaches, and stores, and to strategic loci in and around the city.[55] They desecrated the ground only recently relinquished by the foe, registered the vicious back-and-forth of enmity and contestation, cordoned and enclaved the community. Charged with aggression and meant to insult and provoke the enemy, such markings were the material conduits of the affective intensities, emotional commitments, and circulation of energies that animated the work on appearance during the war, especially that which took place in the streets and was driven (largely) by men—those who defended and fought for their neighborhoods, who gated and branded them with Christian scenes,

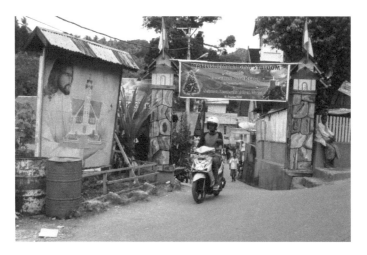

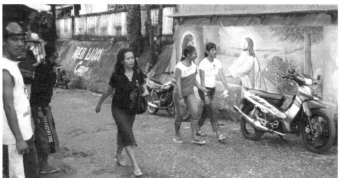

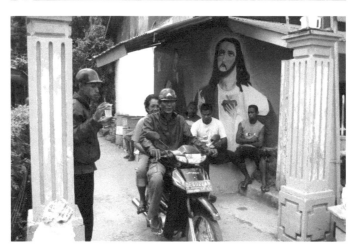

Figure 17. Christian neighborhood gateways, Ambon, 2005 and 2006. Photos by the author.

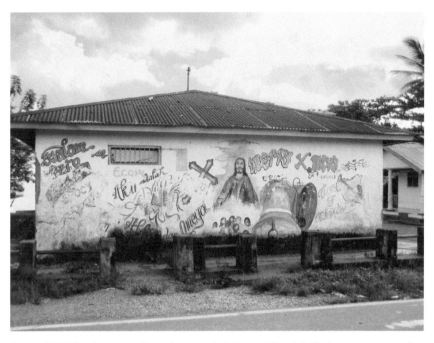

Figure 18. Wall with tags, graffiti, and a painted Christ and church bells that gives a sense of the diverse range to which such urban canvases are put. Soahuku town, Seram Island, 2005. Photo by the author.

who did stunts, posed, and photographed themselves in front of the Christ billboards and murals. It is worth recalling that, besides the Muslim enemy, another factor that must have energized the street art and fed its creative dynamism was the presence of multiple groups of such men around the city and the considerable competition among them, at no time more than in the weeks preceding Christmas and, to a lesser extent, Easter. Certainly, this competition between the men of different bike stands was evident after the war, but it probably also encouraged the spread and popularity of the street pictures during the conflict, something that was suggested to me by Lusi, the Christian woman I mentioned above.

One of the most spectacular scenes I ever witnessed where some of these energies and affective investments were exposed was in a short video clip that a stringer in Ambon showed me of Christian men on their way to fight the Muslims. Following a truck careening down the main thoroughfare and commercial hub of Ambon's A. J. Patty Avenue, the camera zooms in on a handful of young men with red head ties waving and gesticulating with their weapons.

Pulling abruptly curbside, the truck pauses to disgorge the men, who jump out of its back, squat in the street, and scrawl slogans on its tarred surface with white paint—Nazareth, Ambon Mossad, Israel anti-Muhammed, Repoblik Maluku Sarane (*sic*), and a white, six-pointed star on a red background that subsumes the Christians' wartime identification with Israel within the red and white colors of the Indonesian flag.[56]

"*Emosi!*" was the word the stringer used to describe the outburst of youthful energy and aggression that we briefly saw on screen and that left me stunned. Akin to the Dutch word *emotie*, or emotion, from which it derives, *emosi* in Indonesia has a negative connotation. When it comes to *emosi*, the sense inevitably is that there is too much of it, indicating a lack of control and intense anger. In the case of the stringer, himself a Christian, the word expressed less a judgment than a straightforward appraisal of the situation, of just how revved up the young men had been when they set off to confront the Muslims. Similarly, following the stringer, the difference between the wartime graffiti and the banners temporarily suspended over urban streets that we also saw in some clips was that while the former was driven by emosi, the latter responded directly to specific events, such as actions on the part of the Indonesian Armed Forces (I. Tentara Nasional Indonesia, or TNI) in Ambon: "This is the result of the criminality of the TNI," accused one banner; "TNI belongs to Acang [the Muslim enemy]," declared another; still another threatened the then commander of the armed forces in Ambon, substituting his first name, Max, with that of the Muslim Prophet, "Muhammed Tamaela should be strung up and burned."[57] My invocation of *emosi* here and especially the clip that registers its inscription on one of Ambon's main arteries is because, more than any other, this scene conveyed to me with frightening clarity and force how much not only the wartime graffiti but also its companions in the streets, the Christian pictures, emerged and stood their ground as enormously charged, embattled artifacts, aggressive claims to territory, and as a highly defensive articulation of representational redress.

Sighting the Street

In his influential essay "The Rhetoric of the Image," Roland Barthes coins the term *anchorage* for the captions, titles, and other bits of text that rein in and reduce the myriad meanings and interpretations that any image may spawn, with the aim of circumscribing its significance.[58] With respect to the Christian pictures, it is possible to see the array of material practices and artifacts, the sociality, masculine performances, and interpersonal dynamics, the personal and collective identities, the sense of God's estrangement, the drive to

experiment and figure, and the explosion of emosi as constituting an anchorage that helped to channel the impact of the pictures in Ambon's wartime and postwar streets. My intention in using this term is not to circumscribe or, indeed, diminish the power of these images by reducing their impact to contextual considerations. Rather, *anchorage* allows me to marshal some of the connections—or, more actively, the force field—that help to account for the street pictures' undeniable potency by identifying some of the forces that fed and sustained them, including the aggression and territorial commitments that were folded into the pictures. Understood dynamically as a field of heterogeneous energies and palpable materialities, anchorage in Ambon's streets comprised the defensive locations of the guardhouses, the style and sense of threat presented by the bikers, their presence and performances at the edge of Christian neighborhoods, the sociality that converged on the borders of religiously marked urban areas and thickened during the conflict, the myriad inscriptions on the material surfaces of the city, the neighborhood pride and loyalties, the shared histories and shared enmities, and, during the time of my fieldwork, the then still recent experiences of the war.

I began this chapter with an account of how and why Protestants turned to painting Christianity in Ambon's streets and how doing so meant abandoning the long-standing antimaterialist and aniconic tradition of Calvinist Protestantism and how this new material commitment, animated by the desire to bring God into vision and up close, entailed dramatic adjustments to the Christian iconographic canon. As the Christian pictures moved out of homes and stores and became monumentalized in the postwar urban environment, they not only changed but opened themselves to the pressures, desires, and imaginations of the streets—despite the avowed commitment on the part of the painters to copying rather than transforming the Christian canon. It is these streets that, approached from several angles, I have tried to keep in view in this chapter— from the characteristics of the key locations where the billboards and murals first arose, to the young men and biker groups who sponsored the pictures and the more diffuse Christian neighborhood-based sociality clustered around them, to the energies, desires, and expectations that suffuse these sites, keeping in mind also those of the multitudes who regularly passed by the pictures and saw how these conformed or did not conform to what Indonesians expect to see when they approach the entrance to a guarded neighborhood.[59]

In a thoughtful essay, Dilip Gaonkar singles out the rising significance of streets (along with slums), notably in the Global South, as the preeminent site where people congregate and where increasingly a kind of history is made: "The closing years of the last millennium and the opening years of the new millennium have witnessed the so-called people without history, or on the edges

of history, storming the gates of history in the streets and squares everywhere: Tiananmen (Beijing, 1989), Azad (Tehran, 1979, and 2008), Tahrir (Cairo, 2011), Taksim (Istanbul, 2013), Maidan (Kiev, 2013) and elsewhere."[60] To this list, Bundaran HI—Jakarta's huge roundabout in front of the iconic Hotel Indonesia built by Sukarno and the site of multiple student demonstrations and gatherings in 1998—might have been added. During the period of Reformasi, the spectacle and exuberant publicity of a panoply of new political, religious, and artistic forms and performative styles claimed the nation's streets as their recurrent stage. "Take to the streets!" was a recurrent battle cry among the country's young men and women who marched in the capital Jakarta and other Indonesian cities in 1998 and 1999, bravely stood off the army at often considerable risk to their own lives, occupied the parliament, and celebrated under Reformasi's hopeful banner when the downfall of the regime came about.[61] In the years immediately following Suharto's downfall, a "visibility contest" took over.[62] Streets across the nation became crowded with different groups—one more theatrical than the next—that contested and vied with each other for social, political, and economic stakes in postauthoritarian times: intellectuals, artists, and transgender people protesting antipornography and "pornographic action" laws; Islamic militants in white, yelling and waving weapons; or, further afield in wartime Ambon, ecumenical processions of Christians marching against forced conversions to Islam; the local branch of the national organization of Concerned Women gathered in front of the governor's office; people carrying fake coffins in protest of the imposition of civil emergency; Muslims demonstrating against the closure of the Laskar Jihad radio station; and so on.

Like many national histories, Indonesia's has for long been written from the perspective of the center, documenting its influence and reach, imposing a state-endorsed unity on the country's remarkable if depoliticized diversity (including religion) and channeling the ambitions of its huge citizenry. But Gaonkar suggests how, in recent times, the so-called people without history or at the edges of history may be coming out in multitudes, leaving their mark on major spaces of their respective nations and, at times, transforming them.[63] When they break through the proverbial gates of history, they become part of it—as Jakarta's storied pemuda, several times over, have entered history since their canonization as a force of change following Indonesia's independence struggle.

But what happens when the impact is more marginal and ephemeral, when people at the edges of history remain outside of it, not entering and attempting to alter official history dramatically as in Tahrir or Tiananmen Square but more diffusely introducing change from below without, by and large, any awareness of doing so? Ambon offers just such an example of significant, if

unwitting, change that began in the streets, was propelled by young men at the edge of authority and, certainly, the margins of history—the Protestant motorbike-taxi drivers who seized urban sidewalks and walls and subjected them to a vast, anxious work on appearances. To be sure, this example evidences the increasing role of the street in Ambon and Indonesia, as elsewhere, as an especially important site for significant sociopolitical transformation today. But what such a bottom-up history or, better, bottom-up *visual* history may also have to offer is an enhanced attunement to the affective intensities that animate the lifeworld of the street and, as such, bring us closer to some of the desires and motivations of those who congregate, act, and dream there.[64]

Besides the Christian street paintings, photographs of young men—whether taken during the Indonesian revolution, for a motorbiker group's documentation, or culled from my own archive of materials on Maluku—featuring individual men or groups of motorbike taxi-drivers, painted bike stands and walls, and urban neighborhoods and traffic took center stage in this chapter. The stylistic expressions they record, as I have tried to suggest here, come closest to men's highly performative, embodied practice, offering an avenue though which to tap the energies and affective investments of the street. Except when they are incorporated into photographs as backdrops for masculine performances, Ambon's street paintings do not provide the same kind of access in this regard. They do not show us as directly who the young men want to be as when they pose before the camera; as such they are even more mediated than such photographs—by the Christian iconographic canon, by the medium of paint and wall, by the significant departure from Calvinist tradition, by the street painters themselves, by fierce contests among different Christianities, and by a host of uncertainties, longings, and concerns. But, in other respects, they are as bottom-up as the young men's photographs, especially in how they bring us close to the heterogeneous imagination, the creativity, and wild experimentation that propelled the practice of figuration, as the billowing purple smoke enveloping one of Ambon's besieged landmark churches as Christ looks on from above, in the painting reproduced before this chapter, fantastically conveys.

3

Images without Borders

I begin with some fragments from Ambon's postwar urban environment:

> The city is in crisis, its great walls crumble, rocks and debris pile up below. Smoke shrouds large swaths of the country, tongues of flames leap out of churches. A populace in ancient garb is on the move; they raise trumpets and shake tambourines in defiance. Above, the angry face of God etched red and grimacing against dark clouds, behind him a crowd of angels borne on the storm. This is a scene of dramatic devastation. (A painting housed in a warehouse on the outskirts of Ambon City.)

> It's as if we are praying in his hands. . . . One feels as if one is praying in his hands. . . . Gethsemane in miniature. (From an interview with a Protestant minister about the prayer room in his home in Ambon City.)

> A Christ with a heavy beard and a busily patterned shirt gazes down lovingly at the five children held in his embrace. The boys and girls wear necklaces. Bands with flowers and feathers catch their hair. One wears a cloth draped over her shoulder. Noteworthy is the warm intensity of Christ's look and the crisscross of gazes among the children. It is Good Friday, March 31, 2002. (A charcoal drawing by a Protestant minister in Ambon City.)

> A serene Christ portrait with frayed edges stands out against the unfolding canonical scenes from his life—birth in Bethlehem's manger, a boat carrying Christ and his apostles tossed at sea, his body bent under the

great weight of the cross, crucifixion, resurrection. (A billboard and adjacent mural facing a motorbike-taxi stand in Ambon City.)

Scenes from a wreckage, the above fragments—bits of citation snatched from conversation or more formal interviews and my own thumbnail sketches—aim to foreground the provisional, incomplete, and exploratory nature of the images that are the focus of this chapter. My interest is in the diversity of the scenes these images conjure, ranging from God's-eye views and apocalyptic visions to intimate physical exchanges between God and humans, from the Christian sacred geography of Gethsemane to God in situ or in close proximity to Ambon. Christ intimately blends as an Ambonese with local children, dark complexioned, in native dress, with wavy hair and beard, or overlooks from a distance the Malukan islands below—although then, too, he is clearly moved by what he sees. I am struck by the way these pictures seem to pull in different directions. Foreground and background easily trade places or slide into each other; scale is up for grabs, shifting from one picture to the next or even within a given picture as, for instance, in the superimposition of Christ's gigantic portrait onto a narrative unfolding of his life. Perspective and views onto the city and its inhabitants are mobile and varied, while the landscapes envisioned in the pictures migrate seemingly without effort among this-worldly and otherworldly scapes and novel topographical formations. These include those that sacralize Ambon's conventional cityscape, as when Christ overlooks Ambon Bay rather than Jerusalem or his head hovers over the attack on one of Ambon's landmark churches, and more biblically inspired scenes. Striking in all of this is the strong sense of movement.

Keeping in mind the street pictures' more pragmatic function as figures of and claims to territory discussed in the previous chapter, I focus here on the dynamic interplay between the movement implied in many of the pictures and the efforts to contain the disquieting motion of a Christian lifeworld unmoored and rendered strange. Apart from the recurrent sense of movement, the sheer diversity of the street pictures, the visual genres they draw upon—most obviously, that of globalized Christian iconography—and the range of visualities and perspectives they display, each picture installs a landscape, one that turns "site into sight, place and space into a visual image."[1] By using this term, I want to underscore how much, as in traditional landscape painting, the pictures are animated, broadly speaking, by the effort to secure a view on things, both in the sense of a perspective and of an order within a scene that contrasts sharply with the immersive, chaotic surround of the wartime and postwar city.[2] Together with the ubiquitous, stereotypical rendition of Christ's face, the pictures

as landscapes would still a world in restless and, at times, terrifying motion and reestablish the familiar terms of quotidian existence and, not the least, overall appearance of the prior Protestant Ambonese lifeworld. In light of the desire to bring the Christian God into vision and, with it, the Christian self *as seen* by God, visually monumentalizing the Christian God's face amounts to an urgent plea for recognition in which the Protestants position themselves to receive it as the privileged addressees of their pictures.

Yet emergent in a world ravaged by war and uncertainty, neither the painted landscapes nor the Christian self easily establish stability, remaining unable to offer unequivocally an ordering perspective or guarantee of recognition. Moreover, despite the often voiced qualifications about pictures being "just pictures," what Protestants often seemed to want most was not any distanced view on the world but removal from it, in favor of immersion in a wholly Christian sacred space. These affectively charged sacred landscapes undermine any traditional sense of landscape and complicate, in varying ways, the connection between a distant Calvinist God and his devotees. The aggravated conditions in which the Christians made their pictures further demanded a dramatic re-tooling of visual imagination, one that drew upon the range of media and models already at hand and on others salient or introduced during the conflict.

In what follows, I explore questions of framing and backdrops, both visible and invisible, that are relevant to understanding the dynamics of the street pictures and to gauging how they were seen by Christians and others who looked at them or passed them by. Much of the chapter homes in on particular images as I examine closely some of the images without borders that Protestants put in place to resurrect the frames that, disjointed by crisis, had previously sustained their lifeworld, along with the image they held of themselves. On the one hand, these images were borderless in their exploratory impulse and search for new modes of expression, but also in their bringing-into-vision of a universal Christ, unchallenged by other religions, and in their usurpation of the authority of the Indonesian state, an argument I develop below. On the other, the street painters monumentalized the familiar visual frames of Protestant religion, defensively circumscribing a lifeworld on the wane, as the pictures aggressively marked the material borders of urban Christian enclaves. If the last chapter tracked the emergence of the pictures within Ambon's masculine street culture and the phenomenon of Christ at large in the city, this chapter homes in on the dynamics animating individual pictures and introduces their painters. Yet even as I consider individual pictures more closely, it is crucial to bear in mind that none of these can be seen in isolation but must be grasped collectively as something akin to an open-air urban gallery.

Painting Christianity

All told, fewer than a dozen painters produced the pictures that surfaced in Ambon's streets, and even fewer the ones that emerged behind altars and in private homes. I had only one or two conversations with two of the least active among the painters; two others I never managed to meet, since they were either away from Ambon or unavailable when, on several occasions, I tried to see them. I worked especially closely with Jhon Yesayas, Ambon's most prolific painter, but also spent time with Victory, who opened a roadside studio in 2006, as well as with some of the motorbikers connected to the stand featuring his work, including the big, blue-eyed Christ. I visited Pak Lamberth C. Joseph at his home on several occasions. As the former director of Ambon's Siwalima Museum, Pak Joseph was well known locally. Many Christians were also aware of his conversion to Pentecostalism following a narrow escape from an attack on his home during the conflict. The only painter in the city with art school training, having been sent by the government at a young age to study at Yogyakarta's Art Academy, he was designated by some of the street painters as the "master" or "teacher of the arts" in Ambon. Besides these artists and the young men of several motorbike stands who sponsored the pictures, I developed especially warm relations with the late Pak Nus Tamaela, the founder of a museum dedicated to Seram's indigenous culture (especially the island's allegedly brutal headhunting tradition), and his son, the late GPM Minister Chris Tamaela, a teacher at Ambon's Christian University (Universitas Kristen Indonesia Maluku, or UKIM).[3] The father and son stand out from the region's other painters since they were the only ones to portray Christ as an indigenous Malukan, departing from his locally conventional rendition as a white European.

With the exception of Victory, all of the painters claimed some religious conviction or motivation for their work, although the manner in which they did, the kind of religiosity that informed their artistic practice, and their institutional religious affiliation also betray the increasing diversity among Malukan Protestants that, to a large extent, was accelerated by the war. Apart from their professed Christianity, these men were also, not unimportantly, painters or people who love to paint. In terms of how they envisioned their work, they were more ambitious than the persons who, before the war, made the occasional mural or embellished gateway that, from time to time, was sponsored by the city government. In contrast to these incidental productions, the street paintings of the 2000s were, significantly, driven from below, as I argued in the last chapter. Nor should we overlook how all of Ambon's painters active in the 2000s began to paint in the street as a direct response to the violence around them

and their sense of being under attack as Christians. A graphic artist and photographer who, as a Muslim, was forced to leave Ambon with his Christian wife during the conflict because of their mixed marriage had occasionally been asked before the war to decorate a wall in his neighborhood around Christmas or to welcome the New Year. But today's pictures were different, he claimed, since they had everything to do with "identity."[4] Indeed, my friend's long-standing nickname, Mas Embong ("Mr. Wall" in Javanese), underscores just how out of the ordinary street painting had been prior to the war. A number of people, including several artists, remembered one or two occasions when the mayor's office had held a competition focused on painting neighborhood gateways, a practice common in Indonesia especially in connection with the celebration of the country's independence on August 17. Notwithstanding such examples, it is impossible to identify any real precedent for Ambon's street pictures.

Let me begin by introducing Jhon, who I have already quoted in the preceding pages. I first heard about Jhon from a young woman employed at Telkom, Ambon's telecommunications office, who, already before the war, had become a fervent convert to Pentecostalism and an active member of her church. She knew him as a fellow worker at the Telkom office but also because, from time to time, he worshipped at her church. When she brought me to the Telkom Graphics Department, housed in its own small building behind the large office, we found Jhon bent over a drafting table, drawing a map of Ambon's underground cable network. Eager to talk about his painting (and probably also flattered by my attention), we began what evolved into a series of somewhat more formal recorded interviews that punctuated the ongoing conversation that unfolded between us over the years, beginning in 2005 and continuing through 2011. In 2006, we toured Ambon and its outskirts for several days, visiting churches and homes that held examples of Jhon's work. We also traveled together to the Christian village of Waai, which had been the target of a vicious onslaught during the conflict, to visit another painter who spoke of a mural he had painted on the wall of a refugee camp where he and fellow villagers from Waai arrived after a harrowing flight that took them deep into Ambon Island's forested interior. Although it no longer existed, the painting depicted a miracle that took place during the flight: a procession of men, women, and children from Waai being guided to safety by a divine light that cut a path through the nighttime forest, an event I had already heard about from a GPM minister. I often accompanied Jhon on visits to the homes of his two minister friends, one from the GPM who commissioned him to paint a wall and prayer room in his home, another a self-styled minister who, while not ordained or affiliated to any church, Jhon accompanied, when his schedule permitted, on religious

revival trips to the neighboring islands. Besides distributing bibles, this minister took part in the revival sessions that were necessary, Jhon explained, because "during the violence people were close to God but now distance is setting in—this is why we hold religious revivals."[5] Without exception, Jhon referred to and addressed the former Chinese Indonesian businessman as "Minister" and clearly admired him.

Jhon began to draw and paint at an early age, winning several prizes in local contests when he was young. After school, he would practice what he called his hobby at home. He attended a technical high school, where he specialized in technical and architectural drawing but was unable to continue his studies since his parents could not afford the cost. Jhon often complained about the precarity of his position at the telecommunications office where he had already been employed for nine years on a contractual basis when we first met. Nonetheless, during the time I spent doing fieldwork in Ambon, he managed to build a house overlooking the bay in the attractive, tranquil neighborhood of Amahusu with the money he earned from painting: "If you talk about pictures—goodness!" he exclaimed. "In Ambon alone I have so many pictures that a gallery would not be able to hold them—at Batu Gantung, inside that neighborhood, in the [inaudible] Church that was destroyed in the violence of 2001–2002. [I paint] for Christmas, commonly for Easter, often at Christmas to create its atmosphere."[6]

In such conversations, Jhon always emphasized the religious underpinnings of his work and, occasionally, its evangelical potential:

It's like this—many of us have talents. A minister has the talent to give sermons, to show people the true way, but I also have a talent, right? The Lord gave it to me. It is [a talent expressed] through pictures, and sometimes I think maybe those pictures can make people aware, that is, via the pictures. What I mean is that place where we sat before that used to be the hangout for kids, it was a mess—they would drink, get into fights, make trouble, kids from here, youth. So I have a way that might help them change. Maybe if I paint Jesus so that they can see him—certainly there would be some feeling if they got drunk there some time, if they kept creating trouble there. Perhaps that could work in an indirect manner. My style is like that. I don't know how to give sermons. I can't, but maybe through drawings. When it comes to Ambonese, it is not certain that if we reprimand them they will pay attention. It is not at all certain since they are tough, their character is tough. But if we approach them like this, through hanging out, I hang out with them. So when I do something, they want to do it. If we want

to make a garden, I make it; if we want to make pictures, I make them. And I say to them, "These are not just views or other kinds of pictures, this is our Lord, right?"[7]

With this statement, made in lowered voice in respect of the Lord, Jhon offered a twist, even a compromise, between the Calvinist claim that pictures are "just pictures" and portrayals of Christian scenes that are not "just views" but something more akin to sacred, efficacious presences. In the same interview, Jhon described the way he works and the kind of collaboration he had with the motorbikers who not only sponsored the pictures but, before Christian holidays, would clean and touch them up, string colored lanterns above them, and tend to the narrow strips of grass that commonly run along the murals' bases:

> When I made the picture, I did not ask for payment. A payment would have been in the thousands. ["How long did it take?" I asked.] It took about two weeks. I would come home from work and paint until late at night—on my days off, on Sundays, Saturdays, I painted and they helped me. I told them to buy cigarettes, to get some drinks. We did the base painting, they were the ones who painted the base, entirely white. This was the way—after the base painting was done, I took the picture of Jesus from his birth, I started with his birth, I painted his birth. ["Where did you get the image?"] From a book. I actually forgot this book in Kusukusu; I was painting there the other day and left it behind. This painting was of Jesus's life, I made him really big.[8]

Except for the academy-trained Pak Joseph, Victory was the only painter who signed his pictures and, in his case, too, assumed a professional name. A member of the GPM congregation like the majority of the city's Protestants, Victory never mentioned any religious motivation to his work, in contrast to the other painters. Even on those occasions when a religious interpretation might have been offered, religion was clearly not on his mind. For instance, when I asked him about the six-pointed star that he had added to the Jesus face on the wall at Belakang Soya, he claimed that the star had no particular significance. Rather, the Jesus face copied by one of the bikers from a T-shirt onto the wall turned out "small." By enclosing Christ's face in a star, he had aimed simply at achieving some kind of pictorial "balance."[9] In 2006, this most commercially minded among the city's painters opened a roadside studio constructed, among other materials, from an immense billboard featuring the faces of then Indonesian president Susilo Bambang Yudhoyono and his wife, Kristiani. To form the rear wall of the structure, the billboard had been

dismantled and reassembled with the incongruous result that Kristiani's chin and red lips ran vertically down one end of the wall while her eyes gazed out oddly, one stacked above the other, from the other. Commissioned by the Central Malukan governor's office to be displayed at Ambon's airport when the presidential couple arrived, the billboard had not been claimed when the visit was cancelled following the devastation of Aceh in North Sumatra by the December 2004 tsunami. A sign with Leonar Tahalea's professional name, Victory, advertising his specialty, "Airbrush Painting"—a skill acquired during the time he spent in Jakarta—hung next to the studio door (Figure 19). Occasionally, I saw business cards with "Victory '72 Gallery" listing services like "painting a portrait from a photograph" tacked up in stores in the predominantly Christian part of the city. Victory charged considerably more for his work than the other street painters, except presumably Pak Joseph, and could live on what he earned from his work. This may be why the Christian mural at the Belakang Soya bike stand was painted by no less than three men, including one of the motorbikers, since commissioning Victory alone would presumably have been too costly.

Victory's thematic range also stood out from that of the others. Until I visited his studio in 2006, I had always regarded him as just another of the city's Christian street painters, which, of course, he also was. This meant that I was all the more surprised when I visited his studio to see several kitschy, soft pornographic paintings of seminaked women—one bare-breasted with a scrap of cloth loosely draped around her hips standing defiantly in front of a dragon, another with a huge snake coiling around her, yet another full-breasted mermaid with a Marilyn Monroe face, her back arched to further accentuate her breasts—propped up against or hanging from the studio walls. Competing for attention in the small, one-room studio was a crucified Jesus face positioned above the door and another freshly painted Christ face that stood out on a white canvas where the artist had recently begun to copy the image taped alongside it.

When I asked Victory about the paintings of the voluptuous, seminude women that, like all of his work, was copied from examples, he showed no sense of any contradiction between these paintings and his Christian ones. Like the airbrushed Christ with a shepherd's staff standing among a flock of sheep, the pictures formed part of his expanding "collection" and were something new he was trying out. In my experience, even the motorbikers showed some embarrassment if they were caught engaging in allegedly un-Christian behavior in the vicinity of the street pictures. Once when I started to photograph the mural at a bike stand that I had visited many times before, several young men quickly fled the scene, abandoning an open bottle of alcohol as

Figure 19. A composite image of the painter Victory's studio and gallery, Ambon, 2006. Photos by the author.

they did. Certainly, some of the other men painted subjects that were not overtly Christian—faces of political leaders and logos of the political parties that mushroomed in Indonesia after the downfall of the authoritarian regime, murals supporting soccer teams, with the Dutch national Orange team a favorite among Christians, scenic views or motifs taken from local culture commissioned to beautify karaoke bars and hotel lounges. Still, they did not paint images that seemed so directly to contradict predominant sensibilities of Christian morality and modesty.

In stark contrast to Victory, Pak Joseph, who described himself as a teacher of the arts in Ambon, spoke of his Christian paintings as a form of Pentecostal witnessing. During the series of interviews we conducted in his home, his conversion from being "just your ordinary Christian" or GPM Protestant to "living according to what is written in God's commandment" inflected our exchange.[10] Pak Joseph's personal history was especially wrenching. The narrow escape from death as he and his family managed, almost miraculously, to flee their burning home when it was set on fire by Muslims as they hid within, the destruction of the family home and gallery that held his life's work, comprised what Pak Joseph referred to only obliquely as "the event."

Whenever we met, it was amid the tangible signs of his charismatic religion, as even the terrain surrounding Pak Joseph's home had been turned into a space for witnessing "what is written in God's commandment." A white sign, for instance, occupying a prominent place next to a well read in bold letters: "Do unto others as you would have done to you. Matthew 7:12." Besides being a material form of witnessing, the sign was meant to encourage Pak Joseph's neighbors to safeguard the cleanliness of the place. Witnessing and quoting scripture punctuated his speech. At times, he disparaged his former religion, positively contrasting, for instance, his second baptism to his first as like "that of old-style Christians with a full dunking, not just a sprinkling of water."[11] Apart from the conventional Pentecostal attunement to the written and spoken biblical word, Pak Joseph ended one of our conversations by emphasizing his vocation as a painter and the "more attractive" power of pictures over words. Drawing himself up in his chair, he pronounced: "Conclusion: the news of salvation comes not only through the blessings conveyed by God's servants, via sermons or witnessing, but it also comes through paintings. It is through these that I myself offer a witnessing to salvation for peoples of all ethnicities who have not yet heard God's Commandment."[12]

Pak Joseph related how, following his conversion, he felt the need to adopt a style that he deemed more suitable for portraying the subject matter of the apocalypse, including the onslaught of crises and devastation in Indonesia

that he believed augured the Christian end-time. In the home where he settled with his family following several displacements, I saw paintings cataloging traditional Malukan life and folkloric themes like sago roasting, fishnet making, and the bird of paradise dance, along with nationalist portrayals of state-endorsed ethnicities. These works, that he described as "naturalistic," harkened back to the time he was a state employee as director of Ambon's Siwalima Museum (Figure 20). This style contrasted with the "surrealism" of his more recent religious paintings with the shift from naturalism to surrealism dictated, as he explained, by the "supernatural" character of his new religious subject matter. Apart from Ambon's violence, Pak Joseph singled out the October 2002 terrorist bombings in Bali's tourist resort, Kuta, as an important impetus to his adoption of a surrealistic style. For him, as for others in Maluku with an apoc-alyptic bent of mind, the numerous incidents of violence around the archipel-ago, along with disasters like earthquakes and the tsunami that followed the serial crises accompanying Suharto's downfall, evidenced the thick, calamitous conditions of an imminent Christian end-time.[13]

Like Pak Joseph, other painters often invoked the special appeal or power of pictures, distinguishing their effect from that of texts or words. While watch-ing television one evening with his family in Seram, Pak Nus Tamaela remarked, as his grandchildren played around us, how much he loved to paint.[14] Besides the presence of the television, this observation may have in part been provoked

Figure 20. The two paintings on the left are "naturalistic" depictions of traditional Malukan life, according to the painter. The one on the right falls within his "surrealistic" style. It indexes Mazmur 133 from the Bible ("Behold, how good and pleasant [it is] for brethren to dwell together in unity") and Ibu Pertiwi, a personification of the Indonesian motherland. As a whole, the painting on the right is a graphic interpretation of the Indonesian Republic's motto "Unity in Diversity." Paintings by Lamberth Joseph, Ambon, 2005. Photos by the author.

by the box of Dutch Rembrandt paint that I had brought him from Amsterdam along with some fine Belgian linen canvas, a gift from my father—a painter, like Pak Nus, in his eighties at the time. "Painting is great," Pak Nus offered, "I just love doing it."[15] "When people watch television, they watch the stories but I watch the images." Picking up on the thread of our conversation, his son, Chris, a GPM minister and ethnomusicologist, mentioned a picture of his own—"just a sketch," he said, "on an A4 sheet of paper"—that he would show me when we were back in Ambon. Chris went on to describe his charcoal drawing depicting Lord Jesus embracing five children, each representing some aspect of Maluku's cultural and ethnic diversity. "People are tired of talking about reconciliation," Chris remarked, justifying his preference for pictures or, equally important for him, music over words. "Let us embrace each other, pictures work well with the pela song," he went on, referring to a song about the traditional blood brotherhood canonically identified with Christian-Muslim alliances that he had composed during the conflict and that he claimed was still used in reconciliation events.

"When I made this drawing," he said, "I was very moved. People's imagination may be triggered by sentences but with pictures . . . It is good," he continued, if "there are pictures in the streets."[16] Their presence in urban space, following Chris, would allow for "repetition" since people would pass by the pictures on a daily basis. Adding to this insight on the effects of the pictures' publicity, Chris confided that he hoped to enlarge his Jesus picture and display it in places like Indonesia's National Library where many people would see it. Below, I discuss the drawing that Chris showed me when we returned to Ambon and how he connected it to Indonesia's national ideology Pancasila, or the Five Points conveyed by the five Malukan children that he pictured in Christ's embrace. This proposed painting, like one by his father, Pak Nus, conjoins symbols of the nation with the portrayal of a brown Malukan Christ and, in doing so, proposes a connection between Christianity, the Indonesian nation, and Malukan identity.

Given the interest in and deep commitment to the study of Malukan culture on the part of both men, Christ's portrayal as indigenous is hardly surprising. Before his death in April 2020, Chris taught church music, liturgy, and Christian art, as well as Malukan culture, at UKIM. In 2015 he defended his PhD at Amsterdam's orthodox Calvinist Free University, titled "Contextualization of Music and Liturgy in the Moluccan Church, with Special Reference to the Protestant Church of the Moluccas." In an interview at the time with a Dutch Malukan magazine, a fellow minister recalled a service led by Minister Chris in one of the region's languages and how the women in charge of the collection

wore clothing from Tanimbar, a southeastern Malukan island known for its exquisite woven textiles.[17]

Like his son, Pak Nus dedicated much of his life to the study and promotion of Malukan culture. Following his retirement in 1971 as the director of Seram Island's only prison, he devoted his life to the documentation of Seramese culture. Until his death in 2017, he produced prolifically—building and expanding the collection of his Seram culture museum, specializing in portraits and sculptures of headhunters and ethnographically inspired, if somewhat sensationalist, scenes of the ancestral life of the island's indigenous peoples. In addition to his multimedia archiving of Seram's ancient life, Pak Nus ran a musical group, designed the costumes and props for performances, and exhibited his work in cultural events around Maluku. His fascination for headhunting and claim to know "all its secrets"—knowledge he said he acquired during the patrols he made as prison director in Seram's hinterlands—fueled his ongoing project of creative documentation: the statues, portraits of famed war captains, and quasi-ethnographic cameos of native life depicting hunting practices, lice-picking scenes, life-cycle rituals, menstruation huts, trophy heads, and even marriage ceremonies centered improbably upon a skull as bridewealth.[18] This collection became the object of an iconoclastic attack around the time that violence spread from Ambon to Soahuku on Seram Island. I discuss this event elsewhere, the only one of its kind that I am aware of during the violence in Maluku.[19]

When I first visited Pak Nus in 2005, he had only recently resumed his artistic work. Among the pictures of the partly renewed museum collection were several portraying the violence as it had affected the predominantly Christian town of Soahuku and Christians more generally. The most striking among several Christian-themed pictures portrayed a brown Christ in a scene of religiously marked violence holding a burning church and a bible in his raised hands (Figure 21). Apart from the brown Christ, the entire painting is rendered in the colors of the Indonesian flag, known simply as the red and white. Another painting showed people fording a river as Christ beckoned to them from the opposite bank, a harrowing scene of displacement that recalled that of Pak Nus and his family when they were driven out of their home by jihadis (Figure 22). In what follows, on a tour of Ambon's street gallery, I consider more closely some of the street paintings—including the indigenous Christ drawing by Minister Chris. Although Christ, especially his face, is a recurrent feature in all of them, the pictures evidence the creative heterogeneity of Christian world-making via these painted landscapes that sprung up in Ambon's streets during and after the war.

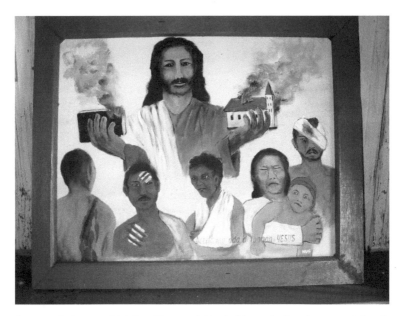

Figure 21. Indigenous Malukan Christ with his clothing and other elements rendered in the red and white colors of the Indonesian national flag. Painting by Nus Tamaela, Soahuku, 2005. Photo by the author.

Figure 22. Christian-themed paintings in the yard of Pak Nus Tamaela's home in Soahuku, Seram Island. The picture at the center reads: "Oh God, please hide me from the violence." The painting on the left shows a mother consoling her child whose father has been killed. The one on the right, titled "Tears Shed at Christmas," enumerates the many sources of grief and suffering caused by the violence. Paintings by Nus Tamaela, Soahuku, 2005. Photo by the author.

Landscape I: Christian Enclave

Tucked away in a Christian neighborhood in the hills overlooking the city, the minuscule prayer room in a Protestant minister's home is painted entirely from floor to ceiling. Forming a single, unbroken surface, it envelops those who enter the room to pray within a miniature Gethsemane Garden.[20] On the far wall that is the room's immediate focus when one enters, Jesus Christ prays in profile against a shiny green background. Although lavishly sprinkled with flowers and boasting luxuriant vegetation, incongruous rock formations, an occasional palm or olive tree, and a few stiff, glossy sheep, the remaining three walls are predominantly green. Not a single spot has been overlooked—even the door to the room has been painted over to resemble a cave. Bent on ensuring its Gethsemane effect, the minister took care to plant leafy green trees in his garden immediately outside the room's only window. Since the room's decor is also minimal, there is little to distract one's eyes from the painted surroundings so that the gaze tends to gravitate toward the quiet, silhouetted Jesus bent in prayer. This directionality, along with the shiny seamlessness of the space, may be one reason why the sense of closeness and of being physically held in Christ's hands is one of the room's celebrated effects—and something the minister, his family, and, reportedly, those congregation members who come for counseling continually remarked upon (Figure 23).

> The moment we enter the special room, the minister explained, it's as if we are in his hands. There are olive trees painted there. And there is a painting of Jesus praying. And if we open the window, I planted some green trees outside, so if we pray with the windows open one feels as if one is praying in his hands. And my desire was like that, Ma'am. I created an atmosphere in the prayer room like that of the Garden of Gethsemane. . . . It happened that in the magazine *Gloria* there is a photo of the Garden of Gethsemane with those olive trees. I said, "Please paint like this. I want a picture with the atmosphere of Gethsemane."[21]

There is a strong sense here of a sacred landscape, a poignant, immersive surround dedicated to prayer and connected to the powerful scene of Christ praying immediately before his arrest and martyrdom. Yet while some Congregationalists may be invited into the prayer room, the majority of those who consult the minister do so in the reception room that one enters upon coming into the house. On the wall opposite the door, an immense Jesus rises behind some chairs with his arms extending to the viewer. When I first visited the minister at his office at the GPM's Maranatha church, he mentioned the

painting, emphasizing how it is "truly full of love and care," conjuring in a somewhat different register another affectively potent scene. As we sat before it in his home some weeks later, he expanded on this dimension:

> After Jhon finished painting [the Christ wall], this room began to be used for counseling and everyone who came here felt really pleased. Before a person would even be involved in the counseling, as soon as he sat down with whatever troubles he had, he would feel very relieved. "Pak Minister, the atmosphere is delicioussssss . . ." It was as if the painting . . . helped him so that he felt there was assistance in an indirect fashion.

Although the painting in the foyer has a soothing atmosphere, it pales by comparison with the effects of the room set aside for prayer. To enter this special room is to leave one world behind and be enclosed in another, a Christian elsewhere that bears only an oblique, tenuous connection to the first.[22] The existence and circulation of such Christian elsewheres and sacred sites or, differently, those of other religious traditions, like Islam, are, in themselves, not remarkable.[23] During Ambon's war, several Gaza Strips divided the city into Christian and Muslim territories, while identification with Israel, in the case of the former, and Palestine and, to a lesser extent, Egypt, in the case of the latter, was a recurrent inspiration for graffiti and T-shirt designs, and a common reference in conversation. Given that Scripture and Christian and Jewish traditions carry with them a certain geography, it is natural for them to employ this geography when they occupy the regions these describe.[24] Along with this inbuilt portable geography, the religious universality of Christian holy places like Rome or Jerusalem, along with affect-laden sites such as Gethsemane, is one that moves them beyond any linguistic or geographical specificity, making it "difficult for them to be circumscribed within entirely regional, not to mention national, geographies."[25]

Notwithstanding such mobility, what strikes one is the careful hedging of such circulation, the carving out of a cave-like enclosure, and the creation of a miniature Christian enclave cut off and framed apart from the world outside. An inherently defensive stance animates the hermetically designed prayer room—one that, highly efficacious, enables sensuous immersion in a purified Christianity that can trigger the experience of being embraced by God. The Protestant minister's prayer room, or otherworldly enclave that lovingly encloses and physically extracts those who pray within from the world outside, also

Figure 23. Composite image of a painted wall in the reception area of a Protestant minister's home overlaid with scenes of the adjacent prayer room, Ambon, 2006. Photos by the author.

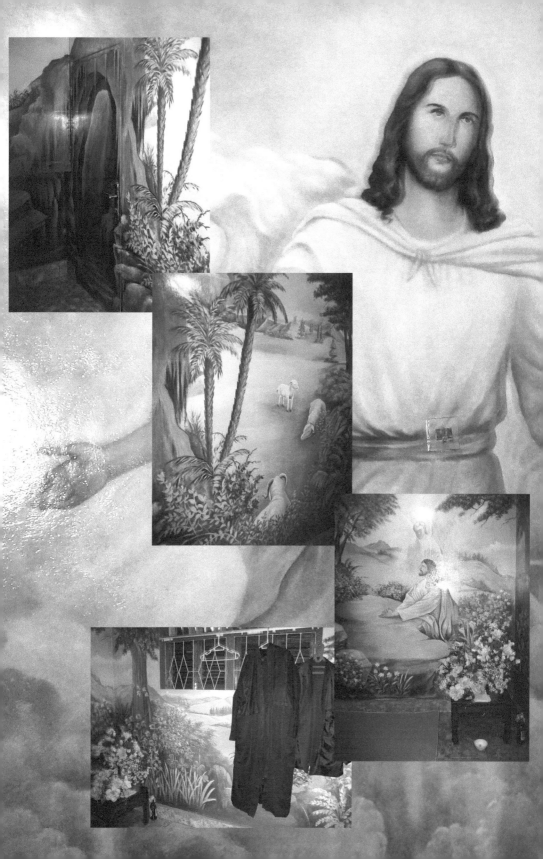

echoes the widespread, postconflict desire to turn time back, to reclaim Ambon as a city with a "Christian impression about it," one dominated politically, economically, and culturally well into the 1990s by Protestant Ambonese.[26] But if before the war a taken-for-granted and hence unmarked Christian hegemony characterized the city, the restoration by Protestants of Ambon's previous Christian look took place as a commanding, aggressively marked Christianity lining its streets and sidewalks.

Apart from nostalgia and the effects of the recent war, the siege mentality prevalent among Ambon's Protestants had to do with the changing nature and physical transformation of public space in Indonesia generally and, in particular, the enhanced public visibility—tantamount to a visibility contest[27]—of the nation's religious composition following the New Order's end. Already from the 1990s when the Suharto regime adopted policies promoting Indonesia's Islamicization,[28] scholars began to write of a burgeoning "public Islam"—singling out its salient visible, audible, and physical presence in Indonesia and beyond, beginning with the 1979 Iranian revolution and enhanced by more recent events.[29] In the streets of Ambon and across Indonesia, Islam's indisputable presence registers visibly and audibly in the many new mosques being built, the popularity of Qur'anic reading sessions and typical Muslim fashions, the rise in the number of Indonesian Muslims performing the hajj (increasingly at a younger age), the popular Muslim boy bands and celebrity preachers, the resurgence of Islamic print media and the spread of Islamic economic institutions, the expansion of *da'wa* or proselytizing into new terrain like cyber-da'wa and cellular da'wa, and the theatrical, public aggression of militant Islamic groups like the Islamic Defenders Front (Front Pembela Islam, or FPI).[30] None of this has been lost on Ambon's Christians. Or, as the GPM minister with the home prayer room volunteered, characterizing the city's street pictures as a direct parallel to this public Islam, "It's the same. They don't make pictures much, but they wear headscarves as their own kind of special characteristic. To show that 'we are Muslims.' Yes, that's what stands out."[31]

In his rationale of the Christian pictures—including, presumably, the painted surround of his home prayer room—the minister marshaled a sea of Muslim headscarves as that which "stands out" but also, by implication, that which the pictures somehow counter. Indexical of the very fact of Muslim presence in Indonesia, the myriad headscarves enfold a host of Christian anxieties and concerns, including the overwhelming numerical dominance of Muslims in the country (some 90 percent of the total population), the visible dominance of Islam around the archipelago, the substitution of Muslims for Christians in Ambon and Maluku province's civil bureaucracies, and the widespread conviction among Christians during the conflict that they were the target of

a Muslim-driven genocide. But this image also reveals a secondary order or invisible backdrop that needs to be taken into account as a force feeding and energizing the affective intensities and enormous investment of Christians in the scenes with which they surrounded themselves and took solace during and after the war. As has been suggested for colonial photographs, backdrops may be twofold: the first a visible backdrop and the second an invisible one, a secondary order that shapes the interpretation of the image's intended audience or addressees.[32] It is the latter, the secondary backdrop of sheer Muslim domination and numerical force in Indonesia, briefly made visible in the minister's evocation of a sea of headscarves, that haunts the prayer room and that it is designed to invisibilize and keep away.

To pray in the miniature Gethsemane Garden is to enter into a kind of tête-à-tête that realizes itself through the embodied mimicry of the painted God's gestures on the part of the person praying and can lead to being swept up in this physical exchange by the incredible sensation that one is caught protectively in his hands. Together with the unbroken seamlessness of the space, this sensation seems to be an effect of being momentarily suspended and closed off from any outside surroundings. With leafy trees planted immediately outside the prayer room's windows, even the city's invisible backdrop can briefly be held at bay. In its place, a delicate and moving closeness comes to the fore that the minister's wife was at a loss of words to describe—one in which the room's painted backdrop forecloses the invisible one pressing in from the outside, thereby allowing those praying in the foreground to merge tenderly with the affectively powerful Christian scene.

I began this tour of Ambon's urban gallery with the minister's home prayer room because it offers the most condensed and, in some respects therefore, clearest expression of the larger Christian landscape that spread more diffusely in the city, carried by the pictures that arose in Ambon's streets. It is one in which Ambonese aimed to gather an affectively charged visual Christian world around themselves, hence the comments I often heard that singled out the pictures' "comforting" or "soothing" nature as well as the need for their multiple large-scale presence and ongoing reiteration. Itself an image, this landscape is mediated by a Christian canon that, while formerly identified with intimacy and interiority—indeed, the prayer room enhances, even exaggerates these effects—and, as such, a long-standing conventional feature of the city's more domesticated Christian spaces, was stood on its head when Protestants began to picture Christ in Ambon's streets. It is worth considering how the pictures' prior association with the more intimate spaces of the Christian everyday may have contributed to their appeal. As the images moved out of houses and stores and grew in size, they did not displace the earlier calendars, posters,

or embroidered Last Supper scenes but merely supplemented them. Given this trajectory, the pictures in the streets and in the prayer room may still somewhat retain the promise and buttress the performance of a Christian Ambonese subject as visually construed in familiar, comfortable, and essentially interiorized surroundings—even as these surroundings were stretched in entirely new directions. At issue, then, in some basic sense, would be a new acute awareness of the subject's emplacement within a field of vision.[33] It is even possible to sense this awareness in the paintings of Christ hovering over the embattled city, since there, too, the desire is that his partisan gaze will recognize and protect the Protestants. In this example, as in the defensive stance evidenced by the prayer room, this awareness is also one that acknowledges, explicitly or implicitly, the precarity of this emplacement. At the same time, the prayer room offers a specific sense of refuge from the war-torn environment and even communion with the Christian God.

Landscape II: Pancasila Jesus

If the previous landscape was faithful to globalized Christian print culture, the following on this truncated tour of the painted postwar city departs explicitly from the canon that, by and large, figured as the reference for Ambon's new pictures. This landscape is deceiving in its simplicity—"just a sketch on an A4 sheet of paper" made at the height of the war by the GPM minister Chris Tamaela. "It was 2002, Ma'am, Good Friday," Chris began. "The war was going on and I made this. I drew this at the time."[34] Rendered in charcoal, the drawing shows a cluster of six figures at its center, boldly outlined against the white page—a swarthy Christ bends over protectively, enclosing five children in his arms, clothed in traditional Malukan dress. One or two are possible to identify with specific regions; others evoke a more generic sense of custom (Figure 24).

The drawing is captioned in Ambonese Malay: "Our Sweet Father lovingly embraces the children of Maluku." Echoing the conversation we had in Seram when the drawing first came up, Chris highlighted the Malukan appearance of Christ:

> Why did I depict Jesus as a Malukan? Because I thought this Jesus would be closer, we would feel his presence more in our lives, more in us. . . . There is no problem even if Jesus has a European face. I can see this is my God, my Jesus. But I thought, well, maybe, maybe ALSO . . . I can feel the presence of Jesus with the face of an Ambonese. I feel that Jesus is really concerned with the lives of us Malukans. Jesus knows exactly what Malukans are like—their attitude, their lives, the way they live. So I believe that Jesus can know our Malukan language;

he can speak Ambonese Malay. If we say "to embrace" in Ambonese Malay he understands [that we mean] "to embrace" in Indonesian. I know that Jesus can know all of our languages. Jesus also knows how to eat cassava. Jesus knows how to eat sago; we eat sago porridge together. Jesus knows how to eat the pickled vegetables like the ones Ma'am eats. So Jesus can feel the hunger of Malukan children. When we cry, we call out to Jesus in our own language. We suffered from the

Chr. I. Tamaela M.Th.CM *Jumat Agung. 31-03-2002*

Tete Manis polo sayang anak-anak di tana Maluku

Figure 24. Pancasila Christ. Drawing by Christian Izaac Tamaela, dated "Good Friday. 31-03-2002." The caption in Ambonese Malay reads: "Our dear God embraces the children of Maluku." Photo by the author, Ambon, 2005.

violence. Jesus embraces us, he cares for us. So this is what I think. . . .
I already did this with music.[35]

And he broke into a song about the Holy Ghost, with refrains in Ambonese
Malay. As Chris spoke, visibly moved, he wove song, drumming, myriad voices
and local expressions, costume pieces, and other custom-marked paraphernalia
through his multiply mediated performance, creating, in so doing, a deeply
embodied, sensually vivid, vernacular Malukan world. Set off and reiterated
by the drawing, this world unfolded and expanded narratively as Jesus's name
became sutured to predicates that in quick succession mapped this world by
drawing the Christian God near and folding him into "the lives of us Malu-
kans." With extreme tenderness, the performance developed a far-reaching
physiognomic and physical identification with a Malukan Christ, the image
of which looked up at us from the floor. In Chris's rendition, this Christ is one
who not only resembles you physically but, with a breathtaking intimacy, knows
and tastes the food in your mouth, has your language on his lips, feels the
weight and texture of your clothing on his skin; he is someone who moves,
breathes, and lives alongside and within you.

Different from though echoing the physical tête-à-tête of the prayer room,
this poetic world-making issues not in any enclave but in a densely knit land-
scape conjoining God and humans, accomplished by riveting Christ as an
"inner presence, present during the violence, quite internal to me" at its core.
It is exemplary of the intimate, affective, libidinal dimension that makes the
divine accessible to devotees "as an empathetic presence," something that other
painters evoked in their pictures, if not always as explicitly or in such localized
terms.[36] Yet Chris's ambition, articulated the same evening, to disseminate his
drawing widely, to blow it up to a grand size and display it in Indonesia's Na-
tional Library in Jakarta, belies or at least complicates this inward-looking,
small-scale vision, as does his understanding of the children caught in Christ's
embrace. While Malukan in appearance, this drawing also folds the state ide-
ology of the Five Points (Pancasila) within this image of local tradition and
paternal shepherding. Pointing to the drawing, Chris indicated how the chil-
dren number five and thereby invoke not only Pancasila but especially its first
point, the belief in one Supreme Being, and, through it, the obligatory alle-
giance for Indonesian citizens to one of the five allegedly monotheistic reli-
gions recognized by the state: Islam, Protestantism, Catholicism, Hinduism,
and Buddhism.[37] Not coincidentally, the New Order state threw up large bill-
boards around the archipelago, showcasing religious harmony as the benign
cohabitation of the five religions. From this perspective, the picture with the
emblematic little group boldly outlined in charcoal as a unitary form presents
an unambiguous image of a state-endorsed Pancasila Christ.

Yet for Chris, not only the portrayal of state-endorsed religion or the richness of Malukan tradition had motivated him but especially the quality of the relationships between Christ and the children, as well as among the children themselves:

> Ma'am, see how they face each other, the one looks at the other, not all are looking ahead. They are asking each other, their faces—one smiles, another looks a bit wary. "Why? Why must I suffer? Why must I become a refugee? I have done nothing wrong." My father is wrong, the government is wrong, or the church is wrong. Or our congregation. Don't blame them [gestures to his sketch]. But then there is one who smiles. Another is like, "Well, we have to be patient." Yet another says, "Quiet!" To give hope, still another is like, "OK, then I will have to be patient." And another looks ahead, full of hope . . . And this is characteristic . . . I intended to blow this picture up to remind [people], I wanted to put this everywhere to show that this Jesus is a universal Jesus. How can we divide Jesus's good will—yes, his good intentions toward everyone?[38]

What I especially want to highlight is the multiplicity of perspectives—indeed, of opinion and experience—the diversity of temporalities and directions, and the movement among widely divergent scales envisioned in Chris's interpretation of his drawing. Besides Christ's enveloping embrace, the picture's Ambonese Malay caption would anchor, in Barthesian fashion, the circuit of visual exchange, mutual gazes, and dispersed looks and tie these to a tradition-bound local world.[39] Yet even at this tightly contextualized level, Christ contracts and expands simultaneously as he inhabits the Malukan subject's image and invokes the objects—language, food, clothing, and custom—that progressively materialize a Malukan lifeworld that, mediated by Christ, appears limitless, even universal. As for the children, their own diversity—underscored by Chris when he noted the divergence in their gaze, attention, attitudes, and aspirations— threatens to overrule or at least displace the unity that keeps them together. Admittedly, this is my interpretation and one that I doubt Chris would have shared. Still, his insistence on such divergence is striking.

If, in part, this Pancasila Christ stands in for the Indonesian state—visualizing the political theology of the paternalistic authority encompassing innocuous diversity on which this state, especially under the New Order, was based—the binaries of state and citizen, unity and diversity, Godhead and religious subject neither neatly subsume nor summarize the relationships or visual field at issue here. Christ's gaze may be steady and close, but those of his children are more dispersed—they look at each other but also away; one

appears wary, another hopeful, still another waits patiently, her eyes on the future. If recognition by authority—albeit as a loving, empathetic presence—is visualized here, there also appears room for imagining a less hierarchical exchange that not only acknowledges a diversity of experience and subject positions but is neither exclusively dependent on nor mediated by authority.

In this respect, Chris's drawing may be described as both foundational and discreetly revolutionary in its novel vision of a Pancasila-informed Indonesia. This is so because the visuality that figures centrally in this drawing is multidirectional and open-ended: folded into some elastic version of the Malukan local, it stretches the regional through the national and toward the universal, spilling over the mobile borders of this loosely centered visual field with an indeterminate excess. Nor is the excess that I identify in the drawing all that different from the future that the children, following Chris, embody or from the multiple scales and directions—and therefore, too, signifying capacities— that are mediated by the Pancasila Christ. Put otherwise, if Chris's Good Friday picture has anything to do with the Indonesian state ideology of Pancasila, then it is one that—unwittingly perhaps—is being submitted to a radical revision, one that intimates a shift from a vertical authoritarian model of connection to another that envisages a horizontality issuing in an expanding array of subject positions and more empathetic mutuality.[40]

Landscape III: Sidewalk Citizenship

In the third stop on our tour, I turn to the street where the large majority of Ambon's Christian pictures emerged. The painted landscapes that I have considered thus far—the prayer room and the Pancasila Jesus sketch, both the initiative of GPM ministers—are more inward-looking than those in the streets, although the latter share their interiorizing impulse. Not surprisingly, however, the hijacked billboards and public walls tagged along Ambon's highways and at Christian neighborhood gateways decidedly win in spectacularity. In Indonesia, this is also due to the startling publicity that the pictures accord to religion. In Ambon, specifically, what stands out as especially provocative within the volatile conditions of the postwar is the explicit promotion of Protestant Christianity, along with the pictures' immense scale and direct, in-your-face mode of address. Also remarkable, as discussed in the previous chapter, is the acute combination of territoriality and mobility condensed in the loci where the public pictures first arose, notably the motorbike stands and neighborhood gateways that mediate between what, for all practical purposes, are gated Christian enclaves and the larger city and island beyond. It is worth pointing out that neighborhoods in Muslim areas, even as they often had their own motorbike stands and gateways, did not brand themselves religiously in the same way.

This is hardly surprising, given that among Muslims there was neither an aim to recuperate a position of dominance nor the same urgency to be recognized and seen as among the Protestants.

Like the minister's prayer room, the street pictures conjure a series of else-wheres or "comforting," exclusively Christian scenes that efface the Muslim as they bring the Protestant Christian forcefully and unequivocally into view. Yet, unlike the minister's prayer room, these images are out in the street in full view of everyone who passes them by. And they are impossible not to see. This asser-tive public presence has several important implications. Representationally, the Christian scenes imaged on city walls articulate a desire on the part of their makers to fence themselves off from the surrounding world as they gesture to an elsewhere of Christian recognition and redemption entirely devoid of Mus-lims. At the same time, as material artifacts and potent ideological statements, the pictures open themselves up to the world around them and, by extension, to risk and contestation. What comes to mind here is less a Christian enclave sealed off from alien surroundings than something more akin to the decor of a bike stand envisioned by a motorbike-taxi driver for the upcoming Christmas celebration: not only were the mural and adjacent Christ billboard due for an annual "refreshening," but cords of lanterns would be strung along the road leading up into the hills "to the left and to the right like the lights on either side of an airport runway."[41] This exuberant vision of the bike stand as a point of departure for an expansive, spectacular mobility belies its more commonplace status, both prior to the war in Ambon and around the archipelago where, taken for granted, the descendants of the Javanese guardhouse tend to blend into their surroundings and remain, by and large, even for scholars, minute constructions at the margin of the architecturally monumental.[42] In Ambon, however, the Christian guardhouses-cum-motorbike-taxi stands—flanked by monumental pictures and, in the mid-2000s, still reminiscent of the interreligious war—ran little risk of being overlooked. Most importantly, once they were out in public demanding attention, the pictures opened themselves not only to all kinds of risks but also to refiguration. In the imagination of at least one biker, the air-port runway he envisioned held the possibility of a dramatic takeoff and tan-talizing journey beyond the everyday troubles and pain of the postwar.

Such striking openness also marks the other street pictures. I consider first one example that, owing to its complexity, helps to highlight the tendencies of others in the street. The cluster that I call a triptych—three adjacent paintings comprising a mural with a series of canonical scenes summarizing Christ's life, a huge cameo portrait of Jesus as a young man, and a billboard showing him looking down on a globe turned to Maluku—faces the motorbike-taxi stand opposite at the crossroads of a road leading into a Christian neighborhood and a busy highway that skirts the city's coast (Figures 25 and 26). Reflective, in this

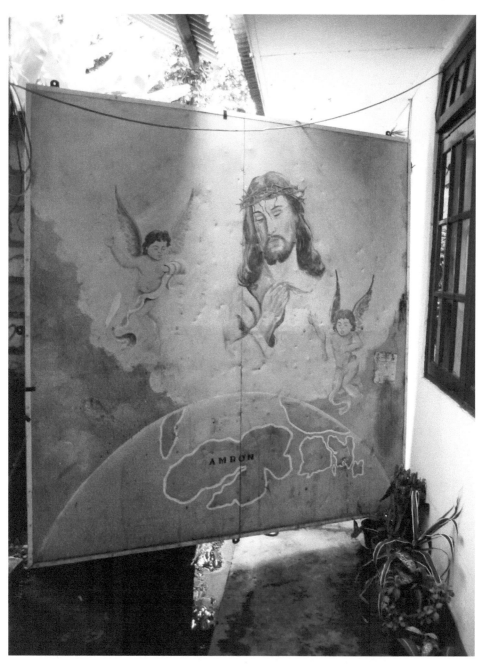

Figure 25. Painted billboard of Christ overlooking a globe turned to Ambon and the neighboring islands, which previously faced a motorbike-taxi stand, Ambon, 2005. Photo by the author.

Figure 26. Crossroads with the motorbike-taxi stand where the billboard once stood next to a painted mural of scenes from Christ's life and a portrait of Jesus, Ambon, 2006. Photos by the author.

respect, of the motorbike stand's general environment and the urban crossroads at which they stand is the strong sense of movement that animates these images. The hijacked billboard conjoins the movement of the rotating globe with that of God's eye homing in on an acute situation. It recalls the establishing shot of many a news feature—including the Indonesian national television station's primetime news program under Suharto—in which the image of a globe turns to zoom in on a particular location or hot spot where something newsworthy is taking place. The wider sense across the nation that, following Suharto's resignation, the eye of the international community was upon them also appears to inform this image,[43] as does Ambon's intense wartime mediation by national and international media representatives, humanitarian aid workers, NGOs, and other visitors to the city. Seen in this light, it is perhaps telling that the picture that captures the precise moment in which Maluku visually enters the Christian world stage, showing Christ looking down on the globe as Ambon Island has seemingly just rotated into view, was cast by the stand's motorbikers as the city's first one.

By the time I arrived in Ambon in 2005, this billboard had been removed from its scaffolding and propped up at the end of a private driveway. Two reasons were given for its removal: the scaffolding had rusted but the time had also come for more "soothing" public scenes, ones that did not, in other words, directly reference the war. The narrative of Jesus's life counts as such a soothing scene due to its contrast with the pictures preceding it, whether those showing Christian Ambonese under siege or incendiary wartime graffiti sprayed on city walls. But this narrative is also soothing because, as I suggested before, its canonical images inflect the Christian interiors that they relinquished for the street. Equally importantly, the visual unfolding of Christ's life along familiar lines is similarly soothing in its normative predictability. It is for this reason, I suspect, that the scenes out of which the mural is composed did not change their general outlines but were commonly retouched or underwent a change of color in anticipation of the Christian holidays.

What did change, and was a privileged object of attention, is the Jesus portrait that is either inserted into or superimposed onto the visual narrative of his life. Thus, I have photographs of different portraits dating from 2003 and 2006, respectively. While both visually mark their difference in relation to the canonical backdrop, the first, from 2003, achieves this effect through the portrait's carefully painted serrated frame, while its successor appears frayed at the edges (Figure 27). The painter Jhon invoked the worn edges of old parchment to explain this distinctive feature. Specifically, he recalled how Romans in films present their official proclamations on unfurled pieces of parchment that are read out in public. Indeed, Jhon took me to see faded walls around the city

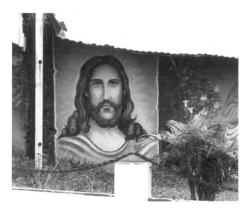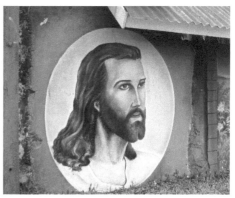

Figure 27. Painted mural with portraits of Jesus Christ, Ambon 2003 (*left*) and 2005 (*right*). Photos by the author.

where, early in the conflict, he had painted Christ surrounded by Roman soldiers. But whether visually explicit or implicit, the Romans—or state power and authority—remain part of the picture. Equally importantly, the parchment model is a fitting one for Ambon's monumental Jesus pictures. What this comparison makes clear is how the enormous Jesus faces in Ambon's streets authoritatively proclaim to all passersby, "This is HE—and, by the same token, this is [the Ambonese Christian] ME." What these cameos codify, in other words, is the precise moment of recognition, the dramatic "That's him!" of identification.[44]

This interpretation is supported by the painter Jhon's spontaneous exegesis of the cameo Jesus face—revealing specifically how this face, while inevitably European, is nonetheless caught within a crucial relay based on its likeness with that of Protestant Ambonese.

> There are many different versions, no? In Europe they say his face looks like this, in America they say it looks like that—maybe different. There are many, many appearances, right? . . . Earlier I said that we humans are created alike and in the image of God. This means that his nose, his mouth, his eyes are like ours. It doesn't matter then what kind of appearance [it is]; maybe it's not like mine, but the important thing is that it is alike and in our image. This is the essence for me, this in itself is what makes me paint. So sometimes people say, "Hey, here Jesus has a different face, this Jesus face is different," [but I answer] "No, that's not true, that face is also like your face, right? It also has a nose, it also has a mouth, it also has eyes, the point being: the face of Jesus is like your face."[45]

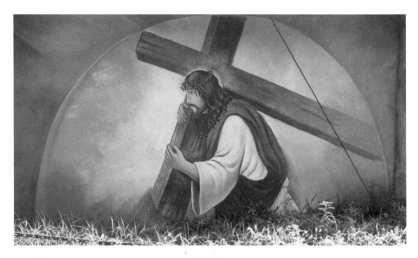

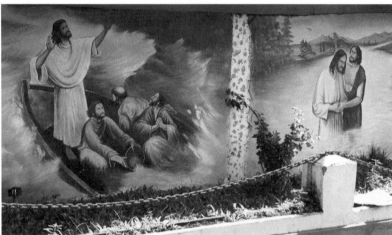

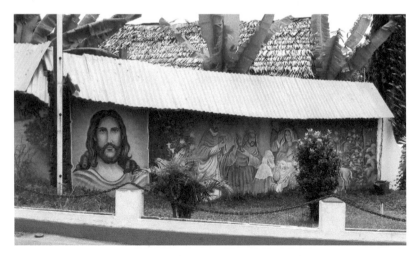

Figure 28. Painted mural with scenes from Jesus Christ's life, Ambon, 2003. Photos by the author.

Invoking the Biblical dictate that God created man in his own image, Jhon inverts its directionality—the Christ face, he insists, "is alike and in *our* image." This is a departure from the biblical formulation in Genesis that he invoked in the same conversation: "Then God said, Let us make man in our image, after our likeness" (Genesis 1:26). Yet, in his rendition of this formulation, Ambonese do not appear in the image of God. Tellingly, the image of God is "alike" and in the image of Ambonese. This identification of God with Ambonese is so important to Jhon that he claims that this is what makes him paint. At the very least, his insistence reveals the desire to establish a tight relay between God and Ambonese that Jhon claims performatively against a host of imagined objections—from persons who claim Christ's European face is unlike "our" Malukan face, to others who marshal the sheer diversity of available Christ images from around the world, to the existence of European versus American representations of Christ's appearance. All such potential objections destabilize Jhon's effort to posit an unequivocal identification based on the recognition of similitude connecting the Christian God to the city's Protestants. If the basic purpose of realistic portraits of persons and landscapes is that of establishing likeness—specifically here, a true likeness connecting Ambonese and the Christ portraits in the street, which were held, as far as I could tell, to be realistic portrayals by ordinary Protestants—then Jhon's imaginary exchange served to buttress the closure that would prevent any skepticism from intruding between Protestants and the God in whose image they alleged themselves to be made.[46]

Yet, what Jhon's unwitting reversal of the biblical formulation intimates is an equivocation in the place of authority. Rather than authority being there to acknowledge Ambon's Protestants as "in our image, after our likeness," Jhon can only insist that "the face of Jesus is like your face." But his assertion involves hedging a slew of doubts that might be raised vis-à-vis this claim. What the reversal between God and Christians, original and copy, hints at is the mounting uncertainty regarding the place and futurity of Protestants in Indonesia, one that ensues from a troubling equivocation or looseness in their long taken-for-granted source of identity and recognition.

This is probably why the identificatory circuit that Jhon aimed to establish between the Ambonese Christian man-in-the-street—not the least the motor-bikers themselves—and a transcendent authority via his Christ portrait appears to be modeled on the Indonesian citizen's identity card (Kartu Tanda Penduduk, or KTP). A critical material token of proper belonging, the KTP lists not only the requisite religious affiliation but also, under Suharto, things like the officially designated "former political prisoner" that marked people for life as politically suspect. The KTP identity photograph, until not too long ago the

only one that people might have of themselves or a loved one, served as a key authenticating token of state power, one that determined who was a citizen and who, in various problematic ways, was not.[47] Among numerous possible examples, the violence of this equation was evident in the Aru Islands in the mid-1970s, when forced conversions to one of the five religions recognized by the Suharto state were common. In anticipation of the 1977 national elections, zealous members of the Central Malukan civil bureaucracy visited the pearl-diving communities scattered off the east coast of Aru's main islands to bribe and coerce the animist population to convert to one of the New Order's authorized religions. Doing so would entitle them to a KTP that, in turn, would enable their participation in the upcoming elections.[48] This close, continually reiterated connection between religion and the Indonesian nation-state was also explicit in Pak Nus's painting of a red and white Christ and in the Pancasila Christ charcoal drawing of his son, the GPM minister Chris.

Given the brutality with which the Suharto state imposed itself on Indonesians, it is not surprising that state authority and forms of governmentality haunt these pictures and become enfolded within religious representations or that the depiction of identity mimics the shape and logic of the national citizen's ID card. Given, too, the prevailing sense of abandonment by the state among Ambon's Protestants, many of whom were civil servants, it makes sense that they would look elsewhere for recognition. Religion in Ambon, perhaps especially among GPM Protestants, was the obvious candidate. It signaled an alternative to the state, while remaining authorized by it, and to the nation within Muslim-dominated Indonesia. But, in many respects, the GPM also resembles the state, being by far the largest nongovernment organization in the province with "a structure that exactly parallels that of the local government."[49] From this perspective, it is possible to see the Romans as stand-ins for a state authority that gestures beyond globalized Christian print capitalism and sacred geography to Suharto's authoritarian governmentality, with the painted Christ identity photograph doubling as the crucial token of visible legitimacy, recognition, and authorized belonging (Figure 29). But it is also possible to see these images in motion by noticing how, over time, between the early and mid-2000s, the Romans recede into the background, disappearing altogether from view as Christ's monumental face comes to the fore. "Closer is better," Jhon explained, "because it is clear from his face that he is suffering, the face is clearer, there are more details so that it will be clearer, more clear," a phrase he kept repeating. He gestured to a section of the mural across from the bike stand where we sat. This image—a close-up of Christ in profile wearing a crown of thorns and shouldering a cross—replaced an earlier one, he explained, of a full-length Christ "with his feet showing" hemmed in by Roman soldiers.[50]

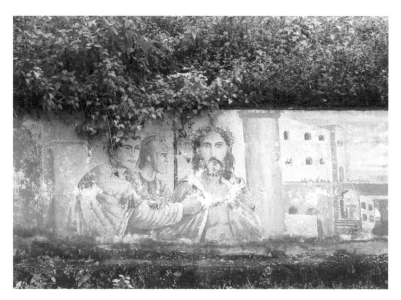

Figure 29. Faded mural painting of Christ and Roman soldiers, Ambon, 2003. Photo by the author.

Seeing these pictures in motion means entertaining the possibility of a shift in which the emphasis changes from a focus on authority and modes of state governmentality to the possibilities conjured by the citizen's identity card in postauthoritarian times. It intimates a move through which the visible token of the exchange between state and citizen, the identity photograph, is pried loose from the state forms in which it was previously moored and opened up to circulation.[51] While this may not seem a momentous change, it offers a way of seeing the Christ face as a landscape in its own right, a heterotopia or Deleuzian deterritorialized world that potentially makes all the difference.[52] Although huge, painted faces rather than cinematic close-ups are at issue here, it is possible that the sheer size of the Christ faces standing like sentinels along Ambon's streets facilitates the kind of projection and identification that has been argued for film. Whatever the case, this Christ face/landscape is mobile and relatively open-ended, pushing beyond the familiar terrain of the nation-state to venture into new territory that may not be either straightforwardly Indonesian or perhaps even Protestant Christian. What this huge face seems to put in place is a call for recognition, in which those voicing the call await, as it were, the arrival of some authority here who would acknowledge the Christian Ambonese as alike and in his image. Caught in this suspended state of desire and uncertainty, the Protestants can do nothing other than insist that the face of Jesus is like

their own. At the same time, the emergent gap between identity and recognition potentially opens a space for a (male) horizontality that moves away from hierarchical authority into the kind of loose fellowship characteristic of the motorbike-taxi groups that set up the street pictures in the first place. Besides the gendered male camaraderie of the streets, female networks based on mutual hospitality and calibrated to church activities and weekly prayer meetings closely knit and ordered GPM neighborhoods, providing an institutionalized counter to the action of the street (see Chapter 4).

Apart from the open-endedness of the Christ face/landscape and the equivocation in Jhon's description of the similitude between Christ's face and that of Protestant Ambonese, the triptych combines different directionalities and subject positions, while also remaining indebted to diverse media forms. As a trio, the mural, portrait, and billboard visualize and reimagine the ties that bind Ambonese Protestants to both religion and the nation-state, two powerful sociopolitical entities that in Indonesia, especially under Suharto, were nearly impossible to prize apart. Besides being creative forms of self-publicizing on the part of the motorbikers, Ambon's street gallery showcased the influence of diverse media—from Christian print capitalism to state forms of governmentality and national television.

Landscape IV: Witnessing the End-Time

To conclude this truncated tour of the painted Christian city, I turn to the academy-trained Pak Joseph and to two examples of the "surrealistic" style he adopted following his conversion from GPM to Pentecostal Protestantism. The first example is one Pak Joseph singled out for commentary during one of my visits. The second, an enormous triptych of the apocalypse, was commissioned by a Chinese Indonesian who some people referred to as a minister but who for me most recalled a prophet in the wilderness, for reasons I explain below. In contrast to the enclaved prayer room, the Pancasila Christ, or his cameo portraits, these paintings visualize the violence, devastation, and divided realities that I foregrounded at the beginning of this chapter.

At its most straightforward, the painting Pak Joseph spoke about is a record of Christ's service. It is challenging to take this picture in all at once since its many scenes pull the viewer in different directions, shattering the sense of a readily accessible whole. Composed of fragments of image and text, the painting resembles a dream in the way it juxtaposes contrasting scenes of ruin and salvation with citations from scripture dispersed among painted vignettes (Figure 30). In the canvas's upper right-hand corner, Christ's hands bathe a disciple's feet in a display of the Lord "humbling himself," the painter explained.

Below, miniature scenes show a nurse bent over a hospital bed, a prison's barred cell, and a ship at sea. To contemplate these vignettes, the viewer must draw close to the canvas, inviting a physical intimacy that absorbs what Pak Joseph called the painting's "witness" into the interiority of the tiny scenes as if she alone were privy to what they portray.[53] Several large footprints stride boldly across the vignettes of dedicated service to humankind, signaling another way of entering the world of this "surrealistic" vision—namely, through mimicry of the Christian God. This became clear to me when, invoking Matthew 12:19–20 ("Thou shalt follow in my footsteps"), Pak Joseph elucidated what he described as the picture's "symbol": "If you want to be an important person, you have to humble yourself."[54]

Pak Joseph's witnessing encloses the viewer in the world of his picture, disavowing any possibility of remaining at a distance or outside it. Put otherwise, with respect to the painted scene of evangelical witnessing and "surrealism's influence," the viewer is either saved or located somewhere on the road to

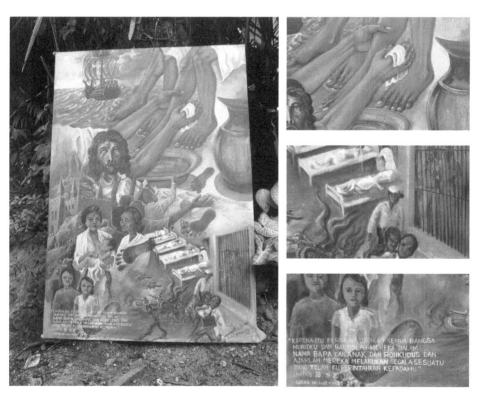

Figure 30. Painting of Christ's service to mankind, with close-ups. Painting by Lamberth Joseph, Ambon, 2005. Photos by the author.

salvation.[55] For Pak Joseph, witnessing this particular painting, as well as being witnessed by it, means actively entering Christian service and, with it, having the path to salvation visibly laid out in advance—all the witness needs to do is follow humbly in Jesus Christ's footsteps. Prophetic and perspectival at one and the same time, the picture not only installs the viewer as a subject of witnessing but also performs the act of witnessing via the painting, demonstrating, in so doing, what Pak Joseph called the exceptional power of pictures.

This particular power was unequivocally brought home to me when I was taken to see Pak Joseph's painting of the apocalypse (Figure 31). Apart from what the painting actually showed, this power had everything to do with how the gigantic triptych leaped into view—startling and taking me aback, exhibiting a force of which the makers of Ambon's street pictures are all too aware. I had been taken to see the painting, stored in a warehouse on the outskirts of Ambon, by a person I will call Minister Ho, a wandering prophet who I met with regularly when he was not evangelizing around Ambon or on neighboring islands. Jhon, who introduced us, always referred to Ho as a minister, spoke about him with some reverence, and, whenever possible, joined him on his excursions. Others, including a GPM minister, spoke with admiration of Ho's devout religiosity and dedication to the promotion of the faith, pronouncing him an "ecumenical man." Upon meeting Minister Ho, this self-described "militant Christian" and former Buddhist "worshipper of statues" related how, following a personal crisis that occurred before the war, he converted to Christianity. He told me that he was baptized in Makassar by a fellow Christian convert, a man he called Minister Muhammed, an ordained minister and former Muslim. Since then, having turned over his business to relatives, Minister Ho dedicated much of his time to spreading the word—preaching, handing out bibles, and running religious revival sessions, often in collaboration with local churches. As a Chinese Indonesian, but also because his wife was a Christian before him, the possibility of conversion had been there all along. Before he converted to Christianity, his home had harbored two altars—one Buddhist with statues and another, presumably sparser, Protestant one. Now fully Christian, their house had a painted Christian prayer corner and, next to the front door, a larger-than-life painted Jesus depicted knocking on a door, both the work of Jhon.

Prone to prophetic visions, Minister Ho had a dream that he claimed predicted Ambon's religious violence, which he had committed to canvas. One Saturday, accompanied by Jhon and Ho's son-in-law, we drove to the warehouse where Pak Joseph's painting was stored, which Minister Ho had already described to me. Still, I was by no means prepared for the apocalyptic scene that jumped out of the dark when Ho and his son-in-law slid back the warehouse's

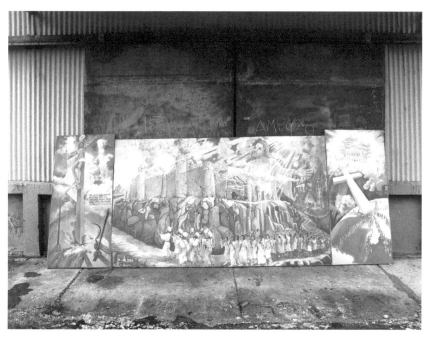

Figure 31. Painting of the apocalypse, with close-ups. Based on a prophetic dream, the painting is dated January 10, 1999, or nine days before Ambon's conflict began. The text on the left panel reads: "Father, forgive them for they know not what they do (Luke 23:34)." Painting by Lamberth Joseph, Ambon, 2005. Photos by the author.

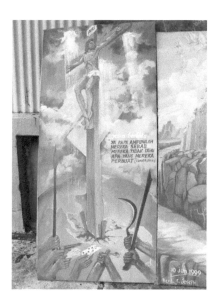

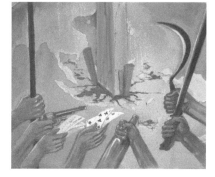

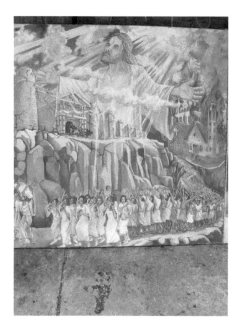

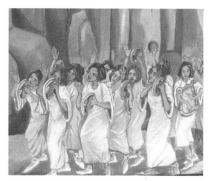

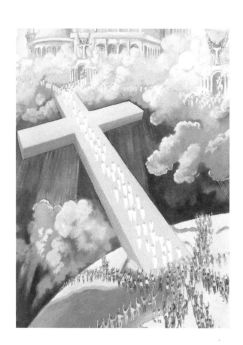

heavy metal doors to reveal the triptych propped up against some furniture. Or, for that matter, for the date "10 Jan 1999," inscribed in luminous white brushstrokes above the artist's signature, documenting the work's completion only nine days before Ambon's conflict broke and authenticating the painting's visualization of Ho's prophetic dream.[56] Unfolding across causally integrated scenes, Minister Ho led me past the three panels that materialized his vision as he tacked back and forth between the biblical story of Jericho's destruction and Ambon's own devastating violence. On the left side a panoply of sins—a hand gripping a bottle, another brandishing a deck of cards, others holding machetes, knives, a pistol, and a spear—fanned out from under Christ's bloodied feet on the cross. To the immediate right of this scene, the triptych's wide, central panel showed Jericho's fortifications collapsing under siege while its inhabitants circumambulated the town below with raised trumpets and tambourines. Against an ominous sky, the adjacent symbols of the Christian cross and the Muslim crescent moon and a star, flanked by a church and mosque pair in flames, float above the city. Presiding over all of this, the face of a fierce Christian God rides the storm. The triptych culminates in a third panel on the right depicting salvation: a multitude of minute, white figures streaming from all corners of the globe converge upon a cross that juts out from the earth to form a bridge over an abyss leading to heaven's wide-open palatial gates.

Painted by Pak Joseph, the distinctly Pentecostal cast of the painting thematizing sin, apocalyptic punishment, and salvation for the elect was hardly surprising. Ho insisted that the painting rendered his prophetic vision faithfully, while his Christian militancy positioned him closest in doctrinal terms to the Pentecostals. Presumably, the painting had been stored in his family's warehouse since it would have caused offense after the war, both through its reminder of the violence and its partisan Pentecostal Christian perspective. Yet, unlike Pak Joseph, who belonged to one of Ambon's charismatic churches, the self-proclaimed minister Ho remained unaffiliated with any church. A bona fide prophet in the wilderness, Ho modeled his evangelizing after that of Jesus Christ, who, much like himself, he claimed, did not found any church but, in helping people, "worked with different churches."

I began this truncated tour of the painted Christian city with the enclaved prayer room as the clearest attempt to consolidate a fully Christian view and ended with an apocalyptic vision of exploding violence, fragmentation, and a world in the grips of its radical unmaking. Chronologically, the home prayer room and the regal Christ behind church altars follow those in the streets. In some respects, it would have made sense to reproduce this trajectory—beginning with the premonition of apocalyptic violence and fragmentation that I evoked at the outset of this chapter, tracking the search for visibility and recognition

in Ambon's streets, and ending with the defensive turning inward exemplified by the prayer room. In choosing not to develop my narrative in this way, I aimed to expose a logic that holds just as much for the street as the home prayer room, even if in the former is it only diffusely present. As the most extreme expression of the Protestant search for solace and refuge, the tiny prayer room exhibits with utmost clarity the defensive stance that, to a greater or lesser extent, is the point of departure for all the Christian pictures that emerged during the war. But it is also the purest expression of the envisioned desire for an affectively charged, new proximity to God, one that departs from the flat surfaces of mere pictures to install something more like a potently atmospheric sacred landscape marked off from overwhelmingly brutal surrounds. In this respect, if the paintings are any witness to the affective stance of the city's Protestants, then it is one that remained in place for at least a decade after the war.

Frames at War

"Imagine the damage caused by a theft which robbed you only of your frames, or rather of their joints, and of any possibility of reframing your valuables or your art-objects," writes Jacques Derrida, inviting us to consider an enormous calamity.[57] His provocation draws attention to the significance of frames, or of processes of enframement, in the generation and circulation of images.[58] Even more, he asks us to consider the immense damage incurred when the frames that sustain a particular understanding of the self or those that uphold the parameters of one's existence and safeguard what one holds dear—a host of certainties regarding personhood, fellowship and belonging, expectations of kindred and adversarial others, and the aspirations one has with respect to life and the future—no longer apply. To make matters worse, Derrida does not simply evoke a situation of framelessness or, more provocatively, out-of-jointness but identifies this with a thorough, irreparable dispossession, the result of a bizarre theft that wreaks havoc at the very core of one's being. I propose that this imaginary situation is not that different from the profound sense of dispossession and disorientation that suffuses Ambon's Protestant pictures. At the same time, the pictures are a response and attempt to repair this situation. Perhaps more than any other factor, the urgency of this response infused the energetic presence of the painted Christian landscapes populating the beleaguered city. As performative stakes in a changing world, the pictures struggled to bolster a Christian perspective on things. And they did so by putting in place the out-of-joint frames of Ambon's shattered Protestant lifeworld, delineating and making visible the borders of the images without borders that give this chapter its name. This accounts for the hypervisibility of the Protestants' acts

of repair that assumed the form of huge public Christian scenes. Representational redress meant coming out demonstrably, making visible to all the process of enframement, hitherto out of view. This occurred at precisely that time when the structures that had kept these frames in place, allowing them to be taken for granted, relinquished their force.[59]

How might we assess the function of a frame in such circumstances? Or even more, that of its joints—those unseen connections that brace and stabilize a frame? In *Frames of War*, Judith Butler explores how frames not only validate a view but also enfold within themselves an entire normative repertoire. Her concern is with photographs of torture—notably those from the Abu Ghraib prison—and how their frames adjudicate between what counts as the human and is deemed recognizable versus life that is not recognized and therefore not grievable.[60] Exemplary of what she calls "frames of war," these frames harbor "broader norms that determine what will and what will not be a grievable life."[61] While Butler's concern departs from my own here, as does her singular focus on photography, her general insights are relevant. What her perspective allows us to see is how not just the reproduction of the canon but also the individual pictures install a Christian point of view. In the latter, this view is conveyed by elements of composition, angle, and by the explicitly imaged, partisan God's-eye view, whether He is depicted floating above the city or authorizing canonical Christian scenes that stage an exclusively Christian world as if it was the only perceptible reality around.[62] Still, it is important to recall that the Christian work on appearances that took place via the Protestant pictures was never simply a matter of reproducing elite privilege. From the outset, these pictures operated within a force field where the reproduction of a Protestant privilege under siege evolved in interaction with other things—first and foremost, the uptake of state forms of governmentality, masculine youth culture, commercial advertising, the wider visual ecology of the city, and the devastation and changes wrought by the war.

Previously, the Dutch colonizers provided the frame that authorized and secured Ambon's Protestants' view of themselves: their sense of entitlement and assumed dominance of the municipal and provincial state bureaucracies and the special treatment they enjoyed compared to the other colonized peoples of the Netherlands East Indies. One way of understanding the Protestants' frequent identification with Israelis during the war is that this claim confirmed the view of themselves as a chosen people, an echo of their status as Black Dutchmen under colonial rule (see Introduction). Following Indonesia's independence and the suppression of the RMS separatist movement, this close identification with the Dutch needed to be revised. Still, if the historically accumulated privileges of the Protestants in Ambon suffered somewhat, especially during

the Japanese occupation of 1942–1945, they still remained largely in place until the 1990s.

If the power to impose a shape on oneself is intrinsic to that of controlling and maintaining identity—of oneself but also others—then the loss or diminishment of this power causes intense disorientation and distress.[63] It can also mean, as in Ambon, seizing upon potent forms like that of the Indonesian citizen's ID and bending it away from the state and toward the Christian self or piggybacking on commercial billboards to brand and consolidate community. This suggests that the proliferation of the Christian pictures and reiteration of Christ's stereotypical face was all about reinstating a visual economy or an effort to secure the frame that was authorized under the Dutch colonizers. Pursuing this metaphor, it is as if during the violence, the frame that for long had sustained Ambon's Christians' view of themselves shattered into a collage or the scenes of wreckage and fragmented realities with which I began this chapter.[64] This may also be why, with few exceptions, Protestant Ambonese have clung with such fervor to the colonial-derived image of a white, European Christ, resurrecting and monumentalizing him in times of rampant uncertainty in their neighborhoods and along city streets. Yet, even as they held onto a disappearing world, they created a new one populated by alternative visions, imaginary landscapes, and heterotopias markedly different from what had been seen before.

A Frenzy of the Visible

There are times, Tom Gunning writes, marked by "a frenzy of the visible," a formulation he borrows from the film historian Jean-Louis Comolli.[65] The latter's interest lies in the "machines of the visible" that helped spur such frenzy, although he situates their emergence within the momentous historical and sociopolitical transformations associated with capitalist modernity. Here is Comolli's characterization of what is probably the most celebrated moment identified with "a frenzy of the visible":

> The second half of the nineteenth century lives in a sort of frenzy of the visible. It is, of course, the effect of the social multiplication of images: ever-wider distribution of illustrated papers, waves of print, caricatures, etc. The effect, also, however, of something of a geographical extension of the field of the visible and the representable: by journies, explorations and colonizations, the whole world becomes visible at the same time that it becomes appropriable.[66]

Frenzy, in this example, involved an intensification in the mechanical re-production of images and the media and modes of their distribution. It resulted in an enhancement of visibility as a means of encountering and knowing the world and the extension of the terrain of the visual in myriad ways. Notable were major shifts and interventions in the visual environment—from the alter-ation of landscapes and the emergence of towns and metropolises to the way the development of public transportation increased opportunities for people to see others for extended periods of time.[67] Structures of feeling accompanied and sustained this process from the fervent desire foreshadowing photography's invention to the investment—emotional and financial—in the question as to whether a galloping horse ever has all four hooves off the ground simultane-ously.[68] In the midst of such frenzy, people become confronted with and ex-perientially immersed in a perceptibly different environment that opened new possibilities for the imagination. As posters proliferated, for instance, during a craze that took hold of Europe and the United States in the 1890s, many of these depicted the *nouvelle femme* of nineteenth-century Paris, offering new images of women and an expanding sense of what they might be.[69] Resistant to conventional ways of seeing, such images may, in other words, also help to change them.

Another moment, more relevant to Maluku, swept up in a frenzy of the visible is that of the seventeenth-century Netherlands, what the Dutch call their Golden Age. This was a time of wonder and violent encounter with new worlds—most notably the famed Spice Islands or what is today Maluku—of scientific and artistic experimentation, including the crafting of optical devices and the depiction of Dutch light—pale daylight spilling from a window onto a milkmaid's hands, the illuminated whitewashed interiors of Calvinist churches, the variegated gray composing a Dutch sky.[70] Like any other such moment, the Dutch frenzy of the visible was unique, inflected by its particular place, time, and culture.[71]

Ambon, around the turn of the millennium, was not in any straightforward sense part of today's frenzy of the visible while access to digital technologies, to which much of the current frenzy is attributed, was limited in the early 2000s. But when war arrived to the city, it introduced new machines of the visible that gave value to visibility, a value enhanced by the reverberations of the Reformasi discourse on transparency and its demand to bring things hidden into view at this eastern end of the archipelago. Considered up close in this chapter, I have given a sense of the interaction between the urgent experimen-tation and hubris in the city's postwar streets and the structure of sentiments that coalesced around the new Christian images as they did, if differently,

around other ephemeral mediations of Ambon's war like rumors, graffiti, and VCDS, discussed in Chapter 1. At the same time, I have aimed to keep in view how the street painters' professed loyalty to the Christian canon depended on a particular economy that became challenged—if only in part—by the Protestants' unprecedented embrace of picturing. It is within this larger force field where a frenzy of the visible converged with the more long-standing visual economy of globalized Christian print capitalism that Ambon's oversized images sprung up in response to violence and loss rather than capitalist modernity's dislocations and colonial expansion. They did so, among other things, as witnesses to far-reaching transformations in the city, including that of urban religion.

4

Religion under the Sign of Crisis

At the height of Ambon's war, a small stone surrendered by a Muslim to a Christian on an urban battlefield circulated with stunning effect in a Christian prayer group. Within no time, it infected this core scene of Christian worship and community, triggering illness and possession, turning the group's prayers into a Qur'anic reading session, and inserting the spectral presence of a North Malukan sultan's daughter into its midst. This scene of haunting and radical displacement sums up so much of Ambon's traditional Protestant community's dilemma. At the same time, it gestures, if obliquely, toward the possibility of generosity as opposed to hatred toward one's others, of moving beyond the friend-enemy dyad to include a third term, that of the neighbor. Apart from what Ambon's possession reveals about religiously defined subjects during the conflict, it also attests to the erosion of the carefully policed difference between magic and religion by church and state. In this chapter, I pay special attention to the sites where the defensively upheld distinction between Muslim and Christian broke down and to the capacious waywardness of things as symptoms of a world in the grips of dramatic change. In doing so, I rely on a symptom-atology of crisis to track the shape-shifting movements of subjects and objects and the ways in which religion in the city became dramatically refigured.

Following the previous chapter, Ambon's scene of possession may come as a surprise. It may require a leap of imagination to recall that, besides Christians, and in particular Protestants, others also exist in the city. The painted land-scapes—the Christian enclave folded in upon itself, the Pancasila Jesus stretch-ing diversity under the sign of the Christian universal, or the masculine street culture congregated around its newfound Jesus icon—equally banish whole parts of urban sociality to the pictures' invisible, if energizing, backdrop. With

what can only be considerable effort, they elide any hint of a Muslim presence but also of any locations, settings, or situations where Muslim and Christian women, men, and children willingly or unavoidably commingle—whether in the transactions of everyday living, in banal or extreme violence, or in settings of mutual hospitality and joy. If not the paintings, then, the synopsis with which this chapter begins intimates other spaces where Muslims and Christians meet—however problematically—here, around a venomous object that indexes practices that may not be embraced by all but are undoubtedly understood.

Times Rich in Demons

This chapter is about the terrain that Muslims and Christians inhabit together; it assumes that, living in the same city, they are part of a common world, where they make up Ambon's urban crowds, walk and brush shoulders in its offices, schools, and streets, that they communicate in the same vernacular Ambonese Malay, share numerous habits and traditions and, by and large, even the same food. It is also about the terrain that these Ambonese share with the many migrants who also dwell in the city, the large majority of whom are economic migrants and Muslims from, predominantly, South Sulawesi. By extension, the chapter addresses the diversity among coreligionists themselves that, thus far, I have glossed, for the most part, simply as Muslim and Christian.

Yet, this chapter also explores how this terrain in common is not as straightforward as this brief description makes it seem and how, in this, as with much else in this book, we may take a cue from the city's street pictures. The argument of this chapter is that the project of cohabitation, while deeply fraught in the aftermath of war, is under any circumstance a project rather than a simple empirical given. Or, in other words, that beyond the powerful pragmatics of living together, cohabitation needs to be imagined in particular ways. The Christian pictures foreclose any such imagination. Rather, they reveal how complicated and contested the project of cohabitation can be, especially in the wake of war. Still, to go by their evidence alone would mean missing the myriad ways that cohabitation manifests itself in Ambon City, obscure as well as more obvious. I explore this proposition by homing in on a number of contact zones and conjunctures where Muslims and Christians, in communication and exchange, avoidance and aggression, have shaped their lives together, side by side and jointly, today and in the past, in Ambon City, on the larger island, and on neighboring ones. As an especially radical instance of Muslim and Christian cohabitation, the scene of possession with which this chapter began has the virtue of raising a number of the most salient issues I address here.

Sometime during the war, a spate of possessions afflicted some among the city's Christian population. A brief account of these happenings, told to me by the GPM minister whose home prayer room I discussed in the previous chapter and who acted as exorcist during the events, will suffice. The account forms part of a longer narrative in which the minister railed against the widespread recourse to magic by Christians and Muslims alike during the war. The possessions began in a Christian prayer group of five persons when the protagonist of the story—a migrant Muslim convert to Christianity and city resident—introduced to the members a small stone that had been given to her by a Muslim woman clad solely in black, a feature that marks this woman as foreign to Ambon. The Javanese Christian convert obtained the stone from the Muslim following a fight between the two within the context of a larger confrontation between Muslim and Christian forces in the city's Ahuru neighborhood. When the Javanese woman prevailed, the Muslim war leader surrendered the stone to her opponent. Once it began to circulate within the Christian prayer group, strange things began to happen. Whoever held the stone fell ill. More unsettling, though, was that whenever the group sat down to pray, they found that they could not, or felt themselves lifted out of place, or prayed as Muslims with their hands held out flat and open in front of them.

The first to be possessed was the Javanese convert at the refugee camp to which she had fled as the latest in a series of similar displacements; the other group members quickly followed suit. Exorcism conducted by two ministers at the GPM's head Maranatha church and backed by the congregation, alternating between prayer and song, disclosed the following: the spirit possessing the Christian convert identified herself as Yanti, the Muslim leader against whom the Javanese had previously stood in battle, but Yanti was merely her Ambonese name and personality. According to the spirit's own declaration, Yanti was none other than Salma, the Muslim daughter of the sultan of the North Malukan city of Ternate.

For many of those in Ambon with whom I spoke in the mid-2000s, these were "times rich in demons."[1] One way of understanding them, in Michel de Certeau's terms, is as a "diabolical crisis."[2] The import of such crisis, he offers, lies in its disclosure of the fault lines and imbalances permeating a culture, as well as in the way it hastens this same culture's transformation. In situations like that of Ambon during the war, where uncertainty reigned supreme, the taken-for-granted social arrangements and values of everyday existence were shot through with suspicion and hollowed out, and the world shifted intolerably under one's feet, deviltries abound as both symptoms and transitional solutions.[3] Ambon's possession appears to lay bare the fault lines of a highly fraught, religiously mixed urban society under radical revision. It came via a migrant Muslim

convert to Christianity, turned a Christian prayer group into a Qur'anic reading session, and introduced into the core of Christian worship the formerly powerful, ancient North Malukan sultanate of Ternate, which, significantly, had become the new capital of an almost wholly Muslim North Maluku province in October 1999. At the story's center is a confrontation and a treacherous object issuing in a poisonous transaction between its two women protagonists, a Muslim war leader, on the one hand, and a multiply displaced Javanese Christian convert, on the other.

One part of this story unfolds into a larger account of this societal revision, comprising, among other things, the changing status and location of religion today, not just in Ambon but more broadly in Indonesia and beyond.[4] Here, I consider the wide-ranging transformation of religion's terrain in the postwar city via the narrative of cross-religious spirit possession. In the most immediate sense, the public drama of Christian erasure and usurpation of place betrays the anxieties, shared by many of his fellow clergy, of the GPM minister who recounted it: anxieties regarding the waning of the power of Ambon's oldest church and, with it, that of the city's traditional Protestant Christian elite. Relatedly, the minister's account appears to register the fears and dismay of many Christians regarding the split, under Indonesia's new decentralization laws, of the former province of Central Maluku into a truncated, religiously mixed Central province and a new, predominantly Muslim North Maluku one. Intimated as well in the occurrence of possession among members of the minister's congregation, and even more in the exorcism held in Ambon's Calvinist Protestant church, is the insidious Pentecostalization overtaking the GPM from within.

Witness to an unhinged, tumultuous world, the minister's account identifies the threats to church and congregation from without but also, equally disconcertingly, those from within. The profound disturbance at its core, suggested by the cross-religious character of the possession, raises questions about the religious integrity of the subject possessed, the nefarious exchange precipitating the possession, and the contagious force it unleashed, along with the larger uncertainties and turmoil that infuse the story as a whole. These questions include: What does it mean when a Muslim spirit—a force that cannot be ignored—seizes upon and usurps the place of a Christian subject? What kinds of concerns might be at play when such Muslim agency can interrupt the space not only of an individual Christian but of the larger Ambonese Christian community by infiltrating its most intimate sites of worship? How does the status of the event's protagonist—both a migrant outsider and a Muslim convert to Christianity, and thus a multiply split subject from the start—complicate the scene of possession? And what, by the same token, should we make of the doubled spirit of the Muslim war leader who overlays the Ternatan sultan's daughter?

Why is the societal and religious displacement identified with women and rooted in the material transaction of a moving stone? What might these multiple layerings and porous cohabitations and inhabitations tell us about the disjunctures, interfaces, and entanglements between the city's heterogeneous Muslim and Christian populations, between native Ambonese and migrants, or, indeed, among coreligionists themselves? Lastly, if most urgently, what might this suggest about how the inhabitation of possession might contain or not contain possibilities for a future cohabitation of Ambonese Christians, Muslims, and others in this historically mixed and migrant city?

Conversion's Unstable Alchemy

If conversion can be understood generally as a narrative through which persons apprehend and describe radical change in the significance of their lives, then the collapse here of conversion and possession into each other proclaims even more dramatically not only the presence of radical change but also the enormous difficulty in grasping or making sense of it.[5] To be sure, conversion takes many different forms and is often a highly fraught and complex process with, among other things, implications for people's sense of history and the experience of rupture or continuity in ways that depart from this Pauline model of conversion.[6] When conversion is understood as a singular, momentous act, it may also cause profound confusion and distress, all the more so when this is carried out under duress.[7] At issue here, however, is less the experience or process of conversion than its rhetoric in the context of Indonesia's, and especially wartime Ambon's, complicated religious plurality. Outside of marriage, where the woman commonly "follows the husband" and adopts his religion, conversion in Indonesia is especially charged since it often goes together with accusations of alleged proselytization on the part of either Christians among Muslims or Muslims among Christians. Not only are the Indonesian terms for proselytization (*Kristianisasi* and *Islamisasi* or Christianization and Islamicization) much more loaded than their English equivalents, but they also circulate widely in both secular and religious media, as they did repeatedly and provocatively during Ambon's war. Conversion's representation as a dramatic scene of enlightenment has also been a recurrent theme in several highly popular contemporary Indonesian films.[8]

"Baptismal children of mine," the minister claimed, "who have converted from Islam to Christianity, generally speaking, see an apparition [of the Lord's face]. I always tell them, 'When you pray, ask the Lord to see His face so that you will be convinced.' And finally they get it. He comes and blesses them. It's extraordinary."[9] Whenever converts came up in conversation during my

fieldwork, as they did from time to time, it was with an analogous sense of the miraculous, as if a singular species of being was being invoked. Occasionally, converts were pointed out to me—all Muslim women who had married into Christian families—commonly with a lowered voice, but such persons were few and far between.[10] Not only were they often spoken of with a certain reverence but, along the lines of the minister's claim, singled out from their core-ligionists for signs of divine attention. Of a woman from "the other side," for instance, who ran a bustling lunchroom, it was said that only God's blessings could explain her remarkable business success. By the same token, these ex-amples suggest that converts enjoy special scrutiny—and, presumably, even more during Ambon's religiously inflected war. As in many religious traditions, converts encode a risk, whether this is conceived of as an inherent potential for duplicity, the dangers of "backsliding," or as an ever-present reminder that any claims to universality are always already contested. Since it is women and not men who convert upon marriage, it is women, too, who are most suspect, as the confrontation between the Javanese convert and Muslim war leader suggests. If the former publicizes the perils of backsliding in an especially dramatic form, the latter gifts a poisonous stone that potentially endangers the entire congregation.

But the possessed Javanese convert is less important for any resemblance she bears to the handful of Muslim women in Ambon who became Christians than to the potentially treacherous, unstable alchemy that conversion evokes. Folded into the fraught, affectively charged figure of the Javanese convert, it is possible to discern not only an interreligious interpellation but also the per-ceived threat of the GPM's eclipse by alternative religions: on the one hand, the Christian's unavoidable haunting by the Muslim, a form of radical cohabitation, to which I will return, on the other, a matter of great urgency and, arguably, one of more immediate concern for the GPM than the Muslims after the war. This matter is that of the numbers of GPM Christians, augmented during the conflict, who abandoned their church for what they deemed more promising alternatives, in a wave of "conversions" away from the GPM. Put otherwise, the figure of the Javanese convert doubly incarnates the threat of displacement for the Ambonese Christian subject—conjuring, at one and the same time, a usurpation of place by one's others and an abandonment by those akin to one-self in favor of more compelling options. Both the Javanese and black-clad Muslim war leader are not only marked as other but as foreign—the first being a migrant and the second, visually, akin to the jihadi women who, at the time, were only recently seen in Ambon.

Beyond conversion, I home in on the treacherous instabilities afflicting both subjects and objects in the minister's account and, more generally, of appearances

in a world in devilish disarray. In ordinary times, the manner in which other people appear to you and the knowledge you have of them remains largely underscrutinized. Similarly, the things that make up one's daily environment, including the cast-off refuse of city life, figure for the most part as unexamined fixtures of everyday existence.[11] In the decade or so under consideration in this book, difficult years marked by conflict and the myriad efforts to move beyond it, the ways in which persons and things manifested themselves, and especially the trust in such manifestations, often faltered. Not only might their familiarity be deceptive, triggering the aesthetics of depth I discussed in Chapter 1, but any sense of certainty tended to dissolve, as I show below. The implications of such alterations in subjects and objects are potentially much more than phenomenological. In such circumstances, the prevailing semiotic ideology or historically grounded background assumptions that constitute and organize people's experience of the materiality of semiotic form may come into question such that this materiality itself may become a significant provocateur of historical change.[12] While it would be a stretch to describe the stone at the heart of the minister's story as an agent provocateur of such magnitude, it is still possible to see it as an augur of some of the momentous transformations that took place in Ambon at the time—in urban religion, generally, but here specifically from the vantage of the GPM, as told, admittedly, by one of its more maverick ministers.

In what follows, I deploy a symptomatology of crisis, attending to the shape-shifting, death-wielding movements of persons and things and the discourses that surround them as an entry into urban religion's reconfiguration and the diffuse transformation of appearances, both being among the most significant changes wrought by Ambon's war. This symptomology operates by taking the signs and material disturbances of a violent situation—including outward appearances that seem at odds with and peripheral to the more serious business of war and were, indeed, often experienced as anachronistic or heterotopic—as core symptoms that betray just how much violence and destruction came to suffuse and rework from within the everyday experience and lifeworld of ordinary citizens.

Religion under the Sign of Crisis

Let me begin by looking more closely at the rolling stone that first shifted hands on an urban battlefield, setting this story in motion and contaminating Christianity from within, triggering possession among congregation members, and substituting Christian with Muslim practice. A token of the treacherous magic that, following the minister, untold numbers of Muslims and Christians would

have relied on in the violence and that, beyond it, would exercise a diffuse influence in everyday Ambonese life, the story of the stone served as an example of the dedicated spiritual warfare conducted behind the conflict's battlelines. In his pastoral work with "broken families," acts of aggression, overwhelmingly sexual in nature, alcohol abuse, and gambling could often be traced back to potent baths given to baby boys, he told me, or to talismanic cords tied around infants' waists, meant to instill them, early on, with the requisite qualities of male prowess and hypermasculinity.[13] Indeed, he attributed the tenacious ferocity of Ambon's conflict to the widespread deployment of what he occasionally called, in English, "magic" or "occultism" on both sides. Symptomatic of a much larger problem—the sway of pagan, tribal religion over the local population—this would have manifested itself in the recourse to magic on both sides during the violence—whether to protectively "seal" their villages against enemy assaults, summon fierce Malukan war captains of bygone times to their side, or otherwise activate the martial prowess for which Malukans are renowned in Indonesia.

Relating how members of his congregation betrayed their engagement with such hidden forces, the minister detailed how, during the multiple wartime prayer sessions convened at the Maranatha church, they surrendered en masse the talismanic cords and amulets that they tucked within their clothing:

> During the violence, I held a service every afternoon at 3:00, there at the Maranatha. It went on like that for four years, every afternoon. From the year 1999 until 2003 when things were somewhat quiet. We did this every afternoon without fail and during the first four months alone we collected four large boxes of cloth cords [A.M. *tali kain*]. We did this during the service, and they voluntarily surrendered them—four boxes of cloth cords. Actually, I had a prayer team, there was a prayer team. So we always prayed and asked people to do this voluntarily after they had received the prayers and words of the sacrament. After that they would come, "Sir, I would like to surrender this, please pray over it so it can be removed." There were people who wore them to avoid the violence and put a distance between it and themselves, while others [engaged in the fighting] felt, "If I wear this, then later I will be killed [on the battlefield], so it would be better if I turned it in." Yes, it was like that. "It would be better if I depended on God." So it was really extraordinary, ma'am. For four years, we held those afternoon services. It had quite an impact on changing things for the better. Young people who liked narcotics or alcohol would come and surrender themselves. Women with shattered family lives, like one

who came devotedly for an entire year and then came to inform me, "Sir, my husband has come home. Because of the minister's and my own ceaseless praying." She came every afternoon.[14]

Magic across Indonesia's extensive territory is remarkably diverse, rooted primarily in local practice, and shaped, among other things, by its interaction with official religion and statist discourse on modernity and by the relatively urbanized or rural character of the setting in which it occurs. At the same time, the wide currency of familiar terms deriving from different localities, the interregional Malukan trade in protective amulets and medicines involving migrants from beyond the province, and the GPM minister's invocation of the English terms *magic* and *occultism* suggests how widespread the relatively underground traffic in magic is in a country that officially bans the sale of magical spells and artifacts.[15] If the minister's use of English underscores magic's mass mediation and, more specifically, the popularity in post-Suharto Indonesia of supernatural horror films and television serials and of books like Dan Brown's *Da Vinci Code*, which circulated among educated Christians and which he claimed to have read, North Maluku's magic trade and terminology evince a similar if, generally, older cosmopolitanism.[16] "People are as likely to refer to sorcery by the Javanese term *santet*, by the general Indonesian terms *guna-guna* or *ilmu hitam*, or by the English term black magic as they are to use local terms as *doti*, *bodiga*, or *fiu-fiu*." Trade in the objects of magical protection in North but also Central Maluku comprises "spells (*syarat*), amulets (*ajimat*), or magical objects such as magically empowered semi-precious stones (*batu dalima*), herbal roots, miniature versions of the Qur'an, or antique Javanese knives (*kris*)" and is carried out "by a steady flow of predominantly Javanese and Buginese healers [who] arrive in . . . Maluku to sell their protective medicines."[17] In Indonesia generally, forms of magical protection are known to be rampant among the Indonesian police and military—with bracelets made of jet black coral especially popular—as well as prevalent in politics, from the lowest to the highest levels.[18]

In Ambon, the minister reminded me, men and boys would often be ritually bathed before heading into battle, a practice intended to instill invulnerability to bullets and other weapons that recalls the potent baths given early in life to Malukan boys.[19] A journalist from a North Malukan newspaper recalled in 2008 how he had stood among a crowd of men waiting to be doused with water and struck on the back with a machete to achieve this effect,[20] while a former Muslim child soldier from Ambon told a Dutch Malukan documentary filmmaker how they would pray and be bathed by an older male relative to purify themselves and to foster invulnerability before battle.[21] The young man also

mentioned red cloth cords that served as protective amulets, were incanted over by a specialist in local custom, and had to be worn invisibly under clothing "since otherwise others might take you for a Christian since they also use red cloth."[22] The powers and agencies of these and other objects like magical stones circulated profusely in discourse—rumors, ordinary conversation, and apocryphal accounts like that of the GPM minister—that attested to and elaborated upon their doings and effects, thereby not only substantiating "the ubiquity of supernatural belief as interpretive practice in contemporary Indonesia" but also consolidating the "narrative experience" particular to Ambon's war.[23]

Not surprisingly, such powers are controversial and suspect. If former Muslim soldiers were wary of speaking of "black magic," calling the topic sensitive, a Christian described how he had fought alongside a man who appeared invulnerable to bullets and machete attacks until he lost his cloth cord. "Then he was hit by a bullet. This is how we knew that Christians also used these things."[24] What strikes one in the brief enumeration of objects affording supernatural protection is how—notwithstanding the careful hedging of religion, whether Christian or Muslim, against magic—a miniature Qur'an (or, for that matter, bible or Catholic prayer book) could operate comfortably alongside an amulet or potent stone. Similarly, men, boys, and occasionally women who set off to battle might magically fortify themselves but also pray beforehand with their coreligionists in a church or mosque. Notwithstanding such accommodations, the resurgence in a reliance on sources of magical protection "signaled a departure from religious and modernist standpoints that were abandoned as young men turned to the magic of their village elders before heading into battle."[25] For city dwellers in particular, especially Christians, the uncanniness that always accompanies the supernatural's appearance would have been enhanced, given its overall banishment to the edge of urban existence for a long time. Sorcery in the city is also uncanny since it turns the everyday materiality of village life, things like sago pith and thorns, into lethal weapons.[26]

Simplifications

To return to the minister's account, beyond pagan magic's destructive inroads into the GPM congregation, it is the fact of interreligious contagion that absorbs him most. Anxieties about church members whose allegiance is in crisis and identity uncertain, who may be swayed by alternative sources of power or drawn to a rival religion animate the tape from our conversation. It is worth recalling that the minister who related Ambon's wartime plague of possessions is the same who cordoned off a prayer room in his home. At work, much as at home, his ideal horizon is seamlessly Christian, his primary concern pastoral, and his

overriding objective that of securing religious identity uncompromised in its proper place. Yet however one looks at it, the Javanese protagonist of the minister's account who sets the calamitous stone rolling augurs anything but that. Rather, she is a figure of religion shot through with competing forces and dangerously on the move in a city where Christians and, especially, GPM members were highly cognizant of how much less powerful and prominent they now were, while many also foresaw their genocide at Muslim hands. Inherently duplicitous, she spectacularly discloses the inability of the GPM to control or even gauge the shape of the Christian self, a self that, in so many ways, appears compromised from the start.

For a host of reasons, not the least because of the way it foregrounds his heroic engagement with the demonic forces assailing Ambon, the minister's account should be understood as highly mythologized. Nonetheless, the reference to Ahuru as the location of the standoff between the Muslim and Christian women and the site of transfer of the infected stone places these events temporally around June 2000, when a large confrontation and mass exodus of Christians—including Catholics—took place in that neighborhood. This was also the time when jihadis from Java began to make their presence felt in Ambon, having begun to arrive in the city the previous month, so that fears among Christians could be expected to have intensified exponentially. It is also a key factor that helped to draw the Catholics into the conflict, since the jihadis targeted Christians indiscriminately, making no distinction between Protestants and Catholics. Their presence was highly visible—male members of the theatrical, media-sensitive Laskar Jihad could be easily recognized due to their white robes and untrimmed beards.[27] When women joined them—often Ambonese Muslim women who "converted" to the group's strict neo-Salafi lifestyle—they commonly covered themselves in black, looking much as one imagines the female war leader in the minister's account.[28] Besides mention of the Maranatha church and Ternatan sultanate, the inclusion of the telltale Ahuru, with all that this place name could be expected to evoke among both Protestants and Catholics, makes more palpable even the sense of violent usurpation motivating the minister's account.[29] A figure of terrifying disturbance at the center of a scene of erasure, the Javanese convert's seizure subsumes a number of displacements that summarize the Malukan conflict as a whole.

First and foremost among these is the displacement of anxieties about the "incompleteness" of religious identities, boundaries, and hierarchies prefiguring the outbreak of violence, while the forced displacement of neighborhoods and villages by armed groups across the religious divide promoted the spread, transformation, and, finally, de-escalation of the violence.[30] Indeed, as internally displaced people, or IDPs, fled violence, their arrival to would-be sites of refuge

often portended and could precipitate violence in these places, creating a deadly contagion effect. Gradually, however, "the violent eviction of people from neighborhoods and villages also effected the spatial segregation and simplification of Christian-Muslim communities seen in other sites divided by inter-religious violence elsewhere around the world, producing an 'interlocking binary spatial grid and inside/outside polarities,' with the 'proliferation of interfaces, the barricading, and the influx of refugee populations' reorganizing towns and villages into a highly militarized and religiously coded topography."[31]

Resistance to displacement occasionally took place, but then only by giving in to conversion. In the face of impending displacement, some Muslim families who lived in neighborhoods where they represented a minority, like Ambon's Batu Gajah, opted to convert to Christianity rather than relinquish their homes and horticultural plots to Christians.[32] Much more common on both sides were circumstances where people were simply driven out or compelled by the violence to abandon their neighborhoods, leaving their property and possessions behind. Several Christians told me that after the war, Muslims would sell their homes cheaply to Christians in areas that had become religiously homogenized, an outcome of the conflict they deemed favorable or "nice," in the sense of economically advantageous.[33] Presumably the same circumstance the other way around resulted in the same solution. Given that Ambon's cadastre burned down in 2004 and the understandable—in these circumstances—pragmatism of city officials in resolving property and land disputes, much remains and presumably will remain unsettled for many years to come, if not, indeed, forever. Apart from the violence that accompanied it, the "simplification" of large parts of Ambon into religiously defined enclaves often had disconcerting and jarring results. In a city emerging from a conflict waged in religion's name, "houses of worship in the wrong place," such as mosques arising in what today are Christian neighborhoods or churches abandoned in what have become Muslim ones, are now traces of a recent, wrenching past.[34]

Overlooking the city's rearranged, religiously coded topography in the immediate postwar years, Ambon's street paintings may be seen simultaneously as signposts and effects of simplification. To understand why this is so, we need to return, briefly, to the years immediately before the conflict. At this time, an anthropologist working in one of Ambon's most cramped, impoverished, and largely illegally settled neighborhoods registered an excess of protective amulets tacked above the doorways of migrant homes.[35] The proliferation of such overt signs of animosity and suspicion were an expression, as he saw it, of the "dangers of living so close by those who were 'strangers' in significant cultural and social terms."[36] In retrospect, this would have fed the mob response and vengeful strikes on Christian Ambonese neighbors "who had demonstrated their sense

of privilege and superiority in various ways over an extended period."[37] Important, too, was the sense of alien but proximate space, something that was felt on both sides of the conflict.[38] Unfortunately, the fears of the many migrants who clearly did not take their presence in Ambon for granted were borne out during the first days of the war when migrants from South Sulawesi—Buginese, Butonese, and Makassarese peoples, or the derogatively collectivized BBMers—became the target of mass aggression and fled the city in droves.[39]

It would not be a stretch to see the Jesus billboards and murals standing guard at Christian neighborhood entrances, along similar lines, as huge amulets aimed at Muslims and other potentially hostile strangers. Much like an amulet, the material presence of God's image served the community as a shield. In soliciting God's presence and bringing him into vision *here* in Ambon, the street pictures seemed to fulfill a protective function analogous to that of the dried seahorses and medicinal phials adorning the lintels of Butonese homes, or those migrants especially reviled by both Christian and Muslim Ambonese.[40] Beyond mere analogy, the paintings can be seen as successors of a sort to the magically potent phials and seahorses. Insofar as the violence succeeded in religiously and ethnically purifying a large majority of Ambon's neighborhoods, blocking the city into homogeneous swaths of red or white territory, it would make sense that the signs erected against threats from hostile neighbors within—dried seahorses and the like—would shift to the neighborhood's external boundaries to face the threats now directed (in principle) exclusively from without. So, too, does the substitution of Jesus's gigantic face for the tiny, if public, tokens of a more traditional power accord to the logic of a conflict that came to be carried out, already early on, in religion's name. Such religious or magical gating in the physical space of the city exemplifies the material ring fencing that often prevails in a field of competing religious discourses.[41]

Still, more than any of the above, it is the Javanese Christian convert's serial displacements that best summarize—and complicate—the process of "simplification" fought out in Ambon's streets. From this perspective, poetic justice may explain why when, following successive flights, the convert finally arrives to a place, this place is a refugee camp. Not only is this setting emblematic of one of the war's most devastating forms of social dislocation, that of the IDP, but as such it offers a fitting mise-en-scène for another aspect of the Christian subject's radical dislocation—it is in the refugee camp, after all, where the serial possession of GPM congregationalists takes place.[42] Yet the particular form taken by the displacements in the minister's story also confounds this process by hinting at how simplification generates not only stark separation along religious lines but also porosity, admitting points of passage between Muslim and Christian and making it less absolute than it may seem. In what follows, I consider

points of passage between Christians and Muslims and among coreligionists, along with the efforts to control them.

Terms of Coexistence

"Coexistence," following Benjamin Kaplan, a historian of the religiously mixed societies of early modern Europe, "exposed members of each group to rival beliefs and practices, and with that exposure came temptations, pressures, knowledge of alternatives and the possibility of choice. . . . Life in a mixed society presented rival groups with both opportunities and perils—the opportunity of gaining members, the peril of losing them."[43]Already before the war, the GPM had begun to feel the competitive pressure of other, primarily charismatic, churches that are relatively recent in Maluku. Many of these, like the popular Pentecostal churches, appeal especially to Ambon's many young people,[44] who are drawn by their lively prayer sessions, musically and technologically supported religious services, their outreach programs, and to a not negligible extent, their cosmopolitan allure—in short, by their general ambiance of conviviality, fun, and modernity. By comparison, the GPM had begun to feel stiff, formalistic, and out of touch with young peoples' lives. The possibility of choice, present in principle in any situation of religious plurality, became an urgent one during Ambon's war when the sureties of everyday existence seemed to evaporate and the need for security, protection, and community became enhanced, forcing people to confront and evaluate their alternatives. Choice can only be understood within this context and is not, in other words, assimilable to an individualist consumerist position—the kind often identified with conversion—or to that of an individual consciously, willfully, and "freely" articulating her choice.[45] Stories of conversion from Ambon suggest a much more complex reality—commonly, a process of gradually coming to conversion, even if it is storied afterward as a singular momentous change. There were also some group conversions of families or, more spectacularly, the conversion to a stricter neo-Salafi form of Islam that was entailed in the mass wedding ceremonies in which local women married jihadi soldiers during the war.

Unlike many of the converts I met in Ambon who had left the GPM for another denomination due to a personal experience with violence or a general disillusionment with the role of the city's traditional church during the conflict, a young woman who I will call Feby had been drawn to Pentecostalism before the war. In this respect, she was part of a slow trend that was already underway when I first visited Ambon in 1984. Having taught herself some English, repeatedly befriending and offering her services as a guide and translator to the foreigner researchers and visitors who came to the city, Feby seemed especially

taken with the cosmopolitanism that characterized her church. Whether a coincidence or not, the English acronym ROCK of the Representatives of Christ's Kingdom church, with its evocation of not only foundational solidity but also Western popular culture, does seem designed to appeal to Western-oriented youth. Besides its name, the church's international orientation comprises regular visits from foreign preachers, singing in English, images of traffic-swollen urban highways or San Francisco's Golden Gate Bridge projected onto huge screens during select religious services, and a sizeable contingent of foreign-marked Chinese Indonesians among its members.[46] As one loyal GPM member put it when speaking derogatively to me about Ambon's Pentecostal churches, "They are full of big people, moneyed people, with lots of Chinese." She went on to complain specifically about ROCK, alleging that it paid people to become members, that they offered a lavish service, then summed up her grievances by claiming that the GPM disapproved of these churches because there were "outside of the GPM."[47] If nothing else, her blunt remarks demonstrate how much, beyond any denominational differences, the mere fact of competition was a problem for the old Protestant church.

In addition to her church's cosmopolitanism, what also appealed to Feby was the less hierarchical, more intimate relation this institution envisioned with God as compared to the GPM. In one of our conversations about religion, Feby spoke not only of how the GPM was changing due to competition from the Pentecostals but of the difference between the old church and ROCK.[48] Striking a rigid military pose with her arms pressed firmly to her sides, Feby evoked the stiff, immobile attitude of the GPM as she related how even these Protestants had begun to depart from their characteristically formal liturgy by introducing "praise and worship" services. To underscore the contrast between the two denominations, she noted how God in the Bible is addressed both as "my father" and "my friend" and that, although both describe an intimate, familiar relationship, she preferred the latter. Reminiscent of the desire for proximity and presence that underwrites the street pictures, Feby insisted that God not be treated like something distant and intangible or, as she put it graphically, "like a ghost." As I proposed in the last chapter, one of the changes occasioned by the war was that the Christian Ambonese subject began to imagine herself emplaced within a larger visual field. What Feby's comments reveal is how, at the other end of what we might conceptualize as a larger process of refocalization, God undergoes a crucial change in which not only his presence but his tangible presence and humanity is increasingly—in the case of the street art, quite literally—drawn to the fore and made visible.[49] Refocalization reveals that what is at stake here is more than a perspective or particular way of seeing but an ideologically inflected vantage that permits, in this case, the Christian God

to come into vision and to cohere as a privileged object of attention.[50] Refocalizations such as these take place especially in transitional historical moments where what was previously seen one way may take on a radically different appearance, stand in a different relation to its general cultural surround, or disappear from view altogether.[51]

Feby described how she and her fellow church members rejected war fought with "blood and body" as they also distanced themselves from the pictures set up in the streets by GPM Protestants.[52] She spoke of how she and others erected a "Prayer Tower" when they deemed the situation in the city especially "hot."[53] And how the nonstop, serial praying went on without interruption twenty-four hours a day in which so-called "intercessors" relieved each other at periodic intervals in what was understood as spiritual warfare targeting the devil. Another aspect of this battle of cosmic proportions was a thoroughgoing "healing of the land" carried out both on land and at sea. Teams of about five or six people descended before daybreak upon appointed sites in the city where violence had occurred and that figured on maps that had been drawn up by the church on the basis of research. Admittedly, as a hub of the international spice trade from the early seventeenth century, Ambon's history has been unusually violent and bloody. According to the Pentecostals, blood spilled violently demands a response, but only Christ's blood can eradicate violence's traces from contaminated, blood-soaked land. Feby described how she and her small "team"—a term that, incidentally, betrays the long reach of state bureaucracy into daily life—would set out before dawn armed with Jesus's authority to pour "the blood of Christ," or consecrated wine, on sites polluted by the spirits of murder, adultery, and prostitution. During lulls in the violence, ROCK's teams ventured out while the rest of the city slept to drench the doorways of gambling dens, karaoke bars, and other infected loci with Christ's purifying blood. When I asked Feby why the Pentecostals took such precautions to remain unseen, she mimicked the voice of a fellow urbanite reacting in colloquial Ambonese Malay to encountering her team going about its purifying work: "Hey, are they crazy or what?" Aside from being a comment that exposes the perception of the close proximity of religious others in Ambon's urban environment, this anticipated reaction reveals how much Pentecostals tended to see themselves on the defensive against not only or so much Muslims or Catholics but especially Protestants of other denominations, notably the GPM.

Another young woman, whom I met through her work with a local interfaith group, related how in 2001 her family had left the GPM to join a Pentecostal church. Previously, Rona had been active in a GPM youth group but also occasionally accompanied friends who belonged to one of the city's Pentecostal churches to attend services there. These churches made her feel different—a

feeling, as she described it, that touched her profoundly—adding in English, "There is more immersion in God."[54] Her parents, however, were adamantly opposed to the charismatic churches, until a nephew died whose family happened to be Pentecostal and her father was quite moved or "struck" by the service. Both Rona's and her father's acquaintance with Ambon's Pentecostal churches highlight the crucial influence of family and friends in introducing religious alternatives and raising the possibility of choice for others. Since, as recalled by Rona, her father did not want to divide his family between different denominations, family members agreed collectively to convert to the new church and were baptized on the beach in 2001, a good two years into the war. Quite consciously, the family chose not to join one of the city's larger Pentecostal churches but opted for a smaller one that Rona described enthusiastically for the sense of community, small-scale intimacy, and freedom of emotional expression it allowed. Besides the less "general" or abstract language of its services, what she repeatedly emphasized was that "there is no feeling of embarrassment if you want to cry and this provides relief—even my father cries if there is something going on at the office."[55] Throughout Rona's account of her family's conversion, any mention of the war going on at the time was significant for its absence. Yet the characteristics singled out by Rona as exemplary of her church establish an implicit contrast with the GPM. They are also those that came to be valorized during the war—namely, community, intimacy, and emotional expression.

While not always articulated, the sense of how much the GPM had fallen short comes across in the stories of those Ambonese who, in retrospect at least, made clean breaks with the church by converting and radically reforming their lives. In these instances, they described the desperate circumstances that had driven them to convert. By focusing on these different conversion stories, I have aimed to situate the competition that in part describes the relations among the city's Protestants and, in particular, the challenge that Ambon's charismatic churches pose for the GPM. While competition, including invidious comparison, may be a common feature of religiously mixed settings, the intensity of the rivalry, the way it is dealt with by religious leaders and managed by state authorities, the relative porosity or firmness of religious boundaries, and the fluidity or strain in mutual relations all contribute to the great variety of inter- as well as intrareligious relations across place and time. Along with significant developments at the national level and the impact of globalizing trends and forces—not the least the rise of Pentecostalism—the war in Ambon had dramatic effects on the place of religion in the city, on its everyday practice and manner of integration into social life, and on its public presence. Besides the delineation of stark religious boundaries or "simplification"—stiff versus more

relaxed liturgical practice, religious services characterized by restrained or more open expression, Christ up close as a friend or distant as a paternal authority—transformation and fluidity also describe and helped to reconfigure Ambon's complicated religious terrain.

Although never static, religious difference within these charged circumstances was exceptionally dynamic, being negotiated again and again on war's unfolding terrain. War, more generally, is a context not always best described as simply one of taking sides.[56] It can help to promote cosmopolitan identities by bringing together people of different ethnicities and religions (often against their coreligionists) and engendering new patterns of circulation.[57] Along these lines and notwithstanding the fears of a traditional Protestantism under storm, a pragmatic if tentative ecumenicalism also began to take root in the city during the conflict. Such rapprochement, encouraged by an acute awareness of commonality forged under fire in a "Christian" versus "Muslim" war, involved a détente not only between different Protestant denominations but also between them and the Catholics, marking a revolution in relations among different Christians in Maluku. It also glossed over the fears of Ambon's traditional Protestants regarding the serious competition posed by the newer charismatic churches.

For much of Malukan history, both under the Dutch and thereafter, relations between Muslims and Christians were unequal. Less acknowledged is the fact that relations between Protestants and Catholics were especially marked by rivalry and mutual suspicion. Undoubtedly, there was some mimicry of the Dutch colonizers in this. But at stake, too, were the considerable numbers of as yet unconverted peoples to be fought over in large parts of Central Maluku like Seram and Buru and in the Southeast Malukan islands. To manage this competition, the Dutch maintained the historical dominance of Protestants in Central Maluku, while allowing Catholics to missionize only in Southeast Maluku beginning in the late nineteenth century.[58] Historically, in some respects then, the Christians had always kept more of an eye on each other than on the Muslims, something that seems exemplified by the spatial location of Ambon's main religious institutions. Today, as in the past, the central artery of Pattimura Avenue, which began to regain its prewar elegance a decade or so after the official peace, boasts at one end the new and older Catholic cathedral and bishopric offices and, at the other, the GPM's head Maranatha church and synod headquarters. As elsewhere in Indonesia, the city's main mosques, the historic Jamu Masjid and the Al Fatah, are located in the area along the coast or the traditional place of Muslim settlement around the archipelago, while Ambon's newer churches are scattered throughout the city in its predominantly Christian areas (Figure 32). This long-standing settlement pattern explains

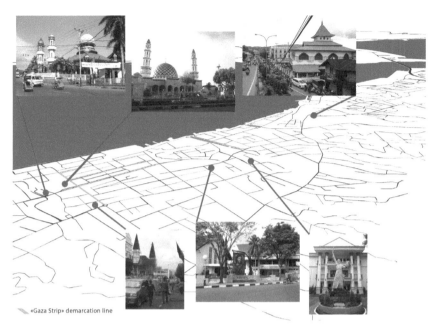

«Gaza Strip» demarcation line

Figure 32. Map of Ambon indicating the location of important mosques and churches and the city's main "Gaza Strip" on A.M. Sangaji Street. From top left to bottom right: Jami Mosque, Al-Fatah Great Mosque, An-Nur Great Mosque of Batu Merah, Silo Church under repair in 2003, Maranatha church, statue of Saint Francis Xavier in front of the Roman Catholic Diocese of Ambon. Map by Marie de Lutz. Photo of the An-Nur Great Mosque of Batu Merah by Ratih Prebatasari, Ambon, 2020. All other photos by the author, Ambon, 2003 and 2016.

why, in Ambon, the Christians are commonly designated as "those who live landside" or "those who live up above [in the hills]" versus the Muslims who "live seaside."[59]

Against the historical background of rivalry between Protestants and Catholics and the more recent interdenominational competition among the former, the unprecedented sense of Christian fraternity, the idea that "we are all Christians," is evidenced, for instance, in the inclusive statement of a GPM church council member who commended the Christian street pictures for showing that "Jesus is . . . *here* [and] he gives strength to all Christians—not just Protestants, but also Catholics, Adventists, Pentecostals, Assembly of God,"[60] in the practice of "pulpit exchange," following which a Protestant minister would lead a service in a Catholic church and vice versa, and most strikingly in the image of Christ clasping the sacred heart to his chest in some of the city's new Protestant-produced pictures. Also important was the public display of Christian solidarity and show of numbers. In a spectacular demonstration of unity,

denominations of Protestants joined Catholics in Ambon's streets, totaling about five hundred church leaders in all, in a December 23, 2000, protest against the forced conversion to Islam of Christians at the hands of jihadis in the Southeast Malukan islands of Kesui and Teor.[61] Once the war was over, Protestants marched behind the Catholics in the latter's Easter Passion parade and the GPM appointed a church representative whose task it was to promote ecumenical relations.[62] This novel fraternity was not without friction. While lamenting, with obvious amusement, how difficult it is to "organize priests," one Malukan priest recalled the displeasure of the Protestants when a group of Catholic clergymen showed up in their lay clothes for one such joint procession to march alongside Protestant ministers and council members fully arrayed in black.[63]

By 2011, a new portrait of Jesus surfaced on city walls depicting Jesus as a King or Jesus of the Second Coming at a time when most other Christian pictures had faded into the texture of city walls (Figure 33). Personally, for the painter Jhon, these portraits confirmed his stabilized identification with the Pentecostal church ROCK. Emergent at this time, almost a decade after the city's official peace, this mural publicly and graphically confirmed the intense religious mobility of Ambon's Protestants, especially the move of sizeable numbers of GPMers away from the city's oldest church. But the image may also be seen as yet another form of simplification, gesturing toward the GPM's quiet transformation from within. This process comprised deliberate innovations, like a praise and worship service, but also the exorcisms organized by a handful of GPM ministers to liberate afflicted congregationalists—due to their reliance on magical agency, sorcery attacks from envious neighbors, or the mere presence of a bloodthirsty ancestor in their family background. To be sure, the GPM's Pentecostalization is slow, contested, and its outcome uncertain. As one of the GPM ministers at the forefront of this movement told me, exorcisms, not being traditional to Ambon's Calvinist church, remain vigorously opposed by a majority of GPM ministers. In his view, they are not sufficiently aware of just how widespread the dark forces besetting Christians are or, indeed, how best to combat them.[64]

Symptomatology: Treacherous Things

Objects, object worlds, and the natural and the built environment are implicated in violence—unmoored, displaced, revalued, disfigured, destroyed, or redrawn by its traces, signs, or denial. They help to delineate the lines of battle and act as crucial media of communication and conveyers of friendship or hostility. They have tangible, at times even disastrous, effects, like the tiny stone

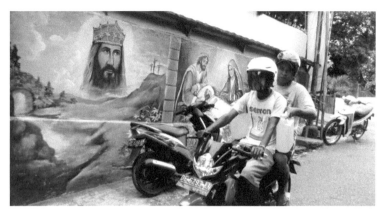

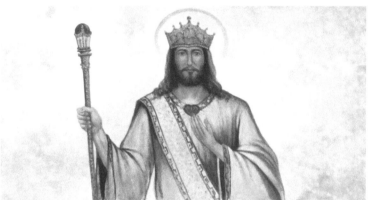

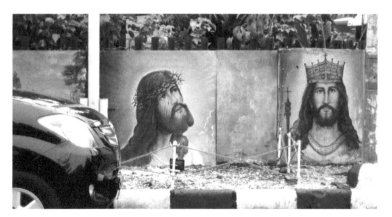

Figure 33. Images of Christ of the Second Coming on two painted murals and, between these, a third painting of Christ of the Second Coming on the interior wall of a church, Ambon, 2005. Photos by the author.

transacted between a Muslim and a Christian woman, or they may stand in for commensurability or its rupture. Some authors propose that material objects assume special salience in situations of religious plurality, as in this quotation that resonates uncannily with Ambon during the war: "Whether Muslims and Christians are protecting or building one another's sacred places or burning them, or sharing a meal or handshake or refusing to do so, it is in material things that the plural is realized."[65] Approaching things as symptoms, this section explores some of the ways in which objects were revamped in style, scale, and import, technologically reproduced, and deployed differently, as well as attacked and destroyed—in short, put to work in war in various ways. I pay special attention to how objects were marshaled and mobilized within the augmented, quickened traffic that both trespassed and redrew religious boundaries articulating anew Christian red versus Muslim white opponents and realigning relations among coreligionists.

If, following the minister, Muslims and Christians resembled each other in their wartime reliance on magic, it was the Protestants who initially turned to the Catholics for protection of a more conventional religious kind. At the outset of the conflict, when Catholics had not yet been implicated in the fighting and the city's bishop profiled himself as a mediator between the warring parties,[66] Protestants visited priests, requesting rosaries to help them "pass" as Catholics. As the war went on and Catholics were drawn into the conflict, the nature of such requests changed. Over time, things produced by the Catholics and initially sought as aids in the dissimulation of religious identity became increasingly coveted for their ascribed protective powers. To meet this demand, several nuns set up a small industry in Ambon that relied on the easy availability of the photocopy machines whose ubiquity attests to the Indonesian state's enormous bureaucracy and the incessant demands it makes on its citizenry. The nuns turned out photocopied, stapled, pocket-size prayer booklets in large numbers, which were worn on the body as protective devices in battle. Muslims, for their part, carried pocket-size Qur'ans and tiny flasks of holy water to be sprinkled over them should they succumb in the fighting.

Recourse to the readily available infrastructure of technological reproducibility, coupled with the need for protective props, also underwrites the account of a Chinese Indonesian refugee from North Maluku, who spoke to me of the extensive use her future assailants had made of the photocopy machine in her Tobelo store.[67] Only later had she realized the significance of the multiple sheets that several Muslims commissioned only a day or so before the onslaught upon her town began. Only later, too, did she recognize the crossed swords supporting an open book as the insignia of the Laskar Jihad movement that

the jihadis who drove her from her home wore folded in neat little packets within their robes.[68]

The protective qualities of such things were often celebrated in stories that circulated on both sides during the war. Take, for instance, this account of a young refugee who spoke of how, upon fleeing an attack by Muslims, she left her father with a "pocket bible, to protect him" as he remained behind to guard the village church. "He put it in his shirt pocket. Later he was hit by a bullet that remained stuck in the bible. That saved his life." In an interview with a Dutch documentary filmmaker, the girl's father confirmed her story: "I survived that shot in my chest because of that little bible," as he showed her the bible with the bullet hole.[69] While miniature bibles and Qur'ans nestled close to bodies, other personalized religious tokens were more public, some even growing in size, like the bling crosses that young Protestant men, often the same persons who helped put into place the monumental Christian murals, took to wearing around their necks. Besides T-shirts and crosses, the colored head ties worn by Christians and Muslims, and the amulets and religious artifacts they carried into battle, jihadist propaganda DVDs display a fantastic array of Islamic calligraphy inscribed on headbands and across shirts in a revival of an older wartime practice.[70]

Things also stood at the center of delicate and aggressive realignments in the relations between coreligionists. As the war dragged on, I heard how some local Muslim leaders began to cautiously complain about the exacting demands of the Laskar Jihad, whose arrival in the city early on in the war they had initially welcomed with open arms. The complaints were articulated across a widening rift in which Muslim Ambonese detailed the jihadis' inherent difference from themselves in primarily material terms—singling out their untrimmed beards, cropped trousers, and robes and the long, black attire of their women. Other border skirmishes include two iconoclastic events—one among coreligionists, the other pitting Muslim against Christian. The first involved Pak Nus Tamaela, one of the indigenous Christ painters, who at the behest of several Pentecostal ministers destroyed, in what his son called a "crisis of faith," the cement statues and paintings of ancestral Malukan war leaders that he had produced over the years.[71] A second event, related by Ambon's former bishop Monseigneur Andreas Sol, involved a saint's portrait whose painted eyes somewhat unsettlingly pursued the viewer. When Muslims occupied the general area in which the church with the saint's portrait was located, it so unnerved them that they rapidly provided the saint with a pair of painted dark glasses. There is much to say about these episodes, in particular the potential for animacy that haunts them both and that was implicitly acknowledged in the first

instance in the destruction of the headhunter effigies and, in the second, the defacement of the saint's portrait, but I discuss them elsewhere.[72]

Through the untoward behavior of things and the ways in which both objects in motion and those serving as community signposts delineated, undermined, and repeatedly reinscribed this Malukan field of urban religion, religion's salience as an important legacy of the long Suharto era also comes to the fore. Center stage in such a field—indeed, the very starting point of this treacherous affair—is not simply matter out of place but a multitude of shape-shifting, death-dealing things whose power to harm is only revealed after the fact, once it is too late, through their affective and material consequences in the world. Much like acts of terrorism, the effects of such things make tangible and visible what hitherto had been present, yet unseen.[73] It is telling, in this regard, that the voice of Salma, increasingly anguished, reportedly cried out in church for the small stone of which she had been bereft and that, fetishistically, held sway over her, "Stone, stone, stone, where are you?" The power of things and the deceptive nature of appearance in Ambon's wartime was further disclosed not only through alterations in the shape of objects, including the impact of dramatically varying scale, but in the discourse surrounding the fugitive identities of persons in the conflict's thick, murky reality.

Symptomatology: Treacherous Persons

Haunting by an Other can also gesture elsewhere—not only to displacement, annihilation, and the forging of hard-edged, simplified identities but to the inability to foreclose the other. Haunting is a disturbed acknowledgment, however tenuous and oblique, of an ethical claim of an Other upon the self. This means foregrounding in the scene of possession the sense of being overtaken by force, or summoned by a call or demand that cannot be refused— an agency, in other words, that has everything to do with haunting. This, I propose, is what Ambon's scene of possession also has to offer. I am encouraged to take this route rather than one that leads only to entrenchment and violence by cues from Ambonese Christians themselves. Many, to be sure, insist that their own faces are illuminated as opposed to what they describe as the dark illegibility of the Muslim, or what is also spoken of as the latter's inherent lack of aura. Allowing the illuminated Christian face to triumph— whether in the miracle of the Lord's appearance to a Muslim convert confirming her "possession" by the Christian spirit or in everyday invidious comparisons from which Christians, in their own view, emerge shining— challenges the Christian eclipse by potent Muslim agency in the GPM minister's account.

Famously, Emmanuel Lévinas singles out the face of the Other as the site of a particular ethical injunction, as bearing within it an infinite demand.[74] The sign of a radical, inassimilable alterity, the face signals an interruption. It conveys "a demand that I become dispossessed in a relationality that always puts the other first."[75] It also assumes that this other is inassimilable, something that interrupts my own continuity, thereby making impossible an "autonomous" self at some distance from an "autonomous" other.[76] This ontology of the self constituted via a prior eruption at the core of the self entails a critique of the autonomous subject, one that also undermines a view of cultures or, for that matter, religions as autonomous domains among which dialogue should be established.[77] It evokes instead a much more complicated, entangled sense of plurality and cohabitation.

This disavowal of the possibility to constitute fixed and stable identitarian positions is characteristic of work in political theory and political philosophy that, while drawing on Carl Schmitt's political theology with its emphasis on the friend/enemy distinction, attempts to move beyond its totalizing implications. Such work highlights the possibilities of semantic slippage and reversal in Schmittian perspectives—underscoring how the enemy can be a friend, the friend is sometimes an enemy, how the border between them is fragile, porous, and contestable.[78] This slippage can open the way to a political theology of the neighbor, a third position alongside that of friend and enemy, an exception to the exception of sovereignty to which I will return.[79] But it can also describe a scene of terror like that of Ambon during the war.

On the ground in Ambon, things were often no clearer, facilitating their own hazardous slippages. If Christian Ambonese tended to assert a clear difference between their own faces and those of Muslims, many also maintained that this difference is immediately apparent. At least in a pronounced sense, this seems a recent development in the relations between Christians and Muslims in Ambon. A journalist friend who called the conflict a monster described how, before it, the city's Christians and Muslims would often be invoked in a single breath as "Salam-Serani" or a conjoined "Muslim-Christian" pair. As a child, he recalled, he could tell the difference between Muslim and Christian, but only during the war did such difference become something truly to be seen, as it also spawned a slew of new terms like *red* and *white*, *Acang* and *Obet*, or *Islam* and *Kristen* that marked the rift of enmity that had become consolidated between former neighbors.[80] Running through a list of distinctions of dress, religious symbols, and dialectical variation, my journalist friend confided, lowering his voice, that "our faces are more illuminated."[81] Similarly, and with equal circumspection, one of Ambon's young painters explained, while speculating that God may have bestowed such signs to distinguish Christians from

Muslims, that the difference between them came down to illumination: Christians bathe in divine light, while Muslims lack aura.

Remarkably, this certainty glosses—if barely—a radical uncertainty. While prepared especially during the Islamicization of the late Suharto years, uncertainty became aggravated during the conflict. It pertains in particular to the identities of friend and enemy, to the positioning, more broadly, of Muslim and Christian with respect to each other, and, most poignantly for Protestants, to the status and location—indeed, even physical presence and futurity—of Christians in Ambon and in Indonesia generally today. Excerpts from an interview with a civil servant from the city's provincial forestry department, who I will call Hengky, demonstrate how the assertion of a radical, discernible difference between Muslim and Christian dissolves, again and again, into uncertainty. Quite canonically, the topic was spies who had infiltrated his majority-Christian neighborhood during the war and had been discovered and brutally killed. Such talk is an instance of the larger discourse distinguished by what I call an aesthetics of depth, since it revolves around the disguises, dissimulations, and deceptive identities held to be prevalent during the war and the countermoves these provoked to penetrate the treacherous appearances of persons and things, the dense, layered reality described in Chapter 1. What this discourse makes clear is that while difference may be something one can see, what one sees cannot necessarily be trusted. This fine line can make all the difference—indeed, even between life and death. Of particular concern were fake national armed forces soldiers who turned out, the man claimed, to be spies, an identity that recalls the army uniform in a stringer's clip that the camera repeatedly circles over as if to summon forth another reality beneath its khaki surface (see Chapter 1). When I asked how he knew they were Muslims, he explained:

> Because you know. There is a difference between Muslims and Christians—they are different. You can see it . . . We have been associating with them for a long time so we can tell, "Oh, that's a Muslim." It's like that for Christians down in the city, they know, too, "Oh, that's a Christian." You can tell right away because it has been a long time that we have been living together.
>
> But once in a while, there's a Christian who looks to us like a Muslim. Like our people from Toraja. Torajans have traits like Buginese, right? [Designating members of the Muslim diaspora from South Sulawesi, many of whom have been present in Maluku for centuries, including in Ambon.] Just like Buginese. "Wah, that's a Muslim!" If you ask him,

[he'll say] "No, I'm a Christian," but he would not be believed. And if at some time, there is an armed crowd, a Christian crowd, and he panics because there's a really large mob—with machetes, all kinds of weapons—and they want to kill him, he panics! But if someone comes along and asks him really calmly, and there is someone who knows him who can say, "Oh yes, it's true! He's from Batugajah, he's a Christian," then it's safe, just like that. But if no one knows him, that's it, it's over right then and there.[82]

While indigenous Christian and Muslim Ambonese would recognize each other spontaneously, he claimed, these other cases had to do with "people from elsewhere, Christians from outside, for instance, like the ones who look like Buginese that I mentioned before. That was sadistic—because we thought they were Muslim."

It took little, apparently, for confusion between Christians and Muslims to set in, for the adamant assertion of certainty to unravel, even if here such confusion is projected onto Christians from outside Maluku. Besides the occasional "Judas" or Christian who, for payment, would set fire to Christian property, another topic that came up in the conversation brought such uncertainty even closer to home. During the war, among the array of signals they used to communicate with each other, Christians deployed secret passwords as a means of recognizing each other and sorting friend from foe. Although Hengky mentioned it was commonly after nightfall when such codes were used—implying that in daylight one would know a fellow Christian by their face—this example suggests that spotting a Christian or, for that matter, a Muslim is less straightforward than many claim. Within the exceptions raised to the immediate recognition of Christian versus Muslim, the password counts as yet another sign of uncertainty that surfaced in our conversation to undermine the certainty with which it began. Even as this uncertainty was displaced into the darkness of night or onto non-Ambonese, it hinted at the enormous fears and risks of slippage and reversal—how the enemy may be a friend, the friend sometimes an enemy. More urgently, the border between them—patrolled by the anticipatory practices of an aesthetics of depth, by passwords to secure identity, and by the other tactics and symptoms of war—is fragile, porous, and dangerous. Like that of the possessed Javanese convert, this example exemplifies the extent to which an aesthetics of depth haunted war's terrain as surface manifestations became suspect and treachery lurked behind the most banal appearances. It also confirms, as the epithet to this book asserts, how the true mystery of the world is not the invisible but the visible.

Neighbors and Neighborhoods

The moving stone that set off Ambon's possession captures the necessary dyna-
mism at the heart of cohabitation, a relationality that, admittedly, only in the
best of possible worlds amounts to a dispossession that always puts the other first.
This is clearly not the situation in Ambon, nor, of course, has it ever been, but
we may catch a glimmer of this possibility—admittedly, oblique and tenuous—in
the Javanese convert's dramatic possession that frames this chapter: "The prin-
ciple of conversion, of one person insinuating his or her mode of interpretation
in the mind of another, informs all dialogue."[83] Street names, family names,
and conventional ways of designating neighborhoods and areas in Ambon
intimate a story of such mutual "insinuation" in the astonishing admixture
and long-standing side-by-side living that these document. Family names like
Gasperz, de Lima, Bahaweres, van Blauw, van Heling, van Houten, de Fretes,
de Queljoe, Basalama, Alkatiri, Alhabsi, Veerman, Camerling, Kastanya, Alfons,
Rugebrek, de Jong, van Room, van Broudhorst, Van Harleem, Muskita, da
Costa, Engels, van Hof, Bremer, Parera, Payer, Seslovski, Olchevski, de Sousa,
Noya, van Delsen, van Bergen, Souisa, de Keizer, Roehoebrek, Hamdan, Waas,
Mendoza, Alhamid, Alatas, Alhadar, Bachmid, Atamimi, and no doubt others
attest to the long history of trade and colonialism—including that of the Dutch
East India Company, designated in the Netherlands as the world's first multi-
national company—and to the presence of Portuguese, Arabs, Spaniards,
English, and others, many of whom preceded the Dutch in Maluku. Add to
this list the names of Indonesians from elsewhere, today and in the past, Java-
nese, Buginese, and Makassarese, Malukans from Ambon-Lease and from the
islands to the north and south, not to mention the many slaves and the colonial
and postcolonial government employees, naturalists, and adventurers who
visited the city through the years. Street and alley names show how this diversity
inscribed itself in Ambon's formal and informal infrastructure: a casual survey
of *gang*, or urban alleys, yielding Gang Violeta, Gang Yosef Kam, and Gang
da Silva; *jalan*, or street, offering Jalan Valentijn, Jalan Franciskus Xaverius,
and Jalan Anthoni Reebok; with the areas of Tantui (Tan Hui), Menerlim—
from the Dutch "Meneer Lim" for "Mr. Lim" or, as my journalist friend Novi
Pinontoan corrected, "actually Tuan Lim"—and Hongko Liong evidencing
the important Chinese presence; and, finally, OSM, an acronym for the Dutch
Opleiding School Maritiem, standing in for the neighborhood where the col-
ony's Maritime Training School once stood.[84] Today, all of these historic names
blend with those bestowed under the Indonesian Republic, commemorating
its many heroes and replicated across the country in the nomenclature of its
cities and towns. In addition to these examples, there are all those groups and

persons who, in myriad ways, also left their marks by passing through or settling in the city, but whose names do not appear in its official topography. Although the old names endure, at least in memory, this palimpsestic urban space was written over and partially erased as the war's violence zoned the city into red and white neighborhoods—the territories, respectively, of Acang and Obet— identified several Malukan Gaza Strips to publicize this difference, and as some streets were renamed in Muslim areas to reflect the successes of jihad, like Martyr Street.

Under what conditions does ideological clarity become urgent, necessary, or unavoidable? When is it more compelling to stake out hard-edged, simplified positions—socially, spatially, and representationally—than to leave things flexible and fuzzy at the edges? This chapter documents the story of religion under the sign of crisis, a story of a dramatically shifting terrain in which the Christian Javanese refugee possessed by Muslim spirits is not alone in her fraught, layered subjectivity but surfaces within a cluster of similarly complicated if less problematically crossed figures. Recall from the previous chapter Minister Mohammed, who baptized the self-described former worshipper of statues and Chinese Indonesian convert to militant Christianity, or the avid fan of Seram's allegedly bellicose ancient headhunting culture and father of ministers from competing Christianities, or the painter of Ambon's apocalypse who embraced Pentecostalism following his narrow escape from death. Far from forgettable instances of religion on the fringe, these persons and others like them occupied the very center of an urban environment in the grips of diabolical crisis, one that exposed its fractures, imbalances, and points of tension—with all the distress, upheaval, and terror that accompanied that. Beyond simple exposure, the fault lines these people exemplify point to deep seismic shifts in Ambon's social, religious, political, and, crucially, aesthetic terrain, contributing over time to transformations in the distribution of the sensible in the city and beyond.

Emerging side by side in Ambon's postwar environment, its scenes of possession and proliferating Jesus faces seem to pull in opposite directions. If the possessions intimate the possibility of an ethical injunction, of the Christian inability to cancel or close out the Muslim, the gigantic Jesus pictures appear to accomplish just that. Monumentalizing the Christian face on the ruins of the recent war appears to proclaim at one and the same time the facelessness of the Muslim. In light of the uncertainty that undermines Christian assertions of a clear-cut distinction between their illuminated faces and the auraless ones of Muslims, the Jesus pictures seem to protest too much. This protest both realizes itself and dissipates in the drive to monumentalize Christian community icons, in the repaintings and refreshings to which the paintings were periodically subject, and in the reiteration of Christ's portrait again and again.

Much as their gigantic scale, the refreshings have the effect of enhancing the pictures—with brighter colors and clearer outlines, they stand out better in public space. In the immediate postwar, it was as if Ambon's Christians could not do enough to proclaim the pictures' presence. All of these efforts imply that a single picture or even multiples did not suffice to carry out the work for which they were intended. Precisely the pictures' huge, multiplying status hints that even infinite reproductions might be unable to achieve the demands made of them, while also highlighting the dubious grounds on which the identitarian claims they portray were constructed. The pictures disclose the inability—no matter how many are put in place or how big they might be—to foreclose the Muslims who live with and alongside the Christians, making Ambon the fascinating, complicated, multireligious, and multiethnic urban reality that it is. From this perspective, Christ's painted face, much like possession, if more obliquely, is haunted—by the Muslim who hedges and delimits the Christian like some energetic dark shadow.

Barring some exceptions, like Silale with its many migrants, most of Ambon's neighborhoods were not only traditionally segregated on the basis of religion and ethnicity, following colonial policy, but also tightly knit. Certainly, this was and continues to be the case for those neighborhoods that are traditional GPM strongholds. This is also where women come into the picture. Recall that among the five members of the GPM prayer group where the possessions took place, four were women. In Ambon, as in many parts of the world, women guarantee the everyday fabric of the religious lifeworld—as the crucial nodes of Christian neighborhood and congregational sector networks and by ensuring the weekly cycle of domestic and neighborhood prayers, organizing life cycle events, producing the food served on these and other occasions, and running the numerous church drives and collections. Within the congregation they occupy important positions; indeed, Ambon boasts many women ministers. As scholars note, for Ambon and other parts of Indonesia that have witnessed religious violence, government institutions and offices, local political economy, and social life tend generally to be organized along religious lines. Religion in such places is not limited to the church but defines the very structure of society.[85] That the large majority of those possessed in the minister's account were women therefore points to something else—namely, the anxiety among Protestants that the very fabric of their lifeworld was under siege, one held and woven together in significant, religiously defined ways by women. If the possessions struck at the intimate core of the GPM's wartime congregational life—the tiny prayer groups set up during the conflict—so, too, does the predominance of women protagonists in this event underscore how invasive the city's diabolical crisis was. In singling out women, the demonic possession

attacked the gendered lineaments that sustain the network of sector and sub-sector organization binding neighbors and neighborhoods, bringing them together regularly in a range of religiously defined constellations, all mobilized by and dependent on women. Besides the daily flow of gossip, mutual assistance, and common need or interest that characterize neighborhoods almost everywhere, the weekly cycles of prayer, along with the socializing and food sharing that accompany them, tightly structure the space and time of Ambon's Christian neighborhoods along gender- and age-based lines—with, for instance, an all-male prayer group scheduled on Tuesday evenings, that of women on Wednesdays, adolescents on yet another day, and so on—that crosscut wider family and extended kin ties. More generally, the New Order and post–New Order state have relied on women's labor to produce key political and economic orders in the name of neighborliness through national organizations like the one for female civil servants and civil servants' wives.[86] From the time of the Japanese occupation of Indonesia during World War II, neighborhoods have also been key building blocks of state control and monitoring of the population, a form of governmentality that was ideologically reinforced by terms that codified the alleged traditional values of neighborly cooperation and mutual assistance.[87]

If the production of a neighborhood, under any conditions, can itself be understood as the exercise of power over some form of recalcitrant environment, then the Christian neighborhood, with its tight skein of crosscutting relations and weekly and annual Christian rhythms, exemplifies this kind of production.[88] This explains why such neighborhoods so readily became the rallying point for collective, religiously defined action in wartime. But other stories also emerged during the conflict, notably from religiously mixed neighborhoods—stories of people protecting and harboring their neighbors from "the other side" against attacks from their coreligionists, often at risk to their own lives. Nor were all the displacements that resulted in the religious purification of the city's neighborhoods solely motivated by aggression. A moving collection of accounts of nonviolent resistance at the grassroots level from different parts of Indonesia, including Maluku, where violence occurred during the unraveling of Suharto's regime offers countless examples of people standing up to defend their neighbors, combatting prejudice and rumors.[89]

At times, this meant escorting them out of their neighborhood to a place of greater safety where they could live alongside people of their own religion. Other stories celebrate soccer's diplomacy or small, courageous gestures, like making token purchases at the Christian kiosk across the road from a Muslim neighborhood, a public performance meant to be seen by others. When neighbors did turn on each other, they often, apparently, relied on others, coreligionists

from elsewhere, to do the dirty work vis-à-vis their immediate neighbors. Apart from neighbors, schoolmates and officemates of different religions would meet each other, when possible, at the barricades set up in the city center, at military checkpoints, or on payday in the case of civil servants. Cellphone text messaging offered another means of connection. To be sure, such contact was limited, often impossible, and came with considerable risk, especially from coreligionists. In the public service announcement featuring the Muslim Acang and the Christian Obet, this kind of contact is sentimentalized in the boys' prearranged, clandestine encounter (see Chapter 1). The fate of this PSA, however, which provided the conflict's most popular names of enmity, suggests how dangerous and contested such contact must have been.

Until now, I have written of literal neighbors, of peoples who have lived side by side for a long time, have shared with or shunned each other, have exchanged and communicated, positively and negatively, in myriad ways and in shifting historical and political circumstances. To restrict this account, however, to a pair of two, the encounter of the neighbor and the self, is to forego the possibility of conceiving of the third or the mediation and symbolic representation on which any politics is based.[90] An ethics of two inevitably involves a choice—one chooses this neighbor over that—and thus ends up dividing the world into friends and enemies. By contrast, politics moves beyond the face-to-face relation to open out onto an infinite series of potential encounters, "without limit and without totalization, a field without the stability of the margins."[91] Seen in this light, the neighbor would coincide with the stranger—not just the faceless one but the faceless many otherwise left in the shadow in the privileging of the one.[92]

With this in mind, it is worth looking again at Ambon's Christian billboards and especially how they are positioned in urban space. With few exceptions, the billboards and murals face outward, turning away from what, for all practical purposes, became gated communities to confront whoever passes them by. Commonly, they stand at Christian neighborhood entrances on curbs and sidewalks at the edge of public streets and on land usually owned by the city. Yet, if these pictures gate and brand the community, they also seem to extend an invitation outward—to others and to strangers to look back. If this appears too outrageous a claim, think then of the advertisements whose location the Christian pictures often usurp or recall the gigantic suffering Jesus faces that dot the highway and greet the visitor on her way from Pattimura Airport into Ambon—whether she is a fellow Malukan or Indonesian from elsewhere, a government or business envoy from Jakarta, a national or international NGO activist or humanitarian aid worker, a returning migrant, a vacationing Dutch Malukan, a journalist, a tourist, a stranger.

A Muslim woman who was active in a local NGO that worked closely in some of the city's refugee camps with a partner Christian organization identified the addressee of the Christian pictures as the stranger or persons from elsewhere who, predominantly as part of the transnational humanitarian aid industry,[93] flocked to Ambon during the war and the years immediately thereafter. In her view, the pictures were not aimed at enemies or ill-intended strangers but served as helpful signposts assisting those unfamiliar with the city to navigate its treacherous georeligious patchwork of segregated space, no-go areas, and friendly versus hostile terrain.[94] The broader conditions of the postwar city—especially its displaced and refugee populations, returning migrants, densely packed neighborhoods, and urban crowds, not to mention its recent history of a city "possessed," along with the sheer pragmatics of living with religious and other pluralities—are relevant to any thinking about neighbors and neighborhoods. While neither the possibility of violence nor the desire for the other's elimination have been exorcised from the postwar city, I close this chapter by suggesting how the scene of Ambon's possession hints at something else—namely, the possibility of a resignification of the friend/enemy contrast, which would open out onto the social bond that moves one away from intractability and the hard terms of stark oppositions. Considering spirit possession and the city's Christian pictures in the same frame positions these two sites in the postwar city that—however strangely and obliquely—open the possibility of a distinct political theology of the neighbor. Taken together, they intimate a way where haunting signals cohabitation, the possibility of a generosity toward one's others and toward strangers.

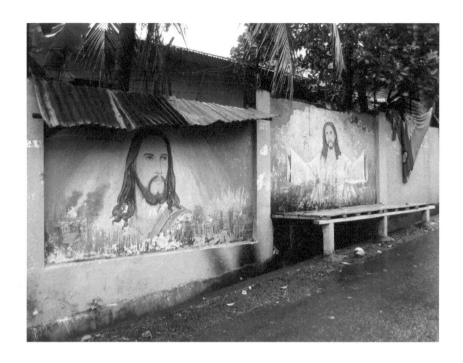

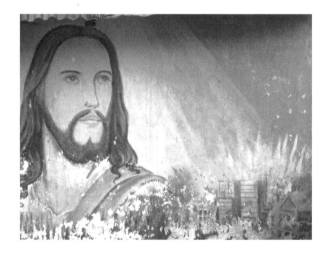

Figure 34. Alleyway with faded murals of Christ overlooking the city of Ambon exploding with violence, Ambon, 2005. Photos by the author.

5
Provoking Peace

The image of peace and reconciliation that cropped up insistently during Ambon's conflict and following February 2002's peace agreement focused on the child. Across different media, ranging from signage and drawings to photographic portraits, short films, and public service announcements on radio and television, the child's face, voice, and bodily presence were repeatedly invoked to depict and affectively charge the peaceful cohabitation of Muslims and Christians in the postwar city. Besides productions featuring single or, more often, paired children, drawings and signs produced by them—in refugee camps, NGO-sponsored posttraumatic healing programs, and schools—that evoked the child indexically via her handwritten slogans and colorful scenes of visual equality between Muslim and Christian were especially popular. To introduce the genre, consider an example from a contest organized in 2003 for Muslim and Christian boys by the Peace and Love Forum of the Jesuit Refugee Service, one among many organizations running reconciliation-themed activities in the period after Ambon's official peace. Awarded first prize, the drawing is exemplary of what postwar reconciliation is supposed to look like (Figure 35). A Muslim imam and a Protestant minister monumentalized and cut off at the waist hover like huge, heroic busts over a cityscape; behind them, an enlarged church and mosque frame an Indonesian flag showing the overlapping hearts of the JRS Peace and Love Forum. A handshake joining the two men mimics the official handshakes of the Malino II Peace Agreement so often profiled in print media and on television, while it visualizes the diffuse influence of Indonesia's state apparatus and bureaucratic rituals within the everyday imagination of the country's citizens.[1] Besides the emblematic handshake bolstered by sentiment in the form of two conjoined hearts, the picture exhibits other features that recur in the

Figure 35. Prize-winning drawing from the Forum for Love and Peace contest sponsored by the Jesuit Refugee Service, Ambon, 2003. Photo by the author.

city's reconciliation genre, especially the church-mosque pair, but also the Indonesian flag and modern Malukan cityscape dominated by skyscrapers. Such images operated within a limited repertoire where the majority echoed and resonated closely with each other. Compositionally, almost all such drawings staged a balance between Muslim and Christian picture halves evident in the image's formal symmetry and the agreement—a handshake, twinned hearts, a pair of doves or white cockatoos—portrayed at its center.

This striking, emblematic picture sets the scene for an exploration of reconciliation and peace initiatives that are the focus of this chapter. Following a discussion of the discourse and practice of reconciliation that framed such initiatives, especially though not exclusively in Ambon, which establishes the main parameters within which such initiatives occurred, I closely follow four of them. They include the ideologically heavy-handed "child in the picture" genre, exemplified by the JRS drawing, and the peace journalism promoted under the auspices of international organizations like USAID, the British Council, and Deutsche Welle as an important part of the wider transformation of media practice within Indonesia's democratic transition. Aiming for balanced coverage, this peace journalism—according to journalists I spoke with in North Sulawesi—advocated a reporting that, with the best intentions, excised and obfuscated many of the explanatory circumstances of the war. By omitting key information, the

journalists aimed to scale the warring parties down to equal size and avoid priv-
ileging one over the other, something that, in their view, risked further exacer-
bating the conflict. If this practice recalls the studied symmetry of the JRS
reconciliation drawing, albeit in a different register, I show how a foundational
sense of inequality underwrote their peace journalism. I then turn to two other
peace initiatives that were less concerned with representing and enabling rec-
onciliation than with preventing violence by promoting positive images of reli-
gious plurality in postwar Ambon. The first are the self-styled Peace Provocateurs,
a loose network of Muslims and Christians who work together to prevent incidents
and reports of violence (often false or aggravated) from spreading and escalating
in the city by countering provocative information with evidence circulated as
text messages and photographs that rely on the widespread use of cellphones in
Indonesia, including Maluku. The second are image-activist collectives, again,
with Muslim and Christian members, who were troubled by the ongoing pres-
ence of online photographs showing Ambon at war several years after peace had
been concluded. To change the appearance of the place in accordance with what
they envisioned as its postwar reality, these young women and men shot sunsets
and other attractive scenes and then posted their photographs online. Another
group that emerged partly out of the earlier photography club is that of Maluku
Sketch Walkers, in solidarity and association with similar sketch groups around
Indonesia and in other parts of the world. These image-makers tour Ambon and
the neighboring islands, sketchbooks in hand, stopping to commit historical sites,
breathtaking scenery, customary performances, and typical Malukan food to
paper. When they upload these sketches on Instagram and, to a lesser extent,
Facebook, their images of compelling localized scenes displace the negative
depictions of Ambon as these are scrolled out of sight.

Spectacles of Reconciliation

When I first visited Ambon after the war in 2003, a sense of the importance of
spectacle already suffused the city. Several factors, both long term and more
recent, fed into the privileging of spectacle as an appealing and dramatic public
display to the aftermath of conflict. First, government officials, along with
community and religious leaders, repeatedly emphasized the entertainment
value of public celebration as a welcome distraction in a city that was still
haunted by the destruction, personal losses, and distress of the war and con-
fronted with numerous problems thereafter. Many ordinary Ambonese seemed
to agree, anticipating in animated conversation the first national Independence
Day celebration on August 17 since the onset of the war, followed closely by the
September 7 commemoration of the city's 428th birthday. Already in early Au-
gust, at market stalls, coffee shops, and on minibuses, I heard people discussing

Figure 36. Collage of photographs from the installation of a raja in Ambon's Batu Merah that was attended by the Muslim neighborhood's blood brothers or *pela* partners from the Christian mountain village of Ema, Ambon, 2006. Photos by the author.

the upcoming events, commenting on the large number of groups that had registered to march on Independence Day. Sitting in front of my hotel on Pattimura Avenue after nightfall, I welcomed the cool evening air as I watched young men and women march back and forth to the tune of whistles and harmonica, interrupted only by their group leader's sharp commands. During the day, the city's larger avenues were cordoned off for public events, especially competitions like a rickshaw race sponsored by a political party or a motorcycle rally, while colorful parades regularly inundated the streets, displacing traffic. Especially memorable were a carnival parade held in anticipation of the Calvinist GPM church's September anniversary and a boisterous procession of truckloads of children arrayed in glittery costumes representing the nation's cultural and regional diversity. Reminiscent of the culture of contests promoted under Suharto to encourage popular participation in state programs or events organized by nonstate agencies but beholden to the regime's discourses and policies, these postwar displays similarly aimed to entice people into committing themselves to a sense of urban and national pride—but also possibility and futurity—in the nervous environment that prevailed after the official peace.[2]

Secondly, apart from the perceived need for entertainment, the implementation of the country's regional autonomy program offered in Ambon, as it did around the archipelago, ample opportunity for public rituals and events. Prominent among these were the installations of community leaders under the reinstated Malukan system of government, displaced in 1979 under the New Order by the widely despised model centered on villages.[3] Commonly, such installments were double in the case of Christians, with the first carried out in accordance with customary law and the second civil bureaucratic. For Muslims, there might

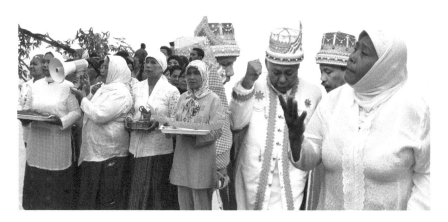

be as many as three ceremonies—customary, civil bureaucratic, and religious—if the leader was also appointed head imam of the village or neighborhood mosque. Another highly visible aspect of authority's decentralization to regions beyond Java was the construction of brand-new government buildings, along with the rituals that marked stages of their completion and inauguration.[4] Alongside the construction boom materializing Maluku's expanding, regional infrastructure, the rehabilitation and reconstruction of churches, mosques, and public offices in the city and around the island that had been damaged or destroyed during the conflict offered other occasions for people to come together and were a punctuation for the process of recovery through fundraising events, foundation-laying ceremonies, and other social gatherings. Custom's valorization and revival, stimulated by regional autonomy and the special role assigned to it, emphasized custom as a widely proclaimed instrument of peace, while providing another source of public spectacle that helped to overshadow the recent trauma and divisiveness of the war (Figure 36).[5]

Among the many events held in custom's name, most visible were the highly ritualized, emotionally charged blood-brother renewal ceremonies that could last several days and involve numerous participants, even from as far away as Jakarta. These especially attracted media attention and were publicized long before they occurred (Figure 37). Under the broad umbrella of reconciliation, the symbolism of blood brotherhood, especially the white cloth of kinship and embodied connection, was extended to myriad ritualized encounters between Muslims and Christians that were unconnected to any alliance relation. Although never realized, the most dramatic example of a ritual involving the popular white cloth was a fantasy shared with me by a GPM minister who had studied entertainment in addition to theology in Jakarta. A major figure in the city's peace and reconciliation activities, he imagined an eye-catching spectacle

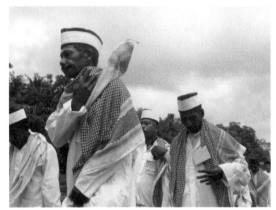
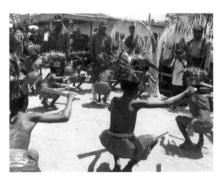
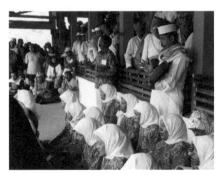

Figure 37. A blood-brother renewal or "warming" ceremony (A.M. *panas pela*) between the host village of Ouw on Saparua Island and their Muslim *pela* partners from Seith on Ambon Island. The photograph on the bottom left shows boys from Ouw welcoming their guests with a performance of the *cakalele* war dance. Ouw, 2005. Photos by the author.

involving a helicopter that would carry men and women dressed in customary clothing dangling on cords beneath it as an enormous white cloth unfurled in the skies over Ambon behind. Should this plan prove too costly, he had thought of an alternative in which an immense one-thousand-meter white cloth, which he claimed could be purchased in Surabaya, would be extended from Latuhalat Cape to Ambon City as the commingled sounds of church bells and mosque drums filled the air.

Thirdly, in Indonesia generally, a recurrent feature of the post-Suharto era has been the pronounced publicity—often highly theatrical—of a panoply of political, religious, and artistic forms and performative styles that claim the nation's streets as their stage. Reformasi and its fallout unfolded as multiple demonstrations in streets across the nation. While most of these demonstrations occurred after Reformasi was the norm, in Ambon they took place during the war. Especially notable was the mass procession of Christian clergy against forced conversion to Islam, mentioned in the previous chapter, another involving Christians who sang religious songs and carried fake coffins in protest of the city's civil emergency, that of Muslim refugees who marched against the civil emergency's closure of the Laskar Jihad radio station, and an antiviolence protest by women affiliated with a national organization that originated in Jakarta in the months preceding Suharto's fall.[6] Early in the conflict, as mentioned in Chapter 1, Protestants filled the streets with their ambulatory prayer sessions.

Apart from official activities held under the banner of peace and reconciliation, many smaller events that claimed reconciliation as their rationale took place around the city. Often, on such occasions, whether more official or not, what reconciliation meant was not well understood or, for that matter, seriously engaged. Nor was it often clear who or what was allegedly being reconciled. Two examples from my fieldwork stand out. The first an "Evening of Re-encounter" in early September 2003, organized at what before the war had been a luxury hotel up the coast from the city but looked shabby in its wake, notwithstanding the efforts that had been made to lend it a festive appearance. Organized to raise funds for the reconstruction of a GPM church that had been burned down during the conflict, the evening began with a buffet meal, followed by a benefit concert featuring some of Maluku's most renowned singers that was repeatedly interrupted by prominent Protestant Ambonese making fundraising pitches and promising cash contributions.[7] If the majority of the guests present, including the singers, were Christian, the evening's professed aim of "Re-encounter" (or, in Ambonese Malay, *baku dapa*) and the invitation to the event—showing a huge handshake between two male hands protruding from white shirtsleeves and jackets flanked by a heart, two cockatoos, and palm

fronds—recalled the Malino II Peace Agreement and, with it, Christian-Muslim reconciliation but also the Malukan phrase *baku baik*. Translated as "being on good terms or at peace with each other," the phrase served occasionally as a substitute for the Indonesianized version of reconciliation. Yet, despite the surplus of such interfaith symbolism, the only re-encounter taking place was one between Christians. Christians were hardly alone in the exclusivity of their reconciliation events. For instance, I attended a children's "reconciliation party" on Haruku Island off of Ambon where the majority of the participants were Muslim, even if the representatives of the sponsoring organization included both young Christian and Muslim men and women.

My second example is a GPM Protestant women's group who put out a VCD titled *Muslim-Christian Reconciliation*. The footage records a ceremony, sponsored by the city government, that brought Muslim and Christian community representatives together in what had been a major Christian wartime stronghold. With the sale of the VCD, the women hoped to fund a trip to the city of Surabaya in East Java to meet with another women's organization that had sent clothing to be distributed to displaced Christians during the war. Using an Ambonese Malay expression that combines a sense of enjoyment with casual social visiting, the group's spokeswoman confirmed my impression that the women had, more than anything else, a pleasure trip in mind. Perhaps reading my thoughts, she volunteered that the group might support, at some future date, the construction of a reconciliation monument.[8] She also claimed that although the GPM women had advocated for a women's part in the reconciliation ceremony, following the event, a delegation from their organization had visited the village of the Muslims where they met functionaries but no women residents. Once the more formal part of the evening's meeting was over, including prayers, the conversation turned to household items like brooms that the women also planned to sell to collect the money for their trip—and to Muslims. Although by that time I had often heard vicious remarks and complaints voiced by Christians about Muslims, I was still shocked to hear the women speak so openly and disparagingly about them—some three and a half years after the conflict ended. One woman insisted, for instance, that "an atmosphere of peace" could only be achieved by Christians, another that the Muslims would have all women wearing headscarves instead of crosses, still another that "God is just since many of them were killed."[9] Such uncensored comments were all the more remarkable given that they had just spent time talking to me, not without pride, about the efforts they had made in the name of reconciliation.

These examples give a sense of just how elusive, misunderstood, and out of touch with postwar realities—especially the lingering fear, resentment, and prejudice on the part of many in the city, and not just Christians—the reconciliation discourse promoted by the city government, international

organizations, and most NGOs was.[10] Abstract, seemingly omnipresent after the conflict, and experienced by many as external—which the foreign-sounding word *rekonsiliasi* only confirmed—many of these initiatives did offer some distraction, as authorities hoped—or a snack or simple meal. Apart from the more official events, small acts, tokens of generosity and mutual recognition between neighbors, and, as time went on, everyday interactions between Muslims and Christians also occurred, and these may have done more to gradually restore a sense of normalcy in the city even if they were not cast as reconciliation. Besides the ordinary exchanges of everyday urban life, there were grassroots as well as more top-down reconciliation initiatives. Exemplary of the former are the Peace Provocateurs and image-activists who responded, respectively, to incidents that threatened to provoke interreligious violence and to the realization that stubborn, inaccurate perceptions of Ambon needed to be addressed. Yet, notwithstanding such examples, the majority of peace and reconciliation initiatives in the city fell somewhere near the middle of a spectrum between the more official, top-down ceremonies, on the one hand, and grassroots action and organization, on the other. This is not surprising. If we consider only the countless handshakes embellishing reconciliation media on television, in newspapers, and in children's drawings, or the ubiquitous white cloth, borrowed from blood-brother ceremonies, then it becomes apparent how artificial—for the most part—binaries between state and civil society, official and grassroots initiatives are. This observation is not meant to detract from the criticisms voiced by many Ambonese regarding the Malino II Peace Agreement's elite character or to devalue the efforts of cultural activists, religious and community leaders, NGO workers, and ordinary Ambonese who worked to move the city beyond war. It is to recognize, instead, how officialdom and the people often share certain references, not the least a certain conception of the aesthetics and stylistics of power, the way it works and expands.[11] In a place like Indonesia, emerging in the early 2000s from decades of authoritarian rule, and in Ambon, specifically, where officialdom in the form of the city's large civil bureaucracy and the people were highly interconnected, the aesthetics and stylistics of power they shared was, not surprisingly, considerable.

The Child in the Picture

As I suggested in the Introduction, the 2001 film *Viva Indonesia! An Anthology of Letters to God*, along with myriad other child-centered productions, visualized and helped to consolidate a pervasive sense of the nation's orphaning after Suharto. Like the forlorn figure of a child against a sea of flames on my airplane ticket flyer in 2003, such images circulated widely in Indonesia in the early 2000s as part of a genre that foregrounded children at risk, amid war's ruins,

or afflicted by violence. While indebted to this genre and to its localized versions like the Acang and Obet television ad, children's reconciliation drawings converged around the city's most urgent postwar problem—that of ensuring sustainable peace and the cohabitation of Christians and Muslims. With few exceptions, the reconciliation drawings double the lone child depicted in violence to accommodate a Muslim-Christian pair in variations on the imam and Protestant minister couple in the JRS prize-winning picture. Radio and television ads achieved the requisite doubling by juxtaposing two children whose faces, bodies, and/or voices stood in for the two religions.

Together the genealogically prior image of the child in violence that surfaced during the New Order's unraveling and the child who endorsed Maluku's reconciliation belong to a genre or "a historically accreted way of seeing that both enables and constrains new possibilities for vision, and casts a selective frame and focus on the world that comes with its own characteristic blindnesses and visibilities."[12] I call this the "child in the picture" genre so as to capture the crucial indexicality that sutures the child's productions to her body and her visual currency as the protoplasmic potential of the Indonesian nation, generally, and the compromised if still hopeful future of the Central Malukan capital, specifically.[13] In what follows, I examine children's drawings and posters, along with radio and television PSAs, the latter highlighting some of the challenges children faced after the war, while countering these with scenes of young people's natural exuberance and expression. I also analyze a children's fashion show, titled "Happy Stage," in which children performed the nation, in ways that they had under Suharto but with a telltale difference after the war.

Besides being an especially clear and well-executed example of the genre, the JRS picture with which I began this chapter does not differ much from others in the contest. For the most part, the children's drawings produced in this setting and in other reconciliation programs represent variations on the same basic scheme that reiterate, above all, the mosque and church pair while portraying their formal equivalence. Less grandly, for instance, in other drawings from the contest, a Muslim-Christian couple holds hands on a road that bifurcates behind them in the parallel directions of a church and a mosque (Figure 38); a minister and imam shake hands in the middle of a road as a soldier approaches them from behind (Figure 39); and a woman wearing a small cross and another with a headscarf stand to either side of a field of flowers (Figure 40). Occasionally, the Christian-Muslim equivalence comes more explicitly framed by the Indonesian state, as in another drawing where precautions seem to have been taken to guarantee its presence: the Garuda bird of Hindu mythology but also of state insignia stands with outspread wings on a plaque inscribed with the national "Unity in Diversity" motto above the canonical church-mosque pair mediated by the Indonesian flag between them

(Figure 41). A number of the drawings feature no people at all, although they show signs of human presence, such as one that provides an aerial view of the city with a soccer field flanked by a church and mosque on one side of a modern highway and a blue sea edged by a beach complete with lounge chairs, umbrellas, and a swimming pool, on the other (Figure 42). Another shows a church and mosque pair with a cross and crescent moon enclosed in a heart (Figure 43). Several drawings emphasize the importance of education through the portrayal of a lively schoolyard or schoolchildren carrying books or depict the postwar city in the midst of energetic reconstruction or its outcome—a busy market, a bank rising among a cluster of high buildings, a crowded street with cars, pedestrians, and a bright yellow bus. Others reiterate the handshake of reconciliation and mosque and church pair (Figures 44–49).

Two years before I saw the pictures from the JRS contest, I was shown strikingly similar drawings made by children enrolled in trauma counseling and healing programs in refugee camps in Manado and the neighboring port town of Bitung in North Sulawesi. These, too, portrayed adjacent churches and mosques—a few boasting parallel smiles—and interreligious couples.[14] In July 2013, a Facebook post of a Malukan journalist described the entry that had been awarded first prize in a GPM–sponsored contest: "There is a church next to a mosque. A Muslim and a Christian meet at the point of intersection between the church and mosque on a flowering lawn with blossoming trees. Even the sky is filled with flowers. Drawing by Rusli Mewar, a child from Batu Nega Negeri Waai, elementary school Negeri 5 Waai, 6th grade."[15] Although he did not upload the drawing, it is evident from this brief description how much it recapitulates the key elements of earlier ones, including many from the JRS contest some ten years before. Apparently, between 2003 and 2013, the aesthetic and ideological criteria for showcasing Muslim and Christian cohabitation, at least in children's drawings, had not changed. Divided in equal halves, the picture remains centered on a church-mosque pair or persons emblematic of the two religions surrounded by a surplus of signs that convey what keeps the imagined, bifurcated world together—whether the flowers and natural exuberance of the Facebook post, the twinned hearts and doves sentimentalizing connection, or the state-backed bureaucratic handshake. Children themselves continue to be brought in to suffuse their productions with the pure sentiment they allegedly embody, untainted by politics or other factors of adult derivation or design, echoing the Acang and Obet PSA, as I elaborate below. Missing from the Facebook post is any mention of the Indonesian flag or other national symbols. However, a minority of the pictures from the JRS contest or those from refugee camps and reconciliation programs, whether in Ambon or North Sulawesi, include such explicit signs of the state like the flag, its red and white colors, the Garuda bird, or the "Unity in Diversity" motto. When the state does

Figure 38

Figure 39

Figure 40

Figure 41

Figure 42

Figure 43

Figures 38–49. Children's drawings from the Jesuit Refugee Service Forum for Love and Peace contest, Ambon, 2003. Photos by the author.

Figure 44

Figure 45

Figure 46

Figure 47

Figure 48

Figure 49

appear in postwar productions, it does so less through such conventional symbols than in the guise of the national army soldier, as I explain below.

Much like the drawings, public service announcements aired on radio and television during and after the conflict exhibit a persistent concern with demonstrating symmetry and balance between Christian and Muslim manifest in the allocation of equal screen time or airtime and in their religiously marked paralleled voices and bodies. Radio PSAs often took the form of successive Q&A sessions between an imam and Muslim child and a Protestant minister and Christian child that simultaneously performed the innocence of the child witnessing violence and her dependency on adults. Occasionally, a more in-the-know child ventriloquizes the pedagogical role of the adult, as in one ad in which a child wonders why so much of the city lies in ruins and another volunteers that "it was torched by people." Excerpts from interviews I conducted in 2003 with journalists from some of Ambon's newer radio stations established toward the end of the war underscore the powerful ideological role of the child and the compelling, affective power of her voice: "Things are more emotionally touching when voiced by children, they express themselves directly without guile," one journalist asserted.[16] "Children suffered more during the conflict," another offered. "They could not go to school or play with each other. . . . Their character is straightforward, 'natural' [in English]." "Anything involving children is of interest," yet another claimed, summing up the conversation.[17]

Somewhat differently, another journalist recalled how the many banners hung over Ambon's streets after the peace interpellating passersby with slogans like "Our peace must recall the future of our children" had influenced their radio PSAs.[18] Such injunctions inevitably have a top-down feel to them not only because they were put there by the city government, the authorities in charge of the civil emergency, or the national army or police but because they were written in the formal Indonesian of state administration or, occasionally, an odd blend of it and vernacular Ambonese Malay.[19] Quite a number explicitly invoke the state or army, such as "With the red and white [flag] planted in your chest we will rebuild Maluku" and "Once Ambon is peaceful we [the armed forces] will also be happy to return home." But such slogans also made their way onto the peace posters and banners made by children in reconciliation programs where they remediated the language and tone of the official pronouncements and radio PSAs. Statements like "We want to study in peace" or "Do not ignore our future" are typical. Even when confronted with the sheer redundancy of tropes and visual forms across reconciliation media, almost all of the schoolteachers, religious instructors, and NGO and humanitarian organization representatives with whom I spoke in Ambon or, for that matter, elsewhere in Indonesia insisted on the spontaneous nature of the child, their innate creativity and unmediated expression and, crucially, too, how they cannot be manipulated.

Marginal images occasionally disturbed the narrow conventions of the reconciliation genre, such as one that mixed English words and slogans with Ambonese Malay and graphically departed from the monochrome block letters and straight lines favored by most. This poster was altogether more decorative, employing a cursive letter type that combined capitals with small-case letters, alternating blue and green ink, and rendering slogans as discrete shapes across the page: "Peace forever" laid out in the form of an arc echoes in English a block in Ambonese Malay that reads "Peace in my heart, in your heart, in Ambon," while "love," again in English, runs up the poster's left side. Graphically and linguistically, the poster contrasts with others where the formal Indonesian jars with the vernacular Ambonese spoken in the city by both adults and children. At the office of a local NGO, children were given free rein to design their own peace messages on a large banner, with several drawing on the partisan language of war in phrases like "A message from Obet" or "We Obets want peace to return" (Figure 50). While organizations involved in reconciliation commonly regarded the elimination of the conflict's incendiary terminology as a crucial step in promoting peace, the name Obet for Christians

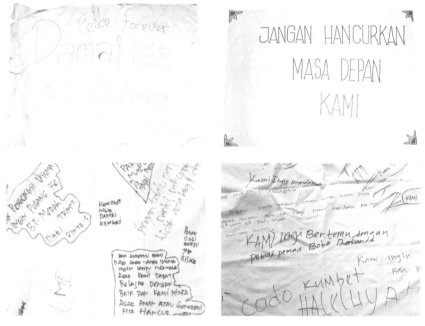

Figure 50. Messages scrawled by children on a banner suggesting a range of graphic and linguistic references—from the freer style of the top left incorporating English expressions to the formal Indonesian next to it that reads: "Do not destroy our future." The two photographs on the bottom display an assortment of statements and desires, including "We refugees from Wisma want to return home to Batu Merah," "We want to meet the soccer players from Holland," "We Obet(s) want peace again," or simply "Haleluyah [sic]," Ambon, 2003. Photos by the author.

that crops up here serves as a signature but also suggests how much terms of enmity became assimilated during the conflict. It also reveals what happens when children rely on their own preferred media examples rather than being instructed to reproduce the preferred models of peace and reconciliation.[20]

Children's drawings are especially telling. Children in refugee camps around Ambon were regularly invited to sketch as part of various NGO projects. Women from a mixed religious NGO were especially committed to inspiring children to imagine their futures through art. A standard question asked, "What are my aspirations?" Drawings that stand out as different include several I saw in refugee camps around Ambon that depicted soldiers rather than "doctor" or notably frequent "president," the more common responses to this standard exercise in national pedagogy (Figure 51). Women from the NGO who worked as a team—dividing their time, not incidentally, between two Muslim and two Christian camps—believed that such drawings spoke less to the ongoing visible presence of national army troops in Ambon under civil emergency than to the persistent sense of vulnerability among children and the security represented by the national army soldier wielding a gun.[21] One woman speculated further that the soldier's popularity among the camp children may be because they "think soldiers are more likely to survive,"[22] a statement that summoned the horrors many of the children had been subject to or witnessed. But like the English words and phrases that surfaced in some peace messages, the pervasive influence of media representations is undoubtedly also at work here. Besides what children heard and saw on television, the army put up large promotional signs and banners profiling itself as safeguarding the common good and future of the city but also as uniquely capable of securing the relative peace imposed by the civil emergency.

Elsewhere in Indonesia, soldiers appear in children's drawings, as in a "Reformasi through Our Eyes" contest held in Yogyakarta where some images portrayed "smiling round-faced soldiers pointing at smiling demonstrators, and demonstrators who smile as they set fire to cars or even lie dead on the ground."[23] In contrast to Java, where these images focus on violence, such explicit images of violence are notably absent in children's drawings from Ambon or those made by Malukan children in refugee camps in North Sulawesi. In Java, the contexts mediating the production of these drawings included not only the culture of contests mentioned above and the pedagogical strategies encouraging children to witness and visualize history but also anxieties about the impact that media images of Reformasi violence might have on them.[24] In Ambon, however, children saw violence mediated in images of their city and, occasionally, even neighborhood at war on television and in print media. These mediations intersected with their own lived experience, as they were exposed directly

Figure 51. Children's drawings on the walls of a refugee camp outside of Ambon City depicting national army soldiers, including a female soldier, and policemen, Ambon, 2005. Photos by the author.

as participants, bystanders, and victims. This may explain all the more why energy seems to have been invested in visually erasing the violence. From this perspective, depictions of smiling mosques next to smiling churches drawn by children sheltering in North Sulawesi refugee camps are especially unsettling, even repressive. Most of the people I met there in 2000 and 2001 in barracks run by Catholic nuns and in a school auditorium and factory complex made to accommodate refugees spoke openly about the violence and terror that had forced them to leave Maluku and, in more than one instance, about their desire

for revenge.[25] In the camp where children drew smiling mosques and churches and where many of the IDPs were either civil servants or Protestant ministers of different denominations, my experience was no different. Given how traumatic the flight of many of these people had been and how recent, for many, their arrival in Sulawesi, not to mention the hardship of life in the camps, admitting any sign of violence or physical or emotional trauma would have immediately disabled the pedagogical and political strategies for which the children's drawings had been designed.[26]

Ensuring that these strategies remained in place had several implications. The production of PSAs in 2006 advocating against violence directed at children reveals the efforts made to ensure that the child's expression, on which the efficacy of the genre depends, appeared natural and authentic. On those few occasions when violence did appear, it did so, consistently, in the form of the national army soldier enforcing religious diversity from the sidelines. Or, in other words, as an image of violence that reveals its presence only to disavow it, since the soldier surfaces as the safeguard of religious cohabitation, as an agent preventing violence rather than one who wields it, as in the drawings from Java. Under Suharto, national integrity was often condensed into the dense but concise concept of "Unity in Diversity" or a visually embellished map of Indonesia. In postwar Ambon, by contrast, the occasional appearance of the armed forces soldier in reconciliation media exposed the state violence that always kept the country together. Now it appears with a new sense of fragility with respect to religious plurality and cohabitation, and it does so even if this token of state violence hovers, as in some drawings, discreetly in the background. In what follows, I turn first to a children's fashion show where the telltale soldier's significance emerged especially clearly and then to the antiviolence television ads.

A "Happy Stage" performance organized by the GPM in 2005 for kindergarten children featured a fashion show in which children dressed in clothing "from Sabang to Merauke," the conventional linguistic trope for the expanse of national territory in official propaganda but also in popular forms like television shows and songs. To the sound of cheers and laughter accompanying the high point in the daylong event, children arrayed as bridal couples from different Indonesian provinces and instantiating its "Unity in Diversity" motto lined up on the stage. During the day, ample attention was given to the celebration of Malukan custom—little girls appeared timidly in the woven sarong and crescent-shaped headdress of Southeast Maluku and a group of boys demonstrated a local tug-of-war game, while another shook small shields and shouted at the audience in an especially noisy rendition of the cakalele war dance. Children entertained their parents, teachers, and a handful of civil servants as butterflies, flowers, frogs, and, with another nod to Southeast Maluku, even cassowaries. There was a procession of white rabbits in long gowns with droopy ears that,

unfortunately, called to mind the signature appearance of the Laskar Jihad—at least for me. Boys and girls representing Indonesia's standard occupational groups like farmers, fishermen, civil servants, TNI soldiers, naval officers, and police trooped across the stage. Especially serendipitous was a trio of children— dressed as an imam, priest, and Protestant minister—arrayed on stage in an image of religious equivalence with, tellingly, a small soldier in army fatigues positioned to one side of the trio as if to secure their unity (Figure 52).

Figure 52. Children's "Happy Stage" performance. The photograph at bottom shows children dressed as an imam, a Protestant minister, and a Catholic priest with a soldier positioned at their side, Ambon, 2005. Photos by the author.

A "Unity in Diversity" poster that was sold in stores on the West Papuan island of Biak in the 1990s featured a map of the nation and three rows of couples wearing their province's traditional dress, visualizing diversity as a function of variation across set categories. Schoolchildren in Papua and across the nation learned from such representations that Indonesia's regions were separate but culturally equivalent, each province having its own traditional wedding costume, house, and dance.[27] If these earlier representations showcased the cultural equivalence of state-endorsed forms like marriage or house styles, framed by a map of the archipelago or national "Unity in Diversity" motto, what is remarkable about Ambon's reconciliation media is the persistence of the principle of equivalence divested of any obvious national framework. If we consider, against the backdrop of the 1990s "Unity in Diversity" poster, the bifurcated portraits of Muslim and Christian or the audible ones allocating equal airtime to their religiously marked voices, then it would appear that, with reconciliation, equivalence itself became a fetish or something that needed to be reiterated compulsively, again and again.[28] Echoing the equal picture halves of the reconciliation drawings and the equal airtime and screen time of the PSAs, a precise balance between Christian and Muslim participants was also sought—and publicized—in reconciliation programs and activities, generally. Across the numerous NGOs and organizations engaged in reconciliation around the city, care was inevitably taken to ensure that the number of participating Muslim children was precisely matched by that of Christians and that resources and attention, whether in camps or neighborhoods, were equally divided between Muslims and Christians. The postwar practice of drawing political candidates like the city's mayor and vice mayor from both religious communities, and the huge faces of Muslim and Christian leaders on billboards congratulating each other on the occasion of their respective holidays, are another medium where the all-important religious equivalence appeared.

My last example focuses on the production of a number of PSAs by a reputable, international child-focused organization in collaboration with a Java-based film crew and facilitator that were broadcast on television in connection with Indonesia's National Children's Day celebration on July 23, 2005. I followed the production from the tryouts of Muslim and Christian children for a part in the ads and the making of storyboards to shooting on location in early July and the discussion several days later that accompanied the screening of the first cuts. These PSAs were ideologically complex productions. The producers and people from the international organization were fully aware of the prevalent stereotypes of children, deployed a participatory mode of work that valued children's input, and aimed to present a less artificial, less tutored, and, in the Indonesian setting, less Java-centric image of the child in their ads. Yet, in spite

of these intentions, the PSAs ended up confirming rather than complicating the stereotype of the spontaneous, natural child, even if she appeared more Malukan than Javanese.

To achieve this result and evidence the child's expressiveness—the title, not incidentally, of one of the ads—meant screening out the mass-mediated experience that surfaced in the children's tryouts and screening in the visual signs of authenticity and lack of adult mediation.[29] When the children, ranging in age from around six to sixteen, were asked to enact in succession a happy and a sad scene, the results varied from the touching to the hilarious. In acting out scenes that often underscored the importance of education—as well as "the culture of contests"—in Indonesia, many of the children drew not surprisingly on the popular televisual examples around them, especially the equally melodramatic Indonesian soap operas and South American telenovelas that enjoyed great success in Indonesia and other parts of Southeast Asia at the time.[30] Striking, too, was the use of national language as Ambonese children abandoned local speech patterns and tried to use words and expressions they had heard on television and been taught in school.

Three of the final ads promoted the children's need for "freedom of expression" against an educational and wider cultural environment where children were held to be silenced and subjected to different forms of violence. To portray this difference, no less than three of the four ads turned on a contrast between a first part that established the particular source or site of violence and a second part that affirmed the free spirit and natural expressiveness of children. One simply titled "To Express Oneself" opens with a close-up of three children who each depict the consequences of school violence differently—one covers his eyes with his hands, another her mouth, a third his ears—followed by the shot of a group of children mimicking these actions that dissolves into a final redemptive scene where children make goofy faces and horse around. A film camera and lamp visible in the last shot are meant, the producer told me, to suggest that children have "their own media through which to express themselves."[31] Another ad opened with a tolling bell and a closing school gate, followed by the shot of an empty classroom with math equations scrawled on a blackboard. This image gave way to scenes of boy-girl pairs, dressed in the national uniform of Indonesia's elementary, junior, and senior high schools, studying with books under trees in a natural, noncoercive environment beyond the disciplinary classroom. A third ad continues in the same vein, with the first part focused on three dejected-looking children—victims of the three kinds of violence highlighted in the ad through statistical charts documenting incidents of violence at school, in the home, and in society—followed by an image of children grouped together and smiling on a pristine Malukan beach with a

pink sunset behind them. With even their own media at their disposal, the children's worlds depicted in these ads feel authentic to adults, precisely because adults are not depicted (Figure 53). Much like the infamous Acang and Obet ad, adult visions of past violence and future peace had to be interpolated through children's eyes.

If not every picture or every PSA is equally indebted to the child in the picture genre, it is striking how much even these more self-aware productions end up reaffirming the same stereotypes that underwrite the children's bifurcated reconciliation drawings, the slogans on banners and posters, and the parallel dialogues of the radio PSAs. It is only by safeguarding the child's authentic expressiveness and showcasing Muslim-Christian equivalence that any of these reconciliation media help to sustain the aesthetic and ideological purposes for which they were conceived. Still, it would be a mistake to assume that the mediation of the nation or peace in Maluku by these aesthetic productions proceeds easily or effectively.[32] Under any circumstance, the constant slippage and uncertainty in the idea of the nation and, here, especially that of religious identity and cohabitation ensures that mediation happens without any guarantee of return or complete fidelity.[33] Moreover, the incompleteness and loss that inevitably accompanies any iterative process is bound to be more pronounced in a situation where the connection between affect, aesthetics, religious plurality, and nation is especially compromised.

Although I have focused in the preceding pages on the spectacles and aesthetic artifacts of reconciliation, these examples ask us to also recall their limits. Most strikingly, the contrast between the sheer weight of the ideology with which these artifacts are invested and the lack of social and political resonance with the realities of the postwar situation in Ambon and North Sulawesi refugee camps demand that we recognize how much they were asked to achieve. Given that the connection between representations and their uptake is always unforeseeable, the child in the picture productions must have often misfired and been dismissed in milder versions of the fate that befell the Acang and Obet ad.[34] Some, however, were clearly compelling enough to scrutinize more closely. What especially comes to mind are depictions of religious difference that include a novel graphic element in the form of a national army soldier, introduced apparently to make the religious cohabitation in the picture more plausible. If, in such examples, a long-standing conception of the aesthetics and stylistics of power remains, the ground on which such power stood both after Suharto and following peace in Maluku was less firm than it had been before, necessitating a visual representation of state power.

Figure 53. Children performing scenes for antiviolence
public service announcements produced for television by
an international child-focused organization, Ambon, 2005.
Photos by the author.

Peace Journalism

In his dedication to the ordinary man at the beginning of *The Practice of Everyday Life*, Michel de Certeau describes a shift in anthropological and sociological attention corresponding to the advent of the number, along with democracy, the large city, and administrations. With this shift comes the waning of the name, the previous mode symbolizing families, groups, and orders, as their representatives disappear from the academic and historical stage they had previously dominated. De Certeau's language illuminates the theater and spectacle of new sensations: "Floodlights move away from actors possessing proper names and social blazons to settle on the mass of the audience, a multitude of quantified heroes lose names and faces as they become the ciphered river of the streets, a mobile language of computations and rationalities that belong to no one."[35]

I draw loosely on Certeau's distinction between name and number to explore another dynamic of Ambon's reconciliation media—namely, the tension between historical and sociological specificity, on the one hand, and a generalizing language that belongs to no one, on the other. A recurrent feature of these media is an insistence on displaying a marked equivalence in pattern, spatial and temporal distribution, and number that would scale the enemies of the conflict down to equal size. Such a move entails bypassing or glossing over all the particularities that can be subsumed by a name, including, most relevant here, those of social location, regional difference, and political positioning, and the considerable heterogeneity within and among different religions. In the case of Muslims and Christians in Maluku, it sidesteps the history of their distinct relations and attitudes vis-à-vis state authorities, both colonial and Indonesian, the differential access they have enjoyed with respect to resources—local, regional, and national—and the longue durée of their interactions under the Dutch colonizers. Yet, as we have seen, in the large majority of reconciliation media, historical specificity and contextualization are frequently replaced by myth and transcendence.[36] By and large, these media are spectacular and monumental or scaled-up in other ways—busts of religious leaders float over skyscrapers in children's drawings, lengths of white cloth dance in the sky above Ambon or extend from cape to city in a Protestant minister's fertile imagination, the sounds of church bells and mosque drums drown out difference while huge bureaucratic handshakes emerge everywhere. As with the fetishized equivalence of the reconciliation media, peace journalists reporting on Maluku's conflict focused on numbers, conferring added significance to number as a category. In their writings, number displaced the specificity conveyed by a name and the contextualized descriptions of the interreligious conflict that

name could convey. Yet, if the example of peace journalism helps to bring out the contrast between name and number as distinct representational strategies, the contrast between name and number in the journalists' reporting is in some respects more apparent than real.

From any perspective, the politics of numbers in wartime is complicated. Scholars, humanitarian activists, peace journalists, and NGO workers often comment how charged and contested the reporting of the numbers killed in conflict is, whether during wartime or in the postwar accounting that follows. If never neutral or inert, the numbers of the dead in conflict situations often assume immense importance since they have the capacity to stand in for the victimization or devastation of the community; can magnify or minimize the harm done, including the manner and objectives with which the violence was carried out; may help to distinguish perpetrators from victims, which, at times, is deduced from the sheer magnitude or atrocity of the deaths suffered on either side; and, crucially, serve as evidence in calls for justice. Numbers of victims are exceedingly difficult to obtain and determine with accuracy, while large numbers of dead are difficult to comprehend. In addition to the difficulty of obtaining accurate numbers of the dead, the political weight they carry and the stakes and claims made through them—as when parties clash in their view of the numerical representation of an event—have crucial implications for the analysis of atrocity and exercise of social justice. In any context, there will also be considerations regarding the timing of the release of important numbers and concerns about how and where they should circulate. Apart from these issues, there is the excess that no numbers can contain—whether the unfathomability of a million versus two million deaths or the incalculability of the acute singularity of a life lost.[37] In tense situations, like that of Ambon's postwar, numbers will be used strategically, as when the equal numbers of Muslim and Christian children who benefit from a posttrauma or reconciliation program are publicized. Along similar lines, the material presence of single-family homes in the massive posttsunami reconstruction in North Sumatra served as a visual accounting of the relative success of rival NGOs.[38] Nor is the reckoning of numbers linked to violence all that different from the tallying that takes place after democratic elections—indeed, when the numbers are contested, elections may result in violence, as they often do.[39] Whether made explicit or not, what underwrites the reckoning of the dead, participation by Muslims and Christians in reconciliation programs, or the results of democratic elections is the urgent question of who counts or who counts most and who, by contrast, does not.[40]

From the early 2000s, numbers played a crucial role in a handful of self-styled peace journalists' reporting on the violence unfolding in Maluku—whether on Ambon, in the North Malukan sultanates of Ternate and Tidore,

or on the island of Halmahera—where they were used to deflect attention from the main protagonists and events of the war. The aim in so doing was to prevent print journalism from contributing to and further aggravating the violence. Echoing the fetishized equivalence of the reconciliation media that visually neutralize the charged contrast of Christian and Muslim, the peace journalists deliberately excised the religious identities of the war's protagonists from their reporting. In the place of these identities, a torrent of numbers, among other obfuscating strategies, systematically elided the supposedly more incendiary names and religiously marked institutions that circulated in the conflict.[41] At issue was less the charged vocabulary of enmity like red versus white or Acang and Obet than the previously commonplace designations of Muslim and Christian or nouns like *church* and *mosque*. The problem of such terms for the journalists is that by definition they name and identify religious difference as the origin of the conflict. By contrast, peace journalism aimed to displace the volatile religious nomenclature by wrapping it in the allegedly objective language of numbers. While the strategies of Ambon's reconciliation media and peace journalism are not identical, since the first neutralizes difference through the depiction of radical equivalence while the second erases it altogether, the impulse behind them and assumptions regarding the difference between name and number are.

In May 2000, during a brief visit to Manado, I spoke with several journalists who had been involved in the project of a new daily newspaper that was initially called *Radar Ternate* but was quickly given the more geopolitically comprehensive name of *Radar Kieraha* in honor of the four historic North Malukan sultanates Ternate, Tidore, Bacan, and Jailolo.[42] As a member of the editorial team of the *Manado Pos* that produced the paper, Pak Agil had supervised the new daily from the distance of Manado. Pak Zamzam, in charge of reporting on events in Ternate City, including the sessions of the regional parliament and activities of the police or, as he put it, matters of government, had been based in Ternate from September 1999 until December 28 of that year when violence in the city forced the paper to halt its production. A third journalist, who reported on economics and development, had also been based in Ternate.

Besides reasons of business, the idea behind launching *Radar Kieraha* had been twofold: to offer a gift to the new province of North Maluku established under regional autonomy laws and to provide people in an area where they "do not yet understand the role of the press" with their own newspaper.[43] The ideological underpinning of this move—indebted to the numerous journalist training sessions and crash courses in peace journalism that mushroomed with the massive international investment in Indonesia's transition to democracy— was that in the era of Reformasi the role of the people would be articulated

through a media controlled by the people who were entrusted with "exercising supervision over [the actions of the] government" and "criticizing things that are wrong."[44] But already in September 1999 when Pak Zamzam arrived in Ternate, a succession of political problems and conflicts conspired to undermine this ideal view of the bond between people and press in the recently proclaimed democracy.

Under increasingly tense circumstances, the newspaper appealed to the Ternatan population to be vigilant regarding the negative influence that events in the unfolding conflict in Ternate City might have and how together—people and paper—they should do everything to deescalate the situation. In spite of this appeal, the different parties in Ternate's conflict accused the paper of partisanship. *Radar Kieraha* went to press for the last time on December 27, and during the heat of the confrontation between enemy forces that night, Pak Zamzam escaped to the police station. Shortly thereafter, the newspaper's office was vandalized, phone lines in the city were dead, and large parts of it had been burned to the ground. By May 2000 when I spoke with the two journalists, refugees from Halmahera had occupied the newspaper's Ternate office.

Both men were highly engaged with and troubled by the violence in Maluku and the larger crises afflicting their country; both struggled to find a way to translate their concerns into a proactive form of reporting that they called peace journalism. And both were certainly right in recognizing the potential role of print and other media in the production of events and in their acute awareness of how the news, say, of a mosque or church burned down (whether true or false) could trigger violent events. Indeed, in Chapter 1, we saw how hearsay or rumors that something bad had happened often preceded, made possible, and could even predict the outbreak of violence. Yet both men also recognized the limitations of the peace journalism they preached. Pak Agil mentioned, for instance, the wider reach of television and especially radio in a part of Indonesia where newspaper circulation was limited and, as he put it, the economic and intellectual level of the population was "lower than the prevailing one," so that even if "we publish a news item to cool down the atmosphere, it is not sure they will read it, even if they know how to read. Maybe their region cannot be reached." Even with these misgivings and reservations regarding reception, the journalists considered it their responsibility to do their utmost in covering Maluku to diminish the possibility of more violence.

> We make comparative news like here, it's like this, life in Manado is like this. The newspaper is sent there, like this, so that whatever thing happens there, we just obliterate it. What I mean is just let it be since they are already so violently implicated, we shouldn't

articulate anything . . . just hush it up, to prevent the Muslim com-
munity from killing Christians or the Christian community from
killing Muslims, but that should not be [in the newspaper]. . . . But
once a violent outbreak happens which causes so many dead, so
many dead, so many dead, it should not be said who did it. Only
that there was a violent outbreak here, don't say Christians died,
don't, just say how many died, directly, the number of dead.[45]

If the presentation of numbers instead of names happens here in the service
of hushing things up, the repetition of the phrase "so many dead" no less than
three times suggests how difficult it is to circumscribe such excess. When
names surface in such accounts, they do so as a kind of nonname, under cover
of the elusive categories of "provocateur," "certain parties," and "political elite"
or other glosses that similarly obscure the identities of the protagonists through
a process that unnames the combatants.[46] Pak Agil continued:

The idea is to give information about current events but not in a trans-
parent manner. If, for instance, there is a conflict between the inhabi-
tants of a place, between people, between members of a different
ethnic group or religion, it is not necessary to mention the ethnic group
or religion, so that this does not cause injury or provoke revenge from
either side. So yes, there were people killed, yes there was an incident,
OK, but who was behind this, who caused this incident does not have
to be written so that the information does not spread to the other side.[47]

Pak Zamzam broke in with an example:

For instance, where, let's see, between Malifut and Kao, we report that
there was a clash between the people of Malifut and those of Kao in
which five people were killed, that's it, enough said. There was a house
of worship burned down, don't say it was a mosque, don't say it was a
church. In this way, we take a kind of action that is objective yet con-
structive, the end all of it is constructive. If we want to be objective in
a transparent manner, then this will in fact be destructive because it
will trigger conflicts. If that is the case, then it would be better not to
report at all. So we have two alternatives: either not to report at all or to
report in a way that is objective and constructive.[48]

I cite these journalists at length not only to give an impression of their dis-
course and the difficulties they encountered in their wartime reporting. These
passages show the degree of care and reflexivity with which they assumed their
self-proclaimed role of peace journalists. This care and professional dedication

are important to emphasize because they became compromised during a second conversation I had with the two men on the evening of the day of the interview when they showed up unannounced at my hotel, as I discuss below.

Noteworthy is how the journalists negatively invoked the notion of transparency, a potent concept that circulated during the Reformasi movement describing the allure of bringing to light political events and New Order crimes. According to these journalists, not everyone could handle knowing all the details about violent events. For them, the relationship between what should be exposed or made transparent and what withheld from public view was reversed. Their understanding of peace journalism demanded that they excise much of what makes violence somewhat locatable, perhaps even comprehensible. In fact, this view contrasts with common understandings of peace journalism that entail an explicit rejection "of the minimalist reporting model favored by some media outlets . . . [that is] ineffectual and corrosive of professional norms."[49] With respect to the minimalist reporting on violence widespread in Indonesia after the New Order's collapse, an Indonesian journalist admonished his colleagues: "Don't bury the facts that are so sacred to journalistic reporting. Peace journalism is a method of reporting the human side of warfare, but it is not a license to delete the facts that arise in a war. It used to be said not to report blood and bombs, but these things are certain to appear in reports."[50]

In the minimalist reporting of the Manado journalists, only the starkest outlines of a violent occurrence make it into the paper and, by extension, public view—the mere fact of a clash or conflict, the number of dead or wounded, the amount of property destroyed. Left out are the grievances and resentments, the historical relations and connections pertaining between the enemies, and the ascribed and self-ascribed identities of the persons and collectivities involved—such things as their ethnicity, religion, race, and class or the potentially politicized differences subsumed by the Suharto regime under the acronym SARA—as well as the causes, triggers, background, and dynamics of the violence. In other words, precisely the kind of information that is needed to fill in the picture, to identify the stakes in a conflict, delineate the range of issues, prejudices, and imaginations that motivate and divide the opposing parties or, more complexly, begin to unravel what makes people recognize their identities in moments of crisis in terms of religion, ethnicity, or other sociological designations, along with the forms and modalities through which they do so. What is lacking in minimal reporting is, in short, any contextualization that would form the starting point of an attempt to come to grips with the complex ways in which otherwise ordinary people are drawn into and engage in extraordinary violence.

Whether practiced by those who called themselves peace journalists or those who did not, the Manado journalists were not alone in their minimalist reporting. A study of Indonesia's two largest metropolitan dailies, the modernist Muslim *Republika* and the originally Catholic *Kompas*, reveals the extent to which these quite different newspapers adopted the same obscurantist approach as practiced by the journalists of the short-lived *Radar Kieraha*.[51] Focused on news reporting around major events and developments during an eleven-month period from late July 1999, when violence surged for a second time in Ambon, to June 2000, when a state of emergency was imposed in Central and North Maluku provinces, the quantitative survey distinguishes between the use of generic and nongeneric descriptors to designate the warring parties. An example of the first, for instance, would be "the two warring groups" where group affiliation remains unidentified versus the second where it is explicitly named, as in "Christian mob."

Results from an analysis of the survey reveal, for instance, that notwithstanding *Kompas*'s much larger avoidance of terms or phrases that would enable its readers to identify the combatants' religious affiliation or the violence as religious, and *Republika*'s tendency to privilege Muslim viewpoints—especially when Muslim casualties were on the rise and the paper began to distinguish these "victims" from their "Christian assailants"—an overall assessment of generic versus nongeneric descriptors for combatants reveals how even *Republika*'s tally for the latter is high, amounting to 59 percent, compared to *Kompas*'s remarkable 81 percent. Also, that notwithstanding the journalistic practice, prevalent at the time in Indonesia, of providing information "but not in a transparent manner"—a holdover, no doubt, from the Suharto era—readers could often read between the lines, recognizing or, when they did not, presumably guessing at the identities behind the generic language. Equally importantly, as journalists deployed obfuscating terms like "the warring parties," "political elite," or "house of worship" in their reporting, they simultaneously found ways to encourage reader recognition of group identity.[52] This suggests how conflicted many journalists must have felt between their desire to act professionally and their at times partisan feelings with respect to one or another party engaged in the fighting.

Much like war watched from the sidelines, the black-and-white language of this minimalist reporting—bereft of the liquid, incandescent colors, shadows, messy contingencies, and horrific contexts that describe the experience of those actually in war—facilitates a reading of the conflict in the starkest of terms.[53] In Maluku, it provided the language and means for glossing over a fraught, mobile terrain made up of histories, grievances, friendships, alliances, long-standing rivalries, customs of trust and accountability, power structures, and political

economy, not to mention the legacies of New Order politics and violence. Even when mentioned, descriptions like "Christian mob" and "Muslim mob" or "Christian attackers" and "Muslim victims" are no better than types, far from the historical actors and social determinations involved in the conflict.

In the conversation at my hotel, the journalists provided in some sense the proper names and situated histories that had been substituted in their reporting by the conflict's quantified heroes and abstract numbers. This was a conversation that long thereafter baffled me since it seemed an odd, unsolicited digression into Malukan history that I could not place at the time. Unannounced and with some urgency, the two journalists appeared at my hotel after nightfall, insisting that they had more to tell me about peace journalism. Since I had thanked them after the interview and left without any further agreement to meet, their visit was not only unexpected but somewhat unusual. As we sat over tea and they reiterated the same information and opinions they had shared earlier, I wondered why they had come. What was different, however, and significant, as I realized later, was that this time it was followed by a long account detailing the antiquity and former grandeur of the four Malukan sultanates for which, not coincidentally, the Ternatan weekly had been named.

The gist of Pak Agil and Pak Zamzam's afterward to their account of peace journalism's balanced reporting was a comparison between unequals—specifically, the early presence of civilization among Malukan Muslims exemplified by their courtly tradition and luxurious attire, including shoes, at a time when the region's Christians went around barefoot, ignorant, and in loincloths. It dawned on me in retrospect that what the two had done that evening is fill in what they saw—though not, I believe, in a manner clear to themselves—as the necessary backdrop to their peace journalism, reintroducing, as it were, into its erasures and equalizing impetus the stark foundational asymmetry between Muslim civilization and Christian barbarism. Introduced after the fact, this history nonetheless prefaced and complicated the men's story about their peace reporting. Beyond superficial forms of generic equivalence or "the mobile language of computations and rationalities that belong to no one," the journalists seemed to be saying that a foundational asymmetry between Muslims and Christians is nonetheless operative. Their digression into North Malukan history did, in addition to setting the historical record straight for themselves, put a stereotypical face on the collectivized actors involved in the conflict. If their peace journalism seemed to solicit the ad hoc insertion of meaningful difference into their balanced reporting, such difference came not in the form of contextualized description subsumed under a name. What I belatedly realized was that the affectively charged preface to their peace journalism was rooted

in partisan stereotypes pieced together from mythologized tales that glorify Muslims while disparaging Christians.

If Certeau's floodlights had panned across Ambon City in war's wake, they would have picked up an analogous response, albeit from the opposite direction, to the perceived equalization of Christians and Muslims in Maluku— namely, the huge Christian billboards whose emergence and adamant presence I have tracked in this book. One way of understanding the street paintings' gigantic scale, as I have emphasized earlier, is as a response to the scaling down of Protestant elite privilege. Put otherwise, it is another way of setting the historical record straight, but for Protestants rather than Muslims. Like the backstory to peace journalism, told to me with some urgency by the Manado journalists, the immense billboards and murals can also be seen as a backdrop that, with equal urgency, demanded public attention.

Scrolling for Peace

Let me fast-forward to September 11, 2011, when violence broke out again in Ambon, sparked by the death of a Muslim motorbike-taxi driver in a Christian neighborhood. Simply put, Christians claimed it was an accident, Muslims that the man had been murdered. Text messages circulated stating that he had been tortured and killed by Christians, and cell phone photographs of his wounds spread rapidly among Muslims and on Muslim websites. By the time the man was buried around noon on September 11, hundreds of mourners had gathered. Violence broke out as they left the cemetery, continuing in two parts of the city until nine p.m., leaving three people dead and dozens wounded. Close to one hundred homes, mostly Muslim but some Christian, were burned. A confrontation the following day claimed four more shooting victims, left fifty Christian homes burned, and displaced about four thousand persons, some having lost their home for the fourth time in twelve years.

In the context of the September 11 violence, an interreligious group of activist journalists, religious leaders, students, and others with strong ties across the religious divide contacted each other and set up a network that aimed, as they put it, to "provoke peace" by deploying a number of simple, low-cost, and frankly quite effective strategies. Two of the main leaders were Jacky Manuputty, an activist GPM minister, and Abidin Wakano, a lecturer at the State Islamic University who had long worked actively to promote peace in the city.

Calling themselves Peace Provocateurs, the network of Muslims and Christians recalls the shadowy provocateur or insidious actor that was sometimes identified with the state but, more commonly, with unnamed elite interests, certain parties, and other potent if unidentifiable agencies. These fugitive actors

proliferated in the reporting of the Manado peace journalists but also in the conspiracy theories rampant in Indonesia, including that of the homegrown puppeteer manipulating events from behind the scenes. In some respects, if differently, this is what the Peace Provocateurs do: they work behind the scenes, intervening in circulation to stop the spread of rumors and false information capable of setting off violence. The tactics and interventions of the Peace Provocateurs rely on the speed and avid use of social media among Ambon's population, something that was not available during the war. Text messaging is especially popular, as elsewhere in Indonesia, but also Facebook, Instagram, and Twitter, the latter used by the Provocateurs to relay interactive news programs to local and national television to counter and prevent inaccurate and sensationalist reporting.[54] As the activist minister Jacky Manuputty put it, "If provocateurs could use the new technology to incite violence, we could use it to undermine their incitement."[55] They formed a core group of about ten people, each with a dozen or so contacts around the city, notably in sensitive, conflict-prone areas. They also identified people they called strategic partners in border neighborhoods and put them in touch with each other to monitor and coordinate information.[56] The members of the network were in constant communication with each other in the chaos following the events of September 11 as they focused on cross-checking, collecting, verifying, and producing evidence— commonly relying on mobile telephony—that confirmed attacks, the massing of crowds, and incidents of violence or, equally importantly, demonstrated these to be false or distorted. For instance, when a member of the network in one part of Ambon heard that the GPM Silo Church had been damaged, he immediately contacted another member of the network stationed at the church who photographed it with his phone, circulated the photo, and proved the rumor untrue. Similarly, if a person was said to have been wounded or killed, a Peace Provocateur would post a cellphone photograph on social media showing the person alive and unharmed. In sum, the main strategies of the Peace Provocateur network were the deployment of persons armed with cell phones to strategic sites and trouble spots around the city to check on rumors, the relaying of information back to a person who acted as editor, and frequent updates sent out via text, Facebook, and Twitter.[57] Since 2011, the local government has become much more aware of the need to work with the telephone company to get mass text messages out when trouble occurs.[58]

While the interventions of the Peace Provocateurs have been crucial in helping to prevent the escalation and spread of violence, they have focused especially on flash points—moments when danger flares up, starting rumors and feeding what, in war's context, I call the infrastructure of imagination (Chapter 1). By interrupting circulation with counterinformation, their work undermines

the kind of spiraling out of control triggered by hearsay, false accusations, and fantasy that helps to create a sense of threat and immanent danger and foster the fearful unknowing that, over time, cloaks the city in what the Prussian general Carl von Clausewitz calls the fog of war. In light of how I proposed that Ambon's conflict began, it is striking that cell phone technology should be the central feature of the Peace Provocateurs' mode of operation. In Chapter 1, I detailed how the walkie-talkies and land lines set up to connect Muslim and Christian leaders to their respective communities in response to religious violence in Jakarta became mobilized in January 1999 in ways that transformed an ordinary fight between a Muslim and a Christian into citywide violence and allowed each side to accuse the other of starting it. With their ability to respond at immediate notice, the Provocateurs prevent precisely such unremarkable, everyday occurrences from escalating. "It is not the big, predictable events we have to worry about most," the city's bishop, Monseigneur Mandagi, commented, recognizing the activists' work, "It's the ordinary days, when the security services will be off guard, and a small incident could blow up quickly."[59] If the Provocateurs' most celebrated actions have been their ad hoc responses to some rumor or incident, in less volatile times they circulate texts and tweets about cross-community events and post photographs of normality, such as a Muslim trader plying his wares in a predominantly Christian area, to demonstrate that the vast majority of people in Ambon get along and have no interest in the violence that some try to provoke.

Other activist collectives also avail themselves of the possibilities afforded by social media—especially Facebook and Instagram—and the specific power of images to transform negative perceptions of the city, both inside and outside of Ambon. They work, in other words, deliberately on appearances—specifically the images of the provincial capital that continued to circulate online after the official peace and portrayed the city devastated by war. In contrast to the Provocateurs' circulation of images to confirm the return of a previously taken-for-granted normality, the image-activists upload their photographs and sketches to show Ambon's natural beauty, the presence of its many historic sites and artifacts, and cultural performances. The first group arose in 2007 as a photography club. Such clubs have a long history in Indonesia but this one was different.[60] Its members—young women and men, Muslims and Christians—set off on photo hunting exhibitions, often around twilight after getting out from work or school, at a time when most Ambonese were hurrying home to their religiously enclaved neighborhoods. Besides taking photographs, the expeditions were meant to leave an impression of interreligious friendship and camaraderie, as well as the sense that after nightfall Muslims could venture safely into Christian areas and vice versa. In

Figure 54. Sketch of Ambon's Pattimura Statue and Maranatha church by Linley Jerry
Pattinama of the Maluku Sketch Walkers collective, Ambon, 2017. Photo by the author.

seeking out especially scenic and beautiful locations, the young photogra-
phers also aimed to show Ambon at its best and bereft of any traces of violence
(Figure 54).

As one of the photographers explained, the group formed after discovering
that, as late as 2006 and 2007, barricaded streets, bloody scenes, damaged
buildings, and dead people still filled the screen when one googled or searched
online for Ambon.[61] In acts that constitute deliberate work on appearances, the
photographers screened away the out-of-date, offending images by substituting
them with peaceful, compelling scenes. Sunsets, not surprisingly, were popular.
Not only because Ambon's are quite spectacular but since they presented a
ready-made photo opportunity during the club's late afternoon excursions. The
Maluku Sketch Walkers collective, some of whose members belonged to the
earlier photography club that is now largely defunct, concentrate similarly on
producing appealing images of Ambon that they consider important in light
of the long-standing damage to the city's reputation caused by the war. A look
at the calendar the group put out in 2017 yields sketches of codified sites of
local history and religion and urban markets and Malukan foods, each foreseen

with a short, handwritten explanation. They range from the calendar's cover showing a paintbrush and handful of brushes alongside a sketch of Ambon's colonial era Victoria Fort to images of Maluku's "crazy bamboo" performance, the city's crowded Mardika market, a dish of *colo-colo* sauce, two featuring local desserts and two of Dutch forts, another a tuna fish boat, still another a beach, and, in an echo of the children's reconciliation drawings, the Jame Mosque and the Saint Franciscus cathedral, albeit allocated to separate pages. Although there is much I could say about the codification of the local here or about how the Maluku Sketch Walkers' style reproduces that of a wider international sketchers' aesthetic, I will not do so here.

Instead, I would like to reflect, briefly, on how the sketches may be seen as part of the larger, diffuse work on appearances that continues after the war and hopefully contributes to the city's recovery, however modestly. Formally, the sketches are small vignettes, encapsulated scenes snatched from the flow of everyday life that appear to float on the white page on which they are rendered. While such vignettes distinguish the genre everywhere, in Maluku they might appear especially disconnected from the complex realities that continue to mark life in the city almost two decades after the peace and that do not figure in the image-activists drawings. But such fields without borders can also have the effect of engaging the viewer in the world seen on the page, of drawing her in.[62] From this perspective, the Maluku sketches would differ from the children's reconciliation drawings that jar with the circumstances around them. Even when the sketches render, for instance, centuries-old forts or sago cakes in watercolor, they promote recognizable, even reassuring artifacts and locally authorized scenes within the general surrounds familiar to Ambonese and to which they have, moreover, been made attuned by local historiography, the celebration of Malukan custom, and other processes of canonization, whether state- or popularly driven. Precisely because the sites and scenes they portray are so codified—"tourist objects and scenic views" as in the photographs of the club that preceded them—they may help to confirm and reinstate more comforting appearances of a city still emerging, in some respects, from a devastating war.

More concretely, the online scrolling on which both of Ambon's image-activist collectives rely assumes a guerilla archival function in their work. To some extent, "the physical act of scrolling can be regarded as a digital counterpart to turning the page in a print novel, and the scroll 'up' or 'down' resembles flipping back and forth between a book."[63] On Instagram and Facebook, moving forward in this fashion happens automatically. Every time images are uploaded, they take precedence over earlier ones as these are scrolled away and out of sight. Scrolling, from this perspective, has both material and digital dimensions, an intimate relationship between the two meanings of *scroll* that draws attention

to the way in which textual meaning is shaped not only through the text's content but also through its form in space and time, present in this case in an online context.[64] Bent on altering the negative online portrayal of Ambon by working on appearances, the image-activists of the photography club and Maluku Sketch Walkers deployed both senses of *scroll* effectively as they uploaded positive images of Ambon, ensuring in so doing that negative depictions disappeared from view. To be sure, these ephemeral mediations are not seen by everyone. But they reinscribe, however faintly, the familiar contours of life in Ambon City even as, presumably, they begin to trace out some new ones.

Conclusion

Ephemeral Mediations

How do we gauge the impact of the street art that gave expression, in so many ways, to the restless uncertainties that haunted the postwar city? Beyond the comfort they offered Protestants, alienated from their past and affected by war, how do we evaluate their broader effects, given that a mere decade or so after official peace the paintings had largely disappeared from view and, perhaps, memory? Whatever power these ephemeral mediations of religion, masculinity, Christian privilege, and subjectivity once exercised in the urban environment, for the most part, is no longer there. For even if I saw a new Christ of the Second Coming on a few scant walls in Ambon's center and in the hills above it in 2011, and Christian and Christmas scenes continued to be painted here and there around the city through my last visit in 2017, none of these had been put in place with the same urgency or desperation as those that surfaced in the war and immediately after. Unlike their predecessors, these street paintings no longer call out stridently to passersby, and even as the city remains largely segregated along religious lines, the overall situation is far from the battlefield in which Muslims and Christians enclaved themselves in vigorously defended territories. The energies that infused them then have long since dissipated as the pictures themselves have faded from view, leaving behind smudged surfaces, flecks of paint, and the occasional dim contour. Much, in other words, has changed, which means that the pictures are less the poignant, affective presences they once were and emerge today predominantly as views to be seen.

In this book, I have stuck close to the Christian pictures, allowing them to ethnographically ground and guide my narrative while telling one version of a story, among other possible versions, of a Malukan city at war from the vantage point of some of its main protagonists. But it is also an account of an

unprecedented turn to the visual and the corresponding valuation and thema-
tization of visual media and experience within the specific circumstances of
an Indonesian city ravaged by conflict and crisis in today's visually attuned
world. Their monumentality, their defiant presence in the urban environment,
and, when freshly rendered, their sharp contours and vibrant colors demanded
that they be taken seriously and not casually dismissed. My reading of these
images suggests that the street art paralleled and most probably abetted the
significant realignments in urban religion, especially among the Protestants.
Yet, how closely knit in actuality was this street art, the work of young motorbike-
taxi drivers who are usually not the most avid churchgoers or dutiful of Chris-
tians, to religion? Earlier in this book, I addressed this question by complicating
it, suggesting how religion in the streets, performed through the production and
engagement with painted Christian billboards and murals, falls within the
undisciplined rather than the official, institutionalized forms of religion, some-
thing that does not diminish their importance.[1] It is my other question regarding
the overall impact and significance of the street art, beyond the predicament
of Ambonese Christians, that requires some final consideration, both because
it is more complex and because I see it as a main contribution of the book.

This is also where the ephemeral mediations come in that give this conclu-
sion its title. Ephemeral mediations do not just designate the street pictures
that have been my recurrent focus, allowing a dispersed picture gallery to come
into view across different chapters. Although they did not receive the same
attention I gave to the Christian paintings, countless other strikingly ephemeral
mediations, intimately connected to the production of violence and the delicate
peace that followed, to figuration within the terrifying, disfiguring momentum
of an embattled city, and to world-making and -unmaking, also appeared in
Ambon, and in my analysis. These include hearsay and gossip, provocative
pamphlets and VCDs, and public service announcements circulated in violence
and reconciliation initiatives, aired briefly on television and radio. I paid close
attention to children's drawings, some of which, fortunately for me, had only
been recently made when I encountered them, or saved by NGOs, or, more
rarely, collected in a book. Many more, no doubt, did not survive the particular
event or contest for which they were done. Children's parades and performances
were one-off occasions. War's unmistakable soundtrack and incendiary termi-
nology, street banners supporting the presence of civil emergency and armed
forces, the text messages and photographs of cell phone telephony, transmitting
crucial information at a moment's notice, and sketches of the city posted on
Instagram and Facebook, scrolled from view almost as quickly as they appeared
onscreen, are some of the other ephemeral mediations I considered. With
respect to all of these relatively fleeting phenomena, I have aimed to describe

and analyze their impact and effects within the evolving circumstances of the wartime and postwar city. Even more fugitive and challenging to catch hold of was war's fog or the elusive appearances, on the very threshold of perceptibility, unleashed by the uncertainties and terror that overtook Ambon City at the turn of the century.

Notwithstanding the disciplinary commitment to understanding everyday life in all its diversity, from banal to extraordinary manifestations, anthropologists have tended to shy away from difficult to grasp if palpable phenomena like ambiance, climate, and atmospherics. One way of getting at such phenomena, as I have tried to do here, is by showing how these fugitive forces suffused and oriented the actions and experience of wartime, giving rise to novel formations of sociality and the sensible, from anticipatory practices meant to ward off danger to a pervasive aesthetics of depth, as in a camera's slow pan of army fatigues as if such scrutiny might summon to the surface undisclosed truths. Somewhat differently, I explored how the newly assertive, yet in the end equally ephemeral, Christian street art helped to materialize and bring about a new relation to the Christian divine—something I became aware of because the appearance of street paintings coincided with the momentous shifts in religiosity and religious affiliation occurring in the urban context. I hope to have conveyed a general sense of how more elusive and ephemeral aspects of social life, perhaps especially in situations of profound sociopolitical upheaval and change, deserve our acute attention. For even as they come and go, they can have lasting impact. Depositing their traces in an assortment of practices and forms, they bring about new distributions of the sensible, altered landscapes of living and cohabitation and subtly different ways of seeing, dwelling, and engaging the world.

The reproduction of Ambon's ephemeral street art and its offshoots in the preceding pages bears material testimony to a particular infrastructure of the imagination, one that fed the momentum and unfolding dynamics of the city's interreligious war and related realignment of religion. But the archive collected here—images that are largely absent today in situ—is also a material tribute to the creativity of a generation of Malukan street painters and a reminder of the energy and resilience with which they sought recognition for their place in the city, as citizens of Indonesia and as Christians.

By alternating full-page, saturated reproductions of billboards and murals with clusters of topographically related paintings and thematically connected assemblages, like the regal Christ behind church altars or conventional Christ portraits in domestic interiors, and close-ups with distanced views of pictures in their urban surrounds, I have tried to highlight the myriad ways in which

such images arose and occupied the space of the city from aggressive procla-
mations of Christianity to unassuming decorative features in Protestant homes
and stores. In dispersing the images across and between chapters, I aimed to
convey how these visual forms echo each other, hinting at their repetition and
sheer redundancy around Ambon.

But nothing, and certainly not the flat surfaces in this book, can come close
to the experience of encountering these enormous blowups in city streets, of
being assailed by their rich, affective force. Nor can it convey the sense of shock
that their appearance must have occasioned among Protestants and others,
including myself, in their resistance to conventional ways of seeing. In caption-
ing the images reproduced in this book and situating them socially, politically,
religiously, and aesthetically in relation to Ambon's conflict and its aftermath,
I have tried to walk a fine line between delineating the shock and dispelling
it. For this reason, I have not offered additional commentary or guidelines on
what contribution they are supposed to make or how a reader of this book might
engage them.

Acknowledgments

This book has taken longer, demanded more, and accumulated more debts than any other project I have done. I am enormously grateful to the many people in Ambon, Manado, Jakarta, and elsewhere in Indonesia who have generously shared their thoughts and insights and assisted me in numerous ways, from small acts of kindness and hospitality to documents, motorbike rides, hours of their time, and recollections of the war and its aftermath. I acknowledge with gratitude Ambon's street painters for allowing me to reproduce their work in this book and for the countless exchanges through which they contributed to my understanding of the city's interreligious conflict of the early 2000s, of the challenges of postwar urban life in Indonesia after Suharto's downfall, and of the work and pleasures of painting. I have benefitted greatly from my relationships and interactions over the years with Malukan and Indonesian journalists, peace activists, academics, representatives of Catholic, Protestant, Muslim, and interfaith institutions and initiatives, humanitarian aid workers, refugees from Maluku's violence, motorbike-taxi drivers, and ordinary women and men. My conversations with all of these people and their insights and views have helped to shape the analysis I develop in this book, and I acknowledge with gratitude their contributions. While the account I have written may not always reflect their understanding of the circumstances I describe, I hope they recognize my deep admiration of the resilience and creativity with which many responded to the hardships and challenges of Ambon's war and thereafter. For the most part, I use the real names of the painters, professionals, and public figures I write about in this book, since they would like to be recognized for what they do. I use pseudonyms for ordinary women and men, following anthropological practice and in cases where the

sensitivity of the topic suggests that it would be better for those involved to remain anonymous.

Although it is impossible to name everyone, in Ambon I am especially grateful to Jhon Yesayas, Joseph Lambertus, Leonar Tahalea, Rudi Fofid, Novi Pinontoan, Zairin Salempessy, Jacky Manuputty, Dino Umahuk, Agus M. Tunny, Bahri Saha, John Reinstein, Hermien Soselisa, the late Jopie Ayawaila, the late Monseigneur Andreas Sol and the staff at the Rumphius Library, Monseigneur Petrus Canisius Mandagi, the late Christian Tamaela and the late Nus Tamaela and the warm hospitality of their families in Ambon and Seram, and Marla and Broeri Makatita, who kindly shared their thoughts and food on more than one occasion. Nelson Djakababa and her team from Yayasan Pulih were stimulating interlocutors and fun companions. From the beginning of this project, I could always count on the generosity and excellent company of Atha Hitijahubessy, for which I offer my deep appreciation. More recently, the friendship and unflagging support of Ratih Prebatasari and Miguel Garcia has been an unexpected gift. In Manado, I am especially grateful to Ibu Bian Loho and Paul Renwarin, to my fellow researchers Chris Duncan and Jennifer Munger, and to Sabir Maidan and Muhammed Uhaib As'ad, who all helped me in countless ways and made my time in North Sulawesi much more enjoyable. Thanks are due to Roger Tol and Ietje Mogi Tol, who always welcomed me to their lovely home in Jakarta, and to Atas and Irwan Habsjah for their warm hospitality. The time I spent in Indonesia working on this project would not have been the same without the friendship and fabulous company of Tinuk and Philip Yampolsky, who provided lavish meals, music, and cultural soirees, nyonya-nyonya outings, and ongoing entertainment whenever I stayed with them in Jakarta.

The period that I began as senior visiting scholar at New York University's Center for Religion and Media and Department of Anthropology and ended as FAS Global Distinguished Professor was crucial to conceptualizing this book. I am enormously grateful to the center and department for offering me such an intellectually exciting and hospitable environment, in particular to the center's codirectors, Faye Ginsburg and Angela Zito, to then department chair Fred Myers, and to Michael Gilsenan, Bambi Schieffelin, Bruce Grant, Rayna Rapp, Adam Becker, and the late Thomas Abercrombie. I was fortunate to be a fellow at a number of institutions that provided precious time and congenial settings in which to work on this book: the Australian National University's Humanities Research Centre, New York University Shanghai's Center for Global Asia, and Cambridge University's Museum of Archaeology and Anthropology and Department of Anthropology. It is a real pleasure to thank Melinda Hinkson, Kathy Robinson, Ken George, Francesca Tarocco, Susan Bayly, Nicholas Thomas, Anita Herle, Yael Navaro, and Rupert Stasch for

making my stays in these various places both productive and enjoyable. Several workshops organized by the Transcultural Visuality Reading Group of Heidelberg University's Asia & Europe in a Global Context Research Cluster provided wonderful venues in which I first tried out some of the ideas I develop in this book. Warm thanks are due especially to Christiane Brosius, Sumathi Ramaswamy, and Barbara Mittler. Field visits were funded by the Royal Netherlands Academy of Arts and Sciences, the Faculty of Social and Behavioural Sciences at Leiden University, and the Netherlands Organization for Scientific Research. Thanks are due to the Graduate Institute Geneva's Research Office for a grant that allowed me to hire Marie de Lutz, a visual artist and anthropologist whose creativity and skills were indispensable to conceptualizing the book's design and preparing its many images. I am immensely grateful for her contribution.

Earlier versions of several of the chapters of *Orphaned Landscapes* appeared in print. Chapter 1 began as "Fire without Smoke and Other Phantoms of Ambon's Violence: Media Effects, Agency, and the Work of Imagination," *Indonesia* 74 (2002): 21–36. It was further developed in "Some Notes on Disorder in the Indonesian Postcolony," in *Law and Disorder in the Postcolony*, edited by John L. Comaroff and Jean Comaroff, 188–218 (Chicago: University of Chicago Press, 2006). Early versions of parts of Chapter 2 appeared in "Blind Faith: Painting Christianity in Postconflict Ambon," *Social Text* 26, no. 3(96) (2008): 11–37, and as "Christ at Large: Iconography and Territoriality in Postwar Ambon," in *Religion: Beyond a Concept*, edited by Hent de Vries, 524–49 (New York: Fordham University Press, 2008), and as "Streetwise Masculinity and Other Urban Performances of Postwar Ambon: A Photo-Essay," in *Youth Identities and Social Transformations in Modern Indonesia*, edited by Kathryn Robinson, 177–99 (Leiden, Netherlands: Brill, 2016). An earlier version of Chapter 3 appeared as "Images without Borders: Violence, Visuality, and Landscape in Postwar Ambon, Indonesia," in *Images That Move*, edited by Patricia Spyer and Mary Margaret Steedly, 101–26 (Santa Fe: School for Advanced Research Press, 2013). Chapter 4 began as "Treacherous Matters, or Some Notes towards a Symptomatology of Crisis," *Material Religion* 10, no. 4 (2014): 494–513. I thank the anonymous reviewers and editors of all of these publications. I also am grateful to the audiences of the universities and institutions where, over the years, I have presented aspects of the arguments I expand on in this book, including the Singapore University of Technology and Design, the Humanities Research Centre at Australian National University, New York University and New York University Shanghai, Musée du Quai Branly, Cambridge University, University of Texas at Austin, University of California, Berkeley, University of Indonesia, Gadjah Mada University, Aarhus University, University of Rochester, Harvard University, University of Michigan, Johns Hopkins University, Sarai in Delhi, and PUKAR in Mumbai.

I owe a special debt of gratitude to the many colleagues who, over the years, have read drafts, commented at talks, and engaged with my work in ways that have helped me develop and clarify my thinking. I would like to extend my heartfelt thanks to my fellow scholars of and from Maluku, especially Paschalis Maria Laksono, Wim Manuhutu, Victor Joseph, Anis de Fretes, and Fridus Steijlen for the countless conversations, contributions of knowledge and practical information, and acts of generosity from which I have benefitted over the years. Warm thanks are due to Jim Collins for always sharing his extraordinary expertise on all things Maluku and for his long-standing support and friendship. Henk Schulte Nordholt, scholar of Indonesia, has been a fast friend and fellow intellectual traveler for many years, for which I am grateful. Early on in the writing process, I benefitted from a discussion of parts of the book organized by the late Mary Steedly with some of her PhD students at Harvard, and I thank them for their comments, in particular Aryo Danusiri and Veronika Sumaryati. More recently, David Kloos of Leiden's Royal Netherlands Institute of Southeast Asian and Caribbean Studies hosted an online discussion of a book draft. My heartfelt thanks are due to David and to Carla Jones, Wim Manuhutu, Annemarie Samuels, and Tamara Soukotta for helpful feedback. Following the workshop, Carla generously read and commented on several revised parts of the book in ways that helped me hone my arguments. As this book neared completion, Karen Strassler, Smita Lahiri, and I formed a writing group that grew out of our collective work on a special issue of *Indonesia* in honor of our dear friend, the late Mary Margaret Steedly. Since the mid-2000s, Karen and I have had animated conversations about our common interests in images, visuality, and Indonesia; it was a special pleasure, at the end of the writing process, to discuss several book chapters with her and Smita. Their acute if inevitably generous reading challenged me to be more precise and to clarify my arguments in ways that were invaluable and for which I am immensely grateful. Webb Keane has been a wonderful, steadfast friend in Indonesia and elsewhere since graduate school, an interlocutor of this project from the start, and a recurrent source of excellent comments and advice. Ruth Mandel has always been there, offering intellectual input, unparalleled hospitality and support, and inevitably distracting me with an assortment of pleasures. The warmest of thanks are due to Peter Geschiere for his exuberant encouragement and friendship. As this book comes to a close, I am poignantly aware of the absence of my dear, late friend Mary Steedly, whose own scholarship on Indonesia has always inspired me to think and write better and whose company and close friendship I miss most. Although she did not see this book to its finish, I am immensely grateful for all that she gave to this project over the years.

Many others have accompanied me in valuable and indispensable ways throughout this project and the writing of this book, giving their time, sharing

their thoughts, commenting on papers and drafts. I would like to thank the late Thomas Abercrombie, Ernst van Alphen, Mieke Bal, Bart Barendregt, Emma Baulch, the late Inge Boer, Hortensia Caballero, Yvette Christianse, Bregtje van Eekelen, Mariane Ferme, Finbarr Barry Flood, Nancy Foster Fried, Robert Foster, Faye Ginsburg, Kenneth George, Michael Gilsenan, Zeynep Gürsel, Charles Hirschkind, Marilyn Ivy, Kajri Jain, Edwin Jurriëns, the late Saba Mahmood, Ruth Mandel, Annelies Moors, Rosalind Morris, Fred Myers, Kirin Narayan, Srinivas Padman, Peter Pels, John Pemberton, Beth Penry, Adela Pinch, Christopher Pinney, Kathryn Robinson, Danilyn Rutherford, Ratna Saptari, Bambi Schieffelin, Henk Schulte Nordholt, James Siegel, Carel Smith, Hent de Vries, Tinuk Yampolsky, Philip Yampolsky, and Angela Zito. I have also been blessed with some remarkably wonderful students over the years who never fail to remind me of how much I enjoy what I do and how much I owe to them and to my teaching. While there are too many to name here, I hope they will forgive me for this general acknowledgment and expression of gratitude.

The last stages of this book were completed after I relocated from Leiden University to the Graduate Institute Geneva. I am enormously fortunate to have joined such a welcoming and intellectually stimulating environment as that of the Department of Anthropology and Sociology and institute and want to especially thank Aditya Bharadwaj, Grégoire Mallard, Alessandro Monsutti, Shaila Seshia Galvin, and Shalini Randeria for their contributions and support.

At Fordham University Press, Thomas Lay took an early interest in this project and provided solid advice and support throughout. Warm thanks are due to Ratih Prebatasari and her team at Asoka Films for producing the maps of Ambon, Maluku, and Indonesia. Thanks are due to Jocelyn Dudding, Manager of Photographic Collections at Cambridge University's Museum of Archeology and Anthropology, for her helpful introduction to their visual archives from which the photomechanical image of Ambon Bay in Chapter 2 originates. Thanks are due to the museum for its permission to reproduce this image. Linley Jerry Pattinama kindly allowed me to use his sketch of Ambon's Pattimura statue and Silo Church in Chapter 5. I am grateful to Danishwara Nathaniel for photographing Jhon Yesayas's painting of the attack on Ambon's Silo Church that appears between Chapters 1 and 2.

And finally, none of this would have been possible or brought me as much pleasure if I had not been accompanied throughout by Rafael Sánchez, who provided me with continual insightful feedback, patiently read numerous drafts, and put up with all my talk about painters and paintings. His love and the joy he brings to our life together sustains me every moment and every day, and it is why I dedicate this book to him.

Notes

Introduction: Violence, Visuality, and Appearance

1. All translations from Indonesian, Ambonese Malay, and Dutch are by the author or follow conventional practice, as in the case of the GPM.

2. See Patricia Spyer, "What Ends with the End of Anthropology?," *Paideuma* 56 (2010): 145–63.

3. Collections on violence in Indonesia that focus on the period immediately preceding and after Suharto's downfall include Benedict R. O'G. Anderson, introduction to *Violence and the State in Suharto's Indonesia* (Ithaca, N.Y.: Southeast Asia Program Publications, an imprint of Cornell University Press, 2001). See also, Dewi Fortuna Anwar et al., eds., *Violent Internal Conflicts in Asia Pacific: Histories, Political Economies, and Policies* (Jakarta: Yayasan Obor, 2005); Sandra N. Pannell, ed., *A State of Emergency: Violence, Society, and the State in Eastern Indonesia* (Darwin, Australia: Northern Territory Press, 2003); Freek Colombijn and Jan Thomas Lindblad, eds., *Roots of Violence in Indonesia: Contemporary Violence in Historical Perspective* (Leiden, Netherlands: KITLV Press, 2002); and Ingrid Wessel and Georgia Wimhöfer, eds., *Violence in Indonesia* (Hamburg, Germany: Abera Verlag, 2001). On anti-Chinese violence specifically, see Jemma Purdey, *Anti-Chinese Violence in Indonesia: 1996–1999* (Leiden, Netherlands: KITLV Press, 2005). For representations and writing on violence in Indonesia, see Jemma Purdey, "Describing Kekerasan: Some Observations on Writing about Violence in Indonesia after the New Order," *Bijdragen Tot de Taal-, Land- En Volkenkunde* 160, no. 2/3 (2004): 207; and Nils Bubandt, "Conspiracy Theories, Apocalyptic Narratives and the Discursive Construction of 'the Violence in Maluku,'" *Antropologi Indonesia* 63 (2000): 14–31.

4. See Marshall Clark, "Cleansing the Earth," in *The Last Days of President Suharto*, ed. Edward Aspinall, Herb Feith, and Gerry van Klinken (Clayton, Australia: Monash Asia Institute, 1999).

5. Named for the city on Sulawesi Island where the peace talks were held, this agreement followed the official resolution of another conflict in Central Sulawesi, hence the designation "Malino II" for this one.

6. See International Crisis Group, "Indonesia: The Search for Peace in Maluku," *ICG Asia Report* 31 (February 8, 2002).

7. Christopher Pinney, *"Photos of the Gods": The Printed Image and Political Struggle in India* (London: Reaktion, 2004).

8. Jacques Rancière, *The Politics of Aesthetics*, trans. G. Rockhill (London: Bloomsbury Academic, 2004), 13.

9. Rancière, *Politics of Aesthetics*, 13.

10. While singling out visual media for attention, I recognize, of course, with W. J. T. Mitchell, that there is no such thing as visual media. W. J. T. Mitchell, "There Are No Visual Media," *Journal of Visual Culture* 4, no. 2 (2005): 257–66.

11. Roland Barthes, *Camera Lucida: Reflections on Photography*, trans. R. Howard (New York: Farrar, Straus and Giroux, 1981).

12. Nelson Goodman, *Ways of Worldmaking* (1978; Cambridge, Mass.: Hackett, 1988).

13. See the introduction to *Figures of Southeast Asian Modernity*, ed. Joshua Barker, Erik Harms, and Johan Lindquist (Honolulu: University of Hawai'i Press, 2014); and Joshua Barker and Johan Lindquist, "Figures of Indonesian Modernity," *Indonesia* 87 (April 2009): 35–72.

14. Although somewhat different from the understanding of the figure that I use here, see Steven Caton's concept of the modular image in his analysis of the white sheik of Western popular media, an ambiguously sexualized image who is both white and Arab. He similarly considers how this image circulates through time and space and even disappears, only to reappear at a later moment as it assumes new significance in different social circumstances—racial ambiguity here, sexual ambivalence there, warrior self-fashioning or counterinsurgency poster boy. See Steven C. Caton, "From Laurence of Arabia to Special Operations Forces: The 'White Sheik' as a Modular Image in Twentieth-Century Popular Culture," in *Images That Move*, ed. Patricia Spyer and Mary Margaret Steedly (Santa Fe: School for Advanced Research Press, 2013).

15. Richard Chauvel, "Ambon's Other Half: Some Preliminary Observations on Ambonese Moslem Society and History," *Review of Indonesian and Malaysian Affairs* 14, no. 1 (1980): 40.

16. The original clove-producing areas are the tiny north Malukan islands of Ternate, Tidore, Moti, Makian, and Bacan. Nutmeg and mace, products of the same nutmeg fruit, come originally from the Banda Islands, southeast of Ambon.

17. Gerrit J. Knaap, "A City of Migrants: Kota Ambon at the End of the Seventeenth Century," *Indonesia* 51 (1991): 105–28.

18. Richard Chauvel, *Nationalists, Soldiers and Separatists: The Ambonese Islands from Colonialism to Revolt, 1880–1950* (Leiden, Netherlands: Brill, 2008); and Gerrit J. Knaap, *Kruidnagelen en Christenen: De Vereenigde Oostindische Compagnie en de*

Bevolking van Ambon, 1656–1696 (Leiden, Netherlands: Brill, 2004). In contrast to the Christian-dominated Leitimor part of Ambon Island, the Muslim polities and federation were concentrated on the northern Leihitu peninsula.

19. Chauvel, "Ambon's Other Half."

20. In recent years, a number of highly publicized court cases in the Netherlands representing the survivors of Dutch colonial massacres and atrocities in Rawagede, West Java, and South Sulawesi have brought attention to the brutality of the Netherlands' efforts to retain its colony after the surrender of the Japanese Imperial Army on August 15, 1945. For alternative accounts of this Dutch colonial history, see Anton Stolwijk's fictionalized *Atjeh: Het verhaal van de bloedigste strijd uit de Nederlandse Koloniale Geschiedenis* (Amsterdam: Prometheus, 2016) and Maarten Hidskes's *Thuis gelooft niemand mij: Zuid-Celebes, 1946–1947* (Amsterdam: Atlas Contact, 2016), based on his father's participation in some of the events in South Sulawesi.

21. In this fraught situation, the position of some four thousand former Malukan KNIL soldiers was uncertain given that the option of joining the Indonesian army or becoming regular citizens were unwelcome to most. In the first half of 1951, about 12,500 persons—predominantly Christian Ambonese soldiers and their families— were evacuated to the Netherlands in what was understood by all parties at the time as a temporary solution. For a short overview of this history, see Wim Manuhutu, "Molukkers in Nederland: een korte terugblik," *Actuele Onderwerpen* AO2691 (February 18, 2000). At the onset of the violence in Ambon in 1999, the surviving members of this largely Christian group and their offspring comprising what, under protest, had become a Dutch Malukan population counted some 40,000 persons. Due to the high profile of the Malukan KNIL soldiers in the former colony, the notoriety of the separatist RMS movement in the context of the Indonesian Republic, the continued existence of an RMS government in exile in the Netherlands, and the politicization in the 1970s of the second generation of these Netherlands-based Malukans, the prevailing impression of Ambonese as exclusively Christian was reinforced over the years—not just in Indonesia but also beyond.

22. Jacob A. Riis, *How the Other Half Lives: Studies among the Tenements of New York* (New York: Penguin Books, 1997), cited in Christopher Pinney, introduction to *Photography's Other Histories*, ed. Christopher Pinney and Nicholas Peterson (Durham, N.C.: Duke University Press, 2003).

23. See James T. Collins, *Malay, World Language of the Ages: A Sketch of Its History* (Kuala Lumpur: Dewan Bahasa dan Pustaka, 1996), 50.

24. Chauvel, "Ambon's Other Half." This also meant that Islam localized, mixing with adat or customary practices and traditions. As recent as 2005, for instance, a women's customary ritual was held in the beautiful mosque of Rohomoni village on Haruku Island, one of the five members of the Hatuhaha confederation devastated by the VOC.

25. Marianne Hulsbosch, *Pointy Shoes and Pith Helmets: Dress and Identity Construction in Ambon from 1850 to 1942* (Leiden, Netherlands: Brill, 2014), 46.

26. N. A. van Wijk, *Memorie van Overgave van Bestuur van den Aftredende Controleur van Amboina* (Amsterdam: KIT, 1937), cited in Chauvel, "Ambon's Other Half," 40–80.

27. Juliet Patricia Lee, "Out of Order: The Politics of Modernity in Indonesia" (PhD diss., University of Virginia, 1999).

28. J. P. Lee, "Out of Order," 96–97.

29. See Gerry van Klinken, *Communal Violence and Democratization in Indonesia: Small Town Wars* (New York: Routledge, 2007); and John T. Sidel, *Riots, Pogroms, Jihad: Religious Violence in Indonesia* (Ithaca, N.Y.: Cornell University Press, 2006).

30. J. P. Lee, "Out of Order."

31. Hatib Abdul Kadir mentions stories about Pattimura being a Muslim. "'Biar Punggung Patah, Asal Muka Jangan Pucat' Melacak Gengsi Dan Gaya Tubuh Anak Muda Kota Ambon" (bachelor's thesis, Universitas Gajah Mada, 2008).

32. See Badrus Sholeh on the repeated challenges to sovereign powers on the part of Malukans, in "Ethno-religious Conflict and Reconciliation: Dynamics of Muslim and Christian Relationships in Ambon" (PhD diss., Australian National University, 2003).

33. John Pemberton, *On the Subject of "Java"* (Ithaca, N.Y.: Cornell University Press, 1994).

34. Hal Hill, "The Indonesian Economy: The Strange and Sudden Death of a Tiger," in Aspinell, Feith, and Van Klinken, eds., *Last Days of President Suharto*.

35. Edward Aspinall, *Opposing Suharto: Compromise, Resistance, and Regime Change in Indonesia* (Stanford, Calif.: Stanford University Press, 2005), xii.

36. Hill, "Indonesian Economy," 14–16.

37. David Bourchier, "Face-Off in Jakarta: Suharto vs the IMF," in Aspinall, Feith, and Van Klinken, eds., *Last Days of President Suharto*, 9.

38. Karen Strassler, "Gendered Visibilities and the Dream of Transparency: The Chinese-Indonesian Rape Debate in Post-Suharto Indonesia," *Gender & History* 16, no. 3 (2004): 705; and James T. Siegel, "Early Thoughts on the Violence of May 13 and 14, 1998, in Jakarta," *Indonesia* 66 (1998): 75n1.

39. Siegel, "Early Thoughts," 75n1.

40. Siegel, 75n1.

41. Karen Strassler notes how the imagining of this international gaze was often articulated in the language of photography, quoting a reviewer from a Reformasi photo exhibition who observed, "Indonesia today had truly become a focal point of the world's lens. All photographers have pointed their cameras at this land since the beginning of the year 1998, when Suharto began to be rocked by the economic crisis and student protests." Karen Strassler, *Refracted Visions: Popular Photography and National Modernity in Java* (Durham, N.C.: Duke University Press, 2010).

42. Mary Margaret Steedly explores the resonances between the media aesthetic of visualization, concealment, and revelation characteristic of Indonesian horror films popular in the aftermath of Suharto's fall and the call for transparency

together with the apprehension, even dread, that often accompanied it. Mary Margaret Steedly, "Transparency and Apparition: Media Ghosts of Post–New Order Indonesia," in Spyer and Steedly, eds., *Images That Move.*

43. Steedly, "Transparency and Apparition," 284.

44. Edward Aspinall and Greg Fealy, *Local Power and Politics in Indonesia: Decentralisation & Democratisation* (Singapore: Institute of Southeast Asian Studies, 2003), 109.

45. Aspinall and Fealy, *Local Power and Politics in Indonesia*, 109; and Henk Schulte Nordholt and Gerry van Klinken, *Renegotiating Boundaries: Local Politics in Post-Suharto Indonesia* (Leiden, Netherlands: KITLV, 2007).

46. See World Bank, *Decentralizing Indonesia: A Regional Public Expenditure Review* (Jakarta: World Bank, 2003).

47. Merlyna Lim qualifies the exuberance of some, especially journalists, who hailed the Indonesian political revolution of 1998 as an internet revolution. Instead, she calls it "an Internet-'coincident' revolution" insofar as the internet was neither the only nor even the main source of information for social mobilization that led to Suharto's downfall. Moreover, the "most important factor was not cyberspace itself but, rather, the linkages between cyberspace: cyber nodes such as the *warnet* [internet cafes] and the physical spaces of cities, towns, and villages." Merlyna Lim, "The Internet, Social Networks, and Reform in Indonesia," in *Contesting Media Power: Alternative Media in a Networked World*, ed. Nick Couldry and James Curran (London: Rowman & Littlefield, 2003).

48. See Intan Paramaditha, "The Wild Child's Desire: Cinema, Sexual Politics, and the Experimental Nation in Post-Authoritarian Indonesia" (PhD diss., New York University, 2014); Katinka van Heeren, "Return of the Kyai: Representations of Horror, Commerce, and Censorship in Post-Suharto Indonesian Film and Television," *Inter-Asian Cultural Studies* 8, no. 2 (2007): 211–26; and Steedly, "Transparency and Apparition," on the particular genre of horror films.

49. Eva-Lotta E. Hedman, *Conflict, Violence, and Displacement in Indonesia* (Ithaca, N.Y.: Cornell University Press, 2008), 27. Of the small number of national and international organizations that had lingered on in Ambon after the 2002 official peace, the large majority of these departed for Aceh when the December 26, 2004, tsunami left that region devastated.

50. See Alan Klima's discussion of images from Bangkok's Black May massacre of 1992 of the "dialectic of local and global imagery," which were "spirited over the surface of the globe by the BBC" only to be returned and recycled in cassettes sold locally by Thai traders in the exact same location where the violence first took place. Alan Klima, *The Funeral Casino: Meditation, Massacre, and Exchange with the Dead in Thailand* (Princeton, N.J.: Princeton University Press, 2009), 1–5. See also Nicholas Mirzoeff, *Watching Babylon: The War in Iraq and Global Visual Culture* (New York: Routledge, 2005). While his concern is how images from Iraq are watched and how this relates to the exercise of power from specific localities, the implications of Mirzoeff's argument for thinking about how "visual subjects"—people defined as

agents of sight and objects of certain discourses of visuality—relate to globalized images, including images of themselves, is generally relevant here.

51. In this I follow Kajri Jain, who understands the category of the aesthetic as ambivalently referring "both to a quality of the object and to an appropriate attitude of judgment. The way an object looks, its color, 'content' or 'style' is indissociable from the way it is looked at, or the locations and modalities of its use." Kajri Jain, *Gods in the Bazaar: The Economies of Indian Calendar Art* (Durham, N.C.: Duke University Press, 2007), 187. On the semiotics of materials and materiality, see Finbarr Barry Flood, *Objects of Translation: Material Culture and Medieval "Hindu-Muslim" Encounter* (Princeton, N.J.: Princeton University Press, 2009), 9.

52. On children's drawings produced in Central Java during the period of Reformasi, see Karen Strassler, "Reformasi through Our Eyes: Children as Witnesses of History in Post-Suharto Indonesia," *Visual Anthropology Review* 22, no. 2 (2006): 53–70. I would like to thank Karen Strassler and Katinka van Heeren for sharing some examples of the Letters to the President genre.

53. Corresponding to the regime's legitimized visibilities were also certain invisibilities, from the specters of the regime itself like the ominous "organizations without shape" (I. *organisasi tanpa bentuk*) lurking just beyond vision, everywhere and nowhere, to its many hidden horrors and crimes—from mass graves, some of which were excavated after the regime's fall (see Lexy Rambadeta's moving documentary *Mass Grave* [Offstream, 2001]), to its forest prison for alleged communists and communist sympathizers on the Central Malukan island of Buru. See Pramoedya Ananta Toer, *The Mute's Soliloquy: A Memoir*, trans. William Samuels (New York: Hyperion East, 1999).

54. Ariel Heryanto, *State Terrorism and Political Identity in Indonesia: Fatally Belonging* (New York: Routledge, 2006), 14.

55. See Paramaditha, "Wild Child's Desire," 117.

56. In 2011, Intan Paramaditha, the Indonesian filmmaker and writer with a PhD from New York University's Cinema Studies Department, wrote:

Violence is . . . neither new nor exotic for us Indonesians. We have been trained to see it, even live with it, since [an] early age. For some of us, watching *Pengkhianatan G30S/PKI* [*The September 30, 1965 Movement/Communist Treason* film] was an initiation to adulthood; we were suddenly forced to learn that we had a history, the one built upon eye-gouging women and decomposed tortured bodies. This was the form of violence legitimized and endorsed for public viewing to suit the interest of the Suharto regime. But later we knew we should look for what was not supposed to be seen. We engaged in the long project of unearthing the New Order crimes to make hidden violence visible. Like information, most violence during those times was spectral. The ability to see was a luxury. What is "new" since *Reformasi*, with thanks to the internet technology, is that we have passed the crisis of visibility. Before our eyes, everything is laid bare. Or is it? (Intan Paramaditha, "Questions on Witnessing Violence," *Jakarta Post*, April 4, 2011)

57. Credited with the same potency as that of their student makers, the photographs that circulated in exhibitions and other public venues during and after

Reformasi were also understood as "witnesses of history." As such, they were prosthetically linked to the students' original morally charged act of seeing and held to be capable of extending this act to their viewers. See Strassler, *Refracted Visions*, 210–11.

58. Produced by Garin Nugroho, the film—like some of his other works, including the 1990s series *Anak Seribu Pulau* and *Daun di Atas Bantal*—mobilizes the figure of the child as an affective and depoliticized allegory of the nation and its appealing colorful diversity. In *Peace Song* ([*Nyanyian Damai*], dir. Hartawan Triguna [SET Filmworkshop, 2011]), photographs of children's faces and their drawings index the child's potent affective force.

59. On the figure of the orphan, see Patrick Greaney, *Untimely Beggar: Poverty and Power from Baudelaire to Benjamin* (Minneapolis: University of Minnesota Press, 2007).

60. Ravi L. Bharwani, Aryo Danusiri, Asep Kusdinar, Lianto Luseno, and Nana Mulyana, dirs., *Viva Indonesia! An Anthology of Letters to God* (2001).

61. See Patricia Spyer, "*Belum Stabil* and Other Signs of the Times in Post-Suharto Indonesia," in *Indonesia in Transition: Rethinking Civil Society, Region, and Crisis*, ed. Rochman Achwan, Hanneman Samuel, and Henk Schulte Nordholt (Yogyakarta, Indonesia: Pustaka Pelajar, 2004).

62. Bernhard Siegert, *Relays: Literature as an Epoch of the Postal System*, trans. Kevin Repp (Stanford, Calif. : Stanford University Press, 1999), 11–12.

63. Jacques Lacan, "Seminar on 'The Purloined Letter,'" in *The Purloined Poe: Lacan, Derrida, and Psychoanalytic Reading*, ed. J. P. Muller and W. J. Richardson (Baltimore: Johns Hopkins University Press, 1988).

64. See Anne Higonnet, *Pictures of Innocence: The History and Crisis of Ideal Childhood* (London: Thames and Hudson, 1998), 45. In the early 2000s in Indonesia, the haunting of purity by its possible violation did not conjure sexual violence or pornography as is often the case in the United States or Europe, where the child has become an increasingly sexualized subject seen as either a source of threat or its object.

65. Saya Shiraishi, *Young Heroes: The Indonesian Family in Politics* (Ithaca, N.Y.: Southeast Asia Program Publications, an imprint of Cornell University Press, 1997).

66. Abidin Kusno, *The Appearances of Memory: Mnemonic Practices of Architecture and Urban Form in Indonesia* (Durham, N.C.: Duke University Press, 2010), 36.

67. Pinney, "*Photos of the Gods*," 204–5.

68. Pinney and Peterson, eds., *Photography's Other Histories*.

69. Pinney, "*Photos of the Gods*," 12.

70. Higonnet, *Pictures of Innocence*.

71. Samuel Weber, *Institution and Interpretation* (Minneapolis: University of Minnesota Press, 1987), xv.

72. Weber, *Institution and Interpretation*, xv.

73. Lieven De Cauter, *Entropic Empire: On the City of Man in the Age of Disaster* (Rotterdam, Netherlands: NAi Booksellers, 2012); Patricia Spyer, "After Violence—A

Discussion," in *Producing Indonesia: The State of the Field in Indonesian Studies*, ed. Eric Tagliacozzo (Ithaca, N.Y.: Southeast Asia Program Publications, an imprint of Cornell University Press, 2014); and Patricia Spyer, "Art Under Siege: Perils and Possibilities of Aesthetic Forms in a Globalizing World," in *Arts and Aesthetics in a Globalizing World*, ed. Raminder Kaur and Parul Dave-Mukherji (Oxford: Berg, ASA Monographs, 2014).

74. Elias Khoury, *Sinacol: Le miroir brisé*, trans. Rania Samara (Arles, France: Actes Sud, 2013), cited in De Cauter, *Entropic Empire*, 124.

75. C. Vogler, "Introduction: Violence, Redemption, and the Liberal Imagination," *Public Culture* 15, no. 1 (2003): 9.

76. Michel de Certeau, *The Possession at Loudun*, trans. Michael B. Smith (Chicago: University of Chicago Press, 2000).

77. *Webster's New World Dictionary*, 2nd ed. (1972), s.v. "symptom."

78. Veena Das and Arthur Kleinman, *Remaking a World: Violence, Social Suffering, and Recovery* (Berkeley: University of California Press, 2001), 1–2.

79. Michael Warner, *Publics and Counterpublics* (Cambridge, Mass.: Zone Books, 2002).

80. Tim Edensor, "Waste Matter: The Debris of Industrial Ruins and the Disordering of the Material World," *Journal of Material Culture* 10, no. 3 (2005): 311.

81. Webb Keane, *Signs of Recognition: Powers and Hazards of Representation in an Indonesian Society* (Berkeley: University of California Press, 1997), 25.

82. Edensor, "Waste Matter," 314.

83. Webb Keane, *Christian Moderns: Freedom and Fetish in the Mission Encounter* (Berkeley: University of California Press, 2007), 14.

84. Henk Schulte Nordholt, ed., *Outward Appearances: Dressing State & Society in Indonesia* (Leiden, Netherlands: KITLV Press, 1997).

85. First and foremost among these are Clifford Geertz, *The Interpretation Of Cultures* (New York: Basic Books, 1973), and *The Religion of Java* (Chicago: University of Chicago Press, 1976).

86. Schulte Nordholt, *Outward Appearances*; Carla Jones, "Fashion and Faith in Urban Indonesia," *Fashion Theory* 11, no. 2–3 (2007): 211–31; Carla Jones, "Materializing Piety: Gendered Anxieties about Faithful Consumption in Contemporary Urban Indonesia," *American Ethnologist* 37, no. 4 (2010): 617–37; Clifford Geertz, *Negara: The Theatre State in Nineteenth-Century Bali* (Princeton, N.J.: Princeton University Press, 1980); Kenneth M. George, "Ethics, Iconoclasm, and Qur'anic Art in Indonesia," *Cultural Anthropology* 24, no. 4 (2009): 589–621; Kenneth M. George, *Picturing Islam: Art and Ethics in a Muslim Lifeworld* (Malden, Mass.: Wiley-Blackwell, 2010); Anna Tsing, "Inside the Economy of Appearances," *Public Culture* 12, no. 1 (2000): 115–44; Kusno, *Appearances of Memory*; Rudolf Mrázek, *Engineers of Happy Land: Technology and Nationalism in a Colony* (Princeton, N.J.: Princeton University Press, 2002); Strassler, *Refracted Visions*; Karen Strassler, *Demanding Images: Democracy, Mediation, and the Image-Event in Indonesia* (Durham, N.C.: Duke University Press, 2020); Adrian Vickers, *Bali: A Paradise Created*. Singapore: Periplus Editions, 1997; and Margaret J.

Wiener, *Visible and Invisible Realms: Power, Magic, and Colonial Conquest in Bali* (Chicago: University of Chicago Press, 1995). For an interesting adaptation of Tsing's "economy of appearances," see Ann Marie Leshkowich, on a "political economy of appearances," in *Essential Trade: Vietnamese Women in a Changing Marketplace* (Honolulu: University of Hawai'i Press, 2014).

87. Pemberton, *On the Subject of "Java."*

88. Pemberton, 3–7.

89. Pemberton, 3–7.

90. A selection of some of the most exemplary include: Zeynep Devrim Gürsel, *Image Brokers: Visualizing World News in the Age of Digital Circulation* (Berkeley: University of California Press, 2016); Mirzoeff, *Watching Babylon*; and W. J. T. Mitchell, *Cloning Terror: The War of Images, 9/11 to the Present* (Chicago: University of Chicago Press, 2011). For an especially subtle reading of the Abu Ghraib photographs, see Judith Butler, *Frames of War: When Is Life Grievable?* (London: Verso, 2016). Increasingly, images are central to the exercise of so-called soft power as, for instance, in the reliance by the Columbian state and FARC rebels alike on branding during the country's civil war. See Alexander L. Fattal, *Guerrilla Marketing: Counterinsurgency and Capitalism in Colombia* (Chicago: University of Chicago Press, 2018).

91. Butler, *Frames of War*.

92. See Ariella Azoulay, *The Civil Contract of Photography* (New York: Zone Books, 2008); Ariella Azoulay, *Potential History: Unlearning Imperialism* (New York: Verso, 2020); Gil Hochberg, *Visible Occupations: Violence and Visibility in a Conflict Zone* (Durham, N.C.: Duke University Press, 2015); and Adi Kuntsman and Rebecca L. Stein, *Digital Militarism: Israel's Occupation in the Social Media Age* (Stanford, Calif.: Stanford University Press, 2015).

93. See, for instance, Shawn Michelle Smith, *American Archives: Gender, Race, and Class in Visual Culture* (Princeton, N.J.: Princeton University Press, 1999); and bell hooks, "In Our Glory: Photography and Black Life," in *Art on My Mind: Visual Politics* (New York: New Press, 1995). See Karen Strassler's *Refracted Visions* on the fraught visuality of Chinese Indonesians insofar as they are excluded from representing the nation while owning the majority of photographic studios in colonial and postcolonial Indonesia and producing many of its iconic images; also her "Photography's Asian Circuits," *IIAS Newsletter* 44 (July 31, 2007): 1, 4–5. See Nicole R. Fleetwood, *On Racial Icons: Blackness and the Public Imagination* (New Brunswick, N.J.: Rutgers University Press, 2015), which tracks the currency of icons of Blackness in public life to show how these register in myriad ways the complexities and shifts in race relations in the United States.

1. Fire without Smoke

1. Gerry van Klinken provides a more precise schema, comprising five phases, that tracks the violence through different waves beginning on January 19, 1999,

through the sporadic bombings and shootings that continued after the Malino II Peace Agreement in February 2002 until the riot on April 25, 2004, the date commemorating the foundation of the separatist RMS movement. Gerry van Klinken, *Communal Violence and Democratization in Indonesia: Small Town Wars* (New York: Routledge, 2007). See also Dieter Bartels, "Your God Is No Longer Mine: Moslem-Christian Fratricide in the Central Moluccas (Indonesia) after a Half-Millennium of Peaceful Co-existence and Ethnic Unity," in *A State of Emergency: Violence, Society and the State in Eastern Indonesia*, ed. Sandra Pannell (Darwin, Australia: Northern Territory University Press, 2003); and George Aditjondro, "Guns, Pamphlets and Handie-Talkies: How the Military Exploited Local Ethno-religious Tensions in Maluku to Preserve Their Political and Economic Privileges," in *Violence in Indonesia*, ed. Ingrid Wessel and Georgia Wimhöfer (Hamburg, Germany: Abera Verlag, 2001).

2. Dave McRae, *A Few Poorly Organized Men: Interreligious Violence in Poso, Indonesia* (Leiden, Netherlands: Brill, 2013).

3. Kirsten E. Schulze, "Laskar Jihad and the Conflict in Ambon," *Brown Journal of World Affairs* 9, no. 1 (2002): 57–69.

4. See Pachalis Maria Laksono, *The Common Ground in the Kei Islands: Eggs from One Fish and One Bird* (Yogyakarta, Indonesia: Galang Press, 2002).

5. The Laskar Jihad is the paramilitary wing of the organization known as the Forum Komunikasi Ahlussunnah wal-Jama'ah (FKAWJ), or the Communications Forum of the Sunna and the Community of the Prophet, which was founded in early 1998 by Ja'far Umar Thalib. The formation of the Laskar Jihad was announced at a mass rally in the Central Javanese city of Solo in April 2000 although its origins can be traced to Muslim mobilization in early 2000 in the wake of a widely mediated massacre at a mosque in Tobelo on the Malukan island of Halmahera. On the Laskar Jihad's background and activities, see Schulze, "Laskar Jihad and the Conflict in Ambon"; Badrus Sholeh, "Ethno-religious Conflict and Reconciliation: Dynamics of Muslim and Christian Relationships in Ambon" (PhD diss., Australian National University, 2003); and Noorhaidi Hasan, "Faith and Politics: The Rise of the Laskar Jihad in the Era of Transition in Indonesia," *Indonesia* 73 (2002): 145–69. On the organization's characteristic theatricality and spectacular violence, see Jacqui Baker, "Laskar Jihad's Mimetic Stutter: State Power, Spectacular Violence and the Fetish in the Indonesian Postcolony" (bachelor's thesis, Australian National University, 2002). For detailed biographical information on Indonesian jihadists, see Muhammad Najib Azca, "After Jihad: A Biographical Approach to Passionate Politics in Indonesia" (PhD diss., University of Amsterdam, 2011). For an analysis of Indonesian jihadi VCDs, see Patricia Spyer, "Reel Accidents: Screening the Ummah Under Siege in Wartime Maluku," *Current Anthropology* 58, no. S15 (2016): S27–40. John T. Sidel situates the emergence of jihad in Indonesia within a long-term historical and structural analysis of the dynamics of Indonesian politics and society and the place of religion therein. John T. Sidel, *Riots, Pogroms, Jihad: Religious Violence in Indonesia* (Ithaca, N.Y.: Cornell University Press, 2006).

6. On this conflict in North Maluku, see Christopher R. Duncan, *Violence and Vengeance: Religious Conflict and Its Aftermath in Eastern Indonesia* (Ithaca, N.Y.: Cornell University Press, 2013); Nils Bubandt, "Malukan Apocalypse: Themes in the Dynamics of Violence in Eastern Indonesia," in Wessel and Wimhöfer, eds., *Violence in Indonesia*; and Nils Bubandt, "Rumors, Pamphlets, and the Politics of Paranoia in Indonesia," *Journal of Asian Studies* 67, no. 3 (2008): 789–817.

7. As Lorraine V. Aragon observes regarding a similar VCD called *The Bloody Poso Tragedy: A Documentary Film about the Slaughter of Poso Muslims (Tragedi Poso Berdarah: Film Dokumenter Pembantaian Muslim Poso)*, which depicts the killing of fourteen Muslims, including women and children, "the source of Muslims' anguish over the attack . . . will be apparent to anyone who watches this video." Lorraine V. Aragon, "Mass Media Fragmentation and Narratives of Violent Action in Sulawesi's Poso Conflict," *Indonesia* 79 (2005): 34. See also Spyer, "Reel Accidents."

8. Baker, "Laskar Jihad's Mimetic Stutter," 22.

9. Interviews conducted by Badrus Sholeh in Ambon in 2002 suggest that the nature of local Muslims' religiosity changed due to the teachings of the Laskar Jihad, fostering confidence in the righteousness and legality of attacking and killing Christians. See Badrus Sholeh, "Ethno-religious Conflict and Reconciliation," 60.

10. See Daniel B. Kotan, ed., *Mediator Dalam Kerusuhan Maluku* (Jakarta: Sekretariat Komisi Katenetik KWI, 2000).

11. Writing about the conflict in Poso, South Sulawesi, Dave McRae identifies a third phase of violence there as "religious violence," understanding it similarly as something that emerged in the conflict's unfolding dynamics rather than as somehow given beforehand. See McRae, *Few Poorly Organized Men*.

12. On the problem of Ambon's "rebel soldiers" or deserters, see "Perang Tentara Pembangkang di Ambon," *Tempo* 10, June 16, 2002, 24–37.

13. Aragon, "Mass Media Fragmentation," 5.

14. International Crisis Group, "Indonesia: The Search for Peace in Maluku," *ICG Asia Report* 31 (February 8, 2002): 17.

15. A selection of the many publications include, among the more academic: Aditjondro, "Guns, Pamphlets and Handie-Talkies"; Bartels, "Your God Is No Longer Mine"; Birgit Bräuchler, "Cyberidentities at War: Religion, Identity, and the Internet in the Moluccan Conflict," *Indonesia* 75 (2003): 123–51; Bubandt, "Malukan Apocalypse"; Eriyanto, *Media Dan Konflik Ambon: Media, Berita Dan Kerusuhan Komunal Di Ambon, 1999–2002* (Jakarta: Kantor Berita Radio 68H, 2003); and Andries Greiner, ed., *De Molukken in Crisis: Machteloos, Ver Weg, Maar Niet Wanhopig*, no. 2691 (Lelystad, Netherlands: Actuele Onderwerpen, 2000). See Gerry van Klinken, "The Maluku Wars: Bringing Society Back In," *Indonesia* 71 (2001): 1; Van Klinken, *Communal Violence and Democratization in Indonesia*; Merlyna Lim, "@rchipelago Online: The Internet and Political Activism in Indonesia" (PhD diss., University of Twente, 2005); Wim Manuhutu, ed., *Maluku Manis, Maluku Menangis: De Molukken in Crisis. Een Poging Tot Verklaring van de Geweldsexplosie Op de Molukken* (Utrecht, Netherlands: Moluks Historisch Museum/

Moluccan Information and Documentation Center, 2001); Steve Sharp, *Journalism and Conflict in Indonesia: From Reporting Violence to Promoting Peace* (New York: Routledge, 2013); Sholeh, "Ethno-religious Conflict and Reconciliation"; Sidel, *Riots, Pogroms, Jihad*; Fridus Steijlen, *Kerusuhan, Het Misverstand over de Molukse Onrust* (Utrecht, Netherlands: Forum, 2000); and Tim Pengkajian, *Analisis sosial tentang peristiwa kerusuhan berdarah di kotamadya Ambon dan sekitarnya Januari–Februari 1999* (Ambon, Indonesia: Universitas Pattimura, 1999). NGO and activist works include International Crisis Group, "Indonesia Backgrounder: How the Jemaah Islamiyah Terrorist Network Operates," *ICG Asia Report* 43 (December 11, 2002); Human Rights Watch, "Indonesia and East Timor," in *Human Rights Watch World Report 1999* (New York: Human Rights Watch, 1999); Zairin Salempessy and Thamrin Husain, eds., *Ketika Semerbak Cengkih Tergusur Asap Mesiu: Tragedi Kemanusiaan Maluku Di Balik Konspirasi Militer, Kapitalis Birokrat, Dan Kepentingan Elit Politik* (Jakarta: Sekretariat Tapak Ambon, 2001); S. Sinansari Ecip, *Menyulut Ambon: Kronologi Merambatnya Berbagai Kerusuhan Lintas Wilayah Di Indonesia* (Bandung, Indonesia: Mizan, 1999); *Luka Maluku: Militer Terlibat* (Jakarta: Institut Studi Arus Informasi, 2000); and Tim Penyusun al-Mukmin, *Tragedi Ambon* (Jakarta: Yayasan Al-Mukmin, 1999). Other sources (including some by protagonists in the conflict) are Erwin H. Al-Jakartaty, *Tragedi Bumi Seribu Pulau: Mengkritisi Kebijakan Pemerintah Dan Solusi Penyelesaian Konflik* (Jakarta: BukKMaNs, 2000); A. Q. Djaelani, *Perang sabil versus perang salib: umat Islam melawan penjajah Kristen Portugis dan Belanda* (Jakarta: Yayasan Pengkajian Islam Madinah al-Munawwarsh, 1999); M. Husni Putuhena, *Buku Putih-Tragedi Kemanusiaan Dalam Kerusuhan Di Maluku. Sebuah Prosesi Ulang Sejarah Masa Lalu* (Ambon, Indonesia: Lembaga Eksistensi Muslim Maluku, 1999); Rustam Kastor, *Konspirasi Politik RMS Dan Kristen Menghancurkan Ummat Islam Di Ambon-Maluku* (Yogyakarta, Indonesia: Wihdah Press, 2000); Rustam Kastor, *Suara Maluku Membantah/Rustam Kastor Menjawab* (Yogyakarta, Indonesia: Wihdah Press, 2000); Kotan, *Mediator Dalam Kerusuhan Maluku*; and Jan Nanere, ed., *Halmahera Berdarah* (Ambon, Indonesia: Bimspela, 2000). Finally, see Patricia Spyer, "Fire without Smoke and Other Phantoms of Ambon's Violence: Media Effects, Agency, and the Work of Imagination," *Indonesia* 74 (2002): 21–36; and Patricia Spyer, "Some Notes on Disorder in the Indonesian Postcolony," in *Law and Disorder in the Postcolony*, ed. John L. Comaroff and Jean Comaroff (Chicago: University of Chicago Press, 2006).

16. On this official in-migration, see Alpha R. Amirrachman, "Peace Education in the Moluccas, Indonesia: Between Global Models and Local Interests" (PhD diss., University of Amsterdam, 2012).

17. Carl von Clausewitz's characterization of the realm of uncertainty associated with war is in his posthumously published book *Vom Kriege* (1832) that appeared in English translation in 1973 with the title *On War*. Carl von Clausewitz, *On War*, ed. Michael Eliot Howard and Peter Paret (Princeton, N.J.: Princeton University Press, 1973), 140.

18. David MacDougall, *The Corporeal Image: Film, Ethnography, and the Senses* (Princeton, N.J.: Princeton University Press, 2006).

19. On the so-called mysterious killings, see Joshua Barker, "State of Fear: Controlling the Criminal Contagion in Suharto's New Order," *Indonesia* 66 (1998): 7–42. A central part of these killings in the early to mid-1980s was what Suharto called "shock therapy." Used to describe the strategic deployment of the public display of corpses of alleged criminals summarily executed during government sponsored "mysterious killings," shock therapy, in the authoritarian leader's own words, "was done so that the general public would understand that there was still someone capable of taking action to tackle the problem of criminality." Suharto quoted in Geoffrey Robinson, "Rawan Is as Rawan Does: The Origins of Disorder in New Order Aceh," in *Violence and the State in Suharto's Indonesia*, ed. Benedict Anderson (Ithaca, N.Y.: Cornell University Press, 2001), 227–28; and Benedict Anderson, "Indonesian Nationalism Today and in the Future," *New Left Review* I, no. 235 (1999). See also Sandra N. Pannell, ed., *A State of Emergency: Violence, Society, and the State in Eastern Indonesia* (Darwin, Australia: Northern Territory University Press, 2003), 1; Henk Schulte Nordholt and Gerry van Klinken, *Renegotiating Boundaries: Local Politics in Post-Suharto Indonesia* (Leiden, Netherlands: KITLV Press, 2007), 6; and Ariel Heryanto and Nancy Lutz, "The Development of 'Development,'" *Indonesia* 46 (1988): 1–24.

20. Remco Raben, "On Genocide and Mass Violence in Colonial Indonesia," *Journal of Genocide Research* 14, no. 3–4 (2012): 485–502.

21. Gyanendra Pandey, *Routine Violence: Nations, Fragments, Histories* (Stanford, Calif.: Stanford University Press, 2006).

22. Schulte Nordholt and Van Klinken, *Renegotiating Boundaries.*

23. Achille Mbembe, *On the Postcolony* (Berkeley: University of California Press, 2001), 175.

24. Mary Margaret Steedly, "The State of Culture Theory in the Anthropology of Southeast Asia," *Annual Review of Anthropology* 28 (1999): 445–46.

25. Steedly, "State of Culture Theory," 445–46.

26. On these markets, see Jeroen Adam, "Displacement, Coping Mechanisms and the Emergence of New Markets in Ambon" (working paper no. 9, Conflict Research Group, University of Ghent, March 2008).

27. On Butonese in particular, see Adam, "Displacement, Coping Mechanisms and the Emergence of New Markets in Ambon"; and Jeroen Adam, "Downward Social Mobility, Prestige and the Informal Economy in Post-Conflict Ambon," *South East Asia Research* 16, no. 3 (2008). See also Hatib Abdul Kadir, "Gifts, Belonging, and Emerging Realities among 'Other Moluccans' during the Aftermath of Sectarian Conflict" (PhD diss., University of California, Santa Cruz, 2017).

28. Recorded interview with author, Pineleng, Indonesia, August 10, 2001.

29. Leena Avonius, "Reforming Wetu Telu: Islam, Adat, and the Promises of Regionalism in Post–New Order Lombok" (PhD diss., Leiden University, 2004).

30. *Preman* are thugs who tend to operate in gangs. Henk Schulte Nordholt calls them "traffickers in political violence" since they are often used as the henchmen of political parties and groups. Henk Schulte Nordholt, A *Genealogy of Violence in Indonesia*, notebooks 1–33 (Lisbon: Centro Portugues de Estudoes do Sudeste Asiatico, 2001), 25. For a genealogy of the preman figure and Loren Ryter on preman during Suharto's New Order, as well as how they changed thereafter, see, respectively, Loren Ryter, "Pemuda Pancasila: The Last Loyalist Free Men of Suharto's Order?," *Indonesia* 66 (1998): 45–73; and Loren Ryter, "Reformasi Gangsters," *Inside Indonesia*, July 24, 2007, which includes a photograph of a Pemuda Pancasila coat of arms that embellishes a motorbike-taxi stand.

31. Van Klinken, *Communal Violence and Democratization in Indonesia*, 98.

32. See, however, Human Rights Watch, *Indonesia: The Violence in Ambon* (New York: Human Rights Watch, 1999), 6; and an interview with historian Richard Chauvel, the Ambon-based Keiese journalist Rudi Fofid, and Sidney Jones, Asian director of Human Rights Watch at the time, "Island of Ambon Is Worst Trouble Spot in Indonesia," *Radio Australia Indonesia Service*, March 5, 1999. In his 2007 book, Gerry van Klinken provides some additional details about this meeting, noting how plans were made to establish community night watches and that the governor of the province, having noticed that the mosques were not as well connected to any communication network as the churches, encouraged the former to install telephones. Van Klinken, *Communal Violence and Democratization in Indonesia*, 97.

33. Van Klinken, *Communal Violence and Democratization in Indonesia*, 98.

34. Nils Bubandt mentions being shown one of several photographs that circulated among Christians in North Maluku, purportedly showing the appearance of God during the early stages of the violence in Ambon, and how such sightings were a critical aspect of the heightened anxiety that took hold of at least the Christian areas. Bubandt, "Rumors, Pamphlets, and the Politics of Paranoia in Indonesia."

35. While it is certainly plausible that Muslims had their own visionaries at this time, I worked primarily with Christians and have no evidence of this.

36. On the role of such colors in elections, see John Pemberton, "Notes on the 1982 General Election in Solo," *Indonesia* 41 (April 1986): 1–22; and among students involved in the Reformasi movement, see Doreen Lee, *Activist Archives: Youth Culture and the Political Past in Indonesia* (Durham, N.C.: Duke University Press, 2016); and Yatun Sastramidjaja, *Playing Politics: Power, Memory, and Agency in the Making of the Indonesian Student Movement* (Leiden, Netherlands: Brill, 2020).

37. Laura Blumenfeld, *Revenge: A Story of Hope* (New York: Washington Square Press, 2003), 54. Bubandt, "Rumors, Pamphlets, and the Politics of Paranoia in Indonesia."

38. Van Klinken, *Communal Violence and Democratization in Indonesia*, 152.

39. In the context of the religiously inflected conflict in Poso on Sulawesi Island in the early 2000s, a VCD titled *The Bloody Poso Tragedy: The Documentary Film about the Slaughter of Poso Muslims* confirms the wide currency of the discourse of victimization across religious boundaries, also evident in the circulation of the term

tragedi (tragedy), because tragedies "require uncritical sympathy and aid from all able witnesses." See Aragon, "Mass Media Fragmentation," 51.

40. Recorded interview with author, Manado, Indonesia, August 8, 2001. Lebaran is the Indonesian name for Idul Fitri.

41. On hardcopy rumors, see Nils Bubandt, "Ghosts with Trauma: Global Imaginaries and the Politics of Post-Conflict Memory," in *Conflict, Violence, and Displacement in Indonesia*, ed. Eva-Lotta E. Hedman (Ithaca, N.Y.: Cornell University Press, 2008). In February 2001, the Aliansi Jurnalis Independen (AJI) convened a meeting in Bogor, Java, that was attended by some forty journalists from Maluku, both Christian and Muslim, and that led to the foundation of the Maluku Media Centre (MMC). From the outset, the goal of the MMC was both to provide a neutral meeting ground for Christian and Muslim journalists to gather and exchange information and to foster peace journalism as a counter to the extreme media partisanship that had developed in the context of the war. Under the tutelage of AJI, the MMC organized multiple training sessions in independent media coverage and peace journalism, with a strong focus on print media. When violence broke out again in April 2004 around the illegal celebration of the RMS separatist movement's anniversary, AJI and MMC revised their project. In addition to a training program for radio journalists held in May 2005, an Interactive Radio News Program was launched on June 11, 2005, a collaborative effort of AJI, MMC, and the Jakarta-based 68H. I attended the third meeting of the MMC in Namlea, Buru, on June 17–19, 2005. I would like to thank AJI's Lensi Mursida for her invitation to participate in this event.

42. I paraphrase Ruth Benedict's famous statement from *The Races of Mankind*, coauthored with Gene Weltfish, and also draw on Carl von Clausewitz's insights into the fog of war. Ruth Benedict and Gene Weltfish, *The Races of Mankind*, Public Affairs Pamphlet no. 85 (New York: Public Affairs Committee, 1943).

43. Arjun Appadurai, *Modernity at Large: Cultural Dimensions of Globalization* (Minneapolis: University of Minnesota Press, 1996).

44. On the role of elsewheres in shaping social reality, see Patricia Spyer, *The Memory of Trade: Modernity's Entanglements on an Eastern Indonesian Island* (Durham, N.C.: Duke University Press, 2000).

45. For an overview of some of the work on violence in post-Suharto Indonesia, see Patricia Spyer, "After Violence—A Discussion," in *Producing Indonesia: The State of the Field in Indonesian Studies*, ed. Eric Tagliacozzo (Ithaca, N.Y.: Southeast Asia Program Publications, an imprint of Cornell University Press, 2014).

46. See John Sidel on the embeddedness of religion in religious institutions but also religious identities as invoked by the religious authorities. This, he argues, made the mobilization under the banner of religion so attractive in Indonesia in the late 1990s and early 2000s. This position dovetails with that of many Indonesians I spoke with, who emphasized that religion had been turned into a "tool" under Suharto in order to manipulate the population. Although Sidel's sociological explanation has none of the instrumentalist overtones of the vernacular ones, both underscore the

privileged position of religion in society and national politics. Sidel, *Riots, Pogroms, Jihad*, 7.

47. See Aragon, "Mass Media Fragmentation"; and David Mearns, "Dangerous Spaces Reconsidered: The Limits of Certainty in Ambon, Indonesia," in *A State of Emergency: Violence, Society and the State in Eastern Indonesia*, ed. Sandra Pannell (Darwin, Australia: Northern Territory University Press, 2003).

48. Regarding the conflict carried out between Christians and Muslims in Poso, Central Sulawesi, Aragon writes that "hundreds of otherwise ordinary rural Protestant men joined [these] vigilante brigades and committed unspeakable acts." Aragon, "Mass Media Fragmentation," 28.

49. Writing of narratives of Partition violence from the Indian subcontinent, Dipesh Chakrabarty speaks of the trope of "thingification" but also notes, crucially, that "for all the rendering of the human into a mere thing that collective violence may appear to perform, the recognition of one human of another as human is its fundamental precondition. . . . That is why it must be said, that even in denying the humanity of the victim of violence, the perpetrator of violence and torture does, to begin with, recognize the victim as human. In this unintentional practice of mutual human recognition lies the ground for the conception of proximity. The denial of the victim's humanity, thus, proceeds necessarily from this initial recognition of it." Dipesh Chakrabarty, *Habitations of Modernity: Essays in the Wake of Subaltern Studies* (Chicago: University of Chicago Press, 2002), 142.

50. In a general sense, violence in Ambon had an affinity with violence in places like Bosnia and Rwanda, one that was regularly identified by journalists who often too eagerly glossed over significant historical and political differences when mainstreaming such specificities within stories about entrenched "primordialisms," as pointed out by Tim Allen and Jean Seaton, eds., *The Media of Conflict: War Reporting and Representations of Ethnic Violence* (London: Zed Books, 1999). Within Indonesia, Ambon may qualify as one more example, following James T. Siegel, of the propensity throughout the republic's history to "kill those in one's image" or those not deemed other than oneself—in short, other Indonesians. James T. Siegel, *A New Criminal Type in Jakarta: Counter-Revolution Today* (Durham, N.C.: Duke University Press, 1998), 1–9. In this respect, Siegel sees a difference between the various large-scale Indonesian killings and those of, for instance, Hutus and Tutsis or Serbs and Croats, who murdered persons whom they considered constitutionally other than themselves or some version of the nonhuman.

51. Notes from interview with author, Manado, Indonesia, 2001.

52. I would like to thank Victor Joseph and Wim Manuhutu for helping me to procure a copy of the public service announcement. The ad was produced by the late Franky Sahilatua, a renowned Malukan singer.

53. Alpha Amirrachman suggests that the strict divide maintained between the world of adults and that of children is a more general feature of Ambonese society where, he claims, statements like "'this is adult's problem, not children's problems like you' are often heard." R. Alpha Amirrachman, "Peace Education in the Moluccas,

Indonesia: Between Global Models and Local Interests" (PhD diss., University of Amsterdam, 2012), 215. I do not believe, however, that sociology is the main issue here.

54. On the workings of backdrops, see Arjun Appadurai, "The Colonial Backdrop," *Afterimage* 24, no. 3 (1997): 1–7; and Robert J. Gordon, "Backdrops and Bushmen: An Expeditious Comment," in *The Colonising Camera: Photographs in the Making of Namibian History*, ed. Wolfram Hartmann, Jeremy Silvester, and Patricia Hayes (Cape Town: University of Cape Town Press, 1999).

55. For Maluku province, around the time of the war the proportion of people under twenty-five years of age was 58.1 percent and more or less the same in rural and urban areas. In East Java province, the corresponding percentage was 48.8 percent; Bali, 47.7 percent; Jakarta, 51.9 percent; while in the United States it was 35.7 percent and in Germany just 27.9 percent. See Van Klinken, "Maluku Wars," 11.

56. Aditjondro, "Guns, Pamphlets and Handie-Talkies," 101.

57. From the refugees I interviewed in Manado, I heard only the term *pasukan agas* or "sandfly troops." Other scholars of Maluku whom I questioned about the meaning of *pasukan linggis* or "crowbar troops" offered different explanations. Wim Manuhutu claimed *linggis* is a kind of fruit, while James T. Collins gave a more historical interpretation. In Indonesian, *linggis* means "crowbar." During the Japanese era, there was a song with the chorus: "Itu Inggris, kita linggis / Amerika kita seterika" ("the English we'll just crowbar [prize] out / the Americans we'll iron flat"). The Indonesian Communist Party used the same melody and kept the chorus. The song, in other words, still circulates, although I doubt most Malukans would be aware of this genealogy. Collins further pointed out that both "team names"—pasukan agas and pasukan linggis—are entirely Indonesian rather than Ambonese Malay. He also suggested how the different names index the different self-images of the opponents (and thus also, I would add, their intended or imagined effect on the enemy Other). Agas simply cause trouble or misery but do not totally displace their victims. *Linggis*, however, implies the entire removal and dislocation of the opponent. As I suggested earlier, the actions of both sides on the urban battlefield were not only equally nefarious and brutal but caught in a dynamic of negative reciprocity.

58. Lim, "@rchipelago Online"; and Bräuchler, "Cyberidentities at War," 127.

59. Bräuchler, "Cyberidentities at War," 149.

60. Lim, "@rchipelago Online," 168; and Bräuchler, "Cyberidentities at War," 141.

61. Lim, "@rchipelago Online," 168; and Bräuchler, "Cyberidentities at War," 141.

62. Many such poems and letters, as well as drawings, have been collected in publications put out by NGOs or other humanitarian-oriented groups. At least some of the children's work was produced in the context of postviolence trauma therapy and rehabilitation programs carried out by some of these organizations. See, for instance, *Kisah di Balik Kehidupan: Anak Pengungsi Maluku Utara di Manado dalam Gambar dan Puisi* (Manado, Indonesia: Yayasan Pelita Kasih Abadi/Catholic Relief Services Indonesia, 2001); Hasil Puisi Yayasan Pelita Kasih Abadi/Catholic Relief Services Jakarta, Manado, "Program Therapi Emosional Pengungsi Anak di Manado" (unpublished manuscript, January–March 2001); "Kumpulan Puisi Sanggar

Kreatif Anak Bitung," (unpublished manuscript, September–December 2005); and *Rumah seng ada Pintu: Anak-anak Maluku "Korban Kerusuhan"/Een Huis zonder Deur: Molukse Kinderen: "Slachtoffers van Geweld"* (Utrecht, Netherlands: Stichting TitanE, 2001). On such projects, see "Ambon Children Express Trauma through Art," *Jakarta Post*, May 20, 2002, which begins with a letter from "Sukardi," a refugee in Makassar, to his friend "Tammi Aimi" in Ternate, North Maluku province, in which he expresses his longing for his friend but adds, "I'm scared, wondering if you, my friend Tammi, are willing to welcome me back, as we saw our family among those who attacked yours." These trauma and postviolence programs are highly complicated projects resting on specific conceptions of childhood, memory, violence, and the future. Some of these issues come up in post-Malino reconciliation programs and are addressed in Chapter 5, "Provoking Peace."

63. On pela, see Dieter Bartels, "Guarding the Invisible Mountain: Intervillage Alliances, Religious Syncretism and Ethnic Identity among Ambonese Christians and Moslems in the Moluccas" (PhD diss., Cornell University, 1977); and Bartels, "Your God Is No Longer Mine."

64. Susan Stewart, *On Longing: Narratives of the Miniature, the Gigantic, the Souvenir, the Collection* (Durham, N.C.: Duke University Press, 1992), 44, 47.

65. Stewart, *On Longing*, 65.

66. On the origins of pemuda in the Indonesian Revolution, see Benedict Anderson, *The Pemuda Revolution: Indonesian Politics, 1945–1946* (Ithaca, N.Y.: Cornell University Press, 1967). On pemuda style, see William H. Frederick, "The Appearance of Revolution: Cloth, Uniform, and the Pemuda Style in East Java, 1945–1949," in *Outward Appearances: Dressing State and Society in Indonesia*, ed. Henk Schulte Nordholt (Leiden, Netherlands: KITLV Press, 1997); and Mary Margaret Steedly, *Rifle Reports: A Story of Indonesian Independence* (Berkeley: University of California Press, 2013), 125–32. On the historically more recent recuperation of pemuda power, see Doreen Lee, "Introduction: Pemuda Fever," in *Activist Archives*.

67. For earlier discussions of the figure of the child in violence, see my articles from Patricia Spyer, *Why Can't We Be Like Storybook Children? Media of Peace and Violence in Maluku* (Jakarta: KITLV Press, 2004); and Patricia Spyer, *"Belum Stabil* and Other Signs of the Times in Post-Suharto Indonesia," in *Indonesia in Transition: Rethinking Civil Society, Region, and Crisis*, ed. Rochman Achwan, Hanneman Samuel, and Henk Schulte Nordholt (Yogyakarta, Indonesia: Pustaka Pelajar, 2004).

68. On the stylistics and spectacular violence of the Laskar Jihad, see Baker, "Laskar Jihad's Mimetic Stutter." In the context of the conflict in Poso, the members of another Islamist group, the Jemaah Islamiyah, eventually became annoyed with the Laskar Jihad's self-publicity, which they dubbed "spray paint jihad" because apparently they would arrive behind the others and spray paint the name "Laskar Jihad" in villages that the Mujahidin KOMPAK and other jihad militias had just attacked. International Crisis Group, "Backgrounder Indonesia: Jihad in Central Sulawesi," *ICG Asia Report* 74 (February 3, 2004); and Aragon, "Mass Media Fragmentation," 44.

69. My discussion here is indebted to Susan Stewart's account of multum in parvo, or "miniaturized language." Stewart, *On Longing*, esp. 52–53.

70. Lieven De Cauter, *Entropic Empire: On the City of Man in the Age of Disaster* (Rotterdam, Netherlands: NAi Booksellers, 2012), 124.

71. Elias Khoury, *Sinacol: Le miroir brisé*, trans. Rania Samara (Arles, France: Actes Sud, 2013), cited in De Cauter, *Entropic Empire*, 124.

72. Khoury, *Sinacol*, cited in De Cauter, 124.

73. *Bang* derives from *abang* and is used by Muslims to address younger men who they do not know well. Christians may use the term but then only to address Muslims. *Bung* is a term associated with the Indonesian Revolution where it meant "brother" or "fellow" and was/is an affectionate term for leaders of that time like Bung Karno and Bung Hatta. In Ambon, *bu*, from the Dutch *broer* or "brother," was widely used to address men of the same age or older. It may have become conflated with *bung* in a context where *bu* must seem increasingly odd as fewer and fewer people speak Dutch. *Usi* or "older sister" among Christians also derives from Dutch, where *zuster* or "sister" led to *zuster-zus-usi*. I have no etymology for *cece*, but it appears to be the equivalent for Muslims of *usi* or "older sister." My thanks to the linguist and Maluku expert James T. Collins for offering his suggestions on these terms.

74. Khoury, *Sinacol*, cited in De Cauter, *Entropic Empire*, 126.

75. See Bart Barendregt, "The Sound of Islam: Southeast Asian Boy Band," *ISIM Review* 22 (2008): 224–25; and Bart Barendregt, "The Art of No-Seduction: Muslim Boy-Band Music in Southeast Asia and the Fear of the Female Voice," *IIAS Newsletter* 40 (Spring 2006): 1, 4–6.

76. Recorded interview with author, Manado, Indonesia, July 22, 2001.

77. Recorded interview with author, Manado, Indonesia, July 22, 2001.

78. Recorded interview with author, Manado, Indonesia, July 22, 2001.

79. By this time, some national army troops had been sent from the city of Ujung Pandang in South Sulawesi (subsequently renamed Makassar).

80. Recorded interview with author, Manado, Indonesia, August 7, 2001.

81. Recorded interview with author, Manado, Indonesia, July 27, 2001.

82. Robert W. Hefner, "Civic Pluralism Denied? The New Media and *Jihadi* Violence in Indonesia," in *New Media in the Muslim World: The Emerging Public Sphere*, ed. Dale F. Eickelman and Jon W. Anderson (Bloomington: Indiana University Press, 2003).

83. Benedict Anderson, *Imagined Communities: Reflections on the Origin and Spread of Nationalism* (London: Verso, 1991), 188.

84. The use of the rhizome as a figure comes from Gilles Deleuze and Félix Guattari, *A Thousand Plateaus: Capitalism and Schizophrenia* (Minneapolis: University of Minnesota Press, 1987).

85. See James T. Siegel's excellent discussion of how "Indonesian violence often stimulates a recourse to recognition outside of the framework of the initial conflict," which he links to the more general lack of sedimented identities or their formulation

in a narrow, dialectical sense—although admittedly both were somewhat under erasure in these circumstances. Siegel, *New Criminal Type in Jakarta*, 347–48.

86. Ariel Heryanto, "Rape, Race, and Reporting," in *Reformasi: Crisis and Change in Indonesia*, ed. Arief Budiman, Barbara Hatley, and Damien Kingsbury (Clayton, Australia: Monash Asia Institute, Monash University, 1999).

87. Kajri Jain, *Gods in the Bazaar: The Economies of Indian Calendar Art* (Durham, N.C.: Duke University Press, 2007), 274.

88. Karen Strassler, *Refracted Visions: Popular Photography and National Modernity in Java* (Durham, N.C.: Duke University Press, 2010); and Karen Strassler, *Demanding Images: Democracy, Mediation, and the Image-Event in Indonesia* (Durham, N.C.: Duke University Press, 2020).

89. Regarding the language of the VCDs with footage of the Poso conflict, Aragon notes that ones in Arabic circulated in the Middle East, while Indonesian-language videos had the capacity to reach audiences not only around Indonesia but also in Malaysia, Brunei, southern Thailand, and the southern Philippines and the Indonesian and Malaysian diasporas in Australia and elsewhere. Aragon, "Mass Media Fragmentation," 40. Among the 9 percent that make up the Christian population in Indonesia, there was much less circulation of their VCDS than among Muslims, as in Ambon. Some Christian-produced VCDs on the Ambon conflict made their way to the Netherlands, where they were watched by Dutch Christian Malukans. Regarding media outreach generally among Ambon's Christians, the difference between Catholics and Protestants was striking. A priest I spoke with contrasted the hierarchy among Catholic clergy under Ambon's bishop as opposed to the fragmentation of Protestants across different competing denominations as a distinct advantage in organization around and getting news out about the conflict (recorded interview with author, Pineleng, Indonesia, July 27, 2001). The Catholic diocese in Ambon also set up the English-language Diocese Crisis Centre Reports. Between June 2000 and April 2003, the Crisis Centre Diocese of Amboina issued reports on the situation in Ambon.

90. Aragon, "Mass Media Fragmentation," 6.

91. Michael Warner, *Publics and Counterpublics* (Cambridge, Mass.: Zone Books, 2002).

92. For an especially striking example, see Yael Navaro, *The Make-Believe Space: Affective Geography in a Postwar Polity* (Durham, N.C.: Duke University Press, 2012).

93. Duncan, *Violence and Vengeance*.

94. The mural can be seen in the Muslim-produced VCD *The Bloody Maluku Conflict (Konflik Berdarah Maluku)*. I was told it was from the Christian village of Waai. The term *amplification* comes from Marshall Sahlins, "Structural Work: How Microhistories Become Macrohistories and Vice Versa," *Anthropological Theory* 5, no. 1 (2005): 5–30.

95. For a facsimile and discussion of the letter, see Nanere, *Halmahera Berdarah*, 63–80. See also Duncan, *Violence and Vengeance*, appendix A, "The Bloody Sosol Letter: Indonesian Original and English Translation"; for his discussion of the

effects of the circulation of this letter in North Maluku, see Duncan, *Violence and Vengeance*, 58–62. Bubandt offers a short history of such "dark leaflets" (*selebaren gelap*) or "can letters" (*surat kaleng*) in Indonesia and also mentions this one. Bubandt, "Rumors, Pamphlets, and the Politics of Paranoia in Indonesia," 790, 796. On fakes, generally, including this one, see Nils Bubandt, "From the Enemy's Point of View: Violence, Empathy, and the Ethnography of Fakes," *Cultural Anthropology* 24, no. 3 (2009): 553–88.

96. Article from *Hati Baru*, November 1999 edition, cited in Kotan, *Mediator Dalam Kerusuhan Maluku*, 75.

97. Bubandt, "Rumors, Pamphlets, and the Politics of Paranoia in Indonesia."

98. I gratefully acknowledge the generosity of a local stringer who shared with me his footage of demonstrations, street banners or *spanduk*, and graffiti in wartime Ambon.

99. For an overview of reporting on conflict in Indonesia, see Sharp, *Journalism and Conflict in Indonesia*. On war and peace journalism, specifically, see 175–207.

100. Similarly, by informal agreement between the local government and journalists, the term *suku* (tribe) was omitted from newspaper articles and other journalistic reports in the wake of the violence between Dayak and Madurese in West Kalimantan. See Huub de Jonge and Gerben Nooteboom, "Why the Madurese? Ethnic Conflicts in West and East Kalimantan Compared," *Asian Journal of Social Sciences* 34, no. 3 (2006): 456–74. One of the most pernicious examples of censorship omissions is the common practice in Indonesia of replacing the names of female rape victims with flower names like Mawar (Rose) or Melati (Jasmine) or even euphemisms like *gelas pecah* (broken glass). See Wiwik Sushartami, "Representation and Beyond: Female Victims in Post-Suharto Media" (PhD diss., Leiden University, 2012).

101. Sharp, *Journalism and Conflict in Indonesia*, 160.

102. Spyer, "Some Notes on Disorder."

103. Notes from an interview with author, Manado, Indonesia, 2001.

104. Spyer, "Reel Accidents"; Spyer, "Fire without Smoke"; and Patricia Spyer, "Shadow Media and Moluccan Muslim VCDs," in *9/11: A Virtual Case Book*, ed. Barbara Abrash and Faye Ginsburg (New York: Center for Media, Culture, and History, 2002).

105. Spyer, "Reel Accidents."

106. Spyer, "Reel Accidents."

107. Bräuchler, "Cyberidentities at War," 132.

108. My thanks to Farish Noor for watching and discussing some of the Maluku-focused VCDs with me.

109. See also Aragon, "Mass Media Fragmentation," 34.

110. On the VCD with the mosque scene of jihadists departing from Ternate for Tobelo, Halmahera, see Spyer, "Reel Accidents." On the cakalele tradition, its celebration of physical prowess, and connection with stories about magic, see Philip Winn, "Sovereign Violence, Moral Authority, and the Maluku Cakalele," in *A State*

of Emergency: Violence, Society and the State in Eastern Indonesia, ed. Sandra N. Pannell (Darwin, Australia: Northern Territory University Press, 2003).

111. Raymond Williams, *Marxism and Literature* (Oxford: Oxford University Press, 1977), 132–34. On "communities of sentiment," mass-mediated sodalities of worship and charisma, and "structures of feeling" in ethnic violence, see Appadurai, *Modernity at Large*, 8–9, 153. See also Deborah Poole's excellent discussion of the formation of transnational bourgeois sensibilities through the circulation of late nineteenth-century cartes de visite. Deborah Poole, *Vision, Race, and Modernity: A Visual Economy of the Andean Image World* (Princeton, N.J.: Princeton University Press, 1997), 107–13.

112. Williams, *Marxism and Literature*, 132–34.

113. Spyer, "Reel Accidents."

114. The VCD is produced by the Muslim NGO Dompet Sosial Ummul Quro, based in Bandung, Java. The organization's address, phone and fax numbers, and bank account information are all listed on the VCD jacket. It has a copyright from 2000.

115. Spyer, "Fire without Smoke"; and Spyer, "Reel Accidents."

116. For a discussion and photographs of talismanic banners and jackets, see Fiona Kerlogue, "Islamic Talismans: The Calligraphy Batiks," in *Batik: Drawn in Wax*, ed. Itie van Hout (Amsterdam: KIT Publishers, 2001). She describes how the jackets were worn in many parts of mainland and island Southeast Asia and in Mughal India and by members of the Ottoman royal household. One such jacket featured in the book is part of the collection of Amsterdam's Tropenmuseum. It is inscribed with a prayer for protection (*zikir*) as well as the *shahada* and some Qur'anic verses. Kerlogue mentions that folktales from Jambi, Sumatra, tell of magical shirts that could protect the wearer.

117. McRae, *A Few Poorly Organized Men*, 98–99.

118. McRae, 98–99.

119. Aragon, "Mass Media Fragmentation," 23.

120. I would like to thank Webb Keane for providing me with this term.

121. This kind of suspicion is common among intimate enemies such as those of Ambon's civil war. Appadurai links the extreme violence often characteristic of such conflict to the sense of betrayal between appearance and reality as "perceived violation of knowing who the 'Other' was and of rage about who they really turn out to be." Appadurai, *Modernity at Large*, 154–55.

122. For another example of the intimate coupling of pockets and identity, see Spyer, *Memory of Trade*, 92–100.

123. Recorded interview with author, Manado, Indonesia, July 22, 2001.

124. Recorded interview with author, Manado, Indonesia, August 10, 2001.

125. Michel Feher, *Powerless by Design: The Age of the International Community* (Durham, N.C.: Duke University Press, 2000).

126. Merlyna Lim, "Many Clicks but Little Sticks: Social Media Activism in Indonesia," *Journal of Contemporary Asia* 43, no. 4 (2013): 636–57.

127. International Crisis Group, "Indonesia: The Search for Peace in Maluku."

128. In contrast to Ambon, the appeal to adat in the context of the conflict in the Kei Islands, southeast Maluku, was largely successful in bringing about reconciliation, something that most observers have attributed to the ongoing prominent position of custom and customary law in the lives of many Keiese. Much has been written about adat's revival in the post-Suharto era, including Jamie S. Davidson and David Henley, eds., *The Revival of Tradition in Indonesian Politics: The Deployment of Adat from Colonialism to Indigenism* (London: Routledge, 2007). With respect to Maluku specifically, Pachalis Maria Laksono and Roem Topatimasang provide a detailed assessment of the reconciliation process in Kei. Pachalis Maria Laksono and Roem Topatimasang, eds., *Ken Sa Faak: Benih-Benih Perdamaian Dari Kepulauan Kei* (Yogyakarta, Indonesia: INSIST Press, 2003). Bräuchler, in *Reconciling Indonesia*, considers the peacemaking process in Central Maluku, including the role of adat.

129. See, for instance, the somewhat congratulatory book that focuses on the bishop of Amboina, Monseigneur P. C. Mandagi, MSC, as peacemaker in the conflict. Kotan, *Mediator Dalam Kerusuhan Maluku*. On the charismatic GPM minister Jacky Manuputty, see Tjitske Lingsma, *Het Verdriet van Ambon: Een Geschiedenis van de Molukken* (Amsterdam: Balans, 2008).

130. Aragon similarly describes how people in Poso were exhausted by war and eager for effective government action. Aragon, "Mass Media Fragmentation," 43.

131. Recorded interview with author, Ambon, Indonesia, July 20, 2006.

132. Notes from an interview with author, Ambon, Indonesia, July 14, 2006.

2. Christ at Large

1. Recorded interview with author, Ambon, Indonesia, June 22, 2005.

2. Notes from an interview with author, Ambon, Indonesia, July 26, 2006.

3. Notes from an interview with author, Ambon, Indonesia, July 15, 2006.

4. Recorded interview with author, Ambon, Indonesia, July 20, 2006.

5. Notes from a sermon, Minister Margaretha Hendriks-Ririmasse, Maranatha church, Ambon, Indonesia, July 23, 2006.

6. Recorded interview with author, Ambon, Indonesia, August 5, 2006.

7. Recorded interview with author, Ambon, Indonesia, June 22, 2005.

8. Recorded interview with author, Ambon, Indonesia, July 20, 2006.

9. Recorded interview with author, Ambon, Indonesia, July 20, 2006.

10. On devotional images, see David Morgan, *Visual Piety: A History and Theory of Popular Religious Images* (Berkeley: University of California Press, 1997).

11. Equally radical, if differently so, is the transformation of the "dot" painting made by central Australian Aboriginal peoples into an international high art shown in galleries and museums around the world. Also remarkable was the prior move of these designs, traditionally painted on bodies and the ground, from these surfaces to two-dimensional canvases. For a fascinating account of this history, see Fred R.

Myers, *Painting Culture: The Making of an Aboriginal High Art* (Durham, N.C.: Duke University Press, 2002).

12. See Michael Warner, *Publics and Counterpublics* (Cambridge, Mass.: Zone Books, 2002), 65–224, esp. 114 on poetic world-making. On what pictures want, see W. J. T. Mitchell, *What Do Pictures Want? The Lives and Loves of Images* (Chicago: University of Chicago Press, 2005). See also Christopher Pinney, who writes regarding Mitchell: "Addressing the 'wants' of pictures is a strategy advanced by W. J. T. Mitchell as part of our attempt to refine and complicate our estimate of their power. Mitchell advocates that we invite pictures to speak to us, and in so doing discover that they present 'not just a surface, but a *face* that faces the beholder.'" Christopher Pinney, *"Photos of the Gods": The Printed Image and Political Struggle in India* (London: Reaktion Books, 2004), 8.

13. Richard Chauvel, "Ambon's Other Half: Some Preliminary Observations on Ambonese Moslem Society and History," *Review of Indonesian and Malaysian Affairs* 14, no. 1 (1980): 40–80.

14. Nomusa Makhubu and Ruth Simbao, "The Art of Change: Perspectives on Transformation in South Africa: Editorial," *Third Text* 27, no. 3 (2013): 300.

15. Gerry van Klinken, *Communal Violence and Democratization in Indonesia: Small Town Wars* (New York: Routledge, 2007), 93–94.

16. For an analysis of the apocalyptic in the violence of both Maluku and North Maluku provinces, see Nils Bubandt, "Malukan Apocalypse: Themes in the Dynamics of Violence in Eastern Indonesia," in *Violence in Indonesia*, ed. Ingrid Wessel and Georgia Wimhöfer (Hamburg, Germany: Abera Verlag, 2001).

17. Notes from an interview with author, Ambon, Indonesia, August 2, 2006.

18. For analyses of Christian popular visual culture and religiosity and, relatedly, religious acts of "seeing" in nineteenth- and twentieth-century America, see Morgan, *Visual Piety*.

19. Mitchell, *What Do Pictures Want?*

20. Mitchell, xv–xvii.

21. Roland Barthes, "The Rhetoric of the Image," in *Image, Music, Text*, trans. Stephen Heath (London: Fontana Press, 1987).

22. Hent de Vries, "In Media Res: Global Religions, Public Spheres and the Task of Contemporary Religious Studies," in *Religion and Media*, ed. Hent de Vries and Samuel Weber (Stanford, Calif.: Stanford University Press, 2001), 28.

23. Webb Keane provides an excellent analysis of the challenges Dutch Calvinist missionaries faced in their efforts to impose strict boundaries between subjects and objects on the Indonesian island of Sumba. More concretely, one of the main problems was that social relations both among Sumbanese and between them and their ancestors were realized through animal sacrifice and the distribution of sacrificial meat or an act of consumption that folded "fellowship with devils" into the materiality of things and the substance of sociality. Webb Keane, "Calvin in the Tropics: Objects and Subjects at the Religious Frontier," in *Border Fetishisms: Material Objects in Unstable Spaces*, ed. Patricia Spyer (New York: Routledge, 1998),

22. See also his *Christian Moderns: Freedom and Fetish in the Mission Encounter* (Berkeley: University of California Press, 2007).

24. Keane, *Christian Moderns*. It is worth pointing out that the Calvinism represented by the Protestant Church of the Moluccas (GPM) is descended from the Nederlandse Hervormde Kerk, or Reformed Church of the Netherlands, the name given in 1816 to the official state church. Although all Dutch Calvinists call themselves "reformed," this is not to be confused with the Gereformeerde Kerken in Nederland or the Neo-Orthodox Churches in the Netherlands that formed in 1892 after a split from the Reformed Church. In 2004, these two churches joined the Evangelical Lutheran Church in the Netherlands to form the Protestant Church in the Netherlands.

25. See Karen Strassler, *Refracted Visions: Popular Photography and National Modernity in Java* (Durham, N.C.: Duke University Press, 2010), esp. chap. 4. Karen Strassler defines *refraction* as a process in which "everyday encounters with photographs entangle widely shared visions with affectively charged personal narratives and memories" (23). She identifies the Indonesian identity photograph as a particularly productive site where individual desires and state designs come together as the latter become appropriated, personalized, and bent to different, usually affectively motivated purposes.

26. For examples of the Suharto state's realization of unity of diversity in different parts of Indonesia, see Greg Acciaioli, "Culture as Art: From Practice to Spectacle in Indonesia," *Canberra Anthropology* 8, no. 1–2 (1985): 148–72; John Pemberton, "Notes on the 1982 General Election in Solo," *Indonesia* 41 (1986): 1–22; and Patricia Spyer, "Diversity with a Difference: Adat and the New Order in Aru (Eastern Indonesia)," *Cultural Anthropology* 11, no. 1 (1996): 25–50.

27. Mary Margaret Steedly, *Rifle Reports: A Story of Indonesian Independence* (Berkeley: University of California Press, 2013), 156. On New Order development specifically, see Ariel Heryanto and Nancy Lutz, "The Development of 'Development,'" *Indonesia* 46 (1988): 1–24.

28. On banners in Indonesia, see Karen Strassler, *Demanding Images: Democracy, Mediation, and the Image-Event in Indonesia* (Durham, N.C.: Duke University Press, 2020), esp. 159–218.

29. For a discussion of some of these issues, see Patricia Spyer and Mary Margaret Steedly, eds., *Images That Move* (Santa Fe: School for Advanced Research Press, 2013).

30. Notes from an interview with author, Ambon, Indonesia, July 15, 2006.

31. Abidin Kusno, "Guardian of Memories: Guardhouses in Urban Java," *Indonesia* 81 (2006): 95–149. See also William H. Frederick, "The Appearance of Revolution: Cloth, Uniform, and the Pemuda Style in East Java, 1945–1949," in *Outward Appearances: Dressing State and Society in Indonesia*, ed. Henk Schulte Nordholt (Leiden, Netherlands: KITLV Press, 1997).

32. Kusno, "Guardian of Memories," 142.

33. *Manado Pos*, August 28, 2000, cited in Dieter Bartels, "The Evolution of God in the Spice Islands: The Converging and Diverging of Protestant Christianity and

Islam in the Colonial and Post-Colonial Periods" (paper presented at the Christianity in Indonesia symposium, Johann Wolfgang Goethe University, Frankfurt, Germany, December 14, 2003).

34. Bartels, "Evolution of God in the Spice Islands," 139.

35. Notes from an interview with author, Ambon, Indonesia, July 25, 2006.

36. See also Hatib Abdul Kadir, "'Biar Punggung Patah, Asal Muka Jangan Pucat' Melacak Gengsi Dan Gaya Tubuh Anak Muda Kota Ambon" (bachelor's thesis, Universitas Gajah Mada, 2008).

37. For a discussion of the Muslim power murals, see Patricia Spyer, "Reel Accidents: Screening the Ummah Under Siege in Wartime Maluku," *Current Anthropology* 58, no. S15 (2016): S27–40.

38. Notes from an interview with author, Ambon, Indonesia, July 12, 2005.

39. Pemberton, "Notes on the 1982 General Election in Solo."

40. Joshua Barker, "State of Fear: Controlling the Criminal Contagion in Suharto's New Order," *Indonesia* 66 (1998): 7–43.

41. Recorded interview with author, Ambon, Indonesia, July 26, 2006.

42. Recorded interview with author, Ambon, Indonesia, June 27, 2005.

43. Basri Amin, "Youth, Ojeg and Urban Space in Ternate," *Asia Pacific Journal of Anthropology* 13, no. 1 (2012): 36–48.

44. Jeroen Adam and Lusia Peilouw, "Internal Displacement and Household Strategies for Income Generation: A Case Study in Ambon, Indonesia," *Social Development Issues* 30, no. 2 (2008): 78–89.

45. Ugik Margiyatin, Lusia Peilouw, Atsushi Sano, and Ben White, "Teenagers Accounts of Insecurity and Violence in Three Indonesian Regions" (unpublished paper, December 2006).

46. See also Amin, "Youth, Ojeg and Urban Space in Ternate."

47. Kadir, "'Biar Punggung Patah,'" 120.

48. Kadir, 297–301; and Suzanne Naafs and Ben White, "Intermediate Generations: Reflections on Indonesian Youth Studies," *Asia Pacific Journal of Anthropology* 13, no. 1 (2012): 3–20.

49. Notes from an interview with author, Ambon, Indonesia, June 20, 2005.

50. On the culture of dokumentasi, see Strassler, *Refracted Visions*, 16–18.

51. Strassler, 80.

52. Christopher Pinney, *Camera Indica: The Social Life of Indian Photographs* (Chicago: University of Chicago Press, 1997).

53. On backdrops as chambers of dreams and transformative theatrical spaces, see Pinney, *Camera Indica*; and Karen Strassler, *Refracted Visions*, chap. 2, "Landscapes of the Imagination."

54. Fieldnotes, Ambon, August 30, 2003.

55. See also Kajri Jain, *Gods in the Bazaar: The Economies of Indian Calendar Art* (Durham, N.C.: Duke University Press, 2007), 112.

56. Video clip seen on August 30, 2003, Ambon, clip from July 28, 1999.

57. Video clip seen on August 30, 2003, Ambon, clip from September 4, 1999.

58. Barthes, *Image, Music, Text.*

59. Kusno, "Guardian of Memories," 142.

60. Dilip Gaonkar, "After the Fictions: Notes Towards a Phenomenology of the Multitude," *e-flux journal* 58 (October 2014): 13.

61. On taking to the streets and activist youth culture during the Reformasi, see Doreen Lee, *Activist Archives: Youth Culture and the Political Past in Indonesia* (Durham, N.C.: Duke University Press, 2016), esp. chap. 2; and Yatun Sastramidjaja, *Playing Politics: Power, Memory, and Agency in the Making of the Indonesian Student Movement* (Leiden, Netherlands: Brill, 2020).

62. Intan Paramaditha, "Questions on Witnessing Violence," *Jakarta Post*, April 4, 2011.

63. Gaonkar, "After the Fictions."

64. Pinney, "*Photos of the Gods*," 203.

3. Images without Borders

1. W. J. T. Mitchell, "Holy Landscape: Israel, Palestine, and the American Wilderness," *Critical Inquiry* 26, no. 2 (2000): 198.

2. Stuart C. Aitken and Deborah P. Dixon, "Imagining Geographies of Film," *Erdkunde* 60 (2006): 330.

3. See Patricia Spyer, "Escalation: Assemblage, Archive, Animation," in "Ethnographies of Escalation," ed. Lars Hojer, special issue, *History and Anthropology* 32, no. 1 (2021): 93–115.

4. Notes from an interview with author, Ambon, Indonesia, July 12, 2006.

5. Notes from an interview with author, Ambon, Indonesia, July 29, 2005.

6. Recorded interview with author, Ambon, Indonesia, June 22, 2005.

7. Recorded interview with author, Ambon, Indonesia, June 22, 2005.

8. Recorded interview with author, Ambon, Indonesia, June 22, 2005.

9. Notes from an interview with author, Ambon, Indonesia, August 2, 2006.

10. Notes from an interview with author, Ambon, Indonesia, July 29, 2005.

11. Recorded interview with author, Ambon, Indonesia, July 30, 2005.

12. Recorded interview with author, Ambon, Indonesia, July 30, 2005.

13. Nils Bubandt, "Conspiracy Theories, Apocalyptic Narratives and the Discursive Construction of 'the Violence in Maluku,'" *Antropologi Indonesia* 63 (2000): 14–31.

14. Fieldnotes, Soahuku, Indonesia, July 28, 2006.

15. Fieldnotes, Soahuku, Indonesia, July 28, 2006.

16. Fieldnotes, Soahuku, Indonesia, July 28, 2006.

17. Fridus Steijlen, "Chris Tamaela en Supu-isatie," *MUMA (Museum Maluku) Nieuwsbrief*, July 2015.

18. On what Karen Strassler calls Indonesia's pervasive "culture of *dokumentasi*," see *Refracted Visions: Popular Photography and National Modernity in Java* (Durham, N.C.: Duke University Press, 2010).

19. Spyer, "Escalation."

20. The Garden of Gethsemane on the side of the Mount of Olives is both the scene of Christ's agony and a place of great mental or spiritual suffering. It is where Jesus went to pray before being crucified.

21. Recorded interview with author, Ambon, Indonesia, July 25, 2006.

22. On the concept of elsewhere, see Patricia Spyer, *The Memory of Trade: Modernity's Entanglements on an Eastern Indonesian Island* (Durham, N.C.: Duke University Press, 2000).

23. Spyer, *Memory of Trade*.

24. Adam H. Becker, "The Ancient Near East in the Late Antique Near East: Syriac Christian Appropriation of the Biblical East," in *Antiquity in Antiquity: Jewish and Christian Pasts in the Greco-Roman World*, ed. Gregg Gardner and Kevin Osterloh (Tübingen, Germany: Mohr Siebeck, 2008), 394–415.

25. Faisal Devji, *Landscapes of the Jihad: Militancy, Morality, Modernity* (London: Hurst and Co., 2005), 66.

26. Richard Chauvel, "Ambon's Other Half: Some Preliminary Observations on Ambonese Moslem Society and History," *Review of Indonesian and Malaysian Affairs* 14, no. 1 (1980): 40–80.

27. Intan Paramaditha, "Questions on Witnessing Violence," *Jakarta Post*, April 4, 2011.

28. Robert W. Hefner, *Civil Islam: Muslims and Democratization in Indonesia* (Princeton, N.J.: Princeton University Press, 2000).

29. The term *public Islam* was coined by Armando Salvatore and Dale Eickelman. See Armando Salvatore and Dale F. Eickelman, eds., *Public Islam and the Common Good* (Leiden, Netherlands: Brill, 2004). For a close analysis of the development of public Islam in Indonesia, see Noorhaidi Hasan, *Public Islam in Indonesia: Piety, Politics, and Identity* (Amsterdam: Amsterdam University Press, 2018).

30. For a selection from the many works on this process, from the late New Order to more recent times, see Suzanne Brenner, "Reconstructing Self and Society: Javanese Muslim Women and 'the Veil,'" *American Ethnologist* 23, no. 4 (1996): 673–97; and Suzanne Brenner, "On the Public Intimacy of the New Order: Images of Women in the Popular Indonesian Print Media," *Indonesia* (1999): 13–37. See also James Hoesterey, *Rebranding Islam: Piety, Prosperity, and a Self-Help Guru* (Stanford, Calif.: Stanford University Press, 2015); Carla Jones, "Fashion and Faith in Urban Indonesia," *Fashion Theory* 11, no. 2–3 (2007): 211–31; Carla Jones, "Materializing Piety: Gendered Anxieties about Faithful Consumption in Contemporary Urban Indonesia," *American Ethnologist* 37, no. 4 (2010): 617–37; and Daromir Rudnyckyj, *Spiritual Economies: Islam, Globalization, and the Afterlife of Development* (Ithaca, N.Y.: Cornell University Press, 2011). On new forms of da'wa, see Bart A. Barendregt, "Mobile Religiosity in Indonesia: Mobilized Islam, Islamized Mobility, and the Potential of Islamic Techno-nationalism," in *Living the Information Society in Asia*, ed. Erwin Alampay (Singapore: Singapore Institute of Southeast Asian Studies, 2009), 73–82; and Ahmad Nuril Huda, "The Cinematic Santri: Youth Culture, Tradition and Technology in Muslim Indonesia" (PhD diss., Leiden University, 2020).

31. While the minister came up with headscarves as something the Christian pictures responded to, a more common way of conjuring Muslim borderlessness is through sound, specifically the call to prayer, five times a day, from numerous mosques in cities and towns. For reasons I argue in this book, visibility was more marked, and hence embraced, for GPM Protestants at this time, although it is worth pointing out that at the height of the war, church services were held three times a day and announced by loudspeaker from the church spire.

32. Arjun Appadurai, "The Colonial Backdrop," *Afterimage* 24, no. 3 (1997): 1–7.

33. See Kaja Silverman, *The Threshold of the Visible World* (New York: Routledge, 1996), 195–227.

34. Recorded interview with author, Ambon, Indonesia, August 3, 2006.

35. Recorded interview with author, Ambon, Indonesia, August 3, 2006.

36. Kajri Jain, *Gods in the Bazaar: The Economies of Indian Calendar Art* (Durham, N.C.: Duke University Press, 2007), 138.

37. In 2006, Confucianism was officially recognized as a religion in a Ministry of Religion circular stating that there were six religions in Indonesia, including Confucianism.

38. Recorded interview with author, Ambon, Indonesia, August 3, 2006.

39. See Barthes's "Rhetoric of the Image" on how the first message of the advertising photograph is linguistic so that caption, labels, and the like fulfill a function of anchorage that serves to limit signification. Roland Barthes, "Rhetoric of the Image," in *Image, Music, Text,* trans. Stephen Heath (London: Fontana Press, 1987), 32–51.

40. On re-vision, including literal re-vision, see Patricia Spyer and Mary Margaret Steedly, introduction to *Images That Move,* ed. Patricia Spyer and Mary Margaret Steedly, 3–39 (Santa Fe: School for Advanced Research Press, 2013).

41. Notes from an interview with author, Ambon, Indonesia, July 17, 2006.

42. For an excellent history of these guardhouses, see Abidin Kusno, "Guardian of Memories: Guardhouses in Urban Java," *Indonesia* 81 (2006): 95–149.

43. Karen Strassler, "Gendered Visibilities and the Dream of Transparency: The Chinese-Indonesian Rape Debate in Post-Suharto Indonesia," *Gender & History* 16, no. 3 (2004): 705; and Karen Strassler, *Demanding Images: Democracy, Mediation, and the Image-Event in Indonesia* (Durham, N.C.: Duke University Press, 2020), chap. 2.

44. Valentin Groebner, *Who Are You? Identification, Deception, and Surveillance in Early Modern Europe,* trans. Mark Kyburz and John Peck (New York: Zone Books, 2007), 138.

45. Recorded interview with author, Ambon, Indonesia, June 27, 2005.

46. Susan Stewart, *On Longing: Narratives of the Miniature, the Gigantic, the Souvenir, the Collection* (Durham, N.C.: Duke University Press, 1992), 51.

47. Strassler, *Refracted Visions,* 138.

48. Patricia Spyer, "Serial Conversion/Conversion to Seriality: Religion, State, and Number in Aru, Eastern Indonesia," in *Conversion to Modernities: The Globalization of Christianity,* ed. Peter van der Veer (New York: Routledge, 1996).

49. Gerry van Klinken, *Communal Violence and Democratization in Indonesia: Small Town Wars* (New York: Routledge, 2007), 97.

50. Notes from an interview with author, Ambon, Indonesia, August 1, 2006.

51. For other examples of how the state identity photo has been remediated for sentimental and familial purposes, see Strassler, *Refracted Visions*, 137–41.

52. In the Deleuzian sense of the face as not just a corollary of the landscape in the sense of a milieu but rather as a "deterritorialized world." Gilles Deleuze and Félix Guattari, *A Thousand Plateaus: Capitalism and Schizophrenia* (Minneapolis: University of Minnesota Press, 1987), 211, 172.

53. On the relationship between the miniature and interiority, see Stewart, *On Longing*.

54. Recorded interview with author, Ambon, Indonesia, August 3, 2006.

55. See Susan Harding's account of how she was unwittingly drawn into a scene of evangelical witnessing that admitted no outside—the addressee being already saved or on the road to salvation. Susan Friend Harding, *The Book of Jerry Falwell: Fundamentalist Language and Politics*, 2nd ed. (Princeton, N.J.: Princeton University Press, 2001).

56. On the crisis of authenticity in the aftermath of Suharto's step-down, see Strassler, "Gendered Visibilities and the Dream of Transparency"; and Strassler, *Demanding Images.*

57. Jacques Derrida, *The Truth in Painting*, trans. Geoff Bennington and Ian McLeod (Chicago: University of Chicago Press, 1987).

58. Spyer and Steedly, *Images That Move*, esp. the section "Enframement and Refocalization," 19–23.

59. On this analysis indebted to Derrida's notion of the parergon, see Rosalind C. Morris, "Two Masks: Images of Future History and the Posthuman in Postapartheid South Africa," in Spyer and Steedly, *Images That Move*, 188–89; and Patricia Spyer, "In and Out of the Picture: Photography, Ritual, and Modernity in Aru Indonesia," in *Photographies East: The Camera and Its Histories in East and Southeast Asia*, ed. Rosalind C. Morris (Durham, N.C.: Duke University Press, 2009).

60. Judith Butler, *Frames of War: When Is Life Grievable?* (London: Verso, 2016).

61. Butler, *Frames of War*, 64.

62. Butler, 64.

63. Finbarr Barry Flood, *Objects of Translation: Material Culture and Medieval "Hindu-Muslim" Encounter* (Princeton, N.J.: Princeton University Press, 2009).

64. I am grateful to Rudolf Mrazek for providing me with this metaphor of a movement from colonial frame to postcolonial collage.

65. Tom Gunning, "Bodies and Phantoms: Making Visible the Beginnings of Motion Pictures," *Binocular* (1994): 86.

66. Jean-Louis Comolli, "Machines of the Visible," in *The Cinematic Apparatus*, ed. Teresa de Lauretis and Stephen Heath (London: St. Martin's, 1980), 122–23.

67. Georg Simmel, "On Visual Interaction," in *Introduction to the Science of Sociology*, ed. Robert E. Park and Ernest W. Burgess (Chicago: University of Chicago Press, 1924), 303.

68. Geoffrey Batchen, *Burning with Desire: The Conception of Photography* (Cambridge, Mass.: MIT Press, 1997); Raymond Williams, "Structures of Feeling," in *Marxism and Literature* (Oxford: Oxford University Press, 1977), 128–35; and Rebecca Solnit, *River of Shadows: Eadweard Muybridge and the Technological Wild West* (New York: Penguin, 2004).

69. Hua Hsu, "Beauty in the Streets: How Posters Became Art," *New Yorker,* July 8 and 15, 2019, 75–77.

70. See the excellent film *Dutch Light* (Dutch Light Films, 2003) for an exploration of the theme of Dutch light, directed by Pieter-Rim de Kroon.

71. Svetlana Alpers, *The Art of Describing: Dutch Art in the Seventeenth Century* (Chicago: University of Chicago Press, 1983), 27.

4. Religion under the Sign of Crisis

1. Michel de Certeau, *The Possession at Loudun*, trans. Michael B. Smith (Chicago: University of Chicago Press, 2000), 2.

2. Certeau, *Possession at Loudun.*

3. Certeau, *Possession at Loudun.*

4. See Hent de Vries and Samuel Weber, eds., *Religion and Media* (Stanford, Calif.: Stanford University Press, 2001).

5. Talal Asad, "Comments on Conversion," in *Conversion to Modernities: The Globalization of Christianity*, ed. Peter van der Veer (New York: Routledge, 1996), 266.

6. Webb Keane, *Christian Moderns: Freedom and Fetish in the Mission Encounter* (Berkeley: University of California Press, 2007), 26.

7. Patricia Spyer, "Serial Conversion/Conversion to Seriality: Religion, State, and Number in Aru, Eastern Indonesia," in van der Veer, *Conversion to Modernities.*

8. See Intan Paramaditha, "The Wild Child's Desire: Cinema, Sexual Politics, and the Experimental Nation in Post-Authoritarian Indonesia" (PhD diss., New York University, 2014).

9. Recorded interview with author, Ambon, Indonesia, July 25, 2006.

10. The question of interreligious marriage, while not illegal in Indonesia, is extremely fraught and, practically speaking, virtually impossible. When it does occur, it almost always means that the woman converts to the religion of her husband; this is called "following the husband" (I. *ikut suami*). For a comprehensive discussion of the issues around not only marriage but also religion and family law, see Mujiburrahman, *Feeling Threatened: Muslim-Christian Relations in Indonesia's New Order* (Leiden, Netherlands, and Amsterdam: ISIM and Amsterdam University Press, 2006), esp. chap. 4.

11. Walter Benjamin, *The Arcades Project* (Cambridge, Mass.: Belknap Press, 1999).

12. Keane, *Christian Moderns*, 14.

13. On the construction of masculinity among young men in Ambon, see Hatib Abdul Kadir, "'Biar Punggung Patah, Asal Muka Jangan Pucat' Melacak Gengsi Dan Gaya Tubuh Anak Muda Kota Ambon" (bachelor's thesis, Universitas Gajah

Mada, 2008). In Indonesia, more generally, and Southeast Asia, see Henk Schulte Nordholt, *A Genealogy of Violence in Indonesia*, notebooks 1–33 (Lisbon: Centro Portugues de Estudoes do Sudeste Asiatico, CEPESA, 2001); and Vicente L. Rafael, ed., *Figures of Criminality in Indonesia, the Philippines, and Colonial Vietnam* (Ithaca, N.Y.: Cornell University Press, 2018).

14. Recorded interview with author, Ambon, Indonesia, July 25, 2006.

15. On spirit mediumship, curing practices, and the narrative experience that describes encounters between humans and spirits in the urbanized setting of North Sumatra's Medan, see Mary Margaret Steedly, *Hanging without a Rope: Narrative Experience in Colonial and Postcolonial Karoland* (Princeton, N.J.: Princeton University Press, 1993). For inhabitants of Ambon City, especially those from elsewhere in Maluku and at a historical remove from situations of warfare, it was often difficult to recall the practices of such unusual times or even the families who traditionally were charged with leading their fellow villagers into battle. Recorded interview with author, Manado, Indonesia, August 8, 2001.

16. On the post-Suharto demonic television programs and other occult media, see Mary Margaret Steedly, "Transparency and Apparition: Media Ghosts of Post–New Order Indonesia," in *Images That Move*, ed. Patricia Spyer and Mary Margaret Steedly (Santa Fe: School for Advanced Research Press, 2013). See also Catherine Quirine van Heeren, "Contemporary Indonesian Film: Spirits of Reform and Ghosts from the Past" (PhD diss., Leiden University, 2009), esp. chap. 5, "The Kyai and Hyperreal Ghosts: Narrative Practices of Horror, Commerce and Censorship."

17. Nils Bubandt, "Sorcery, Corruption, and the Dangers of Democracy in Indonesia," *Journal of the Royal Anthropological Institute* 12 (2006): 413–31.

18. On the magical objects rumored to be found in former President Suharto's body at the time of his impending death and his well-publicized devotion to Javanese mysticism, see Steedly, "Transparency and Apparition." A reconstruction of Suharto's visit in September 1974 to a sacred cave in Central Java can be found in Hamish McDonald, *Suharto's Indonesia* (Blackburn, U.K.: Fontana Books, 1980).

19. This practice has a long history around the archipelago, including by Balinese who aimed to protect themselves against the Dutch colonizers. See Margaret J. Wiener, *Visible and Invisible Realms: Power, Magic, and Colonial Conquest in Bali* (Chicago: University of Chicago Press, 1995).

20. Recorded interview with author, Ternate, Indonesia, July 13, 2008.

21. Leonor Pattinasaray and Dita Vermeulen, eds., *Je kunt niet in elkaars hart kijken: oorlog en vrede op de Molukken* (Amsterdam: KIT Publishers, 2009), 59–61.

22. Pattinasaray and Dita Vermeulen, *Je kunt niet in elkaars hart kijken*, 59–61.

23. Steedly, "Transparency and Apparition." On narrative experience, see Steedly, *Hanging without a Rope*.

24. Pattinasarany and Vermeulen, *Je kunt niet in elkaars hart kijken*, 24, 61.

25. Bubandt, "Sorcery, Corruption, and the Dangers of Democracy in Indonesia," 423.

26. Bubandt, 421.

27. Jacqui Baker, "Laskar Jihad's Mimetic Stutter: State Power, Spectacular Violence and the Fetish in the Indonesian Postcolony" (bachelor's thesis, Australian National University, 2002).

28. On this group, see Noorhaidi Hasan, *Public Islam in Indonesia: Piety, Politics, and Identity* (Amsterdam: Amsterdam University Press, 2018), esp. 185 for a description of the clothing; Kirsten E. Schulze, "Laskar Jihad and the Conflict in Ambon," *Brown Journal of World Affairs* 9, no. 1 (2002): 57–69; Merlyna Lim, "@rchipelago Online: The Internet and Political Activism in Indonesia" (PhD diss., University of Twente, 2005), chap. 6; Sukidi Mulyadi, "Violence under the Banner of Religion: The Case of Laskar Jihad and Laskar Kristus," *Studia Islamika* 10, no. 2 (2003): 75–110; and International Crisis Group, "Indonesia Backgrounder: Why Salafism and Terrorism Mostly Don't Mix," *ICG Asia Report* 83 (September 13, 2004). On the difference and basic incompatibility between Salafism and terrorism, Greg Fealy notes how the three wives of this movement's leader—Ja'far Umar Thalib, a Malang-born teacher and preacher of Arab Madurese descent—wear "Middle-Eastern-style black gowns and headdresses which cover their faces." Greg Fealy, "Inside the Laskar Jihad: An Interview with the Leader of a New, Radical and Militant Sect," *Inside Indonesia* 65 (January–March 2001): https://www.insideindonesia.org/inside-the-laskar-jihad-3. On the term *neo-Salafi* and, more generally, the confusing terminology used to designate these movements, see Martin van Bruinessen, "Genealogies of Islamic Radicalism in Post-Suharto Indonesia," *South East Asia Research* 10, no. 2 (2002): 117–54.

29. See my discussion on the power of the telltale in Patricia Spyer, "Telltale," in "Mary Steedly's Anthropology of Modern Indonesia: A Collection of Keywords," ed. Smita Lahiri, Patricia Spyer, and Karen Strassler, special issue, *Indonesia* 109 (2020): 37–43.

30. John T. Sidel, "The Manifold Meanings of Displacement: Explaining Inter-religious Violence, 1999–2001," in *Conflict, Violence, and Displacement in Indonesia*, ed. Eva-Lotta E. Hedman (Ithaca, N.Y.: Southeast Asia Program Publications, an imprint of Cornell University Press, 2008), 58.

31. Sidel, "Manifold Meanings of Displacement," 58.

32. Pattinasarany and Vermeulen, *Je kunt niet in elkaars hart kijken*, 48.

33. Recorded interview with author, Ambon, Indonesia, July 19, 2006.

34. Fuad Mahfud Azuz, "Rumah Ibadah Salah Tempat: Potret Rumah Ibadah Pasca-Konflik Ambon 1999," in *Praktik Pengelolaan Keragaman Di Indonesia: Kontestasi Dan Koeksistensi*, by Mohammad Iqbal Ahnaf et al. (Yogyakarta, Indonesia: Center for Religious and Cross-Cultural Studies, University of Gadjah Mada, 2015). On the haunting effects of such material remainders, see Yael Navaro, *The Make-Believe Space: Affective Geography in a Postwar Polity* (Durham, N.C.: Duke University Press, 2012).

35. David Mearns, "Dangerous Spaces Reconsidered: The Limits of Certainty in Ambon, Indonesia," in *A State of Emergency: Violence, Society and the State in Eastern Indonesia* (Darwin, Australia: Northern Territory University Press, 2003), 40. Beside amulets and magical objects, James Collins mentions the large numbers of

buku kalanao, or books about magic, written in local languages as well as Malay, that were found in the village of Pelauw on Haruku Island in the nineteenth century. See James T. Collins, "Sejarah Bahasa Melayu di Ambon" (paper presented at a conference on Bahasa Melayu Ambon, Ambon, Indonesia, August 2006).

36. Mearns, "Dangerous Spaces Reconsidered," 46.

37. Mearns, 46.

38. Mearns, 46.

39. Jeroen Adam, "Downward Social Mobility, Prestige and the Informal Economy in Post-Conflict Ambon," *South East Asia Research* 16, no. 3 (2008): 293–311.

40. Jeroen Adam writes, for instance, how the category of BBM for both Christian and Muslim Ambonese carries a negative connotation according to which the migrants are seen as dirty and potentially aggressive. See Jeroen, "Downward Social Mobility." On Muslim Ambonese attitudes and prejudice toward Butonese, see Kadir, "Biar Punggung Patah," 152–54.

41. Julius Bautista, *The Spirit of Things: Materiality and Religious Diversity in Southeast Asia* (Ithaca, N.Y.: Southeast Asia Program Publications, an imprint of Cornell University Press, 2012), viii.

42. On the figure of the IDP, see Eva-Lotta E. Hedman, *Conflict, Violence, and Displacement in Indonesia* (Ithaca, N.Y.: Cornell University Press, 2008).

43. Benjamin J. Kaplan, *Divided by Faith: Religious Conflict and the Practice of Toleration in Early Modern Europe* (Cambridge, Mass.: Belknap Press, 2007), 267.

44. Gerry van Klinken writes of Maluku's "youth bulge," or the significantly larger proportion of the population under the age of twenty-five, when compared to Java. This larger proportion of youth, many of whom are both well-educated and out of work—and this would especially apply to Christians—he suggests, have also exacerbated the potential for conflict. See Gerry van Klinken, *Communal Violence and Democratization in Indonesia: Small Town Wars* (New York: Routledge, 2007), 91.

45. For a critique of a conception of agency associated with Christian conversion, see Asad, "Comments on Conversion."

46. For a description of a church service, see Elizabeth Pisani, *Indonesia Etc.: Exploring the Improbable Nation* (New York: W. W. Norton, 2015).

47. Notes from an interview with author, Ambon, Indonesia, July 31, 2005. On the racial category of "Chinese" in Indonesia and how the alleged inborn quality that keeps them Chinese is the state of being wealthy, see James T. Siegel, "Early Thoughts on the Violence of May 13 and 14, 1998, in Jakarta," *Indonesia* 66 (1998): 83.

48. Notes from an interview with author, Ambon, Indonesia, July 14, 2006.

49. On the refocalization in "aesthetico-epistemological" terms as part of the larger societal and political transformation, see Rosalind C. Morris, "Two Masks: Images of Future History and the Posthuman in Postapartheid South Africa," in Spyer and Steedly, *Images That Move,* 189.

50. Morris, "Two Masks," 194.

51. Morris, 194. See also Spyer and Steedly, introduction to *Images That Move,* 20.

52. As opposed to paintings and still images, Pentecostals have embraced all kinds of televisual forms. See, among others, Susan Friend Harding, *The Book of Jerry Falwell: Fundamentalist Language and Politics*, 2nd ed. (Princeton, N.J.: Princeton University Press, 2001); and Birgit Meyer, *Sensational Movies: Video, Vision, and Christianity in Ghana* (Berkeley: University of California Press, 2015). On the enormous spread and reproducibility of its forms within and beyond Pentecostalism, see Brian Larkin, "Ahmed Deedat and the Form of Islamic Evangelism," *Social Text* 26, no. 3(96) (2008): 101–21; Joel Robbins, "The Globalization of Pentecostal and Charismatic Christianity," *Annual Review of Anthropology* 33, no. 1 (2004): 117–43; Joel Robbins, "Pentecostal Networks and the Spirit of Globalization: On the Social Productivity of Ritual Forms," *Social Analysis* 53, no. 1 (2009): 55–66; and Marleen De Witte, "Pentecostal Forms across Religious Divides: Media, Publicity, and the Limits of an Anthropology of Global Pentecostalism," *Religions* 9, no. 7 (2018): 217.

53. Notes from an interview with author, Ambon, Indonesia, July 14, 2006.

54. Notes from an interview with author, Ambon, Indonesia, July 22, 2006.

55. Notes from an interview with author, Ambon, Indonesia, July 22, 2006.

56. Lisa Brock, Conor McGrady, and Teresa Meade, "Taking Sides: The Role of Visual Culture in Situations of War, Occupation, and Resistance," editors' introduction, *Radical History Review* 106 (2010): 1–4.

57. Finbarr Barry Flood, *Objects of Translation: Material Culture and Medieval "Hindu-Muslim" Encounter* (Princeton, N.J.: Princeton University Press, 2009).

58. P. G. H. Schreurs, *Terug in het erfgoed van Franciscus Xaverius: Het herstel van de katholieke missie in Maluku, 1886–1960* (Tilburg, Netherlands: Missiehuis MSC, 1992).

59. Recorded interview with author, Ambon, Indonesia, August 5, 2006.

60. Recorded interview with author, Ambon, Indonesia, July 15, 2006.

61. Crisis Centre Diocese of Amboina, *The Situation in Ambon/Moluccas*, report no. 117 (December 25, 2000).

62. Recorded interview, Ibu Pendéta Hendriks, July 24, 2006.

63. Recorded interview with author, Pineleng, Indonesia, July 27, 2001.

64. Notes from an interview with author, Ambon, Indonesia, January 17, 2011.

65. Bautista, *Spirit of Things*, 3.

66. Daniel Kotan, ed., *Mediator Dalam Kerusuhan Maluku* (Jakarta: Sekretariat Komisi Katenetik, KWI, 2000).

67. Recorded interview with author, Manado, Indonesia, August 12, 2001.

68. Recorded interview with author, Manado, Indonesia, August 12, 2001.

69. Pattinasarany and Vermeulen, *Je kunt niet in elkaars hart kijken*, 19.

70. Fiona Kerlogue, "Islamic Talismans: The Calligraphy Batiks," in *Batik: Drawn in Wax*, ed. Itie van Hout (Amsterdam: KIT Publishers, 2001).

71. For an account of this episode, see Patricia Spyer, "Escalation: Assemblage, Archive, Animation," in "Ethnographies of Escalation," ed. Lars Hoyer, special issue, *History and Anthropology* 32, no. 1 (2021): 93–115.

72. Spyer, "Escalation."

73. Samuel Weber, "Wartime," in *Violence, Identity, and Self-Determination*, ed. Hent de Vries and Samuel Weber (Stanford, Calif.: Stanford University Press, 1997), 102.

74. Emmanuel Lévinas, "Ethics and Infinity," *Crosscurrents* 34, no. 2 (1984): 191–203.

75. Judith Butler, "Impossible, Necessary Task: Said, Levinas, and the Ethical Demand" (unpublished paper), 28. I would like to thank Judith for her generosity in providing me with a copy of this paper.

76. Butler, "Impossible, Necessary Task," 14.

77. Butler, 14.

78. Kenneth Reinhard, "Toward a Political Theology of the Neighbor," in *The Neighbor: Three Inquiries in Political Theology*, ed. Slavoj Žižek, Eric L. Santner, and Kenneth Reinhard (Chicago: University of Chicago Press, 2005), 19.

79. Reinhard, "Toward a Political Theology of the Neighbor," 19.

80. For an illuminating discussion of how race became something to be seen in nineteenth-century Peru, see Deborah Poole's *Vision, Race, and Modernity: A Visual Economy of the Andean Image World* (Princeton, N.J.: Princeton University Press, 1997).

81. Recorded interview with author, Ambon, Indonesia, July 26, 2005.

82. Recorded interview with author, Ambon, Indonesia, June 27, 2005.

83. Harding, *Book of Jerry Falwell*, 37.

84. For further discussion, see Patricia Spyer, "Beberapa 'Catatan Pinggir' Dari Kota Ambon Manise," *Kanjoli: Jurnal Lembaga Antar Iman Maluku* 1 (2005): 17–19.

85. Lorraine V. Aragon, "Mass Media Fragmentation and Narratives of Violent Action in Sulawesi's Poso Conflict," *Indonesia* 79 (2005): 1–55.

86. Janice C. Newberry, *Back Door Java: State Formation and the Domestic in Working Class Java* (Peterborough, Ontario: Broadview Press, 2006).

87. See, for instance, John R. Bowen, "On the Political Construction of Tradition: *Gotong Royong* in Indonesia," *Journal of Asian Studies* 45, no. 3 (1986): 545–61.

88. Arjun Appadurai, *Modernity at Large: Cultural Dimensions of Globalization* (Minneapolis: University of Minnesota Press, 1996), 184.

89. Jacky Manuputty, Zairin Salempessy, Ishan Ali-Fauzi, and Irsyad Rafsadi, eds., *Carita Orang Basudara: Kisah-Kisah Perdamaian dari Maluku* (Ambon and Jakarta, Indonesia: Lembaga Antar Imam Maluku and Pusat Studi Agama dan Demokrasi, Yayasan Paramadina, 2014).

90. Reinhard, "Toward a Political Theology of the Neighbor," 49.

91. Reinhard, 8.

92. See Slavoj Žižek, "Smashing the Neighbor's Face," Lacan dot com, 2006, https://www.lacan.com/zizsmash.htm.

93. Notes from an interview with author, Ambon, Indonesia, July 19, 2006.

94. Notes from an interview with author, Ambon, Indonesia, July 19, 2006.

5. Provoking Peace

1. Such mimicry is so pervasive in the country that on Java it even surfaces in children's birthday parties. Karen Strassler, *Refracted Visions: Popular Photography and National Modernity in Java* (Durham, N.C.: Duke University Press, 2010), 198.

2. On the culture of contests, see Karen Strassler, "Reformasi through Our Eyes: Children as Witnesses of History in Post-Suharto Indonesia," *Visual Anthropology Review* 22, no 2 (2006): 60.

3. In Maluku, this law did not take effect until 1983. See Juliet Patricia Lee, "The Changing Face of the Village in Ambon," *Cakalele* 8 (1997): 59–77.

4. See the film *Performances of Authority* by Fridus Steijlen and Deasy Simantujah (Leiden, Netherlands: KITLV Press, 2011)—a compilation of footage culled from the Royal Netherlands Institute of Southeast Asian and Caribbean Studies' audiovisual archive "Recording the Future"—for an impression of the immense new governmental structures arising across the country as part of the decentralization process.

5. See Jamie S. Davidson and David Henley, eds., *The Revival of Tradition in Indonesian Politics: The Deployment of Adat from Colonialism to Indigenism* (London: Routledge, 2007). On Maluku specifically, see Birgit Bräuchler, ed., *Reconciling Indonesia: Grassroots Agency for Peace* (London: Routledge, 2009), esp. her own chapter, "Mobilizing Culture and Tradition for Peace: Reconciliation in the Moluccas," and Jeroen Adam's chapter, "The Problem of Going Home: Land Management, Displacement, and Reconciliation in Ambon." On North Maluku, see Christopher R. Duncan's *Violence and Vengeance: Religious Conflict and Its Aftermath in Eastern Indonesia* (Ithaca, N.Y.: Cornell University Press, 2013), esp. chap. 5, "Peace and Reconciliation?" On the role of the GPM specifically in the peace process, see Rachel Iwamony, "The Reconciliatory Potential of the Pela in the Moluccas: The Role of the GPM in This Transformation Process" (PhD diss., Free University Amsterdam, 2010).

6. Notes from an interview with author, Ambon, Indonesia, August 31, 2003. The notes were written as I watched footage of demos taken by a stringer. The Christian protest against forced conversions is from early 2001, the women's protest from September 4, 1999.

7. Patricia Spyer, *Why Can't We Be Like Storybook Children? Media of Peace and Violence in Maluku* (Jakarta: KITLV Press, 2004).

8. Recorded interview with author, Ambon, Indonesia, June 24, 2005. The reconciliation event recorded on the VCD was held on September 6, 2003.

9. Recorded interview with author, Ambon, Indonesia, June 24, 2005.

10. See Christopher Duncan's description of the reconciliation "buzzword" and wider discourse in North Maluku in *Violence and Vengeance*, chap. 5. See also Birgit Bräuchler, who remarks that "while 'reconciliation' has become a key term in international conflict and peace discourse, it remains insufficiently conceptualized and poorly understood." *Violence and Vengeance*, chap. 5; and Birgit Bräuchler, introduction to Bräuchler, ed., *Reconciling Indonesia*, 6.

11. Achille Mbembe, "The Banality of Power and the Aesthetics of Vulgarity," *Public Culture* 4, no. 2 (1992): 1–30.

12. Strassler, *Refracted Visions*, 18–19.

13. Michael T. Taussig, *The Magic of the State* (New York: Routledge, 1997), 114.

14. Some of these projects involved children writing short poems in addition to drawing. See, for instance, *Kisah di Balik Kehidupan: Anak Pengungsi Maluku Utara di Manado dalam Gambar dan Puisi* (Manado, Indonesia: Yayasan Pelita Kasih Abadi/Catholic Relief Services Indonesia, 2001); Hasil Puisi Yayasan Pelita Kasih Abadi/Catholic Relief Services Jakarta, Manado, "Program Therapi Emosional Pengungsi Anak di Manado" (unpublished manuscript, January–March 2001); "Kumpulan Puisi Sanggar Kreatif Anak Bitung" (unpublished manuscript, September–December 2000); *Rumah Seng Ada Pintu: Anak-Anak Maluku "Korban Kerusuhan"/Een Huis Zonder Deur: Molukse Kinderen: "Slachtoffers van Geweld"* (Utrecht, Netherlands: Stichting TitanE, 2001); and on such projects, see "Ambon Children Express Trauma through Art," *Jakarta Post*, May 10, 2002. I would like to thank Katinka van Heeren for bringing the last article to my attention.

15. The Women and Children Exchange drawing competition was held by the implementing team of the GPM on July 20, 2013. The Indonesian original, posted July 20, 2013, on Facebook by Rudy Fofid, reads: "Ada gereja di dekat masjid. Seorang warga Muslim dan seoranga warga nasrani bertemu di titik jumpa depan gereja dan masjid. Pohon dan rumput berbunga di tanah, bahkan di langit juga tumbuh bunga-bunga Lukisan Rusli Mewar, anak Batu Naga Negeri Waai yang duduk di kelas 6 SD Negeri 5 Waai. Lukisan ini menjadi juara pertama lomba melukis Women and Children Exchange oleh Tim Implementing Gereja Protestan Maluku, 20 July 2013."

16. Notes from author's interview with journalists from Radio Pelangi, Ambon, Indonesia, September 2, 2003.

17. Notes from author's interview with journalists from Radio Jalinan Nuansa Seni, Ambon, Indonesia, September 2, 2003.

18. Notes from author's interview with journalists from Radio Jalinan Nuansa Seni, Ambon, Indonesia, September 2, 2003.

19. An example would be "Mari katong membangun Maluku kembali" (Let us rebuild Maluku again) in which the juxtaposition of the Ambonese Malay *katong* with the more formal *membangun kembali* is especially jarring.

20. Although such terminology is not mentioned in the Malino II Peace Agreement, it features as Article 9, for instance, in the Peace Declaration of

the Tobelo Adat Community (North Maluku): "Both parties agree to stop using the term *red* for Christians and *white* for Muslims, and to not use the term or phrase *Christian troops* for Christians or *Jihad troops* for Muslims, or *Acang* for Muslims or *Obet* Christians." See the English translation of "Peace Declaration of the Tobelo Adat Community, Thursday 19 April, 2001, Hibua Lama Field in Tobelo," in Duncan, *Violence and Vengeance*, 195. For a copy of the Malino II Peace Agreement with its eleven points, see Centre for Humanitarian Dialogue, *Conflict Management in Indonesia: An Analysis of the Conflicts in Maluku, Papua and Poso* (Geneva: Indonesian Institute of Sciences and Centre for Humanitarian Dialogue, 2011), 28.

21. In 2003, graffiti that read "Mohammed TNI" was not uncommon. On footage from the war, I saw a banner carried in a protest that read "TNI is owned by Acang" or "TNI Milik Acang." Notes from an interview with author, Ambon, Indonesia, August 31, 2003.

22. Notes from an interview with author, Ambon, Indonesia, July 5, 2005.

23. Strassler, "Reformasi through Our Eyes," 64.

24. Strassler, 63.

25. Some of my fieldwork among refugees in Manado overlapped with that of Christopher Duncan, whose book about the religious conflict and its aftermath in North Maluku is revealingly titled *Violence and Vengeance*.

26. Anne Higonnet, *Pictures of Innocence: The History and Crisis of Ideal Childhood* (London: Thames and Hudson, 1998).

27. Danilyn Rutherford, *Raiding the Land of the Foreigner: The Limits of the Nation on an Indonesian Frontier* (Princeton, N.J.: Princeton University Press, 2003), 208.

28. Horkheimer and Adorno use this expression to suggest how the mimetic practices of shamans reliant on a "yielding to things" in which "fetishes were subject to the law of equivalence" gives way with Enlightenment to an organization of mimesis as it becomes an instrument to dominate nature as equivalence itself becomes a fetish. Although I take this in a somewhat different direction, the role of domination and, with it, repression remains. Max Horkheimer and Theodor W. Adorno, *The Dialectic of Enlightenment*, trans. John Cumming (New York: Continuum, 1987), cited in Michael T. Taussig, *Mimesis and Alterity: A Particular History of the Senses* (New York: Routledge, 1993), 45.

29. I borrow Karen Strassler's adaptation of Marita Sturken's contrast here. Strassler uses it to describe what she calls the "innocenting" of images produced by children. Strassler, "Reformasi through Our Eyes."

30. On the high value accorded to education in Indonesia, see Kathryn Robinson, "Educational Aspirations and Inter-generational Relations in Sorowako," in *Youth Identities and Social Transformations in Modern Indonesia*, ed. Kathryn Robinson (Leiden, Netherlands: Brill, 2016).

31. Notes from an interview with author, Ambon, Indonesia, July 7, 2005.

32. Nayanika Mookherjee, "The Aesthetics of Nations: Anthropological and Historical Approaches," *Journal of the Royal Anthropological Institute* 17, no. 1 (2011): S1–20.

33. Mookherjee, "Aesthetics of Nations," 17. See also Mary Margaret Steedly, "The State of Culture Theory in the Anthropology of Southeast Asia," *Annual Review of Anthropology* 28 (1999): 431–54.

34. On the concept of uptake and media circulation, see Brian Larkin, "Making Equivalence Happen: Commensuration and the Architecture of Circulation," in *Images That Move*, ed. Patricia Spyer and Mary Margaret Steedly (Santa Fe: School for Advanced Research Press, 2013).

35. Michel de Certeau, dedication to *The Practice of Everyday Life*, trans. Steven F. Rendall (Berkeley: University of California Press, 1988).

36. Strassler writes how, in post-Suharto Indonesia, "the figure of the child witness was profoundly implicated in the processes that would, to invert Walter Benjamin's phrase, dissolve history into the space of myth." Strassler, "Reformasi through Our Eyes," 67.

37. See also Robert Cribb, "From Total People's Defence to Massacre: Explaining Indonesian Military Violence in East Timor," in *Roots of Violence in Indonesia*, ed. Freek Columbijn and J. Thomas Lindblad (Leiden, Netherlands: KITLV Press, 2002).

38. Annemarie Samuels, *After the Tsunami: Disaster Narratives and the Remaking of Everyday Life in Aceh* (Honolulu: University of Hawai'i Press, 2019).

39. Peter van der Veer, "The Victim's Tale: Memory and Forgetting in the Story of Violence," in *Violence, Identity and Self-Determination*, ed. Hent de Vries and Samuel M. Weber (Stanford, Calif.: Stanford University Press, 1997).

40. Cribb, "From Total People's Defence to Massacre," 229.

41. Ian Hacking, *The Taming of Chance* (Cambridge: Cambridge University Press, 1990).

42. In 2001, also in Manado, I interviewed a number of North Malukan university students who were in the process of establishing their own small paper with the objective of protecting North Maluku culture against what they saw as Christian plans of encroachment and domination. Much like the *Radar Kieraha* journalists, they also felt supported in their endeavor by the creation of the new province of North Maluku and, with it, the possibility of reinstituting "the old system of government" based on the four Maluku sultanates. Notes from an interview with author, Manado, Indonesia, August 1, 2001.

43. The *Manado Pos* is a subsidiary of the Surabaya daily *Jawa Pos* and, as such, is part of the country's largest press empire. At the time, the *Jawa Pos* was the only paper outside of the capital Jakarta that focused on the development of provincial markets. See Krishna Sen and David T. Hill, *Media, Culture, and Politics in Indonesia* (Oxford: Oxford University Press, 2000), 58–59.

44. Notes from two recorded interviews with author. The first took place in Manado, Indonesia, on April 29, 2000; the second was a more extensive interview with both men again on May 5, 2000, also in Manado.

45. Notes from recorded interviews with author, Manado, Indonesia, April 29 and May 5, 2000.

46. Steve Sharp, *Journalism and Conflict in Indonesia: From Reporting Violence to Promoting Peace* (New York: Routledge, 2013), 160.

47. Notes from recorded interviews with author, Manado, Indonesia, April 29 and May 5, 2000.

48. Notes from recorded interviews with author, Manado, Indonesia, April 29 and May 5, 2000.

49. Sharp, *Journalism and Conflict in Indonesia*, 193.

50. Sharp, 193–94.

51. Sharp, 159.

52. Sharp, 162.

53. This distinction is inspired by a passage from Margaret Atwood's novel *The Blind Assassin* (New York: Rosetta Books, 2003), 442.

54. International Crisis Group, "Indonesia: Cautious Calm in Ambon," *Crisis Group Asia Briefing* 133 (February 13, 2012).

55. Andrew Stroehlein, "How 'Peace Provocateurs' Are Defusing Religious Tensions in Indonesia," *Independent*, March 12, 2012.

56. International Crisis Group, "Indonesia: Trouble Again in Ambon," *Crisis Group Asia Briefing* 128 (October 4, 2011), 4.

57. International Crisis Group, "Indonesia: Cautious Calm in Ambon," 2.

58. International Crisis Group, 2.

59. Stroehlein, "How 'Peace Provocateurs' Are Defusing Religious Tensions in Indonesia."

60. For a discussion of early photography clubs and their popularity in Indonesia, see Strassler, *Refracted Visions*, chap. 1, "Amateur Visions."

61. Notes from an interview with author, Ambon, Indonesia, June 12, 2017.

62. Golnar Nabizadeh, "Comics Online: Detention and White Space in 'A Guard's Story,'" *ARIEL* 47, no. 1–2 (2016): 337.

63. Nabizadeh, "Comics Online," 337.

64. Nabizadeh, 337.

Conclusion: Ephemeral Mediations

1. Charles Hirschkind, *The Ethical Soundscape: Cassette Sermons and Islamic Counterpublics* (New York: Columbia University Press, 2006).

Works Cited

Acciaioli, Greg. "Culture as Art: From Practice to Spectacle in Indonesia." *Canberra Anthropology* 8, no. 1–2 (1985): 148–72.

Adam, Jeroen. "Displacement, Coping Mechanisms and the Emergence of New Markets in Ambon." Working paper no. 9, Conflict Research Group, University of Ghent, Ghent, Belgium, March 2008.

———. "Downward Social Mobility, Prestige and the Informal Economy in Post-Conflict Ambon," *South East Asia Research* 16, no. 3 (2008): 293–311.

———. "The Problem of Going Home: Land Management, Displacement, and Reconciliation in Ambon." In *Reconciling Indonesia: Grassroots Agency for Peace. Asia's Transformations*, edited by Birgit Bräuchler, 138–54. London: Routledge, 2009.

Adam, Jeroen, and Lusia Peilouw. "Internal Displacement and Household Strategies for Income Generation: A Case Study in Ambon, Indonesia." *Social Development Issues* 30, no. 2 (2008): 78–89.

Aditjondro, George. "Guns, Pamphlets and Handie-Talkies: How the Military Exploited Local Ethno-religious Tensions in Maluku to Preserve Their Political and Economic Privileges." In *Violence in Indonesia*, edited by Ingrid Wessel and Georgia Wimhöfer, 100–28. Hamburg, Germany: Abera Verlag, 2001.

Aitken, Stuart C., and Deborah P. Dixon. "Imagining Geographies of Film." *Erdkunde* 60 (2006): 326–36.

Al-Jakartaty, Erwin H. *Tragedi Bumi Seribu Pulau: Mengkritisi Kebijakan Pemerintah Dan Solusi Penyelesaian Konflik.* Jakarta: BukKMaNs, 2000.

Allen, Tim, and Jean Seaton, eds. *The Media of Conflict: War Reporting and Representations of Ethnic Violence.* London: Zed Books, 1999.

Alpers, Svetlana. *The Art of Describing: Dutch Art in the Seventeenth Century.* Chicago: University of Chicago Press, 1983.

Amin, Basri. "Youth, Ojeg and Urban Space in Ternate." *Asia Pacific Journal of Anthropology* 13, no. 1 (2012): 36–48.

Amirrachman, Alpha R. "Peace Education in the Moluccas, Indonesia: Between Global Models and Local Interests." PhD diss., University of Amsterdam, 2012.

Anderson, Benedict. *Imagined Communities: Reflections on the Origin and Spread of Nationalism.* London: Verso, 1991.

————. "Indonesian Nationalism Today and in the Future." *New Left Review* 1, no. 235 (1999): 3–17.

————. *The Pemuda Revolution: Indonesian Politics, 1945–1946.* Ithaca, N.Y.: Cornell University Press, 1967.

————. *Violence and the State in Suharto's Indonesia.* Ithaca, N.Y.: Southeast Asia Program Publications, an imprint of Cornell University Press, 2001.

Anwar, Dewi Fortuna, Hélène Bouvier, Glenn Smith, and Roger Tol, eds. *Violent Internal Conflicts in Asia Pacific: Histories, Political Economies, and Policies.* Jakarta: Yayasan Obor, 2005.

Appadurai, Arjun. "The Colonial Backdrop." *Afterimage* 24, no. 3 (1997): 1–7.

————. *Modernity at Large: Cultural Dimensions of Globalization.* Minneapolis: University of Minnesota Press, 1996.

Aragon, Lorraine V. "Mass Media Fragmentation and Narratives of Violent Action in Sulawesi's Poso Conflict." *Indonesia* 79 (2005): 1–55.

Asad, Talal. "Comments on Conversion." In *Conversion to Modernities: The Globalization of Christianity,* edited by Peter van der Veer, 263–73. New York: Routledge, 1996.

Aspinall, Edward. *Opposing Suharto: Compromise, Resistance, and Regime Change in Indonesia.* Stanford, Calif.: Stanford University Press, 2005.

Aspinall, Edward, and Greg Fealy. *Local Power and Politics in Indonesia: Decentralisation & Democratisation.* Singapore: Institute of Southeast Asian Studies, 2003.

Aspinall, Edward, Herb Feith, and Gerry van Klinken. *The Last Days of President Suharto.* Clayton, Australia: Monash Asia Institute, 1999.

Atwood, Margaret. *The Blind Assassin.* New York: Rosetta Books, 2003.

Avonius, Leena. "Reforming Wetu Telu: Islam, Adat and the Promises of Regionalism in Post–New Order Lombok." PhD diss., Leiden University, 2004.

Azca, Muhammad Najib. "After Jihad: A Biographical Approach to Passionate Politics in Indonesia." PhD diss., University of Amsterdam, 2011.

Azoulay, Ariella. *The Civil Contract of Photography.* New York: Zone Books, 2008.

————. *Potential History: Unlearning Imperialism.* New York: Verso, 2020.

Azuz, Fuad Mahfud. "Rumah Ibadah Salah Tempat: Potret Rumah Ibadah Pasca-Konflik Ambon 1999." In *Praktik Pengelolaan Keragaman Di Indonesia. Kontestasi Dan Koeksistensi,* by Mohammad Iqbal Ahnaf et al., 37–66. Yogyakarta, Indonesia: Center for Religious and Cross-Cultural Studies, University of Gadjah Mada, 2015.

Baker, Jacqui. "Laskar Jihad's Mimetic Stutter: State Power, Spectacular Violence and the Fetish in the Indonesian Postcolony." Bachelor's thesis, Australian National University, 2002.

Barendregt, Bart. "The Art of No-Seduction: Muslim Boy-Band Music in Southeast Asia and the Fear of the Female Voice." *IIAS Newsletter* 40 (Spring 2006), 1, 4–5.

———. "Mobile Religiosity in Indonesia: Mobilized Islam, Islamized Mobility, and the Potential of Islamic Techno-nationalism." In *Living the Information Society in Asia*, edited by Erwin Alampay, 73–82. Singapore: Singapore Institute of Southeast Asian Studies, 2009.

———. "The Sound of Islam: Southeast Asian Boy Band." *ISIM Review* 22: (2008): 224–25.

Barker, Joshua. "State of Fear: Controlling the Criminal Contagion in Suharto's New Order." *Indonesia* 66 (1998): 7–43.

Barker, Joshua, Erik Harms, and Johan Lindquist, eds. *Figures of Southeast Asian Modernity*. Honolulu: University of Hawai'i Press, 2014.

Barker, Joshua, and Johan Lindquist. "Figures of Indonesian Modernity," *Indonesia* 87 (April 2009): 35–72.

Bartels, Dieter. "The Evolution of God in the Spice Islands: The Converging and Diverging of Protestant Christianity and Islam in the Colonial and Post-Colonial Periods." Paper presented at the Christianity in Indonesia symposium, Johann Wolfgang Goethe University, Frankfurt, Germany, December 14, 2003.

———. "Guarding the Invisible Mountain: Intervillage Alliances, Religious Syncretism and Ethnic Identity among Ambonese Christians and Moslems in the Moluccas." PhD diss., Cornell University, 1977.

———. "Your God Is No Longer Mine: Moslem-Christian Fratricide in the Central Moluccas (Indonesia) after a Half-Millennium of Peaceful Co-existence and Ethnic Unity." In *A State of Emergency: Violence, Society and the State in Eastern Indonesia*, edited by Sandra Pannell, 128–53. Darwin, Australia: Northern Territory University Press, 2003.

Barthes, Roland. *Camera Lucida: Reflections on Photography*. Translated by R. Howard. New York: Farrar, Straus and Giroux, 1981.

———. *Image, Music, Text*. Translated by Stephen Heath. London: Fontana Press, 1987.

Batchen, Geoffrey. *Burning with Desire: The Conception of Photography*. Cambridge, Mass.: MIT Press, 1997.

Bautista, Julius. *The Spirit of Things: Materiality and Religious Diversity in Southeast Asia*. Ithaca, N.Y.: Southeast Asia Program Publications, an imprint of Cornell University Press, 2012.

Becker, Adam H. "'The Ancient Near East in the Late Antique Near East: Syriac Christian Appropriation of the Biblical East." In *Antiquity in Antiquity: Jewish and Christian Pasts in the Greco-Roman World*, edited by Gregg Gardner and Kevin Osterloh, 394–415. Tübingen, Germany: Mohr Siebeck, 2008.

Benedict, Ruth, and Gene Weltfish. *The Races of Mankind.* Public Affairs Pamphlet,
　　No. 85. New York: Public Affairs Committee, 1943.
Benjamin, Walter. *The Arcades Project.* Cambridge, Mass.: Belknap Press, 1999.
Bharwani, Ravi L., Aryo Danusiri, Asep Kusdinar, Lianto Luseno, and Nana
　　Mulyana, dirs. *Viva Indonesia! An Anthology of Letters to God.* 2001.
Blumenfeld, Laura. *Revenge: A Story of Hope.* New York: Washington Square
　　Press, 2003.
Bourchier, David. "Face-Off in Jakarta: Suharto vs. the IMF." In *The Last Days of
　　President Suharto,* edited by Edward Aspinall, Herb Feith, and Gerry van
　　Klinken, 9–11. Clayton, Australia: Monash Asia Institute, 1999.
Bowen, John R. "On the Political Construction of Tradition: *Gotong Royong* in
　　Indonesia." *Journal of Asian Studies* 45, no. 3 (1986): 545–61.
Bräuchler, Birgit. "Cyberidentities at War: Religion, Identity, and the Internet in the
　　Moluccan Conflict." *Indonesia* 75 (2003): 123–52.
Bräuchler, Birgit, ed. *Reconciling Indonesia: Grassroots Agency for Peace.* London:
　　Routledge, 2009.
Brenner, Suzanne. "On the Public Intimacy of the New Order: Images of Women
　　in the Popular Indonesian Print Media." *Indonesia* 67 (1999): 13–37.
———. "Reconstructing Self and Society: Javanese Muslim Women and 'the Veil.'"
　　American Ethnologist 23, no. 4 (1996): 673–97.
Brock, Lisa, Conor McGrady, and Teresa Meade. "Taking Sides: The Role of Visual
　　Culture in Situations of War, Occupation, and Resistance." Editors' introduction.
　　Radical History Review 106 (2010): 1–4.
Bruinessen, Martin van. "Genealogies of Islamic Radicalism in Post-Suharto
　　Indonesia." *South East Asia Research* 10, no. 2 (2002): 117–54.
Bubandt, Nils. "Conspiracy Theories, Apocalyptic Narratives and the Discursive
　　Construction of 'the Violence in Maluku.'" *Antropologi Indonesia* 63 (2000):
　　14–31.
———. "From the Enemy's Point of View: Violence, Empathy, and the
　　Ethnography of Fakes." *Cultural Anthropology* 24, no. 3 (2009): 553–88.
———. "Ghosts with Trauma: Global Imaginaries and the Politics of Post-Conflict
　　Memory." In *Conflict, Violence, and Displacement in Indonesia,* edited by Eva-
　　Lotta E. Hedman, 275–301. Ithaca, N.Y.: Cornell University Press, 2008.
———. "Malukan Apocalypse: Themes in the Dynamics of Violence in Eastern
　　Indonesia." In *Violence in Indonesia,* edited by Ingrid Wessel and Georgia
　　Wimhöfer, 228–53. Hamburg, Germany: Abera Verlag, 2001.
———. "Rumors, Pamphlets, and the Politics of Paranoia in Indonesia." *Journal of
　　Asian Studies* 67, no. 3 (2008): 789–817.
———. "Sorcery, Corruption, and the Dangers of Democracy in Indonesia."
　　Journal of the Royal Anthropological Institute 12 (2006): 413–31.
Butler, Judith. *Frames of War: When Is Life Grievable?* London: Verso, 2016.
———. "Impossible, Necessary Task: Said, Levinas, and the Ethical Demand."
　　Unpublished paper.

Caton, Steven C. "From Laurence of Arabia to Special Operations Forces: The
 'White Sheik' as a Modular Image in Twentieth-Century Popular Culture." In
 Images That Move, edited by Patricia Spyer and Mary Margaret Steedly, 295–30.
 Santa Fe: School of Advanced Research Press, 2013.
Centre for Humanitarian Dialogue. *Conflict Management in Indonesia: An Analysis
 of the Conflicts in Maluku, Papua and Poso*. Geneva: Indonesian Institute of
 Sciences and Centre for Humanitarian Dialogue, 2011.
Certeau, Michel de. *The Possession at Loudun*. Translated by Michael B. Smith.
 Chicago: University of Chicago Press, 2000.
———. *The Practice of Everyday Life*. Translated by Steven F. Rendall. Berkeley:
 University of California Press, 1988.
Chakrabarty, Dipesh. *Habitations of Modernity: Essays in the Wake of Subaltern
 Studies*. Chicago: University of Chicago Press, 2002.
Chauvel, Richard. "Ambon's Other Half: Some Preliminary Observations on
 Ambonese Moslem Society and History." *Review of Indonesian and Malaysian
 Affairs* 14, no. 1 (1980): 40–80.
———. "Island of Ambon Is Worst Trouble Spot in Indonesia." Interview with Rudi
 Fofid and Sidney Jones. *Radio Australia Indonesia Service*, March 5, 1999.
———. *Nationalists, Soldiers and Separatists: The Ambonese Islands from
 Colonialism to Revolt, 1880–1950*. Leiden, Netherlands: Brill, 2008.
Clark, Marshall. "Cleansing the Earth." In *The Last Days of President Suharto*,
 edited by Aspinall, Edward, Herb Feith, and Gerry van Klinken, 37–40. Clayton,
 Australia: Monash Asia Institute, 1999.
Clausewitz, Carl von. *On War*. Edited by Michael Eliot Howard and Peter Paret.
 Princeton, N.J.: Princeton University Press, 1973.
Collins, James T. *Malay, World Language of the Ages: A Sketch of Its History*. Kuala
 Lumpur: Dewan Bahasa dan Pustaka, 1996.
———. "Sejarah Bahasa Melayu di Ambon." Presented at the Conference on
 Bahasa Melayu Ambon, Ambon, Indonesia, August 2006.
Colombijn, Freek, and Jan Thomas Lindblad, eds. *Roots of Violence in Indonesia:
 Contemporary Violence in Historical Perspective*. Leiden, Netherlands: KITLV
 Press, 2002.
Comolli, Jean-Louis. "Machines of the Visible." In *The Cinematic Apparatus*, edited
 by Teresa de Lauretis and Stephen Heath, 121–42. London: St. Martin's, 1980.
*Conflict Management in Indonesia: An Analysis of the Conflicts in Maluku, Papua
 and Poso*. Geneva: Indonesian Institute of Sciences, Current Asia, and Centre for
 Humanitarian Dialogue, 2011.
Couldry, Nick, and James Curran, eds. *Contesting Media Power: Alternative Media
 in a Networked World*. London: Rowman & Littlefield, 2003.
Cribb, Robert. "From Total People's Defence to Massacre: Explaining Indonesian
 Military Violence in East Timor." In *Roots of Violence in Indonesia*, edited by
 Freek Columbijn and J. Thomas Lindblad, 227–41. Leiden, Netherlands: KITLV
 Press, 2002.

Crisis Centre Diocese of Amboina. *The Situation in Ambon/Moluccas*. Report no. 117. (December 25, 2000).

Das, Veena, and Arthur Kleinman. *Remaking a World: Violence, Social Suffering, and Recovery*. Berkeley: University of California Press, 2001.

Davidson, Jamie S., and David Henley, eds. *The Revival of Tradition in Indonesian Politics: The Deployment of Adat from Colonialism to Indigenism*. London: Routledge, 2007.

De Cauter, Lieven. *Entropic Empire: On the City of Man in the Age of Disaster*. Rotterdam, Netherlands: NAi Booksellers, 2012.

De Kroon, Pieter-Rim, dir. *Dutch Light*. Dutch Light Films, 2003. DVD.

Deleuze, Gilles, and Félix Guattari. *A Thousand Plateaus: Capitalism and Schizophrenia*. Minneapolis: University of Minnesota Press, 1987.

Derrida, Jacques. *The Truth in Painting*. Translated by Geoff Bennington and Ian McLeod. Chicago: University of Chicago Press, 1987.

Devji, Faisal. *Landscapes of the Jihad: Militancy, Morality, Modernity*. London: Hurst and Co., 2005.

De Witte, Marleen. "Pentecostal Forms across Religious Divides: Media, Publicity, and the Limits of an Anthropology of Global Pentecostalism." *Religions* 9, no. 7 (2018): 2–17.

Djaelani, A. Q. *Perang sabil versus perang salib: umat Islam melawan penjajah Kristen Portugis dan Belanda*. Jakarta: Yayasan Pengkajian Madinal al-Munawwarah, 1999.

Duncan, Christopher R. *Violence and Vengeance: Religious Conflict and Its Aftermath in Eastern Indonesia*. Ithaca, N.Y.: Cornell University Press, 2013.

Ecip Sinansari, S. *Menyulut Ambon: Kronologi Merambatnya Berbagai Kerusuhan Lintas Wilayah Di Indonesia*. Bandung, Indonesia: Mizan, 1999.

Edensor, Tim. "Waste Matter: The Debris of Industrial Ruins and the Disordering of the Material World." *Journal of Material Culture* 10, no. 3 (2005): 311–32.

Ellen, Roy. "Pragmatism, Identity, and the State: How the Nuaulu of Seram Have Reinvented Their Beliefs and Practices as 'Religion.'" *Wacana* 15, no. 2 (2014): 254–85.

Eriyanto. *Media Dan Konflik Ambon: Media, Berita Dan Kerusuhan Komunal Di Ambon, 1999–2002*. Jakarta: Kantor Berita Radio 68H, 2003.

Fattal, Alexander L. *Guerrilla Marketing: Counterinsurgency and Capitalism in Colombia*. Chicago: University of Chicago Press, 2018.

Fealy, Greg. "Inside the Laskar Jihad: An Interview with the Leader of a New, Radical and Militant Sect." *Inside Indonesia* 65 (January–March 2001): https://www.insideindonesia.org/inside-the-laskar-jihad-3.

Feher, Michel. *Powerless by Design: The Age of the International Community*. Durham, N.C.: Duke University Press, 2000.

Fleetwood, Nicole R. *On Racial Icons: Blackness and the Public Imagination*. New Brunswick, N.J.: Rutgers University Press, 2015.

Flood, Finbarr Barry. *Objects of Translation: Material Culture and Medieval "Hindu-Muslim" Encounter.* Princeton, N.J.: Princeton University Press, 2009.

Frederick, William H. "The Appearance of Revolution: Cloth, Uniform, and the Pemuda Style in East Java, 1945–1949." In *Outward Appearances: Dressing State and Society in Indonesia,* edited by Henk Schulte Nordholt, 199–248. Leiden, Netherlands: KITLV Press, 1997.

Gaonkar, Dilip. "After the Fictions: Notes Towards a Phenomenology of the Multitude." *e-flux journal* 58 (October 2014): https://www.e-flux.com/journal/58/61187/after-the-fictions-notes-towards-a-phenomenology-of-the-multitude/.

Geertz, Clifford. *The Interpretation of Cultures.* New York: Basic Books, 1973.

———. *Negara: The Theatre State in Nineteenth-Century Bali.* Princeton, N.J.: Princeton University Press, 1980.

———. *The Religion of Java.* Chicago: University of Chicago Press, 1976.

George, Kenneth M. "Ethics, Iconoclasm, and Qur'anic Art in Indonesia." *Cultural Anthropology* 24, no. 4 (2009): 589–621.

———. *Picturing Islam: Art and Ethics in a Muslim Lifeworld.* Malden, Mass.: Wiley-Blackwell, 2010.

Goodman, Nelson. [1978]. *Ways of Worldmaking.* Cambridge, Mass.: Hackett, 1988.

Gordon, Robert J. "Backdrops and Bushmen: An Expeditious Comment." In *The Colonising Camera: Photographs in the Making of Namibian History,* edited by Wolfram Hartmann, Jeremy Silvester, and Patricia Hayes, 111–17. Cape Town: University of Cape Town Press, 1999.

Greaney, Patrick. *Untimely Beggar: Poverty and Power from Baudelaire to Benjamin.* Minneapolis: University of Minnesota Press, 2007.

Greiner, Andries, ed. *De Molukken in Crisis: Machteloos, Ver Weg, Maar Niet Wanhopig.* No. 2691. Lelystad, Netherlands: Actuele Onderwerpen, 2000.

Groebner, Valentin. *Who Are You? Identification, Deception, and Surveillance in Early Modern Europe.* Translated by Mark Kyburz and John Peck. New York: Zone Books, 2007.

Gunning, Tom. "Bodies and Phantoms: Making Visible the Beginnings of Motion Pictures." *Binocular* (1994): 84–99.

Gürsel, Zeynep Devrim. *Image Brokers: Visualizing World News in the Age of Digital Circulation.* Berkeley: University of California Press, 2016.

Hacking, Ian. *The Taming of Chance.* Cambridge: Cambridge University Press, 1990.

Harding, Susan Friend. *The Book of Jerry Falwell: Fundamentalist Language and Politics.* 2nd ed. Princeton, N.J.: Princeton University Press, 2001.

"Hari Puisi." Unpublished manuscript. Manado, Indonesia: Yayasan Pelita Kasih Abadi/Catholic Relief Services Jakarta, 2000.

Hasan, Noorhaidi. "Faith and Politics: The Rise of the Laskar Jihad in the Era of Transition in Indonesia." *Indonesia* 73 (2002): 145–69.

———. *Public Islam in Indonesia: Piety, Politics, and Identity.* Amsterdam: Amsterdam University Press, 2018.

Hasil Puisi Yayasan Pelita Kasih Abadi/Catholic Relief Services Jakarta, Manado. "Program Therapi Emosional Pengungsi Anak di Manado." Unpublished manuscript, January–March 2001.

Hedman, Eva-Lotta E., ed. *Conflict, Violence, and Displacement in Indonesia.* Ithaca, N.Y.: Cornell University Press, 2008.

Heeren, Catherine Quirine van. "Contemporary Indonesian Film: Spirits of Reform and Ghosts from the Past." PhD diss., Leiden University, 2009.

Heeren, Katinka van. "Return of the Kyai: Representations of Horror, Commerce, and Censorship in Post-Suharto Indonesian Film and Television." *Inter-Asian Cultural Studies* 8, no. 2 (2007): 211–26.

Hefner, Robert W. "Civic Pluralism Denied? The New Media and *Jihadi* Violence in Indonesia." In *New Media in the Muslim World: The Emerging Public Sphere,* edited by Dale F. Eickelman and Jon W. Anderson, 158–79. Bloomington: Indiana University Press, 2003.

———. *Civil Islam: Muslims and Democratization in Indonesia.* Princeton, N.J.: Princeton University Press, 2000.

Heryanto, Ariel. "Rape, Race, and Reporting." In *Reformasi: Crisis and Change in Indonesia,* edited by Arief Budiman, Barbara Hatley, and Damien Kingsbury, 299–334. Clayton, Australia: Monash Asia Institute, Monash University, 1999.

———. *State Terrorism and Political Identity in Indonesia: Fatally Belonging.* New York: Routledge, 2006.

Heryanto, Ariel, and Nancy Lutz. "The Development of 'Development.'" *Indonesia* 46 (1988): 1–24.

Hidskes, Maarten. *Thuis gelooft niemand mij: Zuid-Celebes, 1946–1947.* Amsterdam: Atlas Contact, 2016.

Higonnet, Anne. *Pictures of Innocence: The History and Crisis of Ideal Childhood.* London: Thames and Hudson, 1998.

Hill, Hal. "The Indonesian Economy: The Strange and Sudden Death of a Tiger." In *The Last Days of President Suharto,* edited by Herb Feith and Gerry van Klinken, 14–16. Clayton, Australia: Monash Asia Institute, 1999.

Hirschkind, Charles. *The Ethical Soundscape: Cassette Sermons and Islamic Counterpublics.* New York: Columbia University Press, 2006.

Hochberg, Gil. *Visual Occupations: Violence and Visibility in a Conflict Zone.* Durham, N.C.: Duke University Press, 2015.

Hoesterey, James. *Rebranding Islam: Piety, Prosperity, and a Self-Help Guru.* Stanford, Calif.: Stanford University Press, 2015.

hooks, bell. "In Our Glory: Photography and Black Life." In *Art on My Mind: Visual Politics,* 54–64. New York: New Press, 1995.

Hsu, Hua. "Beauty in the Streets: How Posters Became Art." *New Yorker,* July 8 and 15, 2019.

Huda, Ahmad Nuril. "The Cinematic Santri: Youth Culture, Tradition and Technology in Muslim Indonesia." PhD diss., Leiden University, 2020.

Hulsbosch, Marianne. *Pointy Shoes and Pith Helmets: Dress and Identity Construction in Ambon from 1850 to 1942*. Leiden, Netherlands: Brill, 2014.

Human Rights Watch. "Indonesia and East Timor." In *Human Rights Watch World Report*. New York: Human Rights Watch, 1999.

———. *Indonesia: The Violence in Ambon*. New York: Human Rights Watch, 1999.

International Crisis Group. "Backgrounder Indonesia: Jihad in Central Sulawesi." *ICG Asia Report* 74 (February 3, 2004), 1–33.

———. "Indonesia Backgrounder: How the Jemaah Islamiyah Terrorist Network Operates." *ICG Asia Report* 43 (December 11, 2002), 1–46.

———. "Indonesia Backgrounder: Why Salafism and Terrorism Mostly Don't Mix." *ICG Asia Report* 83 (September 13, 2004), 1–53.

———. "Indonesia: Cautious Calm in Ambon." *Crisis Group Asia Briefing* 133 (February 13, 2012), 1–7.

———. "Indonesia: The Search for Peace in Maluku." *ICG Asia Report* 31 (February 8, 2002), 1–35.

———. "Indonesia: Trouble Again in Ambon." *Crisis Group Asia Briefing* 128 (October 4, 2011), 1–11.

Iwamony, Rachel. "The Reconciliatory Potential of the Pela in the Moluccas: The Role of the GPM in This Transformation Process." PhD diss., Free University Amsterdam, 2010.

Jain, Kajri. *Gods in the Bazaar: The Economies of Indian Calendar Art*. Durham, N.C.: Duke University Press, 2007.

Jones, Carla. "Fashion and Faith in Urban Indonesia." *Fashion Theory* 11, no. 2–3 (2007): 211–31.

———. "Materializing Piety: Gendered Anxieties about Faithful Consumption in Contemporary Urban Indonesia." *American Ethnologist* 37, no. 4 (2010): 617–37.

Jonge, Huub de, and Gerben Nooteboom. "Why the Madurese? Ethnic Conflicts in West and East Kalimantan Compared." *Asian Journal of Social Sciences* 34, no. 3 (2006): 456–74.

Kadir, Hatib Abdul. "'Biar Punggung Patah, Asal Muka Jangan Pucat' Melacak Gengsi Dan Gaya Tubuh Anak Muda Kota Ambon." Bachelor's thesis, Universitas Gajah Mada, 2008.

———. "Gifts, Belonging, and Emerging Realities among 'Other Moluccans' during the Aftermath of Sectarian Conflict." PhD diss., University of California, Santa Cruz, 2017.

Kaplan, Benjamin J. *Divided by Faith: Religious Conflict and the Practice of Toleration in Early Modern Europe*. Cambridge, Mass.: Belknap Press, 2007.

Kastor, Rustam. *Konspirasi Politik RMS Dan Kristen Menghancurkan Ummat Islam Di Ambon-Maluku*. Yogyakarta, Indonesia: Wihdah Press, 2000.

———. *Suara Maluku Membantah/Rustam Kastor Menjawab*. Yogyakarta, Indonesia: Wihdah Press, 2000.

Keane, Webb. "Calvin in the Tropics: Objects and Subjects at the Religious Frontier." In *Border Fetishisms: Material Objects in Unstable Spaces*, edited by Patricia Spyer, 13–34. New York: Routledge, 1998.

———. *Christian Moderns: Freedom and Fetish in the Mission Encounter.* Berkeley: University of California Press, 2007.

———. *Signs of Recognition: Powers and Hazards of Representation in an Indonesian Society.* Berkeley: University of California Press, 1997.

Kerlogue, Fiona. "Islamic Talismans: The Calligraphy Batiks." In *Batik: Drawn in Wax*, edited by Itie van Hout, 124–35. Amsterdam: KIT Publishers, 2001.

Khoury, Elias. *Sinacol: Le miroir brisé.* Translated by Rania Samara. Arles, France: Actes Sud, 2013.

Kisah di Balik Kehidupan: Anak Pengungsi Maluku Utara di Manado dalam Gambar dan Puisi. Manado, Indonesia: Yayasan Pelita Kasih Abadi/Catholic Relief Services Indonesia, 2001.

Klima, Alan. *The Funeral Casino: Meditation, Massacre, and Exchange with the Dead in Thailand.* Princeton, N.J.: Princeton University Press, 2009.

Knaap, Gerrit J. "A City of Migrants: Kota Ambon at the End of the Seventeenth Century." *Indonesia* 51 (1991): 105–28.

———. *Kruidnagelen en Christenen: De Verenigde Oost indische Compagnie en de Bevolking van Ambon, 1656–1696.* Leiden, Netherlands: Brill, 2004.

Kotan, Daniel, ed. *Mediator Dalam Kerusuhan Maluku.* Jakarta: Sekretariat Komisi Katenetik, KWI, 2000.

"Kumpulan Puisi Sanggar Kreatif Anak Bitung." Unpublished manuscript, September–December 2000.

Kuntsman, Adi, and Rebecca L. Stein. *Digital Militarism: Israel's Occupation in the Social Media Age.* Stanford, Calif.: Stanford University Press, 2015.

Kusno, Abidin. *The Appearances of Memory: Mnemonic Practices of Architecture and Urban Form in Indonesia.* Durham, N.C.: Duke University Press, 2010.

———. "Guardian of Memories: Guardhouses in Urban Java." *Indonesia* 81 (2006): 95–149.

Lacan, Jacques. "Seminar on the Purloined Letter." In *The Purloined Poe: Lacan, Derrida, and Psychoanalytic Reading*, edited by J. P. Muller and W. J. Richardson. Baltimore: Johns Hopkins University Press, 1988.

Laksono, Pachalis Maria. *The Common Ground in the Kei Islands: Eggs from One Fish and One Bird.* Yogyakarta, Indonesia: Galang Press, 2002.

Laksono, Pachalis Maria, and Roem Topatimasang, eds. *Ken Sa Faak: Benih-Benih Perdamaian Dari Kepulauan Kei.* Yogyakarta, Indonesia: INSIST Press, 2003.

Larkin, Brian. "Ahmed Deedat and the Form of Islamic Evangelism." *Social Text* 26, no. 3(96) (2008): 101–21.

———. "Making Equivalence Happen: Commensuration and the Architecture of Circulation." In *Images That Move*, edited by Patricia Spyer and Mary Margaret Steedly, 237–56. Santa Fe: School for Advanced Research Press, 2013.

Lee, Doreen. *Activist Archives: Youth Culture and the Political Past in Indonesia.* Durham, N.C.: Duke University Press, 2016.

Lee, Juliet Patricia. "The Changing Face of the Village in Ambon." *Cakalele* 8 (1997): 59–77.

———. "Out of Order: The Politics of Modernity in Indonesia." PhD diss., University of Virginia, 1999.

Leshkowich, Ann Marie. *Essential Trade: Vietnamese Women in a Changing Marketplace.* Honolulu: University of Hawai'i Press, 2014.

Lévinas, Emmanuel. "Ethics and Infinity." *Crosscurrents* 34, no. 2 (1984): 191–203.

Lim, Merlyna. "@rchipelago Online: The Internet and Political Activism in Indonesia." PhD diss., University of Twente, 2005.

———. "The Internet, Social Networks, and Reform in Indonesia." In *Contesting Media Power: Alternative Media in a Networked World*, edited by Nick Couldry and James Curran, 273–88. London: Rowman & Littlefield, 2003.

———. "Many Clicks but Little Sticks: Social Media Activism in Indonesia." *Journal of Contemporary Asia* 43, no. 4 (2013): 636–57.

Lingsma, Tjitske. *Het Verdriet van Ambon: Een Geschiedenis van de Molukken.* Amsterdam: Balans, 2008.

Luka Maluka: Militer Terlibat. Jakarta: Institut Studi Arus Informasi, 2000.

MacDougall, David. *The Corporeal Image: Film, Ethnography, and the Senses.* Princeton, N.J.: Princeton University Press, 2006.

Makhubu, Nomusa, and Ruth Simbao. "The Art of Change: Perspectives on Transformation in South Africa: Editorial." *Third Text* 27, no. 3 (2013): 299–302.

Manuhutu, Wim. "Molukkers in Nederland: Een Korte Terugblik." *Actuele Onderwerpen* AO2691 (February 18, 2000).

Manuhutu, Wim, ed. *Maluku Manis, Maluku Menangis: De Molukken in Crisis. Een Poging Tot Verklaring van de Geweldsexplosie Op de Molukken.* Utrecht, Netherlands: Moluks Historisch Museum/Moluccan Information and Documentation Center, 2001.

Manuputty, Jacky, Zairin Salempessy, Ishan Ali-Fauzi, and Irsyad Rafsadi, eds. *Carita Orang Basudara: Kisah-Kisah Perdamaian dari Maluku.* Ambon and Jakarta: Lembaga Antar Imam Maluku and Pusat Studi Agama dan Demokrasi, Yayasan Paramadina, 2014.

Margiyatin, Ugik, Lusia Peilouw, Atsushi Sano, and Ben White. "Teenagers' Accounts of Insecurity and Violence in Three Indonesian Regions." Unpublished paper, December 2006.

Mbembe, Achille. "The Banality of Power and the Aesthetics of Vulgarity." *Public Culture* 4, no. 2 (1992): 1–30.

———. *On the Postcolony.* Berkeley: University of California Press, 2001.

McDonald, Hamish. *Suharto's Indonesia.* Blackburn, U.K.: Fontana Books, 1980.

McRae, Dave. *A Few Poorly Organized Men: Interreligious Violence in Poso, Indonesia.* Leiden, Netherlands: Brill, 2013.

Mearns, David. "Dangerous Spaces Reconsidered: The Limits of Certainty in Ambon, Indonesia." In A *State of Emergency: Violence, Society and the State in Eastern Indonesia*, edited by Sandra Pannell, 37–48. Darwin, Australia: Northern Territory University Press, 2003.

Meyer, Birgit. *Sensational Movies: Video, Vision, and Christianity in Ghana.* Berkeley: University of California Press, 2015.

Mirzoeff, Nicholas. *Watching Babylon: The War in Iraq and Global Visual Culture.* New York: Routledge, 2005.

Mitchell, W. J. T. *Cloning Terror: The War of Images, 9/11 to the Present.* Chicago: University of Chicago Press, 2011.

———. "Holy Landscape: Israel, Palestine, and the American Wilderness." *Critical Inquiry* 26, no. 2 (2000): 193–223.

———. "There Are No Visual Media." *Journal of Visual Culture* 4, no. 2 (2005): 257–66.

———. *What Do Pictures Want? The Lives and Loves of Images.* Chicago: University of Chicago Press, 2005.

Mookherjee, Nayanika. "The Aesthetics of Nations: Anthropological and Historical Approaches." *Journal of the Royal Anthropological Institute* 17, no. 1 (2011): S1–20.

Morgan, David. *Visual Piety: A History and Theory of Popular Religious Images.* Berkeley: University of California Press, 1997.

Morris, Rosalind C. "Two Masks: Images of Future History and the Posthuman in Postapartheid South Africa." In *Images That Move*, edited by Patricia Spyer and Mary Margaret Steedly, 187–217. Santa Fe: School for Advanced Research Press, 2013.

Mrázek, Rudolf. *Engineers of Happy Land: Technology and Nationalism in a Colony.* Princeton, N.J.: Princeton University Press, 2002.

Mujburramn. *Feeling Threatened: Muslim-Christian Relations in Indonesia's New Order.* Leiden, Netherlands, and Amsterdam: ISIM and Amsterdam University Press, 2006.

Mukmin, Tim Penyusun al-. *Tragedi Ambon.* Jakarta: Yayasan Al-Mukmin, 1999.

Mulyadi, Sukidi. "Violence under the Banner of Religion: The Case of Laskar Jihad and Laskar Kristus." *Studia Islamika* 10, no. 2 (2003): 75–110.

Myers, Fred R. *Painting Culture: The Making of an Aboriginal High Art.* Durham, N.C.: Duke University Press, 2002.

Naafs, Suzanne, and Ben White. "Intermediate Generations: Reflections on Indonesian Youth Studies." *Asia Pacific Journal of Anthropology* 13, no. 1 (2012): 3–20.

Nabizadeh, Golnar. "Comics Online: Detention and White Space in 'A Guard's Story.'" *ARIEL* 47, no. 1–2 (2016): 337.

Nanere, Jan, ed. *Halmahera Berdarah.* Ambon, Indonesia: Bimspela, 2000.

Navaro, Yael. *The Make-Believe Space: Affective Geography in a Postwar Polity.* Durham, N.C.: Duke University Press, 2012.

Newberry, Janice C. *Back Door Java: State Formation and the Domestic in Working Class Java*. Peterborough, Ontario: Broadview Press, 2006.

Pandey, Gyanendra. *Routine Violence: Nations, Fragments, Histories*. Stanford, Calif.: Stanford University Press, 2006.

Pannell, Sandra N., ed. *A State of Emergency: Violence, Society, and the State in Eastern Indonesia*. Darwin, Australia: Northern Territory University Press, 2003.

Paramaditha, Intan. "The Wild Child's Desire: Cinema, Sexual Politics, and the Experimental Nation in Post-Authoritarian Indonesia." PhD diss., New York University, 2014.

Pattinasarany, Leonor, and Dita Vermeulen, eds. *Je kunt niet in elkaars hart kijken: oorlog en vrede op de Molukken*. Amsterdam: KIT Publishers, 2009.

Pemberton, John. "Notes on the 1982 General Election in Solo." *Indonesia* 41 (April 1986): 1–22.

———. *On the Subject of "Java."* Ithaca, N.Y.: Cornell University Press, 1994.

Pengkajian, Tim. *Analisis sosial tentang peristiwa kerusuhan berdarah di kotamadya Ambon dan sekitarnya Januari–Februari 1999*. Ambon, Indonesia: Universitas Pattimura, 1999.

"Perang Tentara Pembangkang di Ambon." *Tempo* 10 (June 16, 2002): 24–37.

Pinney, Christopher. *Camera Indica: The Social Life of Indian Photographs*. Chicago: University of Chicago Press, 1997.

———. *"Photos of the Gods": The Printed Image and Political Struggle in India*. London: Reaktion Books, 2004.

Pinney, Christopher, and Nicholas Peterson, eds. *Photography's Other Histories*. Durham, N.C.: Duke University Press, 2003.

Pisani, Elizabeth. *Indonesia Etc.: Exploring the Improbable Nation*. New York: W. W. Norton, 2015.

Poole, Deborah. *Vision, Race, and Modernity: A Visual Economy of the Andean Image World*. Princeton, N.J.: Princeton University Press, 1997.

Purdey, Jemma. *Anti-Chinese Violence in Indonesia: 1996–1999*. Leiden, Netherlands: KITLV Press, 2005.

———. "Describing Kekerasan: Some Observations on Writing about Violence in Indonesia after the New Order." *Bijdragen Tot de Taal-, Land- En Volkenkunde* 160, no. 2/3 (2004): 189–225.

Putuhena, M. Husni. *Buku Putih-Tragedi Kemanusiaan Dalam Kerusuhan Di Maluku. Sebuah Prosesi Ulang Sejarah Masa Lalu*. Ambon, Indonesia: Lembaga Eksistensi Muslim Maluku, 1999.

Raben, Remco. "On Genocide and Mass Violence in Colonial Indonesia." *Journal of Genocide Research* 14, no. 3–4 (2012): 485–502.

Rafael, Vicente L., ed. *Figures of Criminality in Indonesia, the Philippines, and Colonial Vietnam*. Ithaca, N.Y.: Southeast Asia Program Publications, an imprint of Cornell University Press, 1999.

Rambadeta, Lexy, dir. *Mass Grave*. Offstream, 2001.

Rancière, Jacques. *The Politics of Aesthetics*. Translated by G. Rockhill. London: Bloomsbury Academic, 2004.

Reinhard, Kenneth. "Toward a Political Theology of the Neighbor." In *The Neighbor: Three Inquiries in Political Theology*, edited by Slavoj Žižek, Eric L. Santner, and Kenneth Reinhard, 11–75. Chicago: University of Chicago Press, 2005.

Riis, Jacob A. *How the Other Half Lives: Studies among the Tenements of New York*. New York: Penguin Books, 1997.

Robbins, Joel. "The Globalization of Pentecostal and Charismatic Christianity." *Annual Review of Anthropology* 33, no. 1 (2004): 117–43.

———. "Pentecostal Networks and the Spirit of Globalization: On the Social Productivity of Ritual Forms." *Social Analysis* 53, no. 1 (2009): 55–66.

Robinson, Geoffrey. "Rawan Is as Rawan Does: The Origins of Disorder in New Order Aceh." In *Violence and the State in Suharto's Indonesia*, edited by Benedict Anderson, 213–42. Ithaca, N.Y.: Cornell University Press, 2001.

Robinson, Kathryn. "Educational Aspirations and Inter-generational Relations in Sorowako." In *Youth Identities and Social Transformations in Modern Indonesia*, edited by Kathryn Robinson, 69–90. Leiden, Netherlands: Brill, 2016.

Rudnyckyj, Daromir. *Spiritual Economies: Islam, Globalization, and the Afterlife of Development*. Ithaca, N.Y.: Cornell University Press, 2011.

Rumah Seng Ada Pintu: Anak-Anak Maluku "Korban Kerusuhan"/Een Huis Zonder Deur: Molukse Kinderen: "Slachtoffers van Geweld." Utrecht, Netherlands: Stichting TitanE, 2001.

Rutherford, Danilyn. *Raiding the Land of the Foreigners: The Limits of the Nation on an Indonesian Frontier*. Princeton, N.J.: Princeton University Press, 2003.

Ryter, Loren. "Pemuda Pancasila: The Last Loyalist Free Men of Suharto's Order?" *Indonesia* 66 (1998): 45–73.

———. "Reformasi Gangsters." *Inside Indonesia*, July 24, 2007.

Sahlins, Marshall. "Structural Work: How Microhistories Become Macrohistories and Vice Versa." *Anthropological Theory* 5, no. 1 (2005): 5–30.

Salempessy, Zairin, and Thamrin Husain, eds. *Ketika Semerbak Cengkih Tergusur Asap Mesiu: Tragedi Kemanusiaan Maluku Di Balik Konspirasi Militer, Kapitalis Birokrat, Dan Kepentingan Elit Politik*. Jakarta: Sekretariat Tapak Ambon, 2001.

Salvatore, Armando, and Dale F. Eickelman, eds. *Public Islam and the Common Good*. Leiden, Netherlands: Brill, 2004.

Samuels, Annemarie. *After the Tsunami: Disaster Narratives and the Remaking of Everyday Life in Aceh*. Honolulu: University of Hawai'i Press, 2019.

Sastramidjaja, Yatun. *Playing Politics: Power, Memory, and Agency in the Making of the Indonesian Student Movement*. Leiden, Netherlands: Brill, 2020.

Schreurs, P. G. H. *Terug in het erfgoed van Franciscus Xaverius: Het herstel van de katholieke missie in Maluku, 1886–1960*. Tilburg, Netherlands: Missiehuis MSC, 1992.

Schulte Nordholt, Henk. *A Genealogy of Violence in Indonesia*. Notebooks 1–33. Lisbon: Centro Portugues de Estudoes do Sudeste Asiatico, 2001.

———. *Outward Appearances: Dressing State & Society in Indonesia*. Leiden, Netherlands: KITLV Press, 1997.

Schulte Nordholt, Henk, and Gerry van Klinken, eds. *Renegotiating Boundaries: Local Politics in Post-Suharto Indonesia*. Leiden, Netherlands: KITLV Press, 2007.

Schulze, Kirsten E. "Laskar Jihad and the Conflict in Ambon." *Brown Journal of World Affairs* 9, no. 1 (2002): 57–69.

Sen, Krishna, and David T. Hill. *Media, Culture, and Politics in Indonesia*. Oxford: Oxford University Press, 2000.

Sharp, Steve. *Journalism and Conflict in Indonesia: From Reporting Violence to Promoting Peace*. New York: Routledge, 2013.

Shiraishi, Saya. *Young Heroes: The Indonesian Family in Politics*. Ithaca, N.Y.: Southeast Asia Program Publications, an imprint of Cornell University Press, 1997.

Sholeh, Badrus. "Ethno-religious Conflict and Reconciliation: Dynamics of Muslim and Christian Relationships in Ambon." PhD diss., Australian National University, 2003.

Sidel, John T. "The Manifold Meanings of Displacement: Explaining Inter-religious Violence, 1999–2001." In *Conflict, Violence, and Displacement in Indonesia*, edited by Eva-Lotta E. Hedman, 29–59. Ithaca, N.Y.: Southeast Asia Program Publications, an imprint of Cornell University Press, 2008.

———. *Riots, Pogroms, Jihad: Religious Violence in Indonesia*. Ithaca, N.Y.: Cornell University Press, 2006.

Siegel, James T. "Early Thoughts on the Violence of May 13 and 14, 1998 in Jakarta." *Indonesia* 66 (1998): 75–108.

———. *A New Criminal Type in Jakarta: Counter-Revolution Today*. Durham, N.C.: Duke University Press, 1998.

Siegert, Bernhard. *Relays: Literature as an Epoch of the Postal System*. Translated by Kevin Repp. Stanford, Calif.: Stanford University Press, 1999.

Silverman, Kaja. *The Threshold of the Visible World*. New York: Routledge, 1996.

Simmel, Georg. "On Visual Interaction." In *Introduction to the Science of Sociology*, by Robert E. Park and Ernest W. Burgess, 300–3. Chicago: University of Chicago Press, 1924.

Smith, Shawn Michelle. *American Archives: Gender, Race, and Class in Visual Culture*. Princeton, N.J.: Princeton University Press, 1999.

Solnit, Rebecca. *River of Shadows: Eadweard Muybridge and the Technological Wild West*. New York: Penguin, 2004.

Spyer, Patricia. "After Violence—A Discussion." In *Producing Indonesia: The State of the Field in Indonesian Studies*, edited by Eric Tagliacozzo, 47–62. Ithaca, N.Y.: Southeast Asia Program Publications, an imprint of Cornell University Press, 2014.

———. "Art Under Siege: Perils and Possibilities of Aesthetic Forms in a Globalizing World." In *Arts and Aesthetics in a Globalizing World*, edited by

Raminder Kaur and Parul Dave-Mukherji, 73–83. Oxford: Berg, ASA Monographs, 2014.

———. "Beberapa 'Catatan Pinggir' Dari Kota Ambon Manise." *Kanjoli: Jurnal Lembaga Antar Iman Maluku* 1 (2005): 17–19.

———. "*Belum Stabil* and Other Signs of the Times in Post-Suharto Indonesia." In *Indonesia in Transition: Rethinking Civil Society, Region, and Crisis*, edited by Rochman Achwan, Hanneman Samuel, and Henk Schulte Nordholt, 237–52. Yogyakarta, Indonesia: Pustaka Pelajar, 2004.

———. "Diversity with a Difference: Adat and the New Order in Aru (Eastern Indonesia)." *Cultural Anthropology* 11, no. 1 (1996): 25–50.

———. "Escalation: Assemblage, Archive, Animation." In "Ethnographies of Escalation," edited by Lars Hoyer. Special issue, *History and Anthropology* 32, no. 1 (2021): 93–115.

———. "Fire without Smoke and Other Phantoms of Ambon's Violence: Media Effects, Agency, and the Work of Imagination." *Indonesia* 74 (2002): 21–36.

———. "In and Out of the Picture: Photography, Ritual, and Modernity in Aru Indonesia." In *Photographies East: The Camera and Its Histories in East and Southeast Asia*, edited by Rosalind C. Morris, 161–82. Durham, N.C.: Duke University Press, 2009.

———. *The Memory of Trade: Modernity's Entanglements on an Eastern Indonesian Island.* Durham, N.C.: Duke University Press, 2000.

———. "Reel Accidents: Screening the Ummah Under Siege in Wartime Maluku." *Current Anthropology* 58, no. S15 (2016): S27–40.

———. "Serial Conversion/Conversion to Seriality: Religion, State, and Number in Aru, Eastern Indonesia." In *Conversion to Modernities: The Globalization of Christianity*, edited by Peter van der Veer, 188–218. New York: Routledge, 1996.

———. "Shadow Media and Moluccan Muslim VCDs." In *9/11: A Virtual Case Book*, edited by Barbara Abrash and Faye Ginsburg. New York: Center for Media, Culture, and History, 2002.

———. "Some Notes on Disorder in the Indonesian Postcolony." In *Law and Disorder in the Postcolony*, edited by John L. Comaroff and Jean Comaroff, 188–218. Chicago: University of Chicago Press, 2006.

———. "Telltale." In "Mary Steedly's Anthropology of Modern Indonesia: A Collection of Keywords," edited by Smita Lahiri, Patricia Spyer, and Karen Strassler. Special issue, *Indonesia* 109 (2020): 37–43.

———. "What Ends with the End of Anthropology?" *Paideuma* 56 (2010): 145–63.

———. *Why Can't We Be Like Storybook Children? Media of Peace and Violence in Maluku.* Jakarta: KITLV Press, 2004.

Spyer, Patricia, and Mary Margaret Steedly, eds. *Images That Move.* Santa Fe: School for Advanced Research Press, 2013.

Steedly, Mary Margaret. *Hanging without a Rope: Narrative Experience in Colonial and Postcolonial Karoland.* Princeton, N.J.: Princeton University Press, 1993.

———. *Rifle Reports: A Story of Indonesian Independence.* Berkeley: University of California Press, 2013.

————. "The State of Culture Theory in the Anthropology of Southeast Asia." *Annual Review of Anthropology* 28 (1999): 431–54.

————. "Transparency and Apparition: Media Ghosts of Post–New Order Indonesia." In *Images That Move*, edited by Patricia Spyer and Mary Margaret Steedly, 257–94. Santa Fe: School for Advanced Research Press, 2013.

Steijlen, Fridus. "Chris Tamaela en Supu-isatie." *MUMA (Museum Maluku) Nieuwsbrief*, July 2015.

————. *Kerusuhan, Het Misverstand over de Molukse Onrust*. Utrecht, Netherlands: Forum, 2000.

Steijlen, Fridus, and Deasy Simantujah, dirs. *Performances of Authority*. Leiden, Netherlands: KITLV Press, 2011.

Stewart, Susan. *On Longing: Narratives of the Miniature, the Gigantic, the Souvenir, the Collection*. Durham, N.C.: Duke University Press, 1992.

Stolwijk, Anton. *Atjeh: Het verhaal van de bloedigste strijd uit de Nederlandse Koloniale Geschiedenis*. Amsterdam: Prometheus, 2016.

Strassler, Karen. *Demanding Images: Democracy, Mediation, and the Image-Event in Indonesia*. Durham, N.C.: Duke University Press, 2020.

————. "Gendered Visibilities and the Dream of Transparency: The Chinese-Indonesian Rape Debate in Post-Suharto Indonesia." *Gender & History* 16, no. 3 (2004): 689–725.

————. "Photography's Asian Circuits." *IIAS Newsletter* 44 (July 31, 2007): 1, 4–5.

————. "Reformasi through Our Eyes: Children as Witnesses of History in Post-Suharto Indonesia." *Visual Anthropology Review* 22, no. 2 (2006): 53–70.

————. *Refracted Visions: Popular Photography and National Modernity in Java*. Durham, N.C.: Duke University Press, 2010.

Sushartami, Wiwik. "Representation and Beyond: Female Victims in Post-Suharto Media." PhD diss., Leiden University, 2012.

Taussig, Michael T. *The Magic of the State*. New York: Routledge, 1997.

————. *Mimesis and Alterity: A Particular History of the Senses*. New York: Routledge, 1993.

Toer, Pramoedya Ananta. *The Mute's Soliloquy: A Memoir*. Translated by William Samuels. New York: Hyperion East, 1999.

Triguna, Hartawan, dir. *Peace Song [Nyanyian Damai]*. SET Filmworkshop, 2001.

Tsing, Anna. "Inside the Economy of Appearances." *Public Culture* 12, no. 1 (2000): 115–44.

van Klinken, Gerry. *Communal Violence and Democratization in Indonesia: Small Town Wars*. New York: Routledge, 2007.

————. "The Maluku Wars: Bringing Society Back In." *Indonesia* 71 (2001): 1–26.

Veer, Peter van der. "The Victim's Tale: Memory and Forgetting in the Story of Violence." In *Violence, Identity and Self-Determination*, edited by Hent de Vries and Samuel M. Weber, 186–200. Stanford, Calif.: Stanford University Press, 1997.

Vogler, C. "Introduction: Violence, Redemption, and the Liberal Imagination." *Public Culture* 15, no. 1 (2003): 1–10.

Vries, Hent de. "In Media Res: Global Religions, Public Spheres and the Task of Contemporary Religious Studies." In *Religion and Media*, edited by Hent de Vries and Samuel Weber, 3–42. Stanford, Calif.: Stanford University Press, 2001.

Vries, Hent de, and Samuel Weber, eds. *Religion and Media.* Stanford, Calif.: Stanford University Press, 2001.

Warner, Michael. *Publics and Counterpublics.* Cambridge, Mass.: Zone Books, 2002.

Weber, Samuel. *Institution and Interpretation.* Minneapolis: University of Minnesota Press, 1987.

———. "Wartime." In *Violence, Identity, and Self-Determination*, edited by Hent de Vries and Samuel Weber, 80–105. Stanford, Calif.: Stanford University Press, 1997.

Wessel, Ingrid, and Georgia Wimhöfer, eds. *Violence in Indonesia.* Hamburg, Germany: Abera Verlag, 2001.

Wiener, Margaret J. *Visible and Invisible Realms: Power, Magic, and Colonial Conquest in Bali.* Chicago: University of Chicago Press, 1995.

Williams, Raymond. *Marxism and Literature.* Oxford: Oxford University Press, 1977.

Winn, Phillip. "Sovereign Violence, Moral Authority, and the Maluku Cakalele." In *A State of Emergency: Violence, Society, and the State in Eastern Indonesia*, edited by Sandra N. Pannell, 49–76. Darwin, Australia: Northern Territory University Press, 2003.

World Bank. *Decentralizing Indonesia: A Regional Public Expenditure Review.* Jakarta: World Bank, 2003.

Žižek, Slavoj. "Smashing the Neighbor's Face." Lacan dot com, 2006, https://www .lacan.com/zizsmash.htm.

Index

Adam, Jeroen, 272n40
Adorno, Theodor W., 277n28
aesthetics, 9, 19, 182, 244n51
Ahuru neighborhood, 159, 167
Al Fatah mosque, 174
Aliansi Jurnalis Independen (AJI), 253n41
Ambon City: churches, 175; growth of, 11; map of, 2; markets, 4, 39–40, 41; migrants, 40; mosques, 174, 175; motorbike-taxi stand, 139, 140; origin of, 11; painted landscapes, 136–37; Pattimura Raya Avenue, 2; population profile, 11, 116, 159–60; postwar urban environment, 27, 113–14; property and land disputes, 168; Protestant Christian hegemony in, 7, 11, 12, 130, 136; religious division of, 3–4, 6, 51–52; reputation of, 46; September 11 violence, 222; sketches of, 225–26; transportation, 3; unemployment, 95; Victoria Fort, 226; wartime conditions, 4
Ambon Ekspres (Muslim newspaper), 44
Ambon Island: Christian dominance on, 13–15; Dutch power on, 11–12; map of, 2; population profile, 13; spice trade, 11–12, 240n16
Ambon's Christian University, 116
Ambon's conflict: aftermath of, 2–3, 35, 64–65; amplifications of, 56–57; anticipatory practices and, 61; atmosphere of uncertainty, 38, 182; causes of, 15, 26, 36, 40, 42, 47, 51, 52; comparative perspective, 54, 56, 128, 254n50, 261n128; conspiracy theories about, 64; criminal activities during, 39, 62; geography of, 128; God's presence during, 43, 68–69, 70, 72, 106, 252n34; imagination of

others in, 46–47, 55–56; Laskar Jihad, 34; legal vacuum, 63–64; media coverage of, 8, 18–19, 34, 38, 47–48, 57–58; migration during, 40; outbreak of, 33, 43–44; peacemaking attempts, 64; phases of, 33, 34–35, 249n11; public perception of, 34; reciprocity in, 44; religious divide and, 46, 47, 128, 178; sense of audience, 55; studies of, 36, 45; surge in faith during, 68–69; thick of things implicated in, 45–52; victims of, 34, 44; violence during, 8, 27, 47, 61; visualization of difference, 62–63
Amirrachman, Alpha, 254n53
amulets, 164, 179
Anak Seribu Pulau (documentary), 245n58
anchorage, 109–10
Anderson, Benedict, 54
anticipatory practices, 61
Appadurai, Arjun, 260n121
appearance, 8, 19. *See also* work *of* appearances; work *on* appearances
Aragon, Lorraine V., 249n7, 254n48, 258n89

baku baik (being on good terms), 198
Bali bombings (2002), 123
bang (younger men), 52, 257n73
Bartels, Dieter, 89
Barthes, Roland, 109
Batu Gajah minority, 168
Batu Merah Mosque, 175, 194
BBM (Buginese, Butonese, and Makassarese or Muslim migrants), 40, 272n40
Belakang Soya district: Christian pictures in, 80, 119, 120

Patricia Spyer is Professor of Anthropology at the Graduate Institute, Geneva. She is the author of *The Memory of Trade: Modernity's Entanglements on an Eastern Indonesian Island* (Duke, 2000). She has also edited and co-edited a number of books, including *Images That Move* (SAR Press, 2013), *Handbook of Material Culture* (Sage, 2006, pbk 2013), and *Border Fetishisms: Material Objects in Unstable Spaces* (Routledge, 1998).

CPSIA information can be obtained
at www.ICGtesting.com
Printed in the USA
LVHW072017070322
712831LV00001BA/23